WHAT'S HER NAME

WHAT'S HER NAME

A History of the World in 80 Lost Women

Katie Nelson & Olivia Meikle

DOVER PUBLICATIONS
Garden City, New York

This Dover edition, first published in 2024, is a slightly modified republication of the work, originally published by Michael O'Mara Books Limited, London, in 2024. The text has been edited for an American audience.

Library of Congress Cataloging-in-Publication Data

Names: Nelson, Katie, author. | Meikle, Olivia, author.
Title: What's her name : a history of the world in 80 lost women / Katie Nelson and Olivia Meikle.
Description: Garden City, New York : Dover Publications, 2024. | "This Dover edition, first published in 2024, is a slightly modified republication of the work, originally published by Michael O'Mara Books Limited, London, in 2024. The text has been edited for an American audience"—Title page verso. | Summary: "Sisters Katie Nelson and Olivia Meikle traverse hundreds of years and six continents to present a mesmerizing compendium of captivating stories highlighting women who have shaped history but been overlooked"—Provided by publisher.
Identifiers: LCCN 2024021540 | ISBN 9780486853468 (trade paperback)
Subjects: LCSH: Women—Biography. | Women—History.
Classification: LCC HQ1123 .N45 2024 | DDC 305.4092/2—dc23/eng/20240711
LC record available at https://lccn.loc.gov/2024021540

Publisher: Betina Cochran
Acquisitions Editor: Allyson D'Antonio
Managing Editorial Supervisor: Susan Rattiner
Senior Production Editor: Michael Croland
Cover Designers: Natasha Le Coultre and Peter Donahue
Creative Manager: Marie Zaczkiewicz
Cover and Interior Illustration: Elen Winata
Interior Designer and Typesetter: Claire Cater
Production: Pam Weston, Tammi McKenna, Ayse Yilmaz

Printed in the United States of America
85346201 2024
www.doverpublications.com

For all the women who came before

Contents

Acknowledgments

Historians often get blamed for the lack of women in our popular historical canon. And while that may be a fair accusation to hurl at those who wrote one or two hundred years ago (even one or two *thousand* years ago), the happy news is that it certainly isn't the case today. This book and *What'sHerName* podcast stand on the shoulders of hundreds of historians who have spent years skillfully (often thanklessly) excavating the stories of women. The movement has long been underway and the fruit of those generations of collective labor is inspiring.

To all those who have written painstaking and beautiful biographies of historical women, thank you. To all the teachers and academics who have paused to revisit their narratives and put the women back in, thank you. To those who have recorded the stories of their grandmothers; retold an inherited folk tale; asked a neighbor about their past, thank you. The stories of women are not lost—they just got tucked into dark, dusty corners. Across the world, legions are brushing them off and holding them up to the light again.

What'sHerName podcast has been such an enlightening project for us both. When listeners ask how we choose our subjects, we reply that . . . really, we don't. We choose our experts. We love to ask, "Is there a historical woman in your field that you think deserves more attention than she gets?" The answer is always yes. That very fact is inspiring. So often, we've never heard of the woman before, despite years in academia teaching World History (Katie) and Women's and Gender Studies (Olivia). So this has been a salutary journey that has broadened our lens again and again. To every wonderful human who shares their expertise with us for a podcast episode, thank you from the bottom of our hearts. To Ross Hamilton who asked us to write this book, and to Gabriella Nemeth who helped us finish it, thank you, thank you, thank you.

To every wonderful human who found the episodes we tossed out into the world like a message in a bottle, thank you. You may well be the most important part of this movement. The world is ready and waiting for stories like these to be told and you are the proof.

Really, what we're saying is, this book only exists because of all of you who have sought, found, and painstakingly pieced back together the stories of women who came before. Like St. Brigid's cloak, our own human story will continue to expand.

Prologue

How Did We Get Here?

Well, here we are—all eight billion of us.

Showing some deeply impressive teamwork, we cave-dwelling homo sapiens now inhabit the whole of planet Earth. We've explored the ocean depths, we've flung ourselves into space. And we've figured out some really big stuff along the way.

Yet for all our years here, we've also just been doing the same things over and over. And here's the twist: doing the same things over and over is *how* we figured out the really big stuff. Our story, our collective human saga, may just be the most interesting thing this universe has ever seen.

For three hundred thousand years, a lot of little conscious beings bustling around on planet Earth, just as stupid and just as wonderful as you and me, were doing their best with what they had. And with what they *knew* . . . which most of the time was not much at all. Now *that's* an interesting story.

But here's another twist! The story that's been told to us is not interesting at all. World History (capital W, capital H) is overwhelming, confusing and, worst of all, boring. There are probably lots of reasons for this and we all know our teachers were humans doing their best with what they had.

The thing is, what they *had* was a sad sack of stories strung together by The Man about The Man and the message was: *revere The Man and his exploits.* That made World History not only intimidating, but depressing. *This forgettable factoid I memorized for the exam is important because why, exactly?*

The root of the problem is, our saga has been missing about half the characters. And if half the characters are missing, it takes some serious mental gymnastics to force a compelling, let alone sensible, plotline.

The most amazing lives, with the most shocking plot twists, despairing losses and world-changing triumphs, got left out. These are some of the most iconic lives in human history. We are convinced you will believe it. All we have to do is tell you their stories.

So, here we are.

We're here to tell a *new* human saga. Not the *whole* human saga—no one can do that. But ours is a sweeping, global story of humanity from the very beginning, woven through the lives of women that History left out. Like the rest of us mortals, they aren't perfect. Their stories can be pretty gnarly,

actually. And deeply inspiring, and delightfully absurd, and horrifying, and achingly beautiful. Because those words, it turns out, perfectly describe the whole human story.

Let's begin.

Humans/History

✔ **NOT PERFECT**

✔ **PRETTY GNARLY, ACTUALLY**

✔ **DEEPLY INSPIRING**

✔ **DELIGHTFULLY ABSURD**

✔ **HORRIFYING**

✔ **ACHINGLY BEAUTIFUL**

The Stone Age

ANCIENT HUMANS BUILD ELABORATE STUFF OUT OF STONE—BUT WHY?

In the Beginning, There Were Lots of Naked Ladies

We homo sapiens have been around for about three hundred thousand years and 95 percent of our history was lived in the Stone Age. We call it that because the only things left from this era are stone. Stone tools, like knapped flints or obsidian blades, are just about the oldest things we find where we can firmly say: "A human made this."

We also sometimes find fossilized bones of actual humans. Right now the oldest is from Morocco, but it's possible that recent finds in Australia will turn out to be older. If so, our "out of Africa" story is about to get much more complicated.

Let's fast forward to forty thousand years ago, because that's when things really get interesting—we started making stone art, everywhere. And the more archaeologists find, the weirder it gets, because these artworks are strangely similar all across the world. They also *don't have any clear purpose*. And if we were all doing the same thing, you'd think the reason *why* would be pretty obvious. What's going on?

Venus of Willendorf

Say you were a Stone Age homo sapiens who just discovered that you can, using some pretty cool tools you made, change a lump of sandstone into any shape you want.

Any shape at all! What would you make? Keep in mind, it's going to take you many, many hours, so it's got to be something you like enough to carry on. There are endless possibilities here. And that's what makes these Stone Age archaeological finds so strange.

Pretty much all of the Stone Age art finds are the same weird abstraction of a naked woman. The Venus of Willendorf is the most iconic, but she's one of a zillion. All these little stone figures have no face, giant boobs and bellies, little toothpick arms and stump legs. They've been found all across Eurasia. How many *male* figurines are there? None. Not a-one, over thousands of years. Why?

This question and answer make a beautiful recurring refrain in ancient history. It goes like this: Why? No one knows. Why all the statues of naked ladies? No one knows. They're typically called Venus figurines because academics made this simple calculation:

Ginormous reproductive organs
+ Figurine
= Fertility totem

Mystical, religious explanations are almost always the default explanation. But when we asked you what shape you would have made from stone, was your first idea something religious? Or did you think of something funny? Maybe something useful. Were you going to make a tool, or a decoration, or a reminder of your lost love? Little stone pie, anyone? Cute little doll that looks like your grandma?

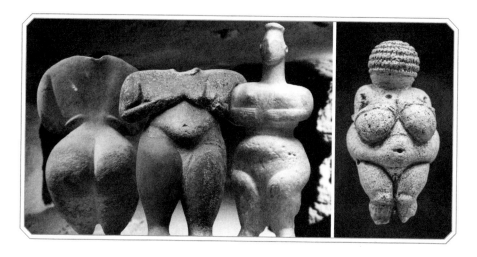

Small sculptures dubbed "Venus figurines" have been found across Eurasia and share the same basic characteristics. The Venus of Willendorf (right).

These are all possible explanations for the likes of the Venus of Willendorf. But there's one more glaring interpretation. You probably already thought of it.

Ancient porn.

What if, when humans first discovered they could make shapes out of stone, they said: "I'm making boobs! Little naked ladies I can carry in my pocket!" It's definitely possible. But we can't prove any one theory. We can tell that these figurines are a huge clue about our own origins—about what it means to be human. We just cannot figure out what the clue actually *is*.

So, the Venus of Willendorf turns out to be a kind of personality test, for now: all our oldest three-dimensional art is faceless boobs on footless legs. What do you think that says about humans?

YOU PICK! THE VENUS OF WILLENDORF SHOWS THAT, IN THE BEGINNING:

- The gods were female
- The ideal female form was large and voluptuous
- Ancestresses (only women) were idolized
- The male gaze objectified the female form
- One prolific porn peddler crisscrossed Eurasia
- We were obsessed with fertility and pregnancy
- We perceived ourselves to be powerful agents in the world
- We perceived ourselves to be powerless and the gods as distant

Sulawesi Handprint

Indonesia, c.39,900 years ago

Once upon a time, a woman inside a rainforest cave sprayed some red pigment over her hand on the wall. When she pulled her hand back, there it was: the world's oldest handprint.

And here we are 39,900 years later, looking at it. How do we know it's a woman? We can't be sure. But compare the ring finger to index finger. Women's tend to be about the same length, while men's ring fingers are longer.

Because we'll never know her name, let's call her Sulawesi Handprint. She made some of the oldest cave art in the world and the more archaeologists look for cave art in Indonesia, the more they find. In fact, ancient cave art is still turning up all over the world. We've found handprints in caves in Argentina, France, Australia, South Africa, Belize, Papua New Guinea, Turkey . . . It makes for a wonderfully universal human story: everywhere, we figured out how to make paint using natural pigments and then we discovered we could blow the pigment through tubes, leaving our handprints on stones.

We painted scenes on a grand scale, too. Artworks featuring all kinds of animals and weird dots and lines. Scenes that seem like stories and sketches that seem like mistakes. The eternal question for ancient historians, philosophers and all of us is: why did we make this art? What does it tell us about being human? Of course, one of the biggest clues about *why* humans made cave art lies in *who* made cave art.

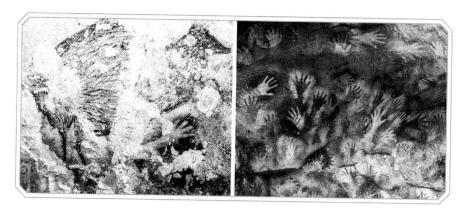

The world's oldest known handprint, Sulawesi, Indonesia (left). Red handprints have been found in caves all over the world, like these in La Cueva de las Manos, Argentina (right), created 9,000–13,000 years ago.

According to archaeologist Dean Snow's analysis, most of these artists were women. Others are skeptical of his findings. They prefer to interpret the hands as adolescent boys—because boys . . . would more likely be exploring in caves? We'll let you do the psychoanalysis there. It must be said, if you interpret the Venus figurines as pornographic products of the male gaze, then maybe the first artists *were* boys. In which case, the teenage boy handprint theory ties it all up nicely. If true, this theory says something pretty profound about human origins. It places young men at the cutting edge of innovation and exploration, while the women are passive, nearly invisible. We've all heard that hot take before: women were too busy with the babies to be out innovating or adventuring. Too busy feeding children to make art, leave a mark, or record a story. We've all been fed that for decades.

On the other hand, if these artists were indeed mostly women—well that's a horse of a different color.

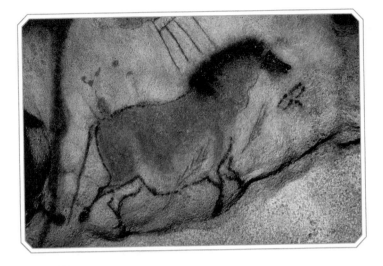

Painting from the famed Caves of Lascaux in southern France. Lascaux's six hundred wall paintings were once believed to be the world's oldest cave art but older finds continue to turn up in other parts of the world.

YOU PICK! STONE AGE HUMANS MADE CAVE PAINTINGS TO:

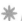 End boredom

Bless the hunt

Decorate their ugly caves

Record or illustrate the tribe's stories

Teach the young about the natural world

Create an amazing stop-motion animation movie theater

Communicate with other nomadic tribes

Take control of the natural world in some magical way

Create a hunting school for kids to practice hurling spears

Take a moment to look again at that Sulawesi handprint. It's the world's oldest message from another human.

"I was here."

What if she's a woman, reaching down through the millennia, showing us where we came from?

Naia

Land of the Lost: Mexico, c.11,000 BCE

When did humans first arrive in Oceania and the Americas? The spread of humankind is one of the biggest mysteries in ancient history. Every couple of years another fossilized skull or tool turns up that gives us even more tantalizing clues and maybe in fifty or a hundred years we'll have our answers. In the meantime, a 13,000+-year-old girl named Naia is delivering the best education we've ever had.

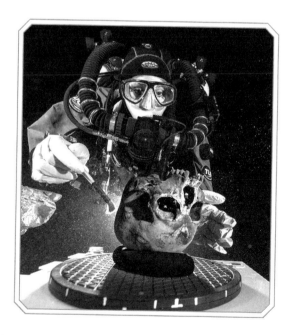

Susan Bird recovers the skull of Naia deep in the underwater cave Hoyo Negro, photographed by Paul Nicklen for *National Geographic*.

The Yucatán peninsula in Mexico is now beloved by hordes of sunburned, drunken tourists, but that's a new phenomenon, historically speaking. During the last Ice Age, about 10000 BCE, much of the world's water was trapped in arctic ice, which made sea levels lower across the globe. Places like Russia and Alaska were connected by land, for example, as were Great Britain, Ireland and France. So, had bikini-clad spring breakers mobbed the Yucatán back then, they would have dried out real quick. Not only were there no beachside taco stands offering bottomless margaritas, there was no fresh water at all.

Why was Naia there in the first place, then, over thirteen thousand years ago? Maybe she didn't know it was so inhospitable. Maybe her people hadn't yet discovered that the limestone rock of the Yucatán had an obnoxious tendency to suddenly collapse into an abyss. The stone sometimes shattered so deeply that it connected to the ocean again; all those collapses created a vast network of tunnels and caves spanning hundreds of miles. Nowadays they're all underwater (thanks, melting ice caps), forming a great uncharted unknown. One that cave divers still die every year trying to explore, which makes the story of the discovery of Naia haunting.

Halfway between Cancun and Tulum, there's a cenote (aka a natural sinkhole) on private property that drops away into an underwater cave system stretching hundreds of miles. In 2007, some intrepid cave divers stocked up with two tanks of air each, plus a little underwater turbine to jet them through the water, in order to explore as far as they could before having to resurface.

They rocketed along for hours, then the tunnel they were exploring suddenly dropped away and they found themselves floating in a completely black abyss. With no "bottom" to reflect from, their underwater flashlights disappeared into the darkness below.

Not all of us would have plunged headfirst into the void, but nothing ventured, nothing gained, right? They dropped a hundred feet into the abyss before their flashlights started to pick up the cave floor again. It was covered in gigantic, prehistoric animal bones. A mammoth skull. A massive thighbone snapped in two. The skull of a cave bear, giant sloths, sabre-toothed tiger fangs . . . the stuff of fantasy.

This was the cache of all caches. But just before their air alarms sent them back the way they'd come, they decided to push on a bit further. And there it was—a human skull, perched on a rise in the cave floor, as if greeting the divers. *Oh, hey there.*

"Oh hey, Naia. How've you been?"

Not so good, it turns out. Naia's skeleton is the oldest complete skeleton ever found in the Americas. And her bones reveal that, in the beginning, life in the Americas was pretty bleak.

WHAT NAIA'S BONES TELL US ABOUT HER LIFE:

* She was fifteen or sixteen years old when she died.

* Her DNA tells us she was new to the area and related to the people of Beringia (that piece of land that connected Russia and Alaska).

* Which may be why she'd had regular periods of starvation. Her people probably didn't yet know what to eat here, or how to catch it.

* She was moving pretty much all the time, carrying heavy bags slung over her back. She had strong legs.

* Her left arm had healed poorly from a spiral fracture. The only way you get a fracture like that is when it's inflicted by another person.

* The segments of her sacrum indicate that she once became pregnant before her body was able to actually carry a child. Oof.

* Her pelvis was broken massively, indicating a fall from a great height. A fatal kind of fall.

Her life was rough, by all indications. Stone Age life in general required a constant struggle to survive. That meant not just finding food, but surviving other humans. Other ancient finds from across the Americas all tell the same disturbing tale, recorded in human bones: extreme aggression seems to have been the norm. The past was not a nice place to be.

The best we can surmise is that Naia must have been searching deep in the cave system looking for water in the dry, hot climate. Maybe her torch went out, or perhaps she didn't have one to begin with. She got lost. It would have

been utterly, completely dark. She could have wandered for hours, even days. And then, in that fateful moment, she took a step and the bottom wasn't there.

She fell 100 feet. If she survived, she would have woken to find herself surrounded by the bones of other prehistoric animals who had made the same mistake. But if she'd tried to get up, her snapped hip bone would have made clear it was hopeless.

Each of us, in moments of terror, have had the thought, "This is it. This is how I die." Did Naia think that too? And could she ever have imagined that the caves would one day fill with water, preserving those bones for thirteen thousand years? That one day, daring underwater explorers would happen upon the spot, passing over her with their underwater lights, then swinging them back again in utter shock?

In her death, in her very bones, she accidentally preserved astonishing clues about the first humans in the Americas.

One thing's for sure. She could never, *ever* have imagined all-you-can-eat shrimp and body shots at Hard Rock Cancun.

Cranborne Woman

The Neolithic Era

Around 8000 BCE, something happened that was so big, we shifted from the Paleolithic Era to the Neolithic Era (Latin for Old Stone Age and New Stone Age, respectively). Around the world, people figured out how to put seeds in the ground and grow stuff, rather than simply moving with the season to eat wild stuff. Farming.

A couple decades ago, the story used to go something like this: One day we figured out we could grow stuff, hallelujah! We were able to stop starving to death, we built cities, specialized our skills, invented writing—and built Civilization with a capital C. We'd saved ourselves from an eternal struggle against the wild!

But then some Wall Street traders started a new lifestyle fad. All our "modern diseases," they said, such as depression, diabetes, ADHD, heart disease and allergies, were caused by this tragic shift to farming back in the Neolithic Era. Live as much like a caveman as you can and you'll be cured, they said. Go spear hunting in the woods, in a loincloth! Climb trees, eat meat and nuts, and reconnect with the Paleolithic lifestyle we were meant to live.

Regardless of the anthropological soundness of the idea, the movement has about a zillion adherents today.

It's not surprising that our historical narratives have also shifted since then. Were we humans *actually happy* to settle into stone-lined cities, never again walking vast distances across sweeping landscapes? Or did we resist? Did we rage against the dying of the light? Some people interpret the mysterious megalithic monuments that litter our landscapes that way. That sea of giant standing stones in Carnac, France, that no one can explain? Maybe hunter-gatherers built a barrier to hold back the tide of Civilization. You can't prove it was that—but you can't prove it *wasn't*.

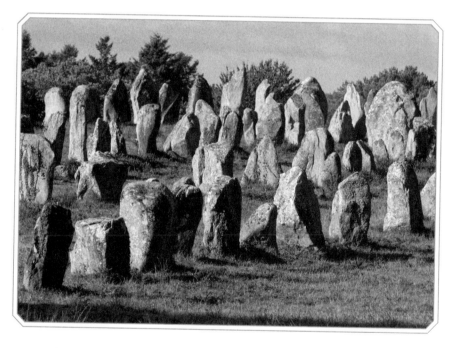

The three thousand stones at Carnac in Brittany, France, are the largest and densest grouping of prehistoric stones in the world.

There are still thousands of megalithic monuments across northern Europe (whether they were once absolutely everywhere and only remain in large numbers in France, Britain and Ireland is an ongoing debate). But the "holding back the tide of Civilization" interpretation of their construction blithely ignores something that most women will think quite important: a great many of the monuments appear to be aligned with moon cycles. Also

known as menstrual cycles. For those of us who ride those brutal tides every month, this is no minor thing.

Tell a group of women that an ancient stone monument could be a sort of menstrual calendar and exactly zero percent of those women will say: "Weird coincidence. But anyway, what is the monument *for*?" Yet, that's been the general interpretive trend for the last three hundred years.

All this makes the discovery of Neolithic Cranborne Woman even more fascinating. The story begins with an endlessly curious English farmer and ends with stunning revelations about the Neolithic lifestyle.

Farmer Green Makes a Miraculous Discovery

Farmer and archaeologist Martin Green had already been digging around Dorset for decades when, in 1996, he was looking over some aerial photographs of the area and noticed something distinctly weird: a perfect circle of pits more than 30 feet across, smack in the middle of his own farm. When early trial digs pointed toward a Neolithic temple site, he knew he was onto something amazing. Little did he know he was about to unearth the archaeological find of a lifetime.

But, as any good treasure hunter knows, the pot of gold never turns up until the very end of the story. So, of course, it was on the final day of the excavation, as the dig shut down and the crew packed up, that an intriguing patch of oddly crumbly rock enticed Martin Green to dig *just a few more inches* ... right into the carefully concealed grave of Cranborne Woman.

The condition of the four skeletons buried there (one woman, three kids) was beyond stunning. Almost perfectly preserved by the alkaline chalk around them, these bones were a mind-boggling find.

But it was once the bones arrived at bioarchaeologist Janet Montgomery's lab that things got really weird, really fast. Montgomery's innovative new "isotope analysis" (basically, tree rings, but for people) revealed something even more astonishing. Cranborne Woman ... wasn't from Cranborne. She wasn't even from Dorset.

Instantly demolishing the "established truth" that once humans began farming, they pretty much stopped going anywhere, these "human tree rings" showed Cranborne Woman traipsing all over England on a regular basis—and picking up children, strange new foods and exciting strontium isotopes in her teeth along the way. And so—as seems to happen every few decades or so—our Official and Very Accurate Story of the Way Humans Were needed to be rewritten, all over again.

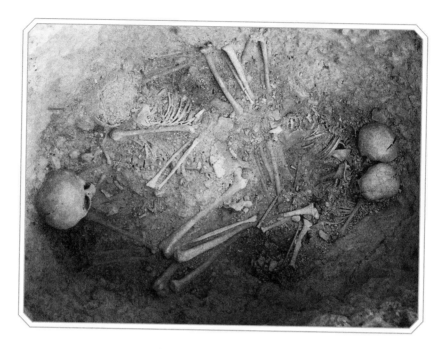

Cranborne Woman and three children, as found buried
in the chalk of Dorset by Martin Green.

Women in Origin Myths

What if we looked for our deepest truths about humanity's origins in our stories, rather than in archaeology? All across the ancient world, our most sacred myths that gave us purpose and meaning centered on women. Biologically, we are generally the "creators," after all. But what's fascinating is how many of these stories are now deeply disconcerting. Sure, there are plenty of tales with women enshrined as nurturers—and those narratives slot pretty neatly into our society's current take on *womanness*.

But that wasn't the only face of women's power. Our oldest stories also invoke women as the *takers* of life, the chaos agents pushing change and progress—and it's not always pretty. Humans have made sacred the stories of women—mortal and immortal—both obeying *and* breaking every rule we've been trained to expect them to follow. What we're saying here is: women can be *all the things*—and all our most ancient myths seem to have known that. Here's a sample of some of the greatest hits.

The Good Moms—Martyrdom Is Their Jam

Nut [pronounced *Noot*]: Ancient Egyptian Sky Goddess Nut's form is the fortress and the "frame" that encircles the *literal* "fabric of the cosmos," her arched body the shield protecting every other being from the limitless chaos of the "Nothing outside." Even her husband, the Earth God Geb, seeks refuge beneath Nut's all-encompassing shadow.

Atahensic (Sky Woman): When the *very extremely pregnant* Sky Woman accidentally falls through a hole in the heavens, a flock of waterbirds bear her down through the clouds. They place her gently on the back of the Great Turtle, swimming through the endless waters below. Then swans, beavers and other water animals carry up big loads of mud from the bottom of the ocean and pile it onto the turtle's shell, creating Turtle Island (aka North America)—the first dry land on Earth. (Clearly, that must have been a *lot* of mud . . . and a *really* big turtle.) Safe on this new continent, Sky Woman will give birth to twin babies—the first Iroquois and first humans on Earth.

The Chaos Agents—Shaking Things Up and Bringing Humanity Down

Eve: Plunked down in the Garden of Eden with only a bunch of animals for company, Adam and Eve are given basically one rule: *This fruit will make you wise—don't eat it.* So, after a couple of chats with a snake, who may or may not be the devil incarnate, Eve weighs her options: a) immortal ignorance or b) rebellious wisdom. Eve chooses option b, comprehends good and evil and—realizing that unless Adam eats too, they'll shortly be heading for the ultimate long-distance relationship—offers him a bite. He accepts and sure enough, this Original Power Couple are swiftly evicted from Eden by a vengeful (or, possibly, secretly pleased?) God. Humanity "falls" from the lofty perch of immortality, consigned by Eve's choice to hard mortal lives in the primaeval wildness of Earth.

Pandora: After Prometheus's treasonous act of giving fire to the lowly humans down on Earth, Zeus wasn't satisfied with just punishing the unruly Titan. (Although having your organs eaten by eagles for eternity seems plenty harsh to us.) But Zeus wanted to punish humanity too. I mean, just *look* at all those humans traipsing around down there with their stolen fire and their

happy, uncomplicated lives! This simply could not stand! So, Zeus got his son Hephaestus to throw together a newfangled, wickedly devious contraption—he called it a "woman"—and then just super-casually dropped her in the vicinity of Prometheus's twin brother, who was still slumming it down in Greece. Then Zeus sat back to watch and wait, unsure if even the famously dopey Epimetheus would fall for such an obvious trap.

He fell for it. Head over heels, in fact, and promptly took Pandora home with him. But, unfortunately for humanity, Epimetheus neglected to check her luggage when she arrived. Because once her curiosity finally got the best of her, Pandora opened the *very special gift* that Zeus had given her, but warned her never to open. In one fatal instant, "all the evils in the world" flew out—and Earth has been overrun with sorrow, vice and violence ever since.

Sigh. Women, amiright?

The Boss Babes—They Got Up like This

The Fates: Talk about *girlbossing*. In ancient Greece, the Morai control every aspect of human life, from when we'll be born to when (and how!) we'll die. These three sisters hold every human life by a thread—literally. Youngest sister Clotho pulls a new strand from her spindle, and *poof*, a child is born. Middle sister Lachesis determines the length of the fragile thread, choosing how long—or how short—each human life will last. Then when elderly Atropos decides the finale has arrived, she snips the cord of your life and . . . time to take a bow.

Oshun: When the Yoruba Supreme God of West African mythology sent seventeen deities to create the Earth, there was only one goddess on the team: Oshun. At first, the male gods insisted on forging ahead without any input from her, confident that the input of a mere *woman* was unnecessary. But, for some baffling reason, their attempts kept failing—over and over and over again.

Once the Godbros were eventually forced to admit defeat, Oshun at last returned to the Earth. And behind her streamed a rushing river of fresh, sweet water—the crucial missing ingredient that would finally bring life to a barren world.

The Naughty Girls—She's the Bad Guy

Tiamat: In the beginning there was Tiamat, the Goddess of the Seas, and Apsu, the God of the Groundwaters. The Babylonian epic of creation, *Enūma Eliš*, tells how their waters mingled peacefully for millennia, spawning the next generation of gods . . . until Apsu got paranoid and decided to kill the kids. You know, just in case one of them decided to usurp his throne? (In other versions, Tiamat and Apsu get terminally annoyed by their offspring's rowdy dance parties—either way, clearly two *totally reasonable reasons* for resorting to mass filicide.) But Apsu's battle skills weren't quite as well-honed as he thought and the kids killed him instead.

Boiling with rage, Tiamat promptly birthed an army of monsters and sicced them on her husband's murderers, aka her own children. But, just like her husband, Tiamat had overestimated her own strength and soon she too was slain—by her own grandson, Marduk. Never one to let a divine corpse go to waste, Marduk sliced Grandma's godly body in two, using one half to form the heavens and the other to create the Earth, happily reigning supreme over both.

Hey, it turns out there's more than one way for a mother to be *involved* in creation.

Izanami: In Japanese mythology, the Gods of the Heavens sent Izanami and Izanagi to organize and populate the world. Dutifully producing children to rule the seas, winds, mountains and trees, Izanami filled the pantheon of this new and turbulent world with (mostly) wise and (mostly) obedient under-deities. But during the birth of Kagutsuchi, god of fire, things went predictably, horribly wrong and Izanami was burned so severely she died.

Devastated, Izanagi mounted a rescue mission to retrieve his wife from the underworld. She agreed to appeal to the Lord of the Underworld the next morning, but begged Izanagi to obey just one crucial rule: until she received permission to leave, he *must not look at her*. So, obviously, the moment Izanami fell asleep, Izanagi lit his magic torch and *looked at her*. And saw a rotting, maggot-riddled carcass, bearing no resemblance to the graceful wife he remembered. (I mean, she's dead, bro. What did you expect?)

Izanagi screeched in horror and, promptly abandoning his quest (and his wife), bolted for the door. Awakened and enraged by her husband's noisy change of heart, Izanami charged after him, pursuing her faint-hearted rescuer all the way across the underworld. Finally, decaying wife hot on his heels, Izanagi scrambled through a rocky fissure back into the light and brought a colossal boulder crashing down behind him.

Now trapped forever in the world of the dead, Izanami screamed out her awful vow: to claim a thousand human lives each day as her eternal retribution. In that moment, she claimed her place as the Shintō Goddess of Creation *and* of Death.

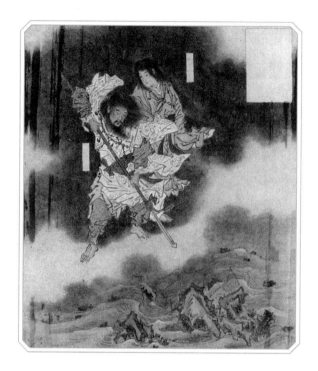

Izanami and Izanagi giving birth to Japan.

And perhaps it is exactly that messy middle space, that defiantly "both/and" ending, which makes Izanami's story so interesting. It's certainly hard to think of a better example of the elusive, tangled, contradictory role of WOMAN (in definite capital letters) across humanity's collective mythmaking.

Girls Just Wanna . . . Well There's No Telling What They Want, Actually

Reading these ancient stories, you can't help but get the sense that humans thousands of years ago seem to have understood something that many of us today still struggle to accept—that "women" are not and never have been a

monolith. And that such a broad and generalized category might be just as useless for decoding "how roughly half of humans were *then*" as it is for explaining "how roughly half of humans are *now*." Women are and always have been as complex, as varied and as individually defined as the human imagination can conceive. So why on Earth did the men so often end up in charge? Let's explore.

First
Civilizations

HUMANS BUILD CITIES:
WEIRDLY, MEN ARE IN CHARGE

Tilafaiga and Taema

The "Mixed-Up Narrative" Narrative

Long ago on the island of Fiji, two sister-goddesses were born conjoined at the spine. Endowed with a spirit of courage and adventure beyond anything before seen in their world, Tilafaiga and Taema were entrusted with an important mission—to bring the art of traditional tatau (tattoo) to the people of the not-so-neighboring island of Samoa. The sisters would pass on the secrets of creating complex designs under the skin using only ash, sugarcane ink and sharpened fishbone needles. Most importantly, they were to share the sacred law of tatau: "Tattoo the women, never the men!"

So Tilafaiga and Taema began their journey, swimming unceasingly through many days and nights, singing their vital command with every stroke. But when a mighty wave thrust them down almost to the ocean floor, it tore their bodies apart! Scrabbling back to the surface, the barely conscious sisters stared in astonished wonder, as each saw the other's face for the very first time. The shock of this sudden rupture jumbled the sisters' song and when they arrived in Samoa, Tilafaiga and Taema taught the people to "Tattoo the men, not the women." And that's why the art of tattoo was strictly "no girls allowed" for more than a thousand years.

What are we to make of this very unusual origin story? It's hard to think of another cultural practice that was acknowledged *at the time* as being "wrong" but still carried on for centuries anyway. What might it mean? On the most obvious level, this is a very familiar pattern: "We've gotta have someone to blame for the way we mistreat women, so . . . let's pin the rap on *other* women!" But maybe there's more going on here.

In some versions of the legend, Tilafaiga and Taema are swimming down to catch an unusually huge clam on the ocean floor when they are struck by the wave. Some variations even point to the giant clam itself as the source of the mix-up: intentionally sidetracking our divine couriers, it jumbled their vital message deliberately. But why? What's this wicked clam's motivation? Are we dealing with The Great Clam of Patriarchy here, or what?

Or is this story really an allegory for how the women of ancient Oceania understood their own choices? Is it "about" Polynesian women choosing to exchange one important, publicly visible form of cultural and social power for a less showy but more highly prized freedom: individuality?

Maybe it's a story about connections (and disconnections) between different Polynesian peoples and traditions. In that case, is the lesson here about respectfully receiving knowledge and skills from other groups, but leaving space for putting your own twist on them too?

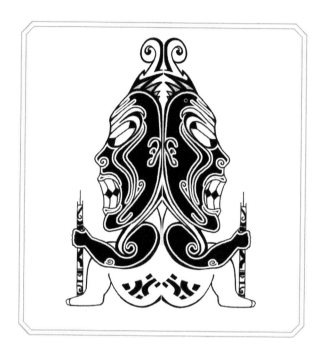

The Polynesian twin goddesses of tattoo
and war, Taema and Tilafaiga.

Or is this a meta-narrative about history itself—a story *about stories*? In a society without written language, tattoos are visual chronicles. They mark the "wearer's" genealogy, their social rank or their accomplishments. Samoan men's histories were inscribed into their own skin, while the women's stories were left unwritten. Is this tale meant as a reminder that decisions about whose stories get to be told are too often arbitrary tricks of fate? Maybe this myth works to preserve the knowledge of a "long ago and far away" time when women's stories, women's power and women's lives were central—reminding folks that "traditional" power structures are anything but traditional.

When a culture openly acknowledges itself as *starting out "upside-down"* like this, the possibilities are wide open.

Civilization Is More Interesting Than You Think

Like Tilafaiga and Taema, after making our epic journeys in the Stone Age, humanity stopped roaming and settled down into a nice wholesome patriarchy called Civilization. Why?

Long story short: where the real estate was really good, where there were rich food sources and nice weather, people crowded in. Come 3500 BCE, those pods of humans were all inventing Civilization sort of simultaneously around the world: cities, industry, plumbing, taxes, writing, war, the whole shebang. There are a few different spots that might be the world's first civilization. The debate constantly rages and, while fascinating, it's really a moot point, since the past is not a race.

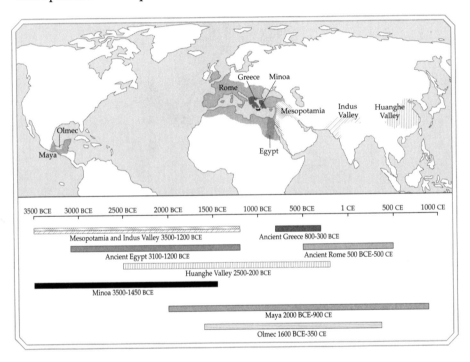

Early world civilizations and their timelines. The fields of Anthropology and History define "Civilization" as a society with a written language.

Life at the birth of Civilization seems like it was packed with hardcore gender roles, with "tattoo only the men" vibes across the globe. But there are some super intriguing exceptions that make for a wonderful puzzle. Let's zoom in on a few actual women and try to imagine what life was really like.

Blue Lady

Heart of the Sea: Crete, 3500 BCE

Ancient Crete draws everyone's eye for one major reason: it appears to have been a female-dominated society that loved music and feasting and didn't know war. And if that's what civilization looked like the first time we tried it? Well now.

It's known as the Minoan Civilization, but that's not what they called themselves. Actually, we have no idea what they called themselves because we can't read their writing. It looks like this. If you can figure it out, do let the rest of us know ASAP.

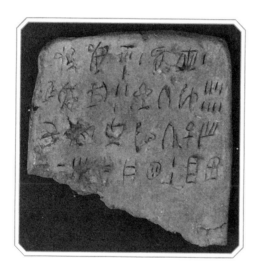

Linear A, the script of the Minoan Civilization, remains enigmatic and even controversial as some argue it isn't a script at all.

The Minoans are utterly mysterious, given that we can't make sense of anything they wrote down. Everything about this civilization is so enigmatic, there's a reason they're the recurring star of *Ancient Aliens*.

Look at that woman on the left in the painting on the next page. Her knowing expression just reaches through time. Her hair is utterly fabulous. She's looking straight at us and smiling like we're sharing an inside joke. Since this fresco is famously dubbed The Blue Ladies, let's call her Blue Lady.

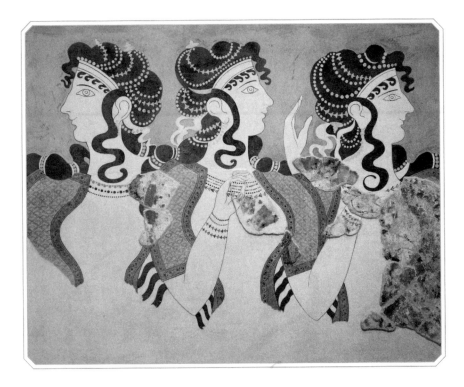

The famed Blue Ladies fresco from Crete. Minoans covered their walls with colorful paintings of feasting, dancing, music and sports . . . and no war.

Blue Lady seems happy to be alive, having a great time. Maybe she wrote down a ton of stuff. Could've been astrophysics, could've been petty gossip, we can't tell. But what *can* we decode about her life? A fair amount, based on Minoan artefacts, architecture and some weird bones at hundreds of sites across Crete. Here are the highlights:

◆ Almost all Minoan figurative art features only women and they always look like our Blue Lady: fabulous dark hair, elaborate gold jewelry, feasting and joy.

◆ They built incredibly sophisticated, sprawling multistory buildings, complete with plumbing and paved streets. Could've been palaces, could've been shopping malls, could've been anything.

◆ We've found tons of sculptures of bare-breasted women holding snakes, each predictably dubbed "the snake goddess."

◆ The only surviving Minoan depiction of males and violence is a fresco of two boys in a boxing match (and that fresco is so damaged, it's controversial).

◆ They really loved sports. Bull jumping was their favorite. It was exactly like it sounds.

◆ We have found zero evidence of weapons, violence, or war. We have found *a zillion* pieces of evidence of jewelry, games, feasts and food storage.

◆ They made a lot of bull-shaped stuff like rhytons (ritual pouring vessels) and possibly topped their buildings with bull-horn decorations. This is why archaeologist Arthur Evans believed he'd found the lost kingdom of Minos and dubbed them Minoans.

◆ Some Minoan paintings show a hazy crowd of people in the background, usually darker skinned than the women in the foreground. While some take these to be racial distinctions, others see social class (darker skinned folks are the peasants working in the sun). Another prominent theory, however, posits that Minoan art actually color-codes genders: women are always presented with lighter skin; men, far in the background, a sort of amber color.

Now you see why the Minoans are so intriguing among early civilizations. Because, if the Minoan artefacts are telling us what we *think* they're telling us, then—hold on. Human civilization is always presented as inevitably linked to male dominance, as if organizing ourselves into large groups meant that of course men would be in charge. But, at least on Crete, humans created a lifestyle very different indeed.

The question you've probably already asked is:

Q: But how long could a civilization last, with no violence, no warfare, no means of defense?

A: About 1,500 years, apparently.

Around 1450 BCE, the Minoan civilization ended. But not before they started cooking children in stews, at remote hilltop ritual sites. Truth is stranger than fiction and the beginning of civilization turns out to be one of the most intriguing episodes in human history.

YOU PICK! WHAT HAPPENED TO THE MINOANS?

- The volcano on Santorini erupted, washing them away in a tsunami
- Their new neighbors, war-obsessed Mycenaeans, invaded
- Their island sank, becoming the legendary Atlantis
- They brought about their own environmental destruction
- They got a weird new cannibalistic religion and died out
- They were aliens and went back home

Dancing Girl

Land of Architecture . . . and Dance?
Indus Civilization, 2500 BCE

Meet Dancing Girl. She's four inches high, two inches wide and made of bronze. If you know what it takes to make a three-dimensional bronze cast figure, you're already impressed. Dancing Girl is 4,500 years old and, since she was unearthed in 1926, she's been the icon of the ancient Indus Civilization.

What can she tell us about the place she came from? We could really use her clues, because the Indus Civilization is as mysterious as the Minoans. They built hundreds of massive, sophisticated cities that had things like uniform bricks, indoor plumbing and waste collection systems. And even in cities that stretch over 270 acres, we haven't found any palaces, temples or military centers. In other words, where is The Man in all this?

Wish we could tell you. But their writing, like the Minoans', is a complete mystery, so we have to turn to Dancing Girl and extract clues from her directly. What was her world like?

There was . . . a lot of dancing? At least that's what people assume, but we can't really prove she's dancing. She's got a sassy pose, that's for sure. Her

confidence radiates. She's got twenty-five bangles on her left arm and she's holding . . . *pulls out magnifying glass* . . . um, an object. She's topless. Also bottomless, maybe? She's rocking a side bun and a cool necklace. Put all that together and archaeologists conclude: dancing.

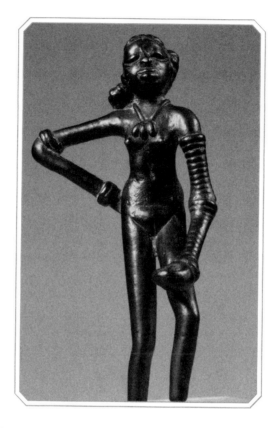

The prehistoric dancing girl statue was made by an ancient Indus artisan using lost-wax bronze casting between 2500 and 1750 BCE.

Dancing Girl is the Venus of Willendorf on Opposite Day. Tiny boobs, no hips, skinny torso; her arms and legs are the main point, instead of shrinking into nothing. Her face is clear and bold, radiating personality. Is this what women's lives look like when The Man isn't ruling over everybody? Was Dancing Girl sculpted because she was a beloved cultural icon? Is she telling us that individuals—individual girls, even—were valued in this civilization of apparent equality? If you've got some spare time this weekend, consider decoding it for us all; you'd answer a lot of questions.

Enheduanna

Land of Clay and Reeds: Mesopotamia

I have given birth, oh exalted lady, [to this song] for you.
That which has been created [here] no one has created before.

Enheduanna

Now here's some writing we *can* read and we've got quite a lot of it. It's cuneiform script from Mesopotamia, composed by pressing a sharp reed (stylus) into a clay tablet.

Cuneiform tablet inscribed with Enheduanna's poem *Innana and Ebhi*. In this passage, goddess Innana vows revenge on the mountains for not showing her due deference.

Thanks to our ability to read it, we've discovered the first named author in human history: Enheduanna. For someone who lived over four thousand years ago, we actually know a surprising amount about her. The daughter of King Sargon the Great (often called humanity's first emperor), Enheduanna was High Priestess of the Moon God (cool title) in the Mesopotamian city state of Sumer.

Sumer and the city states of Mesopotamia are usually presented as the first civilization on Earth. Mesopotamia makes for a stark contrast to Dancing Girl's Indus Civilization or Blue Lady's Minoa: Mesopotamian culture went the "build massive walls, make threats and kill each other" route. Life there would have been testosterone-fueled and violent; if you were a regular Jane, you never would have left the confines of your walled city. So it's fascinating that past historians decided Mesopotamia was the place to begin the human story. Ignoring all the other sophisticated civilizations across the globe, they boldly selected patriarchal, warlike Mesopotamia as the place to tell us who we are and where we came from. It's the famed land of Sargon and Gilgamesh and Hammurabi—powerful kings who were firmly in the "tattoo the men" camp. Helpfully for historians, Hammurabi famously had all his laws carved into a giant basalt monument—known as a stele—and displayed in the center of town. The 282 laws paint a vivid picture of life in Mesopotamia, listing all possible crimes and their punishments.

CRIMES AND THEIR PUNISHMENTS FROM HAMMURABI'S CODE, 1750 BCE:

196. If a man put out the eye of another man, his eye shall be put out. [An eye for an eye]
200. If a man knock out the teeth of another man, his teeth shall be knocked out. [A tooth for a tooth]
195. If a son strike his father, his hands shall be hewn off.

So far so good. However, all punishments actually come in pairs, depending on whether the victim of the crime was wealthy or poor:

198. If he put out the eye of a wealthy man, or break the bone of a wealthy man, he shall pay one gold mina.
199. If he put out the eye of a man's slave, or break the bone of a man's slave, he shall pay one-half a mina.

But what if the victims are women?

209. If a man strike a wealthy woman so that she loses her unborn child, he shall pay ten shekels for her loss.
210. If that woman dies, his daughter shall be put to death.
211. If a man strike a poor woman and she lose her child by a blow, he shall pay five shekels in money.
212. If that woman dies, he shall pay half a mina.

Let's run the numbers here. The life of a poor pregnant woman is worth one half of a mina. The eye of an enslaved man is worth half a mina. The eye of a wealthy man is worth one mina. Cool cool cool.

A few more woman-relevant laws just to bring Mesopotamia to life:

194. If a man gives his child to a nurse and the child die in her hands, but the nurse unbeknown to the father and mother nurse another child, then they shall convict her of having nursed another child without the knowledge of the father and mother and her breasts shall be cut off.
142. If a woman quarrels with her husband and says: "You are not congenial to me," the reasons for her prejudice must be presented. If she is guiltless and there is no fault on her part, but he leaves and neglects her, then no guilt attaches to this woman, she shall take her dowry and go back to her father's house.
143. If she is not innocent, but leaves her husband and ruins her house, neglecting her husband, this woman shall be cast into the water.

If we were choosing a civilization to live in, we'd give Mesopotamia a hard pass. What's a woman to do in a culture like this? The only route with any meaning or freedom is religion. Women could be priestesses. As High Priestess, Enheduanna not only presided over important temple rituals and religious rites, she was also in charge of practical matters such as managing the city's grain storage, which was, interestingly, a religious act. Most importantly (for us now, anyway), she was tasked with helping bridge the gap between the local Sumerian population and her conquerer father's "imported" Akkadian lifestyle.

To complete that assignment, Enheduanna decided to employ a powerful new tool that had only recently come into fashion: a newfangled technology folks were calling "writing." Specifically, she decided on cuneiform. But Enheduanna had vision. Seizing the possibilities offered by the increased flash and flexibility of this new form of writing, she penned (reeded?) dozens of hymns for all the area's major deities. Each poem sung the praises of the Patron Goddess—not God, *Goddess*—of each of Sumer's major cities. Bold move, considering the place of women in Mesopotamia!

But when it came to doing the unexpected, Enheduanna was just getting started. Instead of positioning her subjects in a remote, inaccessible, metaphorical Divine Bubble far beyond mere human foibles, Enheduanna wrote about deeply individualized, oddly human goddesses. They are, in the words of modern translator Betty De Shong Meador, "active, engaging, uncontrollable divine beings," experiencing and expressing love and hate, compassion and fear, in ways never before ventured in print (clay?). Using the written word in this way—to tell stories, especially deeply emotional and personal-feeling stories like these—was a daring and wildly unprecedented strategy. But it paid off big time. These are compelling and personal narratives, told with remarkable skill and remarkable style. No wonder they were a smash hit! From the number of copies that were found to have been circulating in Mesopotamian society, even centuries later, we can confidently crown Enheduanna's poems the first known #1 bestseller in human history.

These innovative hymns unquestionably helped cement Enheduanna's place at the top of Sumerian cultural and religious power. She served as High Priestess in Ur for more than forty years (one brief interval of wandering the desert in exile after a successful but short-lived military coup following the death of her father notwithstanding). But the true success of her efforts to merge the new empire's pantheons is probably best shown in Enheduanna's victory with the myths of Inanna and Ishtar.

By melding the largely unimportant Sumerian goddess Inanna with the powerful and popular Akkadian goddess Ishtar, she created an opportunity for Sumeria (and Sumerian women especially) to elevate their own female deity in status and consequence. These are women of power and consequence. At the same time, Enheduanna is almost nonchalantly merging the two religious traditions in ways that feel completely natural and nonthreatening. Enheduanna's literary skills almost magically turned a bitter religious clash into a mutually beneficial divine integration, promising happy endings for all without asking anyone to so much as change teams.

It turns out the pen (reed?) may just be mightier than the sword after all.

Gargi Vachaknavi

Gargi and the World's First Facebook Fight, c.700 BCE

What did people believe about the universe and our place in it, so far back in time? There are all kinds of interesting theories about Stone Age paganism, mostly focused on holy mountains or sacred springs. But the truth is, we can only guess because we have no Stone Age writing to tell us, *here's what we believe: you stand on this spot, face that mountain who is Earth Mother, turn around three times repeating the magic word, then bury a bag of oats under that statue of the Rain Goddess.*

When we can read their writing, the first civilizations give us better clues. One of the oldest religious texts that survives is a collection of stories from ancient India, the *Upanishads*. It's the first record of one of the world's oldest religions, Hinduism. All the main characters are male (surprise!), so it makes for an interesting counterpoint to Dancing Girl . . . or clue *about* Dancing Girl.

But here's the twist: at the climax of the most profound story in the whole of the *Upanishads*, the one that unveils the deepest truths about the universe and our place in it, a woman makes an appearance. Gargi Vachaknavi quietly rolls onto the scene, asks a few questions and reveals herself to be the wisest of them all.

Here's how it goes. A grand debate is taking place between all the wise men of the land. Naturally, a crowd has gathered, all ears. The debate is actually a performance, for the enlightenment and entertainment of the crowd. It's a Facebook fight, essentially: an argument for show. People are asking all kinds of questions and the gurus are swatting them like Serena Williams on a tennis court. This guy named Yajnavalkya is winning by a long shot.

Gargi steps up. But rather than facing the gurus, she turns to the audience. "I'm going to ask Yajnavalkya two questions. If he can answer them, no one else will ever be able to defeat him," she says. And with that, she's done something quietly revolutionary. She's made herself the judge. *If he can answer these questions, he wins.*

"Here's question one," she says. "On what is the universe woven back and forth?" This is a cool way of asking what is at the root of all existence. Yajnavalkya dodges. "It's woven on space," he says. Gargi throws him some side-eye. "All honor to you, Yajnavalkya, you *really* cleared that up for me. Time for my second question: on what is the universe woven back and forth?"

Zing! Did you see that? The whole audience is grinning and elbowing each other. She knew he was gonna dodge the first time, so she planned to ask it twice. Who is this lady?

This time, Yajnavalkya gives up the goods. His answer is the most famous passage from the Upanishads, illuminating the deepest truth that everything is *Atman*. It's not made of matter, it has no caste or race or gender. It's beyond any physical attributes we put upon ourselves. It's the eternal spiritual essence of all beings. Consciousness.

You could hear a pin drop, but all eyes pivot to Gargi. *Is he right? Tell us, Gargi! Is that the true nature of the universe?* She smiles. "He's right," she declares. "None of you will defeat this man in debate."

So here we have the deepest truths from the Indus, one of the world's oldest civilizations. And it's rooted in Hinduism, one of the world's oldest and (still) most popular religions. It has been spoken by a man, yes, but coaxed out of him by a woman, who just floated all-knowingly into the scene.

We could analyze this all day. Zoom out and everything is *Atman* and our human forms—gender, more particularly—simply do not matter at all. Zoom in and everyone in the Upanishads is a man—except Gargi, who appears to, quietly, be the wisest one of all.

Pythia

Curiouser and Curiouser: the Oracle of Delphi

An amazing archaeological site in Greece preserves another ancient relic of early religious belief. It too revolves around a woman believed to be wiser than them all. Turns out, if there was one thing ancient Eurasia could agree on, it was that the advice of an old lady on a three-legged stool at the top of Mount Parnassus was the most valuable info in the world. The year is anywhere from 800 BCE to 400 CE. Kings, emperors and other powerful men all across the ancient world are making the arduous, sometimes months-long trek to an isolated Greek temple just to ask an elderly Greek peasant woman a single question. Why? Because she is the Pythia and she alone can see their future, direct their destiny and channel the voice of God.

This is huge. This means that for over a thousand years, the most powerful person on Earth was a random elderly peasant woman (and her centuries

of successors) sequestered for life on a remote mountainside. The Pythia's answers to the era's biggest questions will shape the course of human history in mind-boggling ways: sparking (or averting) wars and conquests, preventing (or provoking) assassinations and coups, thwarting or affirming Eurasia's most momentous marriages, treaties and alliances. The word of the Pythia would alter the face, and the fate, of the world.

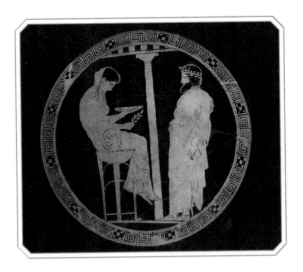

Pythia depicted on a Greek cup, fifth century BCE. She sits on her three-legged stool and holds a bowl and sprig of sacred laurel.

But how exactly does this whole Oracle thing work? The protocol for asking a question goes something like this: on the nine days *per year* when the Oracle is open for business, you may approach the Temple of Apollo, bearing your offerings for the God. This had better be something pretty spectacular if you want to impress Apollo, because the kind of dudes who make it here are usually pretty flush. And only after you place your offering on the pile (frankly, it'll be a relief to finally drop that solid-gold statue of a lion or life-sized bronze chariot complete with horses after schlepping it a few hundred miles) will you be allowed into the temple complex itself.

The next step in obtaining godly counsel: Goat Divination! Place a goat (you remembered to bring your goat, right?) on the temple altar and pray for approval. Does your goat shiver from head to toe when the priests sprinkle it with cold water? If yes: you're in! Apollo is in the mood to listen today. If not: too bad, so sad. You'll have to try again another month. No refunds of

gold lion statues. But lucky you, your goat shivers and you're finally ushered into the presence of the Oracle to ask your question! Yet even here we cannot actually see the Pythia herself. She receives visitors' questions and channels Apollo's answers, from behind a screen, where she sits enveloped in the temple's sacred vapours. But though we cannot watch the Oracle at work, we can definitely hear her—an eerie voice chants the mystical words of Apollo's answer. Unfortunately for us, that answer is not delivered in Greek. In fact, it's not in any language that we—or indeed anybody—have ever encountered. This is obviously going to make following Apollo's advice a bit tricky.

But fortunately for us, after only a few centuries of frustrated pilgrims struggling to puzzle sense out of the Pythia's cryptic replies, a handy solution arrives in the form of a gaggle of helpful priests, sent by Apollo himself! And given that he appeared as a dolphin to recruit them, who could possibly doubt their divine calling? These devoted men (and yes, they are all men—why do you ask?) are always standing by to translate Pythia's answers. And wow are they amazing translators, converting her incomprehensible language of the gods into beautifully polished Greek . . . and sophisticated hexameter verse, no less! Hmmm. Suddenly this refreshing specimen of unexpected ancient girl power has developed a distinctly patriarchal aftertaste. The Oracle is still a woman, certainly. But if all her messages must now be run through an entirely male (all suspiciously politically well-connected) filter system, how much does the Pythia's voice actually matter anymore?

Sadly, it appears that once again the unruly authority of a powerful woman unbossed by any man has been brought not-so-subtly back in line by her society's male power structure. Clearly, the wild and uncontrolled influence exerted by those early Pythian prophets could not be allowed to continue and the privilege of ~~manipulating~~, er, *guiding* the key decisions of the world's most powerful men was firmly handed back to the patriarchal powers that be. So, while Ancient Greece does have a couple of strong examples of influential women, our best advice for living in Ancient Greece is: do not be a woman. It really will not be enjoyable at all.

It's clear that many rulers are happy to travel vast distances to inquire at the temple of the Pythia. But if you live in, let's say, ancient China? It's kind of a pain to trek all the way to Greece to ask the Oracle a single question (though some still do). Luckily, there's another way to contact the divine without leaving the continent. It involves dragon bones, faraway caves and the chance illness of an archaeologist.

But history is changing drastically by the time we get to dragon bones, so we'd better start a new chapter.

Ancient Empires

KEEPING UP WITH THE ROMESES

The Tale of Dragon Bones and a Sick Archaeologist

The story goes that, in 1899, a famous Beijing scholar named Wang Yirong got sick. An antiques dealer told him he'd just got a new shipment of dragon bones, which (as everyone knows) will cure all kinds of illnesses if you grind them up and drink them. How do you spot a dragon bone? They're clearly very ancient and they have faded otherworldly writing on them.

Wang requested his dragon bones *not* ground-up and the rest is history. The Shang Oracle bones are the oldest surviving writing in China and some of the most important discoveries in Chinese history. Annoyingly, scientific analysis has identified the bones as mainly from oxen and turtles; no dragons . . . yet. About a hundred and fifty-five thousand have been found—presumably many more thousands lined the stomachs of Hunan laborers.

As scholars decoded the ancient script, they realized that the bones had, in the deep past, been used for divining the future.

HOW TO DIVINE THE FUTURE WITH AN ORACLE BONE:

1. Ask your question

2. Write the possible outcomes on a bone (preferably dragon)

3. Zap the bone with a red-hot iron, until you hear a snap

4. Wherever the bone cracked, that's your answer

One woman turns up in the Shang Oracle Bones over and over: Fu Hao. Her high-stakes royal life was the focus of everyone's attention. What was the meaning of her dream? What day should she present a feast to the ancestors? What will be the outcome of her pregnancy? Sometimes the priests recorded the actual outcome on the bone, too. For example, the pregnancy bone predicted a "Not Good Outcome." Next to that, a little scribble from the priest tells us: "It was not good. It was a girl." Details like that paint a classic "tattoo the men" society: girl bad, boy good. But other oracle bones show that even though it was a patriarchy, it wasn't the old "women-belong-in-the-kitchen" brand

of patriarchy. Lots of the bones inquire about Fu Hao's battles: will she be victorious? Should she invade *this* neighbor or *that* neighbor? Do the ancestors prefer these captured villagers be boiled alive, burned or decapitated?

Fu Hao, who was born c.1040 BCE, was a warrior queen, personally leading China into a new era of conquest. And she wasn't alone—around the world, everyone who was anyone was trying to take over everyone else. Why did humans go crazy for empires in this era? You'll get a different answer from every historian and different answers still from every philosopher, sociologist and psychologist. We'd discovered how to smelt iron—maybe that was it. Suddenly we could make sharp, stabby things that were also strong. Have dagger, must stab. Maybe that's a universal rule of human nature?

Or, some say, it could have been the opposite. Maybe we evolved enough to set tribalism aside and try for lasting peace and unity. But to get unity, first you have to stomp out everyone clinging to the old tribal ways.

YOU PICK! EMPIRES ARE ROOTED IN HUMAN:

- Curiosity
- Ingenuity
- Aspiration
- Exploitation
- Us vs. Them mentality
- Conformity
- Thirst for power
- Yearning for something bigger than ourselves
- Altruism
- ~~Humans~~ Aliens

Whatever the cause, for over one thousand, five hundred years, humanity had an empire-building phase. But what was it like to live in an ancient empire? Each one offers certain pros and cons. Which one is the best match for you?

QUIZ: WHICH BEST MATCHES YOUR GROOVE?

- Epic battles, but make it fashion
- Political scheming and sabotage sounds fun
- Democracy, aw yeah! Citizen power!
- Give me tolerance and diversity or give me death
- Give me one unified way of life or give me death
- I'd like to rage against the machine, please
- Let's just be so scary no one bothers us
- Less patriarchy, more elephant
- More patriarchy, less elephant
- The important thing is connecting people to each other

Congratulations, you've matched with an ancient empire! Keep these results in mind should you consider any future time travel. Let's dive into your results . . .

Fu Hao

Epic Battles, but Make It Fashion: The Shang Dynasty

If this is your jam, you belong out on the battlefield with Fu Hao. Fu Hao had all the finest things money could buy (money, incidentally, was quaint little seashells). When archaeologists found her tomb in 1976, they couldn't believe their luck. Surely, this couldn't be the famed Fu Hao mentioned on all those oracle bones? But it was. Her body and coffin had long turned to dust, but all her supplies for the afterlife stood the test of time.

What does a warrior queen pack for the afterlife, you ask? *So* many hairpins. Five hundred intricately carved bone hairpins, to be exact. So, imagine Fu Hao's hair as elaborately as you can. She also needed 4 mirrors and hundreds of

delicate jade, bronze and ivory vessels containing . . . who knows? The contents are long lost to time. She needed 755 precious jade figurines, too: little carvings of people and creatures, pretty much everything you can imagine. Some of them were already hundreds, even thousands, of years old when she acquired them. What an icon. Oh also? She packed 130 weapons. Including 4 large execution axes, which she definitely used. She packed 27 knives, 20 arrows and 4 tigers. What?! The foundation of her tomb was lined with 9 dogs and 1 human. She also needed 23 bells.

Finally, surrounding her tomb in little radiating pods, sixteen humans were sacrificed to attend her in the afterlife. Some Shang sacrifices have severed heads; others may have been buried alive. So, if you chose *Epic battles but make it fashion*, you also inadvertently chose to be sacrificed at the grave of Fu Hao. Hope that's okay.

This lady was General of the entire Shang Army, answering only to King Wu Ding, her husband. She dominated the battlefield, winning vicious victories against "hostiles" to the north. Now, we generally don't like labels, but . . . given her penchant for human sacrifice, if anyone deserves the label "hostile," it's Fu Hao. She was constantly asking oracle bones whether she should execute her captives by slow roasting, decapitating, burning or boiling alive. She must have been terrifying. And if Shang China set the model, did all ancient empires follow suit? Was living in an empire a terror from start to finish? Let's look.

Tawosret

Political Scheming and Sabotage Sounds Fun: Ancient Egypt

Partial to a little political scheming? Ancient Egypt will prove the ultimate test of your saboteur skills—especially if you happen to be a woman. Hope you're up to the challenge.

Egypt built empires differently. For the first 500 years (starting around 2600 BCE), as an Egyptian you would have believed that the Pharaoh was a god incarnated, sent here to shepherd us little humans into the afterlife. The key to all that, apparently, was for the Pharaoh to have a massive pyramid tomb. The deal was that we spend large chunks of our lives working on his pyramid and, when he dies, he gets into the afterlife based on all our fine work. He sort of holds the door open for us all and we sneak into the

afterlife behind him. All the famed Egyptian pyramids come from this first 500 years of Egyptian history, known as the Old Kingdom. But eventually, the people of Egypt had the inevitable awakening: *Hold on, why is it my job to get the Pharaoh into the afterlife? Couldn't I just get my own self into the afterlife?* No more pyramid-building. This marks a new period in Egyptian history: the Middle Kingdom.

If you live in the Middle Kingdom, the good news is you get *yourself* into the afterlife. The bad news is you . . . get yourself into the afterlife. What if you do it wrong? What if you're not good enough? The stakes are so high now, someone needs to tell us what to do! Never fear: the *Book of the Dead* explodes onto the scene, telling fearful Egyptians exactly what to expect at the moment of judgment, including all the secret code names you need to memorize to get into the afterlife. You'll want to be mummified, too, anticipating your success, so your *ka* (spirit) can hang around and enjoy all your stuff for eternity.

By the time Egypt has entered the New Kingdom period, other ancient empires have descended upon them (hello, Mesopotamia) and a strange group of monotheists called the Hebrews may or may not have lived there before escaping across the Red Sea (depends on who you ask).

And by the year 1200 BCE, something strange is happening in Egypt and beyond. In hindsight, we call it the Bronze Age Collapse: basically, all the oldest civilizations went *poof* and disappeared, for reasons that are still mysterious to us today. Egyptians wrote about invading "Sea People," but who they were is anybody's guess. Other evidence points to different theories, so take your pick:

YOU PICK! WHAT CAUSED THE BRONZE AGE COLLAPSE?

- All the aliens went home
- The Santorini volcano erupted, blocking out the sun for years
- The Sea People invaded everyone, leaving no archaeology
- A series of domino-effect climate crises
- Revolutions

■ A drought that lasted 150 years

■ A fifty-year "earthquake storm"

The Bronze Age Collapse was effectively the end of the world. Some civilizations would slowly claw their way back, over the course of centuries; others, like the Minoans and Mycenaeans, were gone forever. China and the Maya seem to have been the only two to come out the other side intact.

And at this moment of chaos and desperation in Egypt, Tawosret stepped up to the plate.

It's sometimes tempting to envision a forgotten feminist utopia when we stumble upon one of history's "lost queens." But sadly, when digging into history's more aggressively bro-heavy empires, finding a woman on the throne is usually a sign that things are about to get real bad, real fast. Not because women rulers tend to screw everything up, but because most Ancient Boys' Clubs only ever consent to put a girl in charge when there's no other option. Not until civilization is teetering on the brink will they grudgingly hand a woman the reins—only to then blame her for the inevitable crash. This definitely holds true for Egyptian Pharaoh Tawosret. First arriving on the scene as Regent for the sickly young pharaoh Siptah, her reign would mark the end of the crumbling Nineteenth Dynasty. But Tawosret wasn't Siptah's mother or his sister (or both—we are in Ancient Egypt, after all), making her selection for the position anything but obvious. So how did she take control of one of the most male-dominated, change-resistant empires in history?

Thanks to the *ever-so-slightly* autocratic nature of ancient Egyptian rulers—and the relative durability of stone—our knowledge of ancient Egyptian history is based almost entirely on the "official communications" carved into monuments, temples, or tombs by order of the pharaoh. This means that for the most part, all we know is what the rulers of any given period wanted us to know, minus whatever the rulers who came after them went out of their way to erase. Like, imagine if everything we know about US history came only from official White House press releases? Yikes. Our picture of Tawosret's life is . . . spotty, to say the least. Named Regent after the death of her husband, Seti II, Tawosret is meant (at least in theory) to rule on behalf of ten-year-old Siptah until he's old enough to take the throne properly. In reality, it's impossible to say when—or even if—this sickly, inbred, severely disabled boy will be ready to wield power.

As it turns out, he never gets a chance to try. Because shortly after Tawosret takes the throne, another mysterious figure appears on the scene—and on monuments and statues alongside the official "royal pair": the perplexing character known as Chancellor Bay. So, what's Bay's deal exactly? Where did he come from? Why is he here? We'll probably never know. What we do know is that after several years of this odd ménage, Egyptian artisans received a message announcing that "the Great Enemy Bay" had been killed—by the Pharaoh Siptah himself! So it seems likely that the population rejoiced at word of Bay's removal, viewing him as an illegitimate and despised interloper.

But this development does raise a few new questions, mainly: "How likely is it that a sixteen-year-old, suffering from multiple major health conditions and still firmly under the thumb of at least one adult proxy, independently planned and executed a successful targeted assassination of a powerful court official?" Surely we've got to assume Tawosret was at least heavily involved here, if not the mastermind behind the whole scheme. Especially when we learn that Siptah himself will be dead within a year of Bay's mysterious removal. You can see the chaos of the Bronze Age Collapse in action here, right? But how did Siptah really die? Was his murder the final cold-blooded step of a ruthlessly ambitious Tawosret's master plan? Was his untimely death from natural causes (his litany of ailments was definitely nothing to sneeze at) a catastrophic blow to Tawosret's frantic efforts to hold a crumbling kingdom together? Was the boy pharaoh's death the result of some other unknown wannabe protagonist's botched attempt to seize the throne? With no real evidence to examine, we're gloriously free to speculate.

YOU PICK! WHAT SHOULD WE MAKE OF TAWOSRET? WAS SHE:

- The gullible, clueless puppet of master-manipulator Bay
- A crafty and ambitious usurper, systematically murdering her way onto the Egyptian throne
- A well-meaning guardian whose attempts to protect her stepson/nephew/brother-in-law, maybe? were foiled by the inevitable results of generations of deliberate inbreeding
- An alien (of course)

One thing at least is crystal clear: the Egyptian people were unwilling to accept the Regent without her ruler. Maybe they blamed Tawosret for Siptah's death. Maybe they saw her rule as a liability in a world turned upside down by wider global catastrophes. Maybe they just couldn't bear the thought of a girl being the boss of them. Whatever the reason, only a few years after Tawosret claimed her throne in earnest, a mysterious southern challenger named Setnakhte declared himself Pharaoh. Tawosret was out of the picture and the Egyptian empire continued its slow fizzle into oblivion.

Tawosret is only one of several female pharaohs placed and replaced on the throne in times of chaos or crisis. But her story serves as a reminder to any of us tempted to take on a few political machinations of our own that, while circumstances can sometimes make humanity's most dedicated Boys' Clubs grudgingly accept a girlboss when there's absolutely no other option, nobody can ever make them like it.

Aspasia

Democracy, Aw Yeah! Citizen Power!: Classical Athens

If you chose this option, picture yourself in Ancient Athens. Greece has pulled itself out of the Bronze Age Collapse after 400 years of the Dark Ages, and philosophy is all the rage. There's a special set of steps overlooking the city, where anyone can stand and speak their mind. It's the designated free-speech spot: the *Pnyx*. Visualize yourself there, engaging with your fellow citizens to build a better Athens.

Also, back then you didn't get elected through corporate backing and secret wealthy donors. You got elected only by fate: a device known as a *kleroterion* randomly knocked loose sheets of lead bearing the names of the people's new representatives. If the kleroterion chooses you, it's your time to step up. That's Greek democracy, baby. The foundation of modern western society!

There's just one teensy little caveat. Just a tiny, irrelevant detail, really. Only *citizens* could be elected; only *citizens* could vote; only *citizens* could speak at the Pnyx. To be a citizen, you had to be a land-owning white male whose family had already lived in Athens for generations. Women—yes, all of them—could remain silently at home for the duration of civilization, thank you very much.

Which is what makes Aspasia, one of the great minds of classical Athens, all the more incredible. She wasn't even from Athens—maybe that's how she escaped the fate that confined Athenian women. She was from Miletus (in modern-day Turkey), a city often heralded as the birthplace of philosophy. She could read and write and engage as an equal with the greatest minds of her day. Meanwhile, Athenian women experienced a status very similar to today's pets. The variations in behavior and care that today's dog owners display were the same as those offered by Athenian husbands. Women could get together with each other while their husbands were away, perhaps, though it wasn't unusual for a husband to lock his wife away anytime he left home. And women certainly did not belong out in public.

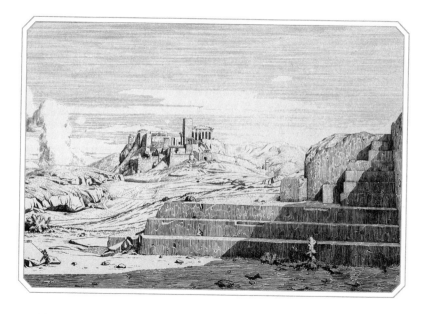

The steps of the Pnyx, Athens, designated "free speech" spot, with the Acropolis in the background. Both remain to this day.

Aspasia, though. She walked around in public, that was shocking enough. She gave public lectures and people hung on every word. She literally founded a school—*the audacity!*—open to both women and men. Who taught Socrates how to hone his rhetoric? Aspasia. Who was the great orator behind Pericles's famous speeches at the Pnyx? Aspasia. Who modeled freedom for the entire population of Athenian women who lacked even basic rights? Aspasia.

What great art or power this woman had, that she managed as she pleased the foremost men of the state and afforded the philosophers occasion to discuss her in exalted terms and at great length.

Plutarch, *Life of Pericles*

If she wrote anything under her own name, it doesn't survive. Some say she was a high-class courtesan; others say she was a silly celebrity who was only mentioned in connection with Socrates and Pericles as a joke. And some say she brought philosophy to Ancient Athens, modeled freedom to the women there and changed the world.

If you've seen the epic blockbuster *300*, then you already know what's in store for Athens. So pleased and proud of their (sans women) Democracy were they, that they elbow-jabbed their neighbor across the Aegean. *Hey Ionia, don't you want* real *freedom, like us? How embarrassing to be part of that massive Persian Empire. You should probably rebel.* Ionia did. If they'd bothered to ask the Oracle, she could have warned: *Not Good Outcome.* Persia wiped Ionia off the face of the planet. We're talking sow-the-ground-with-salt, castrate-all-the-men level destruction. And then Persia stared coldly across the Aegean shouting, "Who put Ionia up to this?!" Athens was suddenly scuffing its feet and whistling determinedly stage left.

Artemisia of Caria

Give Me Tolerance and Diversity or Give Me Death: Ancient Persia

If you chose "Tolerance and Diversity or Death," Ancient Persia is going to make you an offer you can't refuse. Yes, *that* Persia—the one that wiped Ionia off the face of the planet, then came for Athens. It was basically *The Godfather.* Consider yourself inducted.

Imagine living in a massive empire run by the mafia. (In some parts of the world, of course, this isn't hard to imagine.) The mob generally lets you be and things are actually pretty peaceful and secure. You got a problem? It will be solved. The mafia doesn't care what religion you belong to; you can speak whatever language and do whatever you want. They keep things clean; the

roads are good. All are welcome here! But you pay your protection money, you understand? You pay up and you don't complain. You certainly don't rebel—or examples will be made. That's the Persian Empire.

And the same kind of complexities in the lives of mafia women apply to ancient Persian women. You could be a fainting flower, a sweet domestic in need of protection, or you could roll the dice. Artemisia of Caria rolled *so many* dice.

Women in ancient Persia were the most liberated in the ancient world. They were educated and entitled to own businesses and land. And though it was still a patriarchy, women could rise to positions of immense power. (Funny, we could use the same phrases to describe the western world today.) Artemisia had a seat at the table of tables: she was one of the generals of the great Persian war machine. By all accounts, there was no mansplaining or disregard because she was a woman. Her seat was truly equal and her opinion was respected. So when Emperor Xerxes summoned his council of generals, around 478 BCE, she was there to hear his recap:

Okay team, our revenge on Athens is almost complete. After we finally got through the mountain pass at Thermopylae (an embarrassment which we shall never speak of again), we marched straight for Athens and burned it down. However, all the Athenians got away in their stupid little trireme ships. Our sources say the ships are still in the Aegean. So, my question is, should we take our navy right now and zap these little Athenian buggers out of the water once and for all?

They went around the table so each general could advise. Every other general voted yes. Artemisia took a deep breath and voted no. When Xerxes raised an eyebrow she explained her thinking, even though some friends in the room must have been frantically making the neck-slicing motion. "Why commit your whole navy to this?" she said. "We already destroyed the city, which was our goal. Everyone on our hit list is dead. To be honest, in my experience," (and this is her actual, famous line) "at sea your men will be as inferior to the Greeks as women are to men."

What a line! From a female general, as she disagreed with all the men. In that moment, her enemies fist-bumped because they thought Xerxes would have her killed for being so contrary. Instead, he respected her more for it.

None of Xerxes's allies gave him better advice than her.

Herodotus

But Xerxes reminds us that you can be all, "Preach!" and still not listen. He went with the majority and ordered the entire Persian fleet to invade Greece. It was the largest fleet that had yet been assembled in the history of the world. Herodotus says there were 1,207; less enthusiastic scholars put it somewhere in the hundreds.

Artemisia didn't have to go, but she chose to. She commanded a squadron into the eye of a storm that only she saw coming. Xerxes literally set himself up on a hillside to watch the showdown, with all his kids in tow. And the Battle of Salamis played out almost exactly as Artemisia called it: the masterful Athenian sailors expertly manoeuvred their smaller ships, luring the massive Persian fleet into a narrow pass. Pursued at one end and blocked at the other, the Persian ships crashed into each other and sank before Xerxes's eyes. Only a fraction of the world's largest fleet escaped, but Artemisia's ship was among them. Herodotus says she survived by actively ramming other Persian ships that got too close. *Someone's going down and it's not gonna be me.* That gave her own ship a safe radius in which to navigate, with the added bonus of making the Greeks think she was on their side, so they didn't attack.

Again, Xerxes might have executed her for it, but he respected her even more. In the face of a humiliating defeat, he summoned his council, then dismissed everyone but Artemisia. "My advice?" she said, "GTFO." He took it and ran back to Persia, entrusting to Artemisia the safe transport of all his children (there were a lot). After delivering the brood safely to the city of Ephesus, she disappears from the historical record.

It was an almost impossible victory for Greece—for Democracy!—over the evil, wicked powers of . . . tolerance, diversity and women's equality? The future of western culture was in Greece's hands now. Soon, however, Rome would come along and swallow it up, bringing with it a new twist on democracy, patriarchy and tolerance too.

Perpetua and Felicitas

Give Me One Unified Way of Life or Give Me Death: Ancient Rome

If you chose this option, congratulations! You're about to be fed to the lions. Or the bears. Or the . . . cows? Wait, what?

It's been about two hundred years since a Jewish man named Jesus of Nazareth was executed just outside Jerusalem and a movement claiming his name is starting to take hold all across the Roman Empire. Different groups in different places are focusing on different things—but one thing all these folks calling themselves "Christians" have in common is that they're weird. Deeply, deeply weird. Worryingly weird.

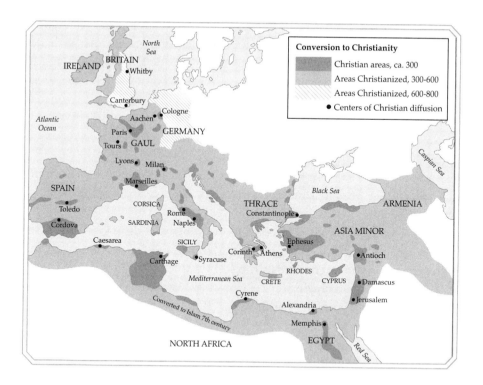

The spread of Christianity c.300–800.

Some groups are rumored to be engaging in religious cannibalism (what's all this "partake of the body of Christ" stuff?!). Some will only worship in secret in old, abandoned catacombs underground. Some preach something called "brotherly love," which sounds dangerously like incest. The word on the street is some groups are even putting *women* in charge?! Inconceivable.

But most annoyingly to the Roman regime, many of these newfangled Christ-followers openly reject the authority of the emperor. They want one truth: one unified way of life—or death! And in the city of Carthage in northern Africa, a handful of recent Christian converts are being particularly obstinate. Led by a twenty-two-year-old prophetess named Perpetua, this band of newly minted monotheists are refusing to make their annual sacrifice to the Cult of the Emperor. Not only is this against the law—not to mention super rude to poor Septimus Severus—it is, frankly, baffling. I mean, honestly, this couldn't be easier. All they have to do is dump a little wine over an altar, light a stick of incense maybe and *bam*—they're good for another year. One thing at least is clear—this appalling deviance simply cannot be allowed to continue. Examples must be made and these confusing Christian traitors must be rounded up and taught a lesson before things get out of hand. Surely a few days in prison is all it'll take to stem the tide. You're trying to tell me these crackpots would choose Death by Gladiator over waving a little frankincense around? Apparently, yes. It turns out that when your particular brand of Christian zeal is heavy on the joys of martyrdom and light on that whole "render unto Caesar" thing, a glorious demise in the name of your God becomes more appealing than one might have assumed.

And this Perpetua woman is certainly an unanticipated problem. A young married mother of a newborn doesn't fit any of our expected criteria for "wildly influential Christian prophet" . . . yet that's exactly what she is. And it's because of her dramatic visions of post-mortal glory that three Christian men, plus Perpetua's enslaved—and pregnant!—servant Felicitas, are preparing eagerly to face death in the arena. In fact, Perpetua and Felicitas spend most of their time in prison praying for Felicitas to go into labor early, so she can be executed "on time" with the rest of them. (Roman law prohibits executing a pregnant woman.)

Luckily (?) their prayers are answered. Felicitas gives birth just in time to join Perpetua et al in the arena, for what could easily go down as one of the weirdest and most unsettling executions ever . . . if it weren't so horrifyingly normal within the grisly, nightmarish setting that is the ancient Roman *ludi*.

Now, thanks to modern audiences' appetite for ultra-violent "prestige historical dramas," most of us probably have a pretty good sense of the

brutality of the ancient Roman arena. But modern moviemakers have seriously underplayed the sheer, fundamental weirdness of these over-the-top extravaganzas of gruesomeness. The spectacle was the point. And rather than the spare and stalwart displays of Manly Warrior Prowess depicted in modern film interpretations, Roman arena shows were very much . . . well, shows. The doomed were lavishly costumed for maximum dramatic effect. Sets and staging were outrageous, extravagant and continually refreshed to provide maximum variety for a cynical and sophisticated spectatorship. And designated victims were likely to find themselves confronting a random mishmash of half-starved wild animals before staring down the sword of a (probably teenaged and terrified) gladiator.

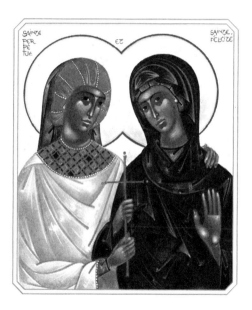

Modern icon of Perpetua and Felicitas.

For this particular production, showrunners have decided to send the two young mothers out into the arena nearly naked, draped only in a gladiator's net. But the audience immediately objects. "This is unseemly! These are pretty young women who have obviously just given birth! Send them back inside! Put some clothes on them so that we can enjoy witnessing their brutal deaths with some decency!!" So they do. Upon reemerging, the now-clothed Perpetua, Felicitas and friends are attacked by panicked and panicking leopards, boars and bears, as well as—in one of the more fantastical twists

in this perplexing (and appalling) story—by "a most ferocious cow." What? *Why?* No one knows.

After a horribly drawn-out interval of prolonged mayhem and mauling, the animals have finally lost interest and the women—badly injured but alive—are clinging to one another, still singing their psalms. Finally, a lone gladiator is dispatched to finish them off. But even this doesn't go according to plan and after his first lunge leaves Perpetua wounded but still breathing, she guides the gladiator's hand "with manly courage" to her own throat, finally ending her life.

In the end, and it's difficult to imagine a more bizarre or gruesome finale, at least it was the death these two had chosen. (Or at least the one Perpetua had chosen . . . it's hard to say for sure what the enslaved Felicitas may have truly wanted.) How about you? If you chose "the pursuit of one unified way of life— or death," would this have been how you'd wanna go out?

If not, we have an alternative part of Ancient Rome you might identify with, that's now Syria.

Zenobia

I'd Like to Rage Against the Machine, Please

Rather than pursuing a martyr's death, maybe you're the type who'd prefer to Rage Against the Machine. Step into the shoes of Zenobia, then: Regent of Palmyra in the Roman Empire. You're on the eastern edge of the empire, which is a pretty amazing place to be: neighboring Persia offers a thrilling hinterland, but more than that, the Silk Road ends right at your front door.

What's the Silk Road? China had, of late, this obnoxious problem called the Huns, who kept raiding their northern borders. The emperor sent messengers west seeking help. "Come save China!" they said to their neighbors in Nepal (no thanks). "Come save China!" they said to India (we'll pass). "Come save China, Persian army!" (no). When the intrepid messengers finally reached the eastern edge of the Roman Empire, they were farther than they'd ever gone before. Roman dignitaries met them. "Come save China!" they said. "Yeah, no," said the Romans, "but what are you wearing? It is absolutely fabulous."

"Oh, this old thing? It's called silk. We've got tons of it."

Thus launched a trading network from the Pacific to the Mediterranean where silk and spices traversed to the west and chests full of gold traveled east. China used the gold to buy off the Huns, so everyone won. Except, of course, most of the merchants who actually transported the goods. To travel the Silk Road was to play a high-stakes game of Survivor with merchants and marauders from across Eurasia. Successfully traversing the Silk Road could mean millions; your chances of surviving, though, were really, really bad.

So put yourself in the bustling trade city Palmyra, in the year 270, in the shoes of Zenobia (which must have been fabulous). You're not yet thirty years old, with a dead husband and a ten-year-old son and it's time to make your move. Raise that army, mount your "she-camel faster than any horse" and pick your battlefield.

Why did Zenobia choose to Rage? This is ancient history so of course, the answer is: no one knows. So as Zenobia, make your choice: who is the enemy here? By which we mean, against which Machine shall we Rage? What's that you say? *I don't care, I just want to Rage and do it well!* Then all you need to know is that the Prefect of Egypt is currently away fighting pirates. *Egypt it is!*

Easy-peasy, done and done. Then it's just a quick jaunt to take Asia Minor (modern Turkey). Your Rage is strong, the Machine is weak. At this point you might as well declare your own Empire of Palmyra, right? This is going well. Why not mint coins with your face on it while you're at it? Silver looks good on you. But, *sigh* . . . the Roman Emperor Valerian, who's been ignoring you all this time, sees the coin and all hell breaks loose. He sends a massive army that hounds you all the way to the Euphrates River.

How would you prefer to go out? Because ancient sources give us very different versions of Zenobia's end.

YOU PICK! HOW DOES ZENOBIA'S STORY END?

- The Tanukh (a confederation of Arab tribes, sometimes called Saracens) sweep in and defeat her. *You're welcome, Rome, let's be buddies.*

- Emperor Valerian captures her and orders her marched back to Rome to face punishment. Zenobia starves herself to death en route to deny Rome the glory.

- Emperor Valerian captures her and orders her marched back to Rome to face punishment. Paraded in a ritual public humiliation, she is then chained to a throne for three days before being beheaded.

- Captured, marched, humiliated, etc.—but instead of being beheaded, she's given a pension and a country villa and lives happily ever after, marrying a Roman senator.

Today, you can find Zenobia on Syrian banknotes and as the central character of a massively popular Arab-language soap opera. She's very famous in the Middle East, not for her success, but because of her bold strike for freedom (or was it power?). Rome did not see her coming and she took full advantage of the patriarchy's blindness. It was the making of her, but also the breaking of her—because *defeat at the hands of a woman*? Not an option. Patriarchal Rome was almost guaranteed to unleash the whole armory in the face of such humiliation.

Could Rome have gleaned important lessons from its encounter with Zenobia and shifted its blinders when it came to the capabilities of women? Maybe. But, it stubbornly refused to learn. Down through the generations, wise women continued to ask themselves, "what would Zenobia do?"

Amanishakheto

Let's Just Be So Scary No One Bothers Us: Meroë

Bold choice, if you selected this one, since being scary usually goes arm-in-arm with conflict. Grab your sword and your scariest face; we're going in.

In 1834, notorious treasure hunter Giuseppe Ferlini could hardly believe his luck. He'd busted into a hundred-foot-tall pyramid that turned out to be a royal tomb packed with treasure. Piles of astonishing jewelry lay alongside bows and arrows with elaborate writing on the walls. Never mind that he completely destroyed the pyramid in a greedy frenzy, he'd made the discovery of a lifetime! He hauled the gold back to Italy and presented it to potential

buyers: *behold, the incredible treasure of a powerful ancient African Kandake*! "You mean a pharaoh?" said the collectors. "No, I found this in Sudan! This is from the tomb of a wealthy, powerful, fierce warrior queen in ancient central Africa!" What a fantasy. The collectors didn't believe him and they didn't buy his stuff.

Nowadays, the ruined tomb (thanks Giuseppe) and the treasure, now in Germany (weird), offer tantalizing clues about Amanishakheto, the Kandake of Meroë buried there around the year 1 CE.

Meroë was famed for its iron, its archers and its terrifying queens, the Kandakes (or Candaces). But since we can't read Meroitic writing, all we have is descriptions from outsiders, like Rome. Happily for us, Rome tried to attack Meroë, was repelled and had a lot to say about it. Rome says a Kandake met their army with such a show of barbaric terror that it was offensive. The Kandake was probably Amanishakheto, but it might have been her daughter or mother. We'll find out when someone decodes their script—this could be you!

Imagine the ultra-masculine Roman general scrambling back to Rome having been defeated by a woman. Emperor Augustus is like, "Explain yourself. We took out Egypt, even Cleopatra, for Elysium's sake. And you're telling me some queen from central Africa is what's sent you sniveling back home? How?" "Okay, first of all, she was *terrifying*:

◆ Her face was covered in brutal scars.

◆ She only had one eye.

◆ She wielded that bow and arrow like a god.

◆ She was physically huge. She was taking up serious space.

◆ She was completely covered in gold jewelry, it was dazzling.

◆ She could not be intimidated, I tried all the domineering tactics.

"So I signed a peace treaty and left. Oh, one last thing, Emperor Augustus. Amanishakheto went to Egypt and stole a bunch of those fabulous statues of you. I got her to return most of them, but she kept your head from the biggest one. And buried it right under the steps of her temple. So, yeah, her people are walking over your head every day. Byeee!"

Remember the "have dagger, must stab" interpretation of historical change? That new technology, iron, was smelted, smithed and traded on a massive scale by the queens of Meroë for over a thousand years. From their sixty-room palace, generations of the famed archer queens served as fabulously wealthy merchants to all of Eurasia.

EXOTIC EXPORTS OF MEROË:

* Iron weapons
* Iron tools
* Leopards
* Elephant skins and tusks
* Wheat and other farm produce
* Charcoal
* Intricate jewelry and gems

The gladiator's sword that killed Perpetua could have been made in Meroë. The bread Christians ate in their eucharist could have come from Meroë wheat. The bejeweled diadems of Greece, the sharpest weapons in Artemisia's fleet... Amanishakheto and her terrifying descendants ruled an empire that fueled all the history around them.

Then, right around the time Rome legalized Christianity, Meroë declined with it. Rome's famed "bread and circuses" was falling out of fashion. The bottom fell out of the market for wheat (for the bread), and iron (for the circuses), and trade shifted from the Nile to the Red Sea. Meroë's neighbor, Axum, seized its chance. Offering the world fancy new things like Christian texts, political treatises and, most importantly, good solid Patriarchy, Axum was the way of the future.

Meanwhile, China was busy keeping up with the Romeses.

Trung Sisters

Patriarchy and Elephants: Vietnam and China

If you chose more elephant, less patriarchy, you've taken Vietnam's side in its thousand-year ancient showdown with China. If you chose more patriarchy, less elephant, you are China and you come bearing irrigation for rice fields, unpopular taxes and Confucianism.

Here's how it happened. As gold flowed east on the Silk Road, China had enough to buy off the Huns and then some. With that kind of wealth, what else are you going to do but attack your neighbors? They couldn't go north (that's Hun land), so they started moving east and south. To the east, the peninsula between China and Japan (now Korea, but back then not yet unified) responded by establishing warrior monasteries and training up some of the world's greatest martial artists. Still, in the north, China dominated (give the monks a few centuries and all will change). China's general tactic was to elevate local elites as bureaucrats, then through them make all the changes. They built infrastructure, like irrigation for rice fields, that dramatically boosted local economies. Then, *ka-ching*, they taxed everyone up the wazoo. But when China moved south to absorb the "barbarians" of Vietnam, they found that local elites had a frustrating habit of standing up for the little guy. Even worse, Vietnamese men exhibited a vexing belief that women were equals.

Thi Sach was one of these local lords who didn't like China's meddling one bit. Around 40 CE, he protested the patriarchal codes of Confucianism that shooed women into the kitchen. He vocally opposed unfair taxes that bled peasants dry. China responded by executing him. Shouldn'ta done that.

Trung Trac, Thi Sach's widow, pulled up alongside her sister Trung Nh like "get in loser, we're going to raise hell." Peasants and aristocrats alike heeded their call. Soon, atop a war elephant, Trung Trac was delivering a rousing speech to her thirty-thousand-strong army. Her rebel army freed sixty-five towns, then created an independent Vietnam, coruled by Trung Trac and Trung Nhi. To defend themselves against the constant Chinese threat, their eighty thousand troops had thirty-six female generals (among them, the Trung sisters' mother). They held on for two years, but this was a humiliation China was not prepared to accept. Ramping up its attacks, China was finally able to break Trung Trac's defense. To avoid capture, the sisters are said to have

jumped into a river to their deaths. Another version of the story, however, has them peacefully floating off into the clouds, so choose your own ending.

A strong Confucian patriarchy and the tax-heavy economy that came with it, would dominate Vietnam for another thousand years. Still, Trung Trac has always been held up in Vietnam as an icon of the strength of the nation and of women. In the 1200s, a Vietnamese historian looked back on the Trung sisters' story and wrote, "What a pity that for a thousand years after this, the men of our land bowed their heads, folded their arms and served the northerners." When war came again to Vietnam in the 1960s, Trung Trac and Trung Nhi were once again celebrated as examples of what Vietnamese women could be. But that's a story for another chapter.

K'awiil

The Important Thing Is Connecting People to Each Other: Classical Maya

Not really into patriarchy *or* elephants? Is connection and community-building more your jam? The Maya kingdom of K'awiil Ajaw might be for you.

Ascending to the throne in 640 CE, K'awiil ruled the Yucatán in the area now known as Quintana Roo, Mexico, for more than forty years. And she certainly wasn't just some puppet ruler—she was a fierce and mighty warrior who personally led her people into battle. Across the many stelae monuments found at her capital city of Coba, K'awiil is shown standing triumphant on the necks of dozens of captives—the defeated warriors of her arch-enemy "Snake Kings" of nearby Calakmul. In these images, she is wearing the full regalia of a Maya warrior-king.

But K'awiil also presided over an intellectual Golden Age for the Maya, with massive advances in writing, science, mathematics, technology and engineering. And her biggest-of-the-big engineering project is probably the one that cemented her legacy (literally) in history: building the first roads in the Americas. Okay, that's cool I guess? Roads are good. I mean, maybe not a super exciting legacy to leave, but . . . au contraire, dear reader. Buckle up, because we're about to discover just how exciting a road can be!

First of all, these roads are big. Really, really big. We're talking 130-foot wide, *ten-lane, California superhighway* big. Built smack in the middle of the

deepest, darkest jungle. Almost 1,300 years ago. And these roads are high. Really, really high. Elevated sixteen, sometimes thirty feet off the ground high. These roads are long, too. So, so long. One of K'awiil's roads winds through 62 miles of rainforest. Another recently discovered example may be up to 190 miles long! And these roads are (well, were) brilliantly, blindingly white. Carefully coated in thousands of tons of limestone plaster to be clearly visible for miles around. Why? Nobody knows.

Why would anyone go to this much trouble to build broad, elevated, smooth, white-painted roads in a society that doesn't even have any horses or wheeled vehicles? What on Earth was K'awiil thinking?! We do know a few things—or at least there's plenty of well-informed speculation. Was the lime-plastered surface of each *sacbe* ("white road") a way to illuminate these highways for moonlit nighttime journeys, removing the need to travel under a blistering equatorial sun? Were the seemingly excessive height and width there for protection? If you were wandering through a jaguar-jammed rainforest in the middle of the night, you'd probably welcome a little extra buffer between yourself and the looming jungle. Or had the forest been mostly cleared by then, making way for a densely populated "suburban" landscape? Archaeological evidence shows smaller settlements scattered all along the *sacbeob* (plural for *sacbe*), which wind between mighty cities like Coba, Tulum and Kantunil. But other roads lead to what appear to be unpopulated religious or ceremonial sites. Were the roads built, as some archaeologists believe, as part of K'awiil's attempt to conquer (or at least subdue) the surrounding areas, cementing her place as supreme ruler of the Yucatán? Or maybe the *sacbeob* are about religion. Did she create a travel network to guide devotees to spaces for worship, or sacrifice . . . or both? These roads could themselves be places where religious work was done, the journey itself a sacred act—a pilgrimage, if you will.

But what if K'awiil's plan was simpler and more relatable than that? What if her roads were simply . . . roads? Her goal simply to connect folks with one another for improved togetherness? What if this massive engineering marvel was really just one visionary ruler's attempt to increase her peoples' interconnection, happiness and mutual understanding?

Whatever you believe, one thing is becoming increasingly clear: as recent LiDAR scans and other new technologies seem to clear up a new centuries-old mystery of the Americas every other week, our outdated narrative of a sparsely populated Maya world, of tiny isolated kingdoms separated by hundreds of miles of impenetrable (and unpenetrated) jungle, simply will not cut it anymore. As it turns out, the Maya world—like Maya roads—was big, broad, beautiful and probably pretty crowded. And just like the other iconic

empires of the ancient world, its plain, unsexy roads were the engineering marvels that would ultimately tell its story, centuries after everything else was gone.

So, would you have wanted to live in an ancient empire? And what was the impulse behind this era in human history? If the two major theories are that humans were driven by either "have dagger, must stab," or else a new pursuit of peace and unity, which do you see? Returning to our list of possible explanations at the beginning of this chapter, we can see evidence of every one of them in the empires we've visited. Might the answer be "All of the above"?

The Middle Ages

**NOTHING CAN STOP ASIA'S DOMINATION
. . . EXCEPT ONE LITTLE BACTERIUM**

Queen Seondeok of Silla

The year is 647. Queen Seondeok of Silla lies on her deathbed after fifteen years on the throne, having already named her cousin Princess Jindeok her successor. But the queen's right-hand-man Lord Bidam has decided he'd rather be on the throne himself. In a shockingly bold act of betrayal, Bidam has declared war on his queen and country, proclaiming, "This Woman Queen has failed to rule the kingdom; therefore women should stop ruling at all!" Sigh. Never heard that one before. Seondeok was actually one of the more admired and effective rulers in the history of the Three Kingdoms—generally regarded as Korea's golden age. Bidam's army had good reason to believe the universe was on their side, though, as on the day he launched his revolution, a particularly bright star had suddenly fallen from the sky, convincing his followers that the queen herself must also soon fall.

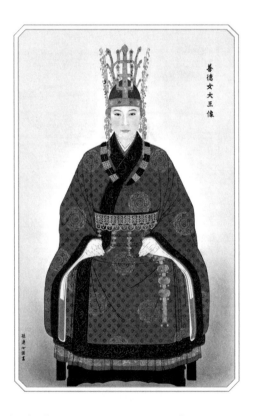

Seondeok of Silla (606–647 CE), Korea's first reigning Queen.

But Queen Seondeok wasn't one to be dictated to by *mere celestial bodies* and she had one last trick up her sleeve. She sent a servant out into a nearby field with a flaming kite, instructing him to fly it so high, that the falling star would appear to be rising back into the heavens. Her defiant gesture, followed by her loyal troops, worked to put the traitorous Bidam and dozens of his coconspirators safely under lock and key within ten days. Executing the traitors was one of the new Queen Jindeok's first official actions, only nine days after Seondeok's death.

So how did this shrewd and clever queen rise to the throne in the first place? Korea's famed "Three Kingdoms" were three distinct nations spread across the Korean peninsula, as well as a large chunk of what is now northeastern China. Sometimes sparring against each other, sometimes banding together against outside foes, the kingdoms maintained an uneasy balance for hundreds of years. In the kingdom of Silla, royal lineage was claimed through both paternal and maternal lines. So theoretically, royal daughters were just as eligible for the throne as royal sons, though it had never actually happened until twenty-six-year-old Seondeok was crowned the first-ever Queen Regnant in Korean history.

Recognizing the rather, shall we say, *ambitious* natures of her nearby neighbors, Seondeok set her sights somewhat higher, sending a diplomat to pay her respects to the powerful Tang Emperor and announce her arrival as New Queen on the Block. Unfortunately, Emperor Taizong's response was somewhat . . . underwhelming. Refusing to acknowledge a woman as Silla's rightful ruler, he sent her emissary back unreceived. Seondeok kept sending diplomats—and Taizong kept sending them home.

Eventually, finding herself under attack from two neighboring kingdoms at once Seondeok sent an urgent message to Taizong, pressing for an alliance. Not averse to teaming up with Silla for their mutual benefit, the Tang Emperor laid out his proposals for a pact:

1. He would attack the neighboring kingdom of Baekje to distract them from their attack on Silla. (Cool, thank you.)

2. He would supply Silla with Tang army uniforms so Queen Seondeok could disguise her own troops as Chinese soldiers. (Nice, thank you again!)

3. He would send a royal male from the Tang Court to rule Seondeok's kingdom for her. (Um, *thanks but no thanks, man*.)

Seondeok went to a Buddhist monk for advice. He advised the queen to ignore the Tang entirely and instead build a spectacular Buddhist temple to block

foreign invasions (not specified: how one wooden pagoda was going to achieve that, but whatever) and to reassure her people that Silla was still strong and prosperous. The problem with this plan was that Silla was *not*, in fact, strong and prosperous and the funds needed to build the prescribed nine-story pagoda would put a serious strain on the national bank account. But instead of abandoning the project, or levying an unpopular new tax on her subjects, Seondeok made a somewhat unexpected suggestion: if Silla didn't have the funds, perhaps the builders should tear down her own palace and reuse its bricks and timbers.

Whether or not the builders actually did that (*they did not*) it seems the offer alone was enough to get folks on board and construction of the Hwangnyongsa Pagoda began. No word on whether it actually worked to deter foreign invaders (presumably the many prayers offered there by devoted worshippers were a major factor in that strategic plan), but, luckily, a few more options were just over the horizon. Goguryeo, another of Korea's Three Kingdoms, was growing fast, and Emperor Taizong eventually admitted he was going to need some backup. Deciding that an alliance with *that woman* was at least better than defeat he finally agreed to team up with Seondeok.

He couldn't resist getting in one last jab, though. To celebrate their alliance, Taizong sent Seondeok a painting of three peonies along with a packet of peony seeds. As the Queen passed the seeds on to her gardeners, she remarked that although they were very pretty, they probably wouldn't have much fragrance—a hunch which was quickly proved correct. When her courtiers marveled at this, Seondeok laughed that the lack of bees or butterflies in the painting had given it away. In fact, she pointed out, the gift was actually just Taizong throwing some elaborate shade: the scentless blooms and lack of insects were a backhanded dig implying that Seondeok was unmarried and childless not by choice, but because of a lack of "interested pollinators." Real mature, buddy.

Still, China's ominous shadow looming behind Silla's much smaller silhouette helped keep the kingdom safe from foreign aggression for decades. Seondeok would rule for fifteen years—preserving her kingdom in the face of both external and internal threats, promoting an incredible "cultural renaissance" in religion, the arts and philosophy, and successfully pivoting the public's opinion on Buddhism from suspicious wariness to popular enthusiasm.

And her clever thinking and indomitable spirit while fending off last-minute threats, like Bidam's "deathbed coup," assured that the Sillan crown would pass to another remarkable Queen who would lay the foundations for the eventual unification of the Three Kingdoms—creating the first incarnation of what we now know as Korea.

Wu Zhao

Meanwhile, 1,000 miles away in Tang Dynasty China . . .

You know good old Emperor Taizong, who refused to acknowledge Queen Seondeok as ruler because she had the almighty gall to be a *girl*? He's dead now. So who's running the dynasty? Oh that's right—it's Taizong's widow, Wu Zhao. First taking power as Regent over her already-very-much-an-adult son, she'll eventually drop all pretense of proxy power, crowning herself the first—and, it turns out, only—female emperor in Chinese history.

So how does a woman in seventh century China work her way from teenage Beauty Pageant Champion (Grand Prize: lifetime gig as the emperor's lowest-ranked concubine) to unquestioned ruler of 50+ million people? Very carefully. How to tell the story of Wu Zhao? She is usually known as Wu Zetian, named after the palace gate where she was named Empress, but we prefer to call her by the name she gave herself. Her life is still a contentious mystery. Over the centuries, she's been painted as everything from "psychotically-ambitious harridan who routinely slaughtered her own children just to preserve her grip on power" to "enlightened progressive hero whose high-minded attempts at social reform eventually got her killed."

The truth, as usual, is probably somewhere in the middle. But for the average citizen, at least, Wu was a wonderful ruler. Her reign was one of the most stable, innovative and peaceful periods in Chinese history and her campaigns promoting increased prosperity, creative revitalization and religious tolerance (a strange new foreign religion called "Buddhism" gained its first real ground in China under her rule) made her wildly popular with the general public. She even installed what was possibly the world's first Suggestion Box in front of her palace, inviting even the lowliest peasants to propose improvements or offer suggestions for the *emperor herself* to read!

But Wu Zhao's iron-fisted control over her royal court, willingness to use ferocious violence to keep the aristocracy in line and unprecedented war on corruption set off tidal waves of resentment among the ruling class. You know that public Suggestion Box? It was also a Tattling Box! *"Got good dirt on some double-dealing official? Spill the tea here, friends—Auntie Wu will take care of it!"*

She was never naive about the risks she was running, trying to push Change With a Capital C onto one of the most change-resistant societies in human history. Her most controversial reforms were always the ones focused on improving the standing of women—such as requiring children to officially

mourn both their parents, not just their fathers, or allowing women to ride horses in public, or renaming the ranks of the imperial concubines to echo the titles of important male court officials.

Wu Zhao's biggest changes were always bolstered by vigorous PR campaigns—she understood the power of a good story. And by linking her changes to important characters or events from China's glorious past, she gave her subjects a comfortable way to embrace new ways of thinking, speaking and being. It's a tried and true tactic: trying to push some massive social change? Package it up as a return of the Good Old Days. But in the end, her campaigns to jettison centuries of misogynistic tradition so infuriated China's Imperial-Patriarchal Machine, that not even her popularity with the people could save her. Or perhaps it was her unfortunate penchant for conveniently disposing of her opponents that caused her downfall? After all, even members of her own family had an alarming tendency to suddenly *leave the stage* anytime they stood in the way of what Wu Zhao believed was best for China. And knocking off your own grandkids to maintain your place at the top of the imperial pecking order isn't exactly great in terms of "winning hearts and minds." We'll probably never know what was the final straw, but when she was finally deposed by her son Zhongzong in 705 CE, Wu Zhao was demoted to a mere Empress Dowager and imprisoned in a minor palace for her final year. She was eighty-one years old when she died.

Wu Zhao was, in the end, an uncommonly complicated woman. What do you say about Wu Zhao? What *can* you say? In the end, perhaps the most perfect commentary on her life is this: that even her own children were so befuddled by the question, they couldn't decide what to write on her grave. They never did figure it out. 1,300 years later, her massive memorial stele is still blank.

World Religion Goes Viral

Something was going on in this time period, all across the world: a handful of the world's religions went viral. The process wasn't always peaceful, like millions of people just retweeting a charming idea. Religion has always been tied up with power and money, wars and social change. When it comes from the top down, it's laden with particular baggage; when it comes from the bottom up, it's got a very different flavor.

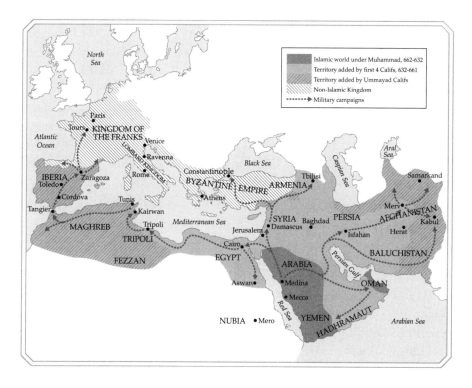

The spread of Islam over the course of the Middle Ages.

Buddhism, born in India, was taking Asia by storm—especially once queens like Seondeok and Wu Zhao began promoting it to help secure their own power. (Whether it benefited the common women in those countries is a very different question.) Catholicism, too, was spreading across Europe and butting heads with Irish Christianity and Norse Arianism; even Judaism was taking hold in Africa alongside Christianity and Indigenous beliefs (as we'll see later in this chapter).

But in 621, a new global religion was about to enter the scene: Islam. Founded by Arabian merchant Muhammad after a revelation from Allah the one true god, it's another take on the ancient monotheistic tradition. Islam, Christianity and Judaism are all rooted in the same Hebrew text (the Pentateuch/Old Testament)—in other words, these three monotheist religions worship the same god. Where they differ is on where the story goes after that. For example, the tale of old Abraham and his two baby mamas: Sarah, his wife, couldn't have children, so Abraham conceived a son with their slave, Hagar. Then—surprise!—the *extremely* elderly Sarah birthed a child as well. The sons, Ishmael and Isaac, were rivals from the start. Islamic traditions tend

to place more religious significance on the story of Ishmael, while Judaic and Christian traditions tend to follow Isaac. Christianity adds on the god Jesus; Islam figures that Jesus was a lovely prophet but not a god; Judaism says we're still waiting for the Messiah to arrive.

Islam spread so quickly out of Mecca in Saudi Arabia that by the end of the 600s, the whole of North Africa had changed teams. Mostly it spread by sword-point (Christianity would use the same technique the following century), but after the threat of decapitation was gone, many people stayed Muslim, so presumably their conversion was real.

Fatimah al-Firhi

By the 800s, North Africans were settling into the new religious map. Some towns expelled Muslims, others Christians or Jews, and some towns did no expelling at all. The year is around 818, in a small north African settlement and a spectacularly important innovation is about to take place.

A young Muslim girl named Fatima al-Firhi and her family have just been expelled from their home in Kairouan, Tunisia. Luckily, safe harbor awaits the al-Fihris in the newly established city of Fes, in present-day Morocco. Here, Fatima's father will eventually become a prosperous merchant and Fatima will grow up, gain an education, marry, be widowed—and, when her father dies just a few years later, inherit his very considerable fortune. So what is a suddenly financially independent young woman in ninth century Fes supposed to do with all that money? Presumably, anything but what she did do, which was launch the first university in the history of the world.

Okay, maybe it didn't happen *quite* that seamlessly, but how it did happen is nearly as surprising. Recognizing that there was a serious shortage of schools and teachers for the growing population of their rapidly-expanding hometown, Fatima and her sister Marium decided to spend their inheritance on building two new mosques, the al-Qarawiyyin and the al-Andalusiyyin. Each mosque also offered a *madrasa* (school) where students of all ages could receive a secular and religious education for free. Fatima al-Firhi's madrasa at al-Qarawiyyin would eventually come to be so renowned, it is now generally acknowledged as the oldest university in the world—a title it would not officially embrace until a name change in 1963.

Over the past 1,200 years, hundreds of thousands of students have received an education at al-Qarawiyyin. But for nearly a thousand of those years (and despite these madrasas having been founded by women in the first place) formal education in Fes was strictly *no girls allowed*! Female students weren't admitted to al–Qarawiyyin until the 1940s, although a few oral histories assure us that women were occasionally allowed to listen in to lectures from a special side gallery. (Gee, thanks, guys!) Still, Fatima and Marium's educational revolution certainly made an incalculable impression on the world.

Or did it? These days, the accomplishments of the al-Firhi sisters—and even whether they actually existed at all—are topics of fierce debate among historians of the region. Some scholars argue that the narrative of two sisters building perfectly-paired mosques on either side of a river is too good to be true, so at least one of the buildings must have been built by someone else. Others argue that the entire idea of a woman (let alone two) founding a madrasa in northern Africa during the Middle Ages is ridiculous and the al-Firhi sisters are probably mere figments of a fourteenth-century historian's romantic imagination. Others point out that the pattern of "learned men" refusing to believe that *women have always been doing stuff* is not an unfamiliar one, so perhaps we should question the wisdom of dismissing established oral history anytime it happens to involve the notable accomplishments of remarkable women?

Regardless of the genders of their founders, Islamic schools led to a flowering of knowledge and the whole world sat up and paid attention. Knowledge seekers from everywhere except the Americas (for obvious reasons) trekked all the way to the Islamic World to learn. It would have been a pretty cool vibe: tolerance reigned and a true mix of global people came together to explore the Good the True and the Beautiful. Córdoba, one of the major intellectual centers of the Islamic World, is a good example: a Christian cathedral, nestled inside a mosque, symbolized the tolerant spirit of truth-seeking that dominated the global city.

Wait, Córdoba? In *Spain*? Part of the Roman Empire? What happened to Rome? Good question. Thousands of worthy pages have been penned on the subject, but let's cover it in two sentences: around the year 500, the western half of the Roman Empire went *poof*—and collapsed. Three hundred years later, Spain was an integral part of the Islamic World. Farther north, things were getting curiouser and curiouser, as we shall see later in the chapter. But the eastern half of the old Roman Empire—all the land on the eastern half of the Mediterranean, basically—thrived for another thousand years. What was the key to avoiding total governmental collapse? For one thing, it rebranded

itself Byzantium. No benefit in keeping that dusty old term "Rome" around. For another thing—possibly a much bigger thing—Byzantium allowed women to hold some power.

Irene of Athens

One of those women was named Irene Sarantapechaina. But because humans are generally lazy and don't like learning to pronounce things, these days most folks call her Irene of Athens. Married at seventeen (or thirteen? or nineteen? nobody really knows) to the Byzantine Emperor's son Leo IV, this proud and tenacious Greek aristocrat would give birth to their son Constantine one year later and ascend to the throne as Empress Consort by age twenty-five.

I hope you like drama, Irene, because that's literally your in-laws' whole brand. What kind of drama? Every kind imaginable. For example:

Political drama: Emperor Constantine V (Irene's father-in-law) had been a big fan of military conquests. He'd cleverly piggybacked on civil wars in nearby Arab nations to solidify the empire's hold in the Balkans. But he'd also lost some long-held territories in Italy, causing major angst back home in Constantinople.

Family drama: Did we mention that Leo had five younger half-brothers who were constantly scheming to take his throne? Like—*constantly*. Every few years they'd pop up again, attempt another coup, Leo would exile them to some Black Sea settlement somewhere, and a year or two later—here they are again.

Religious drama: It's all about the icons. Religious images are a very big deal in eighth century Byzantium. A few decades earlier, Leo's grandfather had decided that icons were *out* and banned all religious images across the empire. This did not go over well with icon fans, aka iconophiles, and a century-long religious scuffle was unleashed.

The practice of praying through (or to?—that's a big part of the fight) an "intermediary," such as a saint or the Virgin Mary, was fully ingrained in Christianity by the sixth century. Praying in front of images of those intermediaries was no big deal in the "Roman church," but was a subject

of increasing debate in Byzantium. Were icons the "graven images" warned against in the Old Testament? Were people (purposefully or accidentally) worshipping the *images themselves* instead of God? Controversy abounded, and being pulled back and forth with the religious whims of successive emperors was putting the empire under massive stress.

Further complicating things for Irene, her husband Leo was an iconoclast—literally an "icon smasher"—while she was firmly in the iconophile camp. This must have made Sundays rather awkward. Luckily, Leo's commitment to icon-smashing was fairly lukewarm and the couple managed an uneasy truce on the topic for several years. Until . . . according to one eleventh century historian, it was Leo finding icons hidden under his wife's pillow that sparked his sudden crackdown, though others dismiss this story as fiction. Whatever it was that sparked the fight, in spring of 780 Leo launched a campaign of fiery persecution. He even had a bunch of his own iconophile courtiers arrested, tortured and . . . given a horrible haircut. Forcing the Queen's fashionable friends to walk around with a monk's humiliating hairdo was apparently the worst punishment imaginable.

All of this could have turned out really bad for Irene but, luckily for her, Leo died of tuberculosis just six months later and their only son Constantine succeeded to the throne with Irene as Regent.

There were rumors his wife had sped death along with a little poison in the wine, though nobody seemed all that upset about it. But *of course* Leo's little brothers were not about to let this golden opportunity pass them by. Storming back once more from exile in Crimea (or wherever), they assumed the empire was finally theirs for the taking. But they, like many men after them, were about to learn that you should never underestimate Irene of Athens. Unlike her late husband, Irene was in no mood to coddle her brothers-in-law. Nor was she willing to spend her life waiting for the next attempted coup. She wanted this nonsense ended once and for all. So what did she do? A less savvy sovereign might have had the traitors executed, risking the wrath of her court and the kingdom at large. Irene was well aware of her shaky position as a woman (and even worse, iconophile) trying to maintain power in this deeply sexist society. She was much too clever to fall into that trap. No, instead of trying the brothers for treason or chopping off their heads, she . . . had them ordained to the priesthood.

Wait, what? It was a masterstroke, actually. As ordained priests, the brothers were officially ineligible to be emperor. By transforming the brothers into *fathers*, Irene had made the threat of her ambitious in-laws disappear. It was a staggeringly clever scheme and it worked brilliantly. She then exiled, er, *relocated* the brothers to a far-off monastery—but not before forcing them to perform

the Communion service at the Hagia Sophia on Christmas Day. Then, having publicly cemented their status as totally out of the running for the throne, Irene moved on to her next order of business: managing her emperor son.

Although her gig as Regent had officially ended once Constantine came of age in 790, Irene continued to run the show from behind the scenes. The teenage emperor, chafing under his mother's continued meddling, quickly made a series of unfortunate PR moves—everything from major battlefront losses to blinding a popular military general in a fit of pique. But divorcing his wife to marry his mistress seems to have been the final sordid straw for a scandalized populace. Seizing her opportunity, Irene had her son arrested, imprisoned and blinded—and herself crowned Empress Regnant of Constantinople. Bet you didn't see that coming.

Gold coin struck around 790, the year Irene ousted her son.
Irene is depicted alongside Constantine wearing a *loros*, a
ceremonial robe worn only by Byzantine imperial families, and
holding a cruciform scepter, a symbol of divine authority.

The bold, if horrifying, gambit worked and Irene had successfully installed herself as the first-ever female ruler of Byzantium. For a few years, at least. But despite her efforts to build strong alliances to keep her grip on the crown (she's even rumored to have proposed marriage to Charlemagne himself!), just five years after the dramatic deposition (and possibly death—nobody's quite sure when he died) of her son, Irene herself was deposed. Banished to the island of Lesbos and forced to support herself by spinning wool—she seems to have been spared the popular "blinding" treatment, at least—Irene was dead within a year.

Byzantium itself, despite the internal royal strife, would continue to thrive for a thousand years, while the western half of the old Roman Empire—Europe—shattered and did battle with itself. There had been a moment when Charlemagne made an interesting move to unite it all and convert everyone to Catholicism by sword point, but when he died his sons took different chunks of the empire and—surprise!—fought with each other. If you had a bird's eye view of the globe around the year 900, you would never have said, "now, that *Europe* over there is shaping up nicely."

Coppergate Woman

As far as the rest of the world was concerned, after Rome fell, Europe became a disgusting backwater unworthy of even the slightest concern. Coppergate Woman might have tended to agree. Her Viking skeleton, a surprise find on the banks of York's river Foss, has come down to us as a time capsule. The truth she reveals about life in medieval Europe is . . . frankly revolting, so finish that snack before you read on.

In the 1970s, British archaeologists found the remains of the Viking city of Jorvik, sloping from downtown York to the river Foss. The waterlogged soil had basically mummified an entire thousand-year-old city. As months of excavation went on, you couldn't just see Jorvik—you could *smell* it.

Viking life, it seems, was crowded, filthy and rank. The town's population lived in mud-floor huts jammed along one main street and every hut had a long backyard where they both housed animals and dumped their waste (yes, *all* their waste).

What have we found in their waterlogged piles of trash? Here's a sample:

◆ 42 horse bone ice skates

◆ Amber jewelry

◆ Combs made of antlers

◆ Ear scoops and tweezers

◆ 1,700 leather shoes, plus a very rare find—one sock!

◆ A padlock and key that still works

- An ivory board game, Hnefatafl

- 250,000 pieces of pottery

- 5 tons of animal bones

- Thousands of fish bones

- Goods from as far away as Samarkand

- Pan pipes you can still play

- Spears, swords and daggers

- Sooo much poop

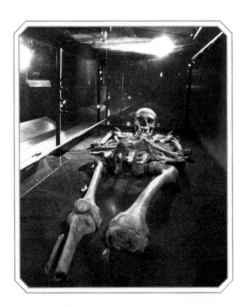

The skeleton of Coppergate Woman displayed
at the Jorvik Viking Center, York.

Oh and also, Coppergate Woman. The excavator broke her legs off, so unexpected
was her appearance. Vikings were always buried with grave goods, but she had
none, possibly not even a shroud. Christians, on the other hand, were buried
without grave goods, but always in a designated churchyard, not randomly on
the banks of a river. What on Earth?

Off to the lab with her! All Professor Janet Montgomery needed was a tooth to learn that Coppergate Woman had made a long journey to Jorvik from Norway. She was 5 feet 2 inches tall and aged about forty-six when she died. She suffered from hip dysplasia, so was never able to use her right leg. She walked with a severe limp and, based on the immense strength of her upper body, must have walked with a crutch. She had a number of additional bone ailments and would have been in constant pain.

YOU PICK! BASED ON THE EVIDENCE, COPPERGATE WOMAN IS:

- A Christian, who was so special they buried her overlooking the river
- A slave that was tossed aside when she died
- A powerful sorcerer or spooky witch (the only ways someone that severely disabled survive in Viking culture)
- A murder victim

But wait! There's more. The Coppergate dig turned up one artifact that paleoscatologist Andrew "Bone" Jones declared "as precious as the crown jewels": the Lloyd's Bank Coprolite. It's the world's largest piece of fossilized human poop and it's a whopper; 8 inches long and 2 inches across, it was first mistaken as a piece of ironworking slag. What can a giant poo tell us about Dark Ages Europe? A fair sight more than we wanted to know, to be honest.

First there are diet facts: whoever pooped this poop ate lots of meat, pollen grains and bran. No surprise there: Vikings hated veggies, apparently. Their middens, as we saw, were packed with animal and fish bones, but nary a caesar salad to be seen. Also in the poop? Hundreds of parasitic worm eggs. This person was absolutely riddled, not with any old parasite, but with *ascaris lumbricoides,* remarkable for its ability to bore through tissue and emerge from every orifice, including eyes. And here, a moment for us all to pause and give thanks for our *ascaris lumbricoides*-free lives.

We can't prove Coppergate Woman pooped that poop, but we can't prove she didn't. Somebody had to do it and she is one of two people we know for sure lived there.

Taken together, the Coppergate dig paints a vivid picture of life in Medieval Europe. Thousands of worthy books have debated how "dark" the Dark Ages were, and how bleak/backward Europe was or wasn't. Sure, we could look to the palaces of Charlemagne for our history, or even powerful abbeys such as Hildegard of Bingen's. But would they really tell us anything about ordinary people's actual lived experiences? Bones can't hide the truth. Poop doesn't lie. Coppergate Woman's world was one of putrid filth and endless pain. But also board games, ice skating and global trade. People combed and styled their hair. They knitted warm socks, tweezed stray hairs and scooped wax out of their ears. They had plenty to eat and kept lots of animals. They didn't write stuff down, instead preferring a rich oral culture of storytelling and song. There was plenty of beer.

Still, there was also *ascaris lumbricoides*. The worms would have been constantly itchy, eternally emerging from your bum, your nose, your ears, your *eyes*. And in the end, you might end up tossed into a shallow grave on the riverbank. Say, what time period from the past would you want to live in?

Gudit

Before we return to Asia's total domination, let's look back to east Africa to see what the Middle Ages are serving up. When we last left Meroë, it had been conquered by its hard-core patriarchal neighbor, Axum. Eventually claiming all of the horn of Africa (what's now Eritrea and northern Ethiopia), its capital city was a spectacle of monumental building. Huge stone obelisks, some more than 100 feet tall, were the largest structures in the world hewn from a single rock. We're still not exactly sure what they were for, but funerary monuments is the going theory. Axum (also spelled Aksum) started using iron plows instead of plain old hoes and agriculture boomed. Accruing massive wealth and power through global trade, Axum then did exactly what you'd expect: became obsessed with bureaucratic recordkeeping, taxes and telling women to go home.

But Gudit decided to go big instead. There are lots of versions of her story, recorded in the oral histories of different communities from Axum and beyond. Some even say she's Judith from the Bible, but that's a stretch. Our

main written source is the *Chronicle of Ethiopia*, a medieval history that was written centuries after she was gone, but tales of her violence are still part of the folklore of Ethiopia. She was, they say, born into the royal family of Axum. Because of "intrigue at the palace" (use your imagination), she was banished and forced to become a prostitute. Making the best of it, she quickly targeted a Catholic Deacon, became his mistress and got him wrapped around her finger. He gifted her gold shoes, they say, made from curtains from the holy church! When the people heard about it, they tracked down Gudit and cut off her right breast (as you do). Though the different stories all state this matter-of-factly, it is a motif worthy of some analysis. Amazons, the legendary warrior women, were said to cut off their right breasts in order to be better archers. So are the people of Axum calling her a wild woman? Or was it a ritual she submitted to intentionally, in order to become an Amazon? Because from here on out, she's definitely turning the warrior dial up to 11.

She ran to the Red Sea, where she could go no further. (Another familiar motif. Where's Moses when you need him?) No deliverance came from Yahweh, but Zenobis, a real-life Syrian prince, came to her rescue. After trauma bonding, the two joined forces and converted to Judaism together.

Normally when you maim a prostitute and banish her to the wilderness, she does not return as a warrior princess at the head of an unstoppable army. So, the Axumite army was not prepared. In the year 970, the King of Axum wrote frantically to neighboring kingdoms, "Help! Axum has been conquered by a woman and she is burning all the churches!" And those extant letters are actually some of our best corroborating evidence that the stories about Gudit are true. They say she ruled Axum for forty years (another Biblical motif, whaddaya know). In the stories, Gudit is given the nickname Esato, which means fire; some churches today still bear black marks from the flames of her rage. Ousting Christianity, she established a new religion that was a hybrid of Judaism and Indigenous beliefs. And it's during her reign that Axum collapsed.

Gudit is often blamed for triggering the "Ethiopian Dark Ages," and you could see it that way. All the wealth, bureaucracy and massive phallic obelisk erections came to an end. But it wasn't because she mishandled her power. She *ended* Axum, very intentionally. Her new kingdom would last for many generations, eventually evolving into Abyssinia, which was destined to make vengeful Grandma Gudit very proud . . . but that's for another chapter.

So, Axum's gone and Europe is mired in its own filth. At the same time, over in the Americas, the Maya have mysteriously wiped themselves out as well. We're still not sure why or how, but there are plenty of fascinating theories.

YOU PICK: WHAT ENDED THE MAYA GOLDEN AGE?

- The aliens went home
- They had very slow heartbeats and died out (one cardiologist's theory)
- They migrated north and learned violence from the Toltecs
- A peasant revolution drove out the rich
- They were invaded by Teotihuacan
- They clear-cut the rainforest to make lime, triggering a climate disaster

The Khatun

By the late Middle Ages, it's in Byzantium and east Asia that civilization is thriving. China has discovered magnetism, Japan has invented samurai (women allowed) and Korea is deep in its Goryeo golden age, when the Three Kingdoms finally united (peak costume drama material).

No one cares what's going on up on the north Asian steppe, because that real estate is so bleak, you couldn't build a civilization there if you wanted to. But the year is 1206 and a confederation of nomadic tribes has just elected a vengeful young man named Temüjin their leader—their Genghis Khan. Exploding onto the global scene, he took everyone by surprise (that was one of his main strategies, actually). He smashed armies from Korea to Byzantium, building the largest contiguous empire in the history of the world. But when it came time to set up a functioning empire, Genghis Khan knew his limits: the skills that make a person good at destroying are not useful once you aim to *build*.

Genghis turned not to scheming advisors, priests, or even his many sons for help building the Mongol Empire. Instead, he chose his daughters, the Khatun (Queens). The Mongols had swallowed up many distinct cultural regions, so

he matched a daughter with a region and said, "build an empire that works. I'll just be out there with my army smashing people."

They nailed it. Without the Khatun, there would have been no Mongol Empire. They were the brains and also the real face of the Empire. They were its political philosophers, its public relations experts, its legal advisors and its figureheads.

Alaquai-Beki, who ruled the Oirat south of the Gobi Desert, was the political mastermind. She believed that an empire based on tolerance was the most enlightened, so she declared that anyone under the authority of the Mongols was free to believe whatever they wanted, speak whatever language they pleased and to pursue their own lives. So long as they paid their protection money and acknowledged the Mongols as rulers, fine. It's a very ancient Persia kind of move.

Al-Altun was the shrewd businesswoman. She ruled in central Asia operating from a desert oasis that was a major hub of the Silk Road. That long-established network of trade routes traversed Asia from the Pacific to the Mediterranean and filled her court with incredible diversity. It was her job to coordinate the massive trade operation, so she spoke many languages and cultivated a dazzling "business casual" personal style by combining elements from all over Eurasia. Strangely enough, Genghis Khan was suspicious of written messages, so news from across the Mongol Empire came to al-Altun in the form of men, who recited poetry. Encoded in the poems was all military news required to mastermind the empire. When she made decisions, she too, had to encode her messages into poems, and entrust men to recite it for her hundreds of miles away. And they say Literature is useless in the real world.

The daughter who ruled the west remains nameless to us (the Persians called her Temelun, but they were probably confused). She was famed for joining in men's wrestling championships and winning. An adrenaline junkie, she loved horse racing, quests and the heat of battle. Genghis Khan, who usually forced his sons-in-law to fight alongside him, welcomed his daughter at his side as well. In one such battle, her husband was struck by an arrow and died. She turned to her dad and gave him the look. In one fell swoop, every last one of the rebels was put to the sword. Unnamed daughter of the west was really a chip off the old block.

Checheyigen was the wild child, so she was sent to rule Siberia in the north. She adopted local culture, hunting on snow and ice, wearing furs and harvesting the area's natural resources to send to al-Altun to sell on the Silk Road. She also succeeded in having a whole brood of children, which no other sister did, and matched them in marriages all over the place, Queen Victoria–style. So even though she was sent to the boonies, her impact in the long-term

was massive. Most of the descendants of the Mongol royal family came down through her line.

Under the sisters' leadership, the Mongol Empire thrived. Some call this period the Pax Mongolica (Mongolian Peace) because, what with the booming economy, roads, schools, markets and stability, life was good—for those who survived to see it. Everything had changed on the Silk Road, too. For starters, it was illegal to kidnap, rape, or traffic women. For about a thousand years, thieves and murderers had been harassing everyone who dared travel the Silk Road, until the Khatun came along. The whole of the Silk Road was now under their control and guaranteed to be safe. The global economy danced.

There is no other time in history when women ruled over such a vast empire and so many people. "In their lifetime they could not be ignored," wrote historian Jack Weatherford, "but when they left the scene, History closed the door behind them and let the dust of centuries cover their tracks."

To be fair, it wasn't just the Khatun that left the scene. After just over one hundred years, the entire Mongolian Empire comes undone. How exactly? Let's ask a skeleton from a graveyard in Kyrgyzstan.

Bačaq

1338, Kara-Djigach, Kyrgyzstan

Bačaq and her husband Yohannan, both just under 4 feet 10 inches tall, were among the adventurous pioneers who ventured onto the Silk Road once the Khatun had made it safe. They settled into the Chüy Valley, west of lake Issyk-Kul in modern Kyrgyzstan. The area seems to have attracted Nestorians, followers of a sect of Christianity who were hounded and harassed elsewhere. But this was Mongolia, the largest land empire of all time and the Khatun had dictated that anyone could believe anything here. So, in the early 1300s, Nestorian migrants from across Eurasia built a new town, Kara-Djigach.

It would have been a fascinatingly varied place, not just because of the immigrant population, but because of the global merchants passing through. In the bustling inns and marketplaces, treasure from across the world changed hands: pearls from the Pacific Ocean, silk and spices from China, bronze from

Ireland and iron from Africa. You would see barrels of oils, corals and seashells from the Mediterranean. And if silk (worth its weight in gold) wasn't fancy enough for you, you could also buy golden brocade: silk elaborately interwoven with fine gold thread. Imagine the smells and tastes of cuisines from across the world, the sounds of so many different languages and musical instruments, the incredible display of the world's cultures!

But in 1338, it all went sideways. A plague was visited upon the town and no one knew what caused it, where it came from, or how to stop it. Symptoms were pretty horrifying: first your lymph nodes swelled into massive blood blisters. Then, slowly, you bloated with blood-filled pustules inside and out, reeking of rotting flesh. If you were lucky, you died quickly as your phlegm-filled lungs gave out. If not, you gradually drowned in your own body fluids while your body burst its seams. It was the bubonic plague. And thanks to the DNA in her teeth, Bačaq has newly been identified as one of the first confirmed victims of the global pandemic known as The Black Death.

We're almost sure it's *yersinia pestis* bacteria that caused the Black Death, though wild alternative theories will always abound. Whatever toxin or infectious disease is the fear *du jour* will inevitably storm social media as the cause of the Black Death. But internet sensations, creative as they are, will never hold a candle to the real-life drama of the Black Death.

Bačaq and her husband were buried together in a brick-lined pit, without coffins or any grave goods. She was in her forties when she died and wore a simple wool gown. Her gravestone reads, "In the year 1338, it was the year of the Hare. This is the tomb of Bačaq, a faithful woman."

Other graves in the cemetery are resplendent with wealth and status—even those from the outbreak year—so what are we to make of Bačaq? Was she less successful than other migrant entrepreneurs? Was she perhaps a servant, or even a slave? Or maybe, was she that rare type of Christian who heeded that whole *rich man, eye of a needle* thing from the Bible?

The death rate in the town leaped 2,000 percent that year. Archaeologists keep finding coin hoards from 1338 as well. It paints a picture of panic. What would you do? Stay and risk it? Bury all your treasure and run? Run

with the treasure and hope to keep it safe, even while the world around you falls apart?

The Mongol army sourced its millet by the ton from Kara-Djigach, so things got real bad, real fast. Soldiers started dropping like flies in a nightmarishly fleshy self-destruct. The Mongol generals, bless them, took a cavalier approach. "If we're going down, they're going down with us!" they shouted as they loaded the dying into trebuchets and sent them flying over the walls of Caffa.

In the end, *yersinia pestis* was coming for you wherever you ran: to the Middle East, to India, to China, to Africa, to Europe. The scale of global destruction, social upheaval and unfathomable devastation was akin to pushing "reset" on planet Earth. One tiny bacterium, a genius of reproduction and survival, entered the global trade market in Kara-Djigach, multiplied itself in the guts of a flea, and never looked back. More than any conqueror, any religion, any empire, any invention—a microscopic organism changed the whole history of the world:

◆ It ended the unstoppable Mongolian Empire.

◆ It shattered the Islamic World, the global leader of all things intellectual, medical and mathematical.

◆ It removed half the population of Europe—but didn't break its political systems.

And therein lies the plot: once the Black Death had run its course, backwater Europe—that funny little place no one ever thought would amount to anything—was the last man standing. Its governments *were not* in shambles; its population was only half gone—only *half!* It had been overpopulated anyway, so you could even call it an improvement.

So Europe leapfrogs to the front of the pack. Christianity is about to get a new lease on life, capitalism is about to blow up and European sailors—not Mongol ones—are about to realize an entire continent exists across the pond.

The New World

AMERICA ENTERS THE CHAT. ABSOLUTELY
EVERYTHING GOES BANANAS.

Zazil-Ha and Malintzin

1511 CE. Playa del Carmen, Mexico

On the shores of Xaman-Ha, the Maya were celebrating a holiday when the gods suddenly delivered an unexpected gift. Through the pounding waves scrambled a dozen or so hairy, weirdly pale forms, clinging to bits of flotsam.

The creatures seemed to be attempting to speak, mumbling nonsense (spoiler: it's Spanish) like *todo el oro! La catastrofe! Tormenta! Todo el oro!* Nobody had ever seen creatures like this before.

Must be a gift from the gods. Prepare the sacrifice!

But the moment before death, two of the strange pale creatures began to frantically show off their skills. Geronimo Aguilar, a Catholic priest, somehow conveyed that he was a holy man and the Maya set him aside.

Gonzalo Guerrero's task was harder: he first needed a knife and some wood. And some catgut, ideally. *La música, la música*, he kept saying. The Maya watched with wary curiosity. But as he strummed the first guitar America has ever seen, they decided this guy might be worth keeping around.

It didn't take long before he caught the eye of Chief Nachan Can's daughter, sixteen-year-old Zazil-Ha. The interest was entirely mutual, but this pairing was shocking to the Maya on several levels. First, they were still not certain Guerrero was totally human. Second, and perhaps more importantly—he had this strange and terrible habit *of listening to what Zazil-Ha had to say?* He treated her as his equal, instead of like the silent servant women were meant to be. Rumor had it he even believed women should be allowed to speak?! *To men!?* In public!?

Zazil-Ha believed him to be human. Gurerro believed she should speak and be heard. It was a meeting of open minds.

It was surprising that the tribe allowed the relationship at all, but Guerrero also offered up a wealth of military know-how. He taught his true love and her family how to fight, Spanish style. Led by this bearded weirdo, they kept winning battles against their neighbors, so the Maya made some allowances for Guerrero's . . . *unorthodox* views on women.

These Maya, it's worth noting, are descended from the classical Maya of K'awiil (in fact, Zazil-Ha's kingdom wasn't too far from K'awiil's massive

94

city of Coba). But Zazil-Ha's people came centuries *after* the mysterious Golden Age collapse. K'awiil was about nine hundred years in the past at this point: a distant myth, if she was remembered at all. The grand cities and their pyramids had long been abandoned; the jungle had been completely eroded . . . and then grown back again. K'awiil's roads had long been swallowed up by the jungle.

Ruscelli's 1561 map of New Spain, showing Yucatán correctly as a peninsula, not as an island as previously depicted. Playa del Carmen is situated on the coast opposite the little island of Cozumel.

So, rather than living deep inland, the Maya of Zazil-Ha's time lived on the coasts, where life could be sustained a little more easily. Tulum (the famed coastal ruin, now mobbed by tourists) was a major center during this time— the last holdout of the Maya cities.

Meanwhile, 800 Miles Away in Tabasco . . .

The Chontal Maya had also discovered some bizarre hairy humanoids on the shore at Potonchán. These ones weren't shipwrecked, though, so they came ashore laden with shiny metal armor (*metal*? inconceivable), horses (whoa, what?!) and armored war dogs (what the actual . . . ?). Add in the muskets and you know who won the fight. The Chontal Maya offered the strange pale leader, Hernán Cortés, a tribute: *here's food, gold and twenty enslaved girls—now go away.*

Spoiler: he did not go away. And one of those girls, Malintzin, seized her moment to change the Americas—and the world—forever.

Sold into slavery as a young girl (possibly by her own family), Malintzin is believed to have been a high-born member of Mexica (Aztec) nobility. Resold across the region, Malintzin was forced to learn a variety of languages and dialects. And from the moment Cortés arrived in (what is now) Mexico, he had been searching for a translator. Hearing rumors of two shipwrecked Spaniards still living nearby, he searched for them nonstop. When he finally managed to track down Geronimo Aguilar, the priest who'd been captured alongside Guerrero, he immediately enlisted him as translator. And Aguilar was fully on board—after his long enslavement, he *hated* the Maya.

There's just one small problem (actually, two really big problems)—Aguilar only spoke one local Mayan dialect. Also, he had an obnoxious personality.

Then, one day (or night, we can only imagine the circumstances), Malintzin made it clear that she not only spoke several Mayan dialects, but she also knew the Mexica language, Nahuatl and was picking up Spanish at lightning speed.

Cortés immediately mobilized Malintzin for his cause, making her co-translator with Aguilar. As soon as she'd learned enough Spanish to no longer need the priest, Malintzin became Cortés's *only* translator for every interaction he was to have with any Mexica or Maya ruler, warrior, or messenger for the next *ten years*.

It's not just regular language translation Malintzin was taking on here. This was essentially a full cultural rewrite. She had to translate not just vocabulary, but intention, tone, subtext, personality and even entirely foreign concepts—ideas so unfamiliar there weren't even close approximations in their world.

So when, for example, Cortés instructed Malintzin to inform a local Aztec dignitary that his Spanish forces were "representatives of the King, who have the Pope's blessing, the Pope being the representative of God, the Holy Trinity, on Earth . . ." we cannot even begin to imagine how much of that parade of incomprehensible gibberish she actually managed to convey—nor how she would have gone about attempting it. And what incredible skill and

creativity must she have shown while transforming statements from Maya or Aztec leaders into content even remotely understandable by these outsiders from another world?

Whatever Malintzin managed to communicate, she did it well enough that soon she was no longer Cortés's translator. She was his *voice*—and the voice of *every other* prominent leader involved, at every stage and on every side, of this watershed moment in world history. She was the messenger *and* the message—the only person on the entire continent who understood exactly what was on the line and exactly how each party understood, or failed to understand, the stakes.

A depiction of Malintzin—known also as La Malinche or Doña Marina—interpreting on behalf of Cortés.

Cortés's game plan initially was to first move south and conquer the Yucatán Peninsula. But the troops he sent into the area came back soundly defeated. "It's like they knew we were coming and were ready for us! They even fought us using Spanish tactics!"

Malintzin scoffed. *There's no way.* For one, the Maya are constantly fighting each other and would never come together long enough to fight someone as formidable as *us*. What's more, they've never seen tactics like these in their lives!

What in the world was happening? *Zazil-Ha* was happening. She and Guerrero were rallying the Maya to unprecedented unity, persuading them to set aside centuries-long feuds in favor of a united front against Cortés—giving them the information needed not just to fight, but to win.

Combining Guerrero's knowledge of Spanish warfare with Zazil-Ha's ability to persuade (a *woman*, speaking to everybody!), the couple managed to do something nobody had ever done before: unite the Yucatec Maya under one cause.

Traveling to every Maya village and tribe to persuade them to join a cooperative plan of defense, Zazil-Ha turned the Yucatán into Cortés's worst nightmare: a united enemy who not only appeared to anticipate his every move, but consistently outsmarted him on his own terms. Zazil-Ha was in the center of it all—translating Guerrero's impassioned warnings, training Maya warriors in new tactics and then leading the troops in battle herself at the front of the line.

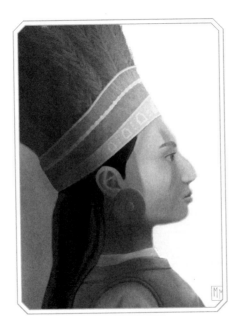

Zazil-Ha wearing a Mayan royal headdress and Spanish armor.

Cortés sent good old Aguilar the priest as an emissary to Guerrero. His message was essentially, "Leave the Maya right now and join me, your rightful commander." According to Aguilar's account, Zazil-Ha was having none of it. She laid into Aguilar: "How dare you speak to our King that way." "King?" said Aguilar, "you must be confused. I'm talking to the Spanish guitarist Guerrero."

Over the years, the couple had come to rule their kingdom. They'd had children, built a life, and the most unified Maya movement in history. Zazil-Ha

sent Aguilar running back to Cortés and Co., bearing the news that the Yucatán would be a difficult nut to crack. Learning this, Malintzin made a strategic decision—one that changed the course of history. She said, "Forget the Yucatán. It doesn't have any gold anyway. What we should do is head north instead, on an epic march to Tenochtitlan, capital of the Mexica Empire."

It began with a death-defying trek inland from the sea, across unimaginably dense rainforest and dogged by atrocious weather. One terrifying hailstorm killed several of the Caribbean slaves the Spanish had been dragging across the continent. There were endless fevers, poisonous bug bites and animal attacks unlike anything they'd ever experienced. When they finally arrived at the nine-foot wall marking the border of the southern kingdom of Tlaxcala, Malintzin and Cortés were ready for war. A decisive victory here was the only chance they had left.

After days of fighting, Cortés was getting desperate. There was only one strategy and Malintzin laid it out: wait for nightfall, then burn the surrounding villages to the ground, slaughtering anyone who resisted. Malintzin watched Cortés's forces utterly destroy a succession of villages. And after each massacre, she would speak to the survivors: "You see what these people are capable of. Go and tell your King what happened—tell him to make peace with the Spaniards."

They did exactly as she said. After eighteen days of battle and burning, the Tlaxcalan king surrendered. And as the Spanish recouped, resupplied and continued their assault on the Mexica empire, Malintzin's voice facilitated every step of that process. In Mexica images of the conquest, Malintzin is *always* there, telling everyone what to do. Rather than hovering like a sidekick in the background, she's usually portrayed as larger, more imposing and more important than Cortés. In fact, Malintzin became so synonymous with Cortés's power and authority that several Indigenous kings began calling *him* by *her* name. Cortés was now "Malintzin"—absorbed into her persona and her power. He's the hanger-on, riding her coattails to glory. When Cortés finally met Montezuma II in that fateful meeting in Tenochtitlan, Malintizin translated with panache.

The Mexica Empire fell—and Malintzin was the reason why. How did she feel about that? There's no way to know. But her impact, at least, is undeniable. Really, it's hard to think of *any* woman who has ever had a more direct and measurable impact on her world—on *the* world—than Malintzin. How would things have turned out for Cortés without her intervention? (A swift death right out of the gate, probably.) What would the Americas look like today if she hadn't been in that exact place at that exact time?

MOTHER OF THE MESTIZO: WHO OWNS THE CROWN?

Malintzin the Mastermind

* Translated everything everyone said (Spanish, Maya, Nahuatl)
* Added her own filter and flair to each translation
* Advised on poisonous plants and how to survive in the rainforest
* Devised ingenious, villainous plots to destroy each kingdom
* Repeatedly saved the Spanish conquistadors' lives
* Translated the historic meeting between Cortés and Montezuma II
* Brought about the total destruction of the Mexica Empire
* Shared Cortés's bed and birthed (possibly) "the first mestizo"

Zazil-Ha the Mastermind

* Realized Guerrero's knowledge was crucial to their survival
* Summoned the courage to speak publicly when women were not allowed to speak
* Traveled to tell every Maya tribe of the threat
* Unified the whole Yucatán peninsula
* Trained the Maya in Spanish military tactics after learning the skills herself
* Led the Maya army
* Saved the Maya from Spanish invasion for a generation
* Married Guerrero and birthed (possibly) "the first mestizo"

There are so many what ifs in the story of the "conquest" of the Americas, it boggles the mind. The result, in the big picture, was nothing less than a total reshuffling of planet Earth. People, religions, diseases, foods, natural resources—*everything* changed. That whole phenomenon is called the Columbian Exchange but, honestly, it would be much more aptly called the Malintzin Exchange.

Imagine! Learning for the first time that tomatoes exist. Or coffee. Horses. Wheat. Sugar. Syphilis. *What a time to be alive.*

Skipping to the end of this dramatic global shuffle, we can say with confidence that for all Natives of the Americas, it was in fact *not* a time to be alive. The brutal conquest—by biology more than anything else (we're looking at you, smallpox)—led to a 90 percent death rate in the Americas.

Take a second to let that sink in. Then you'll be able to connect more dots, like:

◆ How Europeans started mass plantations on the "blank slate" continent

◆ Why Europeans started transporting thousands of enslaved Africans across the ocean to work on said plantations

◆ How, with no one around to stop it, Spain won the global lottery, extracting tons of silver from South America

◆ Why Spain transporting literal shiploads of silver—and shiploads of slaves—across the Atlantic led to the rise of a new, ocean-bound, rebel lifestyle

◆ How the fact that a whole other continent existed—all this time!—without any Bible, Torah, Upanishads, I Ching or Koran mentioning it inspired some serious questions about Truth

A Sea Change

Did God send Spain to the Americas? Was smallpox His way of removing pagans from the continent, to clear the way for good hearty Catholics? Then maybe it felt cute to throw in some massive Bolivian silver mines for a flourish?

It's laughable now, but five hundred years ago it wasn't hard for the Spanish to 100 percent believe it. Remember, they didn't yet know germs existed, so

when they saw the total devastation of an entire continent by a disease which somehow left Spaniards untouched, they were like, *Behold.*

Native Americans who miraculously survived it believed it too and converted—because the Spanish God was so very clearly someone with whom you *do not mess.*

At the same time, there were a lot of people who watched the triumph of Spain in horror. A sea change was on the horizon. Drink up, me hearties, yo ho.

SURVEY: It's the sixteenth century and you're watching all this go down—what do you do?

- Just steal Spain's silver
- Embrace Catholicism hard (if you can't beat 'em, join 'em)
- Try your luck in the New World (find your own silver?)
- Get really into witchcraft
- Ignore it and it will go away

Congratulations, you just took the definitive "What's your early modern historical personality?" quiz!

Your results:

* **Just steal Spain's silver** You've become a pirate! Or, if your loyalty to your monarch knows no bounds, you're a privateer.

* **Embrace Catholicism hard (if you can't beat 'em, join 'em)** Gear up, you're about to be a perpetrator or victim of the Spanish Inquisition. Hope you have the stomach for watching people slowly melt to death on a pyre.

* **Try your luck in the New World (find your own silver?)** Bold move. Spoiler: you will not find silver. For your consolation prize, do you choose "living in a wildly oppressive religious community," or "genociding beavers in the wild to sell their furs"?

* **Get really into witchcraft** You'd think this would work, wouldn't you? But *surprise!* Europe is about to unite over its hatred of witches. You'll need to be *extremely* clever, or extremely rich.

* **Ignore it and it will go away** Congratulations, you are *the whole of Asia!* While pleasant and seemingly wise in the short-term, this will, alas, turn out to be a pretty ruinous move.

Let's explore.

Stealing Spain's Silver: Granuaile, the Pirate Queen of Connacht

There have been pirates since the beginning of history, but what made the early modern era especially piratey was the fact that the oceans were awash with Spanish ships packed with silver. It was also a time of powerful, centralized states: strict hierarchies, bossy royal courts—The Man ruled supreme. Put those two things together and you get the Golden Age of Piracy. Piracy was a persistent, almost defining threat to governments in and around the Atlantic in the early modern era. But who was the bigger threat to people, peace and prosperity: wild, free pirates . . . or the state? Let's ask Granuaile.

Gráinne was born around 1530 on the west coast of Ireland. With a network of tower houses (tall, skinny castles) along the coast, the O'Malley clan played in a brutal game of thrones in the wild west of Connacht. The freedom of the sea called her even as a child, they say, and she begged to join her father's voyages.

Girls were not allowed on boats, of course. So the little girl chopped off her wild red curly hair, dressed as a boy and snuck onto her father's ship. By the time she was discovered, they were far off to sea. Her father tousled her rough-hewn locks and agreed to teach her all he knew. From then on, she was known as Granuaile—meaning Gráinne the Bald. She became the most notorious pirate queen Ireland has ever seen, harrying the Atlantic from Scotland to Spain.

Granuaile was ruthless to be sure, like all pirates are supposed to be. Married young to a brute named Iron Dick (you can't make this stuff up), she claimed his castle, barred the door and told him to jog on. But when a neighboring clan murdered Iron Dick, she exacted revenge on an incredible scale. First, she killed everyone involved in the murder. Then she killed their allies and any friends and neighbors who had even vaguely known about it. Then the neighbors' neighbors . . . you get the idea. It was a tried-and-tested technique she would employ throughout her life.

But Granuaile was also principled, in her own way. She had a code of behavior, as so many pirates famously do. This code enshrined old Brehon laws—for example, that chieftains offer each other hospitality while passing through each other's territory. So, when one evening she was passing by Castle Howth, she called at the gate, requesting an evening's accommodation. "Lord Howth is at his dinner," she was told. "Go away."

Murder the casual acquaintances of your enemies? Yes, fine. Seize a Spanish ship at sea and drown all its inhabitants? Absolutely. Reject a chieftain's request for hospitality?! Never.

She left Castle Howth, but not before grabbing the lord's son, tying him up and taking him hostage. Back in her castle at Westport, she threw the boy in the dungeon and waited for Lord Howth to come sniveling at her door. He came, duly sorrowful. She returned the son, on the promise that Castle Howth would never again fail to provide hospitality. To this day, Castle Howth sets an extra place, for Granuaile, every night.

Her favorite castle, Rockfleet, still stands. It's said that when she was forced to sleep on land instead of upon the wild sea she loved, she'd run a rope from her ship through a little arrow slit on the top floor of the castle and tie it to her toe. Thus she could feel the rhythm of the waves while tethered to the ground.

Granuaile's arch nemesis was Sir Richard Bingham, a scheming and ruthless Englishman appointed Governor of Connacht for the sole purpose of bringing the Irish to heel. He represented The Man, the state and centralized governmental power. Bingham declared martial law and went after the

O'Malleys with unmatched ferocity. He murdered Granuaile's oldest son in a Red Wedding–style deception. He kidnapped her younger son and sent him off to be raised an Englishman. He took her cattle, diverted entire fleets in an attempt to seize her ships and captured and executed everyone even vaguely related to her. Bingham did absolutely everything in his power to make Granuaile's life a living hell.

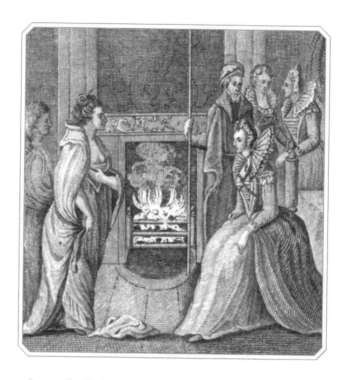

Granuaile (Gráinne O'Malley) is introduced to Queen Elizabeth I at Greenwich Castle, September 1593.

Why did he target her? Was she *really* that much of a threat to the crown of England? Ireland was full of chieftains and rebels and had been for centuries. Was it that she wasn't just a rebel, but a pirate? The sea was full of pirates, too: some of them were Queen Elizabeth's favorites. Was is that she wasn't just a pirate, but a woman?

There's a really interesting theory about The Golden Age of Piracy. Its basic premise is that piracy was really all about class—it was about the haves and the have nots. In the face of the absolutist hierarchical states that

dominated Europe at the time and which exploited commoners to the point of death or despair, people opted out to start floating utopias of freedom and equality.

It's quite a spin on the traditional tale. But the traditional tale (pirates would be first to point out) was told to you by the state.

YO HO, IS A PIRATE LIFE FOR YOU?

The Philosophy of Piracy, according to pirates:

* Give up your national identity, so no state can control you. You are now "from the seas."

* Learn to speak Pidgin, our own language, so no country defines us.

* Embrace being multiracial, multicultural: a true motley crew. We treat anyone from anywhere as an equal.

* Don't attack the little guy. We're here to attack agents of The Man.

* Practice true democracy: pirates vote on everything, share all booty equally and have equal accommodation (no fancy captain's quarters).

* No religious rules or requirements. Superstitions welcome.

* When seizing a ship, put the captain on trial. Ask the sailors if he treated them fairly or if he was the typical type who abused and starved his crew. Bad captains die. Good captains (plus any sailors who don't want to join the pirates) are dropped off at the nearest port.

* Some women allowed . . . sometimes, under peculiar circumstances. In such circumstances, said women are very powerful and deeply respected.

* Everyone contributes to an insurance pot. If any pirate dies, the pot goes to his/her family to support them for life.

That's an amazing and whimsical way to view the story of piracy. In an era of authoritative, hierarchical, super sexist governments, did thousands of people follow Granuaile's lead and forge a life "from the seas"? Did girls chop off their wild hair, dress as boys and free themselves? Did they all collectively dream of real liberty and equality (we're looking at you, Republic of Pirates, 1706–1718)?

The ideals of liberty and equality *did* start to take root in the early modern era (we'll pick up this thread in Chapter 7). Traditional History gives credit for the spread of these ideas to essayists like John Locke and Thomas Paine. But what if it was actually down to the pirates? For centuries, their swashbuckling tales spread far and wide, especially among the 99 percent who had zero interest in the snoring prose of political treatises and who couldn't read anyway. The masses told and retold many a tale of the nationless galleons on the high seas: of unprecedented equality, of collective codes of behavior. Maybe they started to believe such freedom was possible.

In the end, after decades of cinematic struggle, Granuaile, aged sixty, emerged victorious over Sir Richard Bingham. The story of how she achieved this is the most incredible episode of her life. She literally sailed right up the Thames, to the palace of Queen Elizabeth herself. "Yes, 'tis I, the Pirate Queen of Connacht," she said, "I, whom England has notoriously hunted these forty years, request an audience with the Queen."

Unfathomably, Queen Elizabeth, also aged sixty, agreed. They chatted in Latin, their only shared tongue. No one knows what was said, but how could it *not* have included commiserations about being a powerful woman in a man's world? When Granuaile returned to Ireland, the Queen's writ in hand, she got her lands back, her cattle back, her castles and her people back. The Queen even signed off on her pirating. Sir Richard was recalled to England and promptly thrown in prison.

Granuaile's tale was told for centuries in Ireland, until it was consigned to legend: surely there couldn't have been an *actual* woman who lived that *actual* plot. Now, thanks to a young historian named Anne Chambers, who ambitiously searched Westport House in the 1990s, we have documentation that proves it was true. You can take the pirates—and the women too—out of history, but eventually we'll put them back.

Embracing Catholicism Hard: Margaret Clitherow and Reformations

Just as Catholic Spain was annihilating the Americas, religious Reformation movements were bubbling up across the globe. These were rooted in the deeper questions about Truth people had long been asking themselves. First the Black Death killed holy people while leaving the biggest jerks alone; now we find out a whole continent exists that not even the most enlightened or godly of us was told about? Vexingly, the new realities of a global world continued to prove wrong the old truths. Religious movements that favored the individual over The Man grew in all the major world religions during the early modern period.

The Christian version of this in Europe is widely called The Reformation and the finger is usually pointed at Martin Luther for posting his ninety-five problems with the Catholic Church on the door of a church in Wittenburg, Germany. It makes a great dramatic moment, but deeper fractures were already appearing across the globe.

Christian reformers in Europe were starting to believe that they could map their own route to salvation and they didn't need Latin-speaking popes or priests to tell them how to be. *The Bible is all we need*, said Protestants, *kindly translate it into our modern vernacular and then go away, thank you*. When the Catholic Church cracked down hard (using the age-old burning-people-alive technique), Europe shattered into religious war.

Team Catholic (Most Valuable Player: Spain) went head-to-head with Team Protestant (basically all of northern Europe). Calling it "The Reformation" or "The Thirty Years' War" or even "a series of religious wars" really skims over the fact that, for a century, Christians exiled, attacked and even massacred each other on an incredible scale.

The culture war led to the birth of The Netherlands, a nation established explicitly in the name of tolerance and freedom (Americans: for a thought-provoking moment of amazement, read the Dutch Declaration of Independence, 1581). People who were hounded for their beliefs across Europe (Jews in Spain, Protestants in southern France, Catholics in Germany) flocked to Amsterdam in search of peace. Extremist Protestants

called Puritans from England joined the new nation, but promptly tried to force everyone else to live by their beliefs. Intolerance was the one thing the Netherlands could not tolerate—*bye*. The Puritans boarded the *Mayflower* and headed to the New World where, they dreamed, they could finally, freely practice the true religion—and force everyone else to do it, too. (If you chose "Try Your Luck in the New World," the ramifications of your decision will become clear when we get to witchcraft.)

Ireland, in contrast, held the religious banner high as a rallying point. The Reformation created a seductive lens through which to view England's five-hundred-year-long attack on Ireland. England, now Team Protestant, was enemy number one. Naturally, Irish folks who may happily have been Catholic-lite before, became some of the most hardcore Catholics in Europe. Ireland bonded with Spain and France, united in their hatred of Protestant England.

But there were Catholic holdouts in England, too, operating a kind of high-stakes spy network. Ever since England had changed to Team Protestant (thanks Henry VIII), the stage was set for some ferocious showdowns. Even in the far north, far from the dramas of continental Europe, religious fervour played out.

Margaret Clitherow is remembered today as a remarkable example of the brutality of the age. A staunch Catholic in Protestant England, she joined a kind of Catholic Underground Railroad across England, with supporters famously building "priest holes" in their houses. Masterfully disguised, the claustrophobic spaces could hide a priest in a wall, floor, or fireplace for hours, days, weeks.

In the city of York, among the butchers of the Shambles, Margaret Clitherow hid priests in her home. They say it was a servant boy in the household who ratted her out. Hauled before the Protestant court, she refused to enter a plea. Had she entered a plea (guilty or not), she would have triggered a trial that very likely would have engulfed her children, husband and the servant boy. They could have been forced to testify by means of torture. Instead, she was ready to face the punishment meted out for refusing to plea:

Judge Clench: "You will be stripped naked, laid down, with your hands and feet tied to posts and a sharp stone placed beneath your back, with as much weight laid upon you as you are able to bear, until you are pressed to death."

In a bizarre act of symbolism, Margaret's own front door was used as the crusher, more and more weight piled upon it. The sharp stone beneath her back would have snapped her spine first, before the added weights slowly suffocated her. Also, she was likely pregnant.

A young mother, a butcher's wife, she was not a powerful or prominent threat to the nation, nor, dare we say, to God, but there she was, crushed to death at the tollbooth on the banks of the river Ouse. Her crime is now moot: Catholic priests are free to move around England once again. And so with hindsight, the brutality and seeming pointlessness of her death bring the broader religious conflict across Europe into sharp focus. Why did it matter so much to some people? What do we today believe with such ferocity?

Get Really into Witchcraft? Mother Shipton

In that same region of York, back when Margaret Clitherow was yet an infant, another famed woman took a very different tack. She turned to witchcraft but, more than that, she dared to take on King Henry VIII himself . . . and won. Since, with the benefit of hindsight, we know that she'll turn out to be Mother Shipton, *The Witch upon whom all subsequent witches are modeled—the Icon of Icons*, let's start at the beginning.

It was a dark and stormy night. Cliché, yes—but it really was. The year is 1488. The place, the sleepy little town of Knaresborough, Yorkshire. A storm is raging, the river Nidd is high and no decent Christian soul would dare to be out on such a night.

But let's zoom in on the river for a minute—something unusual seems to be happening. Against the wind and waves, a tiny rowboat is struggling and who's at the oars? It's a teenage girl, crying so hard we can even hear her over the crashing thunder. Wait, this can't be right. Maybe zooming in closer will give us a few more clues.

Okay, yes—the girl is definitely pregnant. In fact, she's visibly in labor—no wonder she's sobbing so hard. But in that case, what on Earth is she doing in a rowboat in a river in the middle of a thunderstorm? And where on Earth is she going? Everyone knows the woods on that side of the river are haunted. And not even just regular haunted—*super-duper* haunted. Like, *terrifying skull-shaped waterfall that magically turns stuff to stone* haunted. *Nobody* crosses the river here—and yet there she goes.

Her name is Agatha. She's fifteen years old, an orphan and about to give birth to a child whose father she refuses to name. Turned out of her home and with

nowhere to go, she's apparently decided she prefers the perils of the Devil's Wood to the sneers of her human neighbors. She will make it across the river, give birth in a cave near the magic petrifying well and name her daughter Ursula.

The petrifying well in Knaresborough.

This was no ordinary child. First of all: her appearance. Contemporary descriptions are not exactly kind, describing the newborn as deformed, devilish, monstrous. A hunched back, a hook nose—essentially, picture the classic "cartoon witch" face, but baby-sized.

Her looks are only the tip of the iceberg. Young Ursula's powers started to show up early: at two years old, she was found perched on top of a chimney stack, stark naked and giggling. By six years old she was being openly bullied by the important men of the town (real mature, guys)—and here's where Ursula begins to emerge as someone who's *not going to put up with this crap anymore.*

The way this little girl fights back is not exactly . . . conventional. One source from 1686 informs us, "One of the principal men, that thought himself spruce and fine, had in an instant, his neck ruff pulled off and the seat of a toilet clapped in its place." But Ursula wasn't done. "He that sat next to him, bursting into laughter at the site [sic] thereof, was served little better, for his hat was invisibly conveyed away and the pan of a chamber pot put on his head instead."

As Ursula grew, so did her reputation for dangerous magic powers—so whenever the rejection of her neighbors got to be too much, she would escape

across the river to the place of her birth. She found peace in the cave, the woods and even the petrifying well. And though the townsfolk may have whispered behind her back, speculating about her pact with the devil, they also came to her for help anytime their problems felt too big for normal human solutions. Her magic potions, aka herbal remedies, were brewed from ingredients gathered in her beloved haunted woods, and were famed for their strength and potency. But what really skyrocketed Ursula into fame and fortune (well, fame at least) as the wise and powerful Mother Shipton, were her incredible prophecies of the future.

A poster dated between 1851 and 1881 showing Mother Shipton and many of her prophecies, including the Crystal Palace, gold rushes in the New World, plague, iron ships, war, ballooning and radio transmission.

What did she prophesy? Depending on who you believe, all kinds of things: running water, airplanes, the end of the world . . . Of course, like any decent self-respecting prophecy, they're sometimes a little hard to decipher. Let's try one ourselves, shall we?

Water shall come over Ouse Bridge, and a windmill shall be set upon a Tower, and a Elm Tree shall lie at every man's door.

Well, that's cryptic. The people of Knaresborough puzzled over these lines without any clue what they could mean. Then, centuries later, the locals of York marveled at an amazing new piped-water system. Water ran through hollowed-out elm trees across the Ouse river bridge, with a windmill drawing the water up to the pipes. The elm trees carried fresh water straight up to "every man's door." This new technology felt almost like magic—and once people connected those pipes with the prophecy, there was no *almost* about it.

Mother Shipton's prophecies weren't always so cryptic though. This one, for example, is extraordinarily straightforward:

When there is a Lord Mayor Living in Minster Yard, let him beware of a stab.

Pretty hard to miss the meaning there. And yet, shortly afterwards, the Lord Mayor of York moved to Minster Yard and was indeed mugged and stabbed three times. Why didn't he listen?

As Ursula's fame grew, so did her daring, and she began to make prophecies about the highest and most powerful in the land: even the King himself. Her predictions about Henry VIII were startlingly accurate. As for Henry's disgraced right-hand-man Cardinal Wolsey, already on his way north to take the "consolation prize" of being Archbishop of York, she announced that though he would see York, he would never reach it. This effrontery made the Cardinal so furious that he sent men to visit her, secretly and in disguise, to arrest her for witchcraft.

But the moment Wolsey's men arrived, she told them, "I know who you are and why you're here." This unnerved them a bit, but they pressed on, warning Mother Shipton that Wolsey would have her burned at the stake as soon as he arrived in York.

"Really?" she said, "Let's see." Mother Shipton took off her cap and threw it into the fire, but it didn't burn. She reached for her wooden crutch and threw that into the fire—it too didn't burn. So she pulled them back out, dusted them off and said, "Well, there you go. If these had burned, I would have too." Then the men were afraid. She could see their fear—and she could also see their future. "I see all three of your heads on the bridge over the river Ouse," she warned. That's about the point when the men took off running.

Meanwhile, Wolsey, old and ill, was nearing the end of his long journey from London. His final stop was just ten miles outside York, at an old medieval tower overlooking the city. "Ha!" he said, "I'll show that so-called sorceress!" Wheezing but determined, Wolsey climbed to the top of the tower and there on the horizon was York. He could see it! He had won.

"This is proof that that witch deserves to be burned!" he declared. "She said I would never see York, but there it is!" Then a calm voice behind him broke in. "My lord, no. She said you would *see York, but never reach it.*"

Whirling around, Wolsey saw Lord Percy—one of the men he'd sent to arrest Mother Shipton weeks before. But this time, Percy had been sent by Henry VIII to bring Wolsey back to court, to be tried for high treason. They left for London the following day and Wolsey died en route—still having never set foot in York.

Mother Shipton's story ended much more happily. Safe in the knowledge that "this witch will not burn," she lived to a very old age, then lay down on her bed and died—on the very day and at the very hour she predicted. Her life gave us the prototype for "what a witch is"—with one massive difference: her story has a happy ending. That's not something we can usually count on, especially once "witch hysteria" really kicked off across Europe in the sixteenth century, culminating in the infamous Salem witch trials in the seventeenth century, in the American colonies. Because, spoiler alert: witch stories nearly always end up very badly.

Given all this drama in Europe and America, let's spin back to the part of the world that embraced that age-old strategy of . . .

Ignore Spain's New World and It Will Go Away: Asia

As with other holy books, the Hindu *Upanishads* (where the great proto-feminist sage Gargi appeared with a flourish long ago) and China's ancient *I Ching* had failed to inform even the wisest that a whole new continent existed. They had also failed to rescue vast swathes of the population from the Black Death.

The existential crisis in the East, however, was far less pronounced than the crises of the West. The reasons for this are as old and deep as mythos itself, but a simple explanation is that the main premises of eastern religion maintain the illusion of the individual, the endless cycle of life and death and the divinity in

everything. ("On what," Gargi asked Yajnavalkya, "is the universe woven back and forth?" *"Atman"* was the answer: "the universal spirit within us all.") No punishing monotheistic God, no limited map of a finite cosmos for this part of the globe.

So, when the global world presented all kinds of new ideas and ways of seeing, Asian monarchs tended to respond very differently to European ones. It was the great age of Philosopher Kings (and Philosopher Queens, as we shall see), of spectacular gatherings of sages from across the globe, of deep conversations with missionaries from everywhere. So if you chose *Ignore it and it will go away*, allow us to present your possible variations of ignoring.

Sea Trade Killed the Silk Road Star

Remember how the Silk Road was the center of global trade and wealth for over a thousand years? Well, when America entered the chat, absolutely everything went bananas. Overland routes were *so* last millennium and the Asian cities that used to dominate the globe were losing their grip. But that's only obvious in hindsight. At the time, no one (except maybe Mother Shipton?) would have guessed it would turn out that way.

In the Middle East, Europe was still considered a backwater nothing of a place; even paying attention to what Europe was doing was deemed eccentric. Sure, Spain had briefly won some kind of silver lottery, but it couldn't last. The world's eyes were still on Istanbul, Agra, Samarkand and Xi'an . . . right? All were well recovered now, two hundred years after the ravages of the Black Death. Rich and powerful monarchs had more important, more immediate things to worry about than silly little Spain, or spiceless, silkless, tealess America.

When Sultan Mehmet II conquered Constantinople in 1453 by a feat of truly jaw-dropping military prowess (soldiers carried their own massive warships overland to bypass the chains blocking the Bosphorus), the Ottoman Empire exploded onto the global scene. It became an Islamic powerhouse plonked right at the hub of global trade by land and sea—at the crossroads of Europe, Asia and Africa. Istanbul (which was Constantinople . . . you know the song) positively overflowed with interesting people, artisanal masterpieces and exotic products from all over the world. Flanked by a host of spires, the magnificent dome of Holy Wisdom (Hagia Sophia) watched over the city as it had for nine hundred years. And under its gaze, in the center of the city, a magnificently tiled complex of rooms was shut away from all the hubbub. In this most elaborate gilded cage lived the many women of the Sultan's harem.

Roxelana

As a child in Ruthenia (now Ukraine, Belarus and Lithuania), Roxelana probably never imagined destiny would deliver her to the Sultan's harem, but that's life. Her people were conquered by the Ottomans and female captives were a part of war. In fact, the Sultan's concubines were always foreign, captive women—it was politically safer that way. These women would bear the Sultan's children and the Sultan could virtually guarantee there would be no meddling in-laws. The harem was an all-female world-within-a-world, made up not just of concubines, but the Sultan's female children, siblings and his mother. Their servants were eunuchs.

Now here's where it gets interesting: the Sultan could have whomever he liked, even name a favorite—but once a woman bore a son, the gig was over. Mother and son would be shipped off to some distant precinct where she would tiger mom 'til the end of her days.

Or more likely, to the end of *his* days. Because when the Sultan died, all the sons would hurl themselves into the fray to claim the throne. No primogeniture for this empire. It was expected and accepted that all sons would duke it out for the throne and the strongest, bravest, smartest would emerge victorious. Sibling rivalry to the death. (Pause here, for those of us with siblings to imagine this entire episode with a rich autobiographical overlay.)

How could such a practice possibly build a stable empire, though? Roxelana wondered the same thing. She wondered it even harder when she bore a *second* son to the Sultan. Such a thing had never been done before—who let her and the Sultan get away with it? Suleiman the Magnificent was, by all accounts, so utterly in love with Roxelana that the two cast aside all the Ottoman palace rules and lived happily ever after. Together. In the palace. Having lots of kids. Meeting world leaders, making alliances. Learning how to forge diplomatic solutions instead of going to war.

For thirty-seven years Roxelana and Suleiman ruled the Ottoman Empire, going from strength to strength. Among her more brilliant insights was the potential political power of the harem. Basically, she said to her husband, "Listen. Nobody pays attention to us ladies. Powerful men from all over the world come to meet formally with you. When they do that, their wives and daughters are shuffled into the harem and everybody thinks we're just drinking tea and, I dunno, looking at jewels. But what if I were to actually get to know these ladies, to learn the innermost details

about their lives—the hopes, dreams, fears of their husbands? Wouldn't that be useful?"

And to his credit, Suleiman replied, "You know, I think that would be very useful."

Roxelana changed so much about how the Ottoman Empire operated. It became even more powerful, successful and wealthy—it became an acknowledged global superpower. But she never could eliminate the palace enthusiasm for sibling rivalry to the death. Best she could do was have her sons' older brother (by another mother) murdered. *Don't mess with Roxelana.* Still, she died full of angst about the future for her sons.

What she achieved for women, however, was a cultural transformation. A harem was no longer a gilded cage; the harem became an all-female political arena with remarkable power. In short, life got much more interesting for women across the Islamic World.

The Ottoman Empire would continue to dominate global trade for centuries, blithely ignoring the West, which would never amount to anything without tiles, spices, hygiene . . . They could never ever guess that a little thing called the Industrial Revolution was on the distant horizon and with it, a ferocious Greek woman with a warship. But that's for another chapter.

The Mughal Empire

Let's spin the globe further east in the Islamic World, where Mughals united northern India in another powerhouse of an empire. Muslim rulers dominated the Hindu population, but presented a vision of tolerance, strength and education for all. Global trade and the (about to drastically decline) Silk Road had made the Mughals rich. Having won wealth and power, they made it known that they were now on the fast track to enlightenment. Philosopher Kings gathered mathematicians, astronomers, sages, mystics and missionaries from around the globe to compare notes (oh, to be a fly on that wall). The Mughals did not completely ignore Spain as the Ottomans were inclined to do, but they had learned not to hope that its Catholic monks would have many open-minded things to say. A couple of generations in, Emperor Jahangir presented himself to the world as the greatest, most enlightened Philosopher King of all time. He had a drug problem and a drinking problem . . . and all the problems. Luckily for him, he also had Nur Jahan.

Nur Jahan

Nur Jahan is super-famous in India, if largely unknown everywhere else—but even on her own stomping grounds, her story tends to end where it should actually begin: at her marriage. Her romantic love affair with Jahangir is rightly legendary, but what she accomplished after their marriage is the real headline.

Stuck between a rock (a husband sidelined by addiction or chronic illness, or both) and a hard place (a culture with extraordinarily high walls around "a woman's place"—literally, in the case of the royal harems), she somehow managed to find a way around them. Successfully walking the tightrope between allowing the kingdom to descend into chaos and being branded an overbearing shrew by the masses, she would be the "power behind the throne" for nearly two decades.

Uncovering her place in the story after centuries of erasure involves a lot of detective work, requiring historians to peel back layers and layers of assumption and misdirection to find the real "woman behind the curtain." But even a bare-bones listing of facts from Nur Jahan's life ends up reading like an extremely unlikely adventure novel.

◆ As an infant, she was abandoned on the side of the road. When her suddenly repentant father rushed back to reclaim her, he found her about to be devoured by a huge black snake, rescuing her just in the nick of time.

◆ She had a secret love affair with the Emperor Jahangir before being married off to another man—but was finally reunited with the love of her life nearly two decades later.

◆ She once killed four man-eating tigers with six musket shots—from the top of an elephant.

◆ She successfully broke her husband (and a few hundred soldiers) out of prison, directly under the nose of an entire enemy camp.

But these facts tell us so much more than just "this lady is beautiful, a bit bonkers and apparently really good with a gun." They tell us, if we only look at them right, that Nur Jahan really was *the* sovereign, *the* ruler, of the Mughal Empire at this point. She's not "the Boss's wife"—she is The Boss.

How? Well, let's look at the tiger thing, shall we? It's an incredible story—taking out four tigers in six shots is a ridiculously impressive feat, for anyone, at any point. But to do this from atop a (presumably) anxious, antsy, currently-being-attacked-by-tigers elephant? *Come on.* This story's importance goes way beyond just sharing her stats as a sharpshooter. Because there's only one person in the empire who's allowed to kill a tiger—and that person is the emperor. And Nur Jahan does it. And nobody says a thing.

The powerful Empress Nur Jahan holding a gun.

She is entrusted with the imperial seal; essentially handed the power to run the Empire as she sees fit, issuing imperial orders in her own name, as Padsha Begum—Lady Emperor. This is absolutely unprecedented. No woman has ever held such a title or exercised such power in Mughal history. She is issuing coins in her own name (remember when Zenobia tried that? Not Good Outcome). And in case anyone was unsure about this woman's courage and willingness to dash straight into danger when she believes her duty calls, there's of course the evidence of The Great Husband Rescue of 1626.

Several prominent court officials were growing alarmed over Nur Jahan's increasing autonomy and influence over the empire and the emperor, but one prominent Mughal general-turned-royal-treasurer called Mahabat Khan took things to a new level. Waiting until the royal entourage was en route to Kabul, Mahabat Khan attacked the encampment, took Jahangir hostage and declared himself the rightful Emperor of India. Okay, that terrible woman Nur Jahan had escaped, but Mahabat Khan had the emperor and most of his royal guard, so what was one bossy, overbearing little female going to do about it?

At this point, Nur Jahan had a lot of reasonable options. She could have arranged to pay the (literal) king's ransom. She could have sent one of Jahangir's sons to attempt to extricate him. She could have asked her trusted military leaders to get the emperor back. Instead she decides, *You know what? I'm gonna go rescue him myself.* So off she goes—atop yet another elephant (apparently the *only* way for the stylish Mughal lady to travel) and leading an army—to retrieve her husband from the bad guys. This bold (and, okay, perhaps a bit foolhardy) move so annoys one stepson, he refuses to obey Nur Jahan's orders and ends up sabotaging the rescue campaign. As a result, the attempt fails and the empress is herself taken captive.

So now Nur Jahan is locked up in an enemy prison camp, along with her husband and a sizeable chunk of their army. Most people finding themselves in this situation would probably have felt a bit deflated. *Well, that didn't exactly go the way I'd planned.* But Nur Jahan is not most people. Instead, she appears to have gone, *Hey, this is great! Now I'm on the inside, all I have to do is break us all out of here.* Sure, Nur.

But she does. She knows *exactly* how these guys feel about her "influence" over her husband and she knows how to use it. She tells her husband to pretend to be agreeable to whatever Mahabat wants, as long as he promises to help Jahangir "finally get away from that bossy old ball and chain." The ruse works, just as she'd known it would: relieved and reassured, Mahabat cancels the nightwatchman's overtime. *No need for extra security—this guy isn't going anywhere.* Knowing these guys would never believe a man might *actually like* his wife—let alone respect her as an equal—Nur Jahan has used their own misogyny against them. *Take my wife, please!*

Meanwhile, the empress has been quietly assembling a massive cavalry right under the kidnappers' noses—even rehearsing manoeuvres in broad daylight, under the guise of "keeping up morale among Jahangir's captured troops." After a bit more misdirection from the emperor getting Mahabat out of the way for a night, the couple adroitly flew the coop (complete with mounted military escort—and elephant) barely a hundred days after Jahangir was first captured.

Swaggering back into Lahore with their power (and their egos) still fully intact, the royal couple must have made quite an entrance. They were probably also banking on one convenient side effect of the whole sensational affair—that being publicly outsmarted by a *woman* had permanently destroyed their captor's social status.

But the glory and honor of rescuing a kidnapped emperor notwithstanding, this seems to have been the beginning of the end for Nur Jahan. As historian Ruby Lal points out, the kingdom was willing to put up with a woman on the coinage, a woman using the imperial seal, a woman shooting tigers in the hinterlands—but this was a bridge too far. *You simply may not lead an army into battle on the back of an elephant, ma'am. That's only for men.*

Or perhaps it was the emperor's increasing frailty that brought tensions to a head in the Mughal court. For Jahangir's sons, it was one thing to have your stepmother running the kingdom while your father is alive—it was an entirely different matter when succession was looming on the horizon. Or maybe she just backed the wrong stepson? Hoping to install the fifth son Shahryar and his wife Ladli Begum (Nur Jahan's daughter from her first marriage—what can we say, royal families are messy, y'all) on the throne, the empress dove headfirst into a bloody civil war. And for a while it looked like Team Shahryar might win—but it was third son Shah Jahan who finally claimed the crown. (Aided by his own father-in-law, Asaf Khan—aka Nur Jahan's big brother. Like we said, *messy.*)

Shahryar was promptly executed by Uncle Asaf; Nur Jahan was sentenced to house arrest in Lahore. And there she stayed for the next twenty years, watching as her stepsons and grandsons deliberately—and depressingly successfully—erased any trace of her unprecedented legacy. She was sixty-eight years old when she died.

Shah Jahan would go on to be the most celebrated and successful emperor in Mughal history, expanding his kingdom's borders, exerting quite unprecedented levels of religious and political influence and turning the Empire into a nearly unstoppable (except by another uppity Indian Queen named Chand Bibi . . . but that's another story) imperialist conquering machine.

Well, until he was deposed and imprisoned by his own son—condemned to spend his final decade under house arrest in his own royal fort.

Déjà vu.

That son was Aurangzeb, who took that whole *Mughal Philosopher King, united in tolerance, strength and education for all* schtick and tossed it in the bin. *No, what we'll be doing now is forcing Islam upon the entire population, taking a hard ideological stance and cracking down on all the things.* The Mughal Empire crumbled.

Anastasia Romanova

Russia, too, has a fascinating tale of the woman holding it all together while the man stirs up all the drama. It's 1547 and a very unstable sixteen-year-old Prince of Moscow, Ivan, is about to be crowned the very first Tsar of a new place called Russia. He's going to need a wife. Let's stage a spectacular pageant to find her!

It's said there were between 500 and 1,500 "contestants" in attendance, supplied by all the noble families of the kingdom. Who did he pick? The most beautiful, the wealthiest, the cleverest, the sexiest? No, the quietest. Anastasia Romanova had a soft face and spoke so low you had to strain to hear. It was love at first sight (hear?) for Ivan: *she is the calming vibe I need in my life.*

Why was he desperately seeking calm? Because ever since he became Prince of Moscow at the age of three, everyone around him had been scheming, shouting and murdering. Since the Middle Ages, cities along the Dnieper and Volga rivers had emerged as trade centers, largely founded by Vikings who had sailed the rivers and settled in. It was a full-on bloody game of thrones out there.

Ivan Vasilyevich fell hard and fast for his new bride. They were both sixteen years old and their marriage was a pairing of opposites. But they appear to have been (at least as far as one can tell from five hundred years away) a devoted and unusually happy royal couple. They say he never so much as looked at any other women and Anastasia was a crucial stabilizing and softening influence on the temperamental Tsar. In the first years of their marriage they enjoyed working together to build grand ideals for this new nation that was coming of age, alongside their six kids.

We're not saying these years were all peace, love and balalaika jam sessions—Ivan was definitely difficult to live with. He was hot-tempered, prone to paranoia and not exactly the humblest of historical rulers. But he wouldn't earn the moniker *Ivan The Terrible* until after Anastasia's death.

Or maybe *because* of it?

Anastasia got sick in the summer of 1560 and was confined to bed. What could be done? Pulverized pearl poultices, tinctures of diamonds, he spared no expense, all the while hovering at her bedside and growing increasingly unhinged. When she died, the whisperings had already begun: she was poisoned.

He immediately pointed his shaking finger at the boyars—court nobles who had been scheming their own contrary visions for the future of Russia. He had

several of them tortured and executed, felt a bit better, so kept going with his own personal witch hunt. Modern science may have at least slightly vindicated Ivan's accusations, if not his actions. Scientific analysis in the 1990s found huge amounts of mercury in Anastasia's remains (along with a sprinkling of arsenic on top, as a treat).

We now know it was mercury poisoning that killed Tsaritza Anastasia. But was that poisoning intentional, as Ivan believed, or merely a sad by-product of one of the more ill-informed medical interventions of the age? Mercury was commonly used in medicines in sixteenth-century Russia. What if they'd given it to her as a treatment?

Ivan Vasilyevich IV, Grand Prince of Moscow, Tsar of all Russia, went well and truly mad. The boyars—his enemy nobles—actually ousted him and he went happily into exile to battle his own psyche forever. But the political climate was so brutal and so extreme, the boyars couldn't handle it and they invited him back. He returned with a maniacal grin and every boyar must have realized that they had just laid the blueprint for Russian government *ad infinitum*. Ivan the Terrible had complete autocratic control of the country and established the *oprichnina,* an all-powerful personal army/secret police who promptly executed or exiled thousands of nobles. It seemed like he launched new pogroms and started wars practically every other week. One day, after picking a fight with his daughter-in-law over her choice of outfit, he even killed his own son and heir in a fit of rage.

Some historians (and Ivan himself) tie it all back to Anastasia's murder—the Tsar simply lost his mind and never recovered. Others point out that the Tsar was never exactly stable even before his wife's death and that while grief can explain a lot of rude behavior, most bereaved husbands don't spend the next few decades wreaking murderous havoc on the lives of thousands of innocent bystanders. In any case, Anastasia's death created the extreme circumstances under which Russia's status quo would be established. Political brutality became its whole identity. Autocratic rulers would preside over intrigue, exile and murder for many centuries to come.

China Almost Discovers the New World

Spinning the globe even further east, we return to China, which was probably "ignoring Spain and its New World" the hardest. After all, in 1403 the Ming Dynasty's Yongle Emperor had built the world's largest fleet of ships. Commanded by Zheng He, the fleet made seven voyages toward the distant

horizon in the spirit of Boldly Going Where No One Had Gone Before. They went to Nur Jahan's India, Bahrain, Arabia, Africa and the Ottoman Empire. They conquered Sri Lanka; they defeated the notorious pirate Chen Zuyi in Indonesia and played kingmaker in Sumatra. The Ming Dynasty dominated the whole world by sea. Did they ever bother to sail to Europe? Don't let's be silly . . . nothing there to see. How about heading east, maybe to see if there's anything on the other side of the Pacific?

Some say Zheng He was eyeing an expedition across the Pacific. But then the emperor died and his son, predictably, hated everything his dad had loved. He shut the whole thing down. Ming China was officially Not Interested.

Sure, they allowed Catholic missionaries to come to China from Europe—they were wisdom-seeking, open-minded and curious after all. But the Jesuit monks, bless their hearts, continually belittled or ignored seminal texts—the *I Ching, Tao Te Ching, Han Fei Zi*, the *Analects*. What do you mean, "all you read is the Bible"? How could a conversation even begin with someone so ignorant? Catholicism did not fare well in China.

Buddhism, an import from India, fared much better, across the whole of Asia. Anyone, *everyone* can reach Nirvana, it said: no matter your social rank, no matter your caste, gender, or race. We're all one, really—it's thinking we're only small little humans that impedes our understanding of the Truth.

Maybe it was that kind of thinking that inspired intrepid Ming Dynasty *yiji* (singer, dancer and poet) Wang Wei. Maybe she was inspired by the story of Siddhartha Gautama, the Buddha, who went off in search of enlightenment, leaving everything behind. Maybe it was the stories of Zheng He's voyages. Whatever the spark, she seized her short life and used it to do something unprecedented: she set off to see the world.

Wang Wei

Not for Wei a lifetime stuck in the supremely class-conscious drawing-rooms of the Chinese elite, catering to the aesthetic and artistic desires of wealthy middle-class men (but aesthetic and artistic desires *only—yiji* does not correspond to the more sexualized western concept of a "courtesan"). Rejecting her allotted place in life, Wang Wei embraced Buddhism, bought herself a boat and set off to explore her country. Happily for Chinese literature then and now, she also *wrote it all down.*

Together with her friend Yang Wan (the pair called each other "sworn sisters"), Wang Wei traveled nearly the entire Ming Empire. Piloting their small wooden skiff over 800 miles of river, the women wended their way from Suzhou to Hunan, Shaoxing to Mount Tianzhu, reveling in the beauties of nature and hanging out with loads of famous poets and philosophers along the way. Their little "floating library" was packed to the gills with manuscripts by the time they reached each new destination. And everywhere they went, Wang Wei transmuted each breathtaking new vista into vivid poetry or prose.

But Wei's words didn't just capture the landscapes they explored, they also asserted her own unique identity as a traveler and an individual—nearly unheard of for a woman in her time and place. Wei penned hundreds of travelogues, some of them hundreds of pages long and her evocative prose sparked a new trend for travel across the empire.

Everyone who was anyone was reading Wang Wei's works and, all of a sudden, adventuring was *in*. A culture that had long prided itself on the virtues of staying home suddenly went wild for the family road trip. The Ming had caught the travel bug.

Thing is, so had the rest of the world. As public appetite for the exotic and strange boomed worldwide, colonies became a favorite new way for states to boost resources at home. The age of Imperialism was coming, with Enlightenment in its wake.

Land Grabs and Enlightenment

THE WORLD PLAYS AN EPIC GAME OF RISK AND SOLVES EVERYTHING

If you are convinced you have it better than your neighbor, taking over their life is probably what's best for everyone. This is the general worldview during the seventeenth and eighteenth centuries. Empire building is back in style!

What's fascinating is that it occurred simultaneously with an intellectual movement: the Scientific Revolution and Enlightenment. Humanity set out on an inspiring collective quest to find the answers to Life, the Universe and Everything, for the benefit of all. How were Imperialism and Enlightenment connected? Let's ask Maria Sibylla Merian.

Maria Sibylla Merian

Germany was still burning witches when Maria Sibylla Merian daringly filled her home with spiders, moths and all kinds of toxic plants. She was *not*, however, burned at the stake, but instead set off on a Darwinesque scientific voyage to South America—a hundred and thirty years before Darwin.

She was fascinated by bugs—specifically metamorphosis—and it would have been an exciting time to be discovering science. The Scientific Revolution was in full swing in the late 1600s and being the daughter of a prominent book printer, she had a front-row seat. The annual Frankfurt Book Fair overflowed with new ideas: What is really at the center of the Universe? Are fungi animals or plants? Does this horn prove the existence of unicorns? Does this skull prove the existence of Cyclops? What's our blood made of and how does it work?

Merian's favorite question was, how does one thing turn into something entirely different? How come a dead chicken turns into flies? She'd seen a caterpillar turn into a chrysalis and then into a butterfly. And sometimes the butterfly turns into wasps. But why? Metamorphosis—what a mystery! So even though the path before her was clearly labeled "housewife" (she married her father's apprentice and had two daughters), she couldn't let the metamorphosis thing go.

Her bug collection was beyond creepy, especially because the "where do flies come from" mystery compelled her to gather all kinds of rotten masses for the study. Will this battered ox leg turn into flies? What about this pig's head? If I feed *this* caterpillar *that* plant, will the butterfly turn out purple? If I feed *that* caterpillar *this* plant, will it turn into a wasp? She published two richly-illustrated books about caterpillars and their

metamorphosis, handing humanity a whole bunch of useful new scientific information.

Merian was also awakening to the surprising possibility that Nature was full of parasites. Staring across the table at her husband one night, she decided he was one of them. *Bye.*

Let's say you're a single mom of two girls, in late seventeenth century Germany, who collects bugs and knows a whole lot about plants. Burning at the stake seems inevitable, yes? But only because you haven't yet considered *joining a cult!* Maria Sibylla Merian grabbed her daughters and her widowed mom and joined the Labadists, sequestered in a castle in the Netherlands. The Labadists believed in stomping out pride in all its forms. They said it's the afterlife that matters, not this wicked physical world. They also believed in gender equality.

So, when she rolled up with her girl crew, Maria was all-in. "I shall cease my condemnable studies of Nature!" she said to herself, "Curse my ego-driven pursuit of knowledge and publication!"

But here's where Imperialism slips in the back door and changes everything. While Merian is shut away in her Labadist enclave for years, empire-building is all the rage out there in the world. China is expanding across Asia, Spain, Portugal and France are claiming basically the whole New World, England is deeply entangled with India, Russia is absorbing the whole of Siberia, the Ottomans are smashing everyone around them—if the Persian Safavid Empire doesn't get there first. The Dutch, with their impressive fleet of ships, get in on the game. Their empire is more economic than militant (their 1581 Declaration of Independence does talk a lot about freedom, after all). They're not so much interested in creating a huge land mass as they are in building a global economic powerhouse. For that, they'll need a foothold in the Americas: Suriname.

For the Dutch, Suriname was a handy source of New World natural resources. It was a helpful pit stop for Dutch ships navigating the world. It was a good environment for sugarcane, worked (*ka-ching*) by human slaves purchased in Africa. But for the righteous-minded Labadists, none of that mattered. Suriname appealed as the purest test of faith: who so dareth to establish a colony there to convert the natives?

Back in the castle, Merian and her fellow believers looked forward to letters from the courageous few who'd sailed to Suriname years before. Would they save the souls of thousands? Would they reap God's myriad blessings?

"This place is the worst and I hate it," the letters read. "Everywhere I look I see bugs from hell and they're poisonous and terrifying and gigantic."

Merian frantically wrote back. *Say more.*

If it was a struggle with pride, pride won. But if Merian's years with the Labadists represented the turmoil of having to choose between loving this world or Heaven, this world won. After her elderly mother died and her eldest daughter was married, she and her younger daughter Dorothea left the Labadists and spent all their savings on a voyage to Suriname.

Thus the pursuit of enlightenment and empire go hand in hand, with Maria and Dorothea up the Suriname River into darkest jungle. They're constantly stopping to collect this fascinating beetle, or that shockingly large moth. They stay for months, gathering specimens, witnessing insect life cycles in nature and discovering things about the rainforest canopy (first and foremost, that it exists). They see a spider so big it eats birds (no one believes them). They see a moth come out of an egg. They see parasites so nefarious they can only stare in silence. If this is Nature as God designed it, it's brutal, it's hungry, it's beautiful, it's terrifying. It's constant metamorphosis.

Merian's most controversial illustration depicted a spider eating a bird (bottom left). European scientists mocked her for womanish fancy but history has since vindicated her sighting of the Goliath birdeater.

Her resulting book, *The Metamorphosis of the Insects of Suriname* was a best-selling scientific standard for centuries to come. But her life—her big, daring, dance of a life—encapsulates the seventeenth century in all its complexity. Did Merian personally believe in imperialism, evangelism and slavery? Hard to say. But in one part of her book, she illustrated a beautiful flower, then noted that enslaved women used it to prompt abortions. Her message was subtle, but clear: slave owners, consider the implications and take a hard look in the mirror.

She participated, though, in Dutch imperialism and used it as a means to bring incredible new science to the world (besides all her books, she also finally found out why flies "spontaneously" emerge from dead meat). She didn't set the stage or choose the play—and she never could have. She did her best with the part she was given. The same is true for most humans in most time periods, really.

In the seventeenth century, the stage was global for the first time and the play turned out to be something like the board game Risk. The global game of imperialism actually led to vast improvements in human knowledge and enlightenment. It was our never-before-seen connectedness that allowed us to discover new things, new ways of thinking and to see ourselves in a new light. Like all things in life, though, it came at a price.

What kind of life could a person create inside those parameters? With what would *you* choose to fill your hour upon the stage? Merian's wild life was one option. Let's look at some more.

Sor Juana

In a way, Juana Inés de la Cruz lived a kind of "through-the-looking glass" version of Maria Sibylla Merian's life. She was born in 1648 and raised in New Spain (Mexico), a century after Malintzin and Cortés's conquest of the Aztecs. The New World was booming, largely thanks to the extraction of silver and the authoritarianism of Catholic monks. Juana was gifted and curious from a young age—reading at the age of three, teaching herself Latin and dreaming of university. But she was a girl, so (you guessed it) education was not an option. She begged her parents to let her dress up as a boy so she could go to school, but they insisted on a good Catholic marriage instead.

So she became a nun.

In the eighteenth century, life in a convent was basically the only acceptable alternative to marriage for intellectually curious women in Christian nations.

Sure, you had to take a vow of poverty and chastity and pray seven times a day, but you could also spend your life reading and writing, singing and hanging out with other radical sisters. So, Sor (Sister) Juana entered the convent and claimed her future. She had access to hundreds of manuscripts—incredibly rare and valuable in the New World. She learned mathematics, astronomy and experimented with science and chemistry in the convent kitchen, famously quipping that "Aristotle would have written more if he had done any cooking." Sor Juana even invented her own musical notation. She cranked out poems like this and sent them out into the world:

Excerpts from "You Foolish Men"

You foolish men who lay
the guilt on women,
not seeing you're the cause
of the very thing you blame [. . .]

No woman wins esteem of you:
the most modest is ungrateful
if she refuses to admit you;
yet if she does, she's loose. [. . .]

Your lover's moans give wings
to women's liberty:
and having made them bad,
you want to find them good.

Who has embraced
the greater blame in passion?
She who, solicited, falls,
or he who, fallen, pleads?

Who is more to blame,
though either should do wrong?
She who sins for pay
or he who pays to sin?

Juana Inés de la Cruz, 1680 (translated by Michael Smith)

An absolute banger. Is it going too far to say she was the iconic pop star of her day? . . . Probably, because she was a cloistered nun, literally shut away from the world. Still, she was famous even across oceans. Eventually the Church Fathers stepped in, telling Sor Juana to get back in her lane. She wrote a fierce letter to her confessor, *Autodefensa Espiritual:* "But who has prohibited women to study? Do they not have a rational soul like men? Why shouldn't they enjoy the privilege of enlightenment in an education? What divine revelation, what determination of the Church, what dictate of reason made for us such a severe law?" She signed with her usual big, bold signature, underlined with a dramatic flourish.

It feels so good to read, learn and grow, doesn't it? It's truly thrilling to make new discoveries about the natural world! But are those feelings . . . good? If you really truly believe in your religion—I mean, you've literally married God—and your religion never ever stops telling you you're committing the cardinal sin of pride, when do you set that ego aside? Maria Sibylla Merian attempted to bury her curiosity for five years and failed. Sor Juana, on the other hand, eventually won her battle against herself. *Less study, more prayer:* she sold her library, all her musical and scientific instruments and confessed herself "the worst of women." She dedicated all her remaining years to atoning for her pride. Then she died in a plague the very next year.

Nowadays, she's held up as an icon of feminism, hailed as a hero by just about every social movement in Mexico City, from decolonization to Indigenous lesbianism. And if she is indeed dwelling in the Catholic afterlife—the one she wholeheartedly believed in—then her soul spent a good many years in Purgatory burning away her lifetime of pride. She could very well still be there, actually. So, every time we hold her up, praise her name and make her an icon, are we . . . doing the exact wrong thing? Do we owe it to historical figures to respect their wishes to be forgotten?

How to Play Risk in the Early Modern Era

Spain's strategy in its game of Risk was to wield religion as a powerful tool of social control. Missionary monastic Jesuits, Franciscans and Carmelites dedicated their lives to saving souls across the world, which conveniently dovetailed with colonization. Spain got their silver; the church got their souls.

So, let's say you're surveying the global game board of the seventeenth-century, deciding where to make your move. You gotta conquer *somewhere,*

right? Or they'll conquer *you*—that's the game. Spain, Portugal and France are already dominating the New World. England's making a surprise grab in India, China is stomping across central and southeast Asia, and the Middle East is one big showdown between the Ottomans and the Safavids. You could target Oceania, but that's ever so far from everything . . . you'd have to be desperate.

Guess we're comin' for you, Africa.

The Scramble for Africa

It's one of the weirder moments in world history: suddenly, European nations scramble to grab whatever pieces of Africa they can get. Why are they doing it? Not clear. While parts of the continent were rich in particular resources, most of it was barely sustaining the current population. The land would not support lucrative ventures such as massive slave-powered sugar plantations, for example. But various justifications for owning a piece of Africa were proffered, including:

◆ Controlling a coastal region could be a great way to dominate the slave trade

◆ Maybe we could turn this rubber plant that's growing everywhere into something useful

◆ If we find a way to cut across the continent by water, we could stop wrecking and drowning at the Cape of Good Hope

◆ It is our moral duty to help Africans by taking over, building them up and bringing them Christianity. This is the "White Man's Burden."

The Dutch had claimed South Africa (and it was there, they said, that the famed Flying Dutchman ship had wrecked). Belgium, in a surprise move, sent their mad king to personally rule over the Congo, with catastrophic results. But the primary contestants in Africa were England, France, Portugal and Germany. England aimed for one continuous colony stretching "from Cape to Cairo," while France was quick to claim most of western Africa. Germany and Portugal battled it out for claims farther south. None of them were prepared for Nzinga.

Nzinga

Nzinga Mbande, future queen of Ndongo and Matamba, was born in 1624 with her umbilical cord wrapped around her neck—a sign that she had unusual gifts and would live a remarkable life. From our vantage point four hundred and fifty years later, it was clearly true.

Areas of Africa under European Colonial Powers, 1913.

The Kingdom of Ndongo (part of what is now Angola) had already been battling the Portuguese for a decade by the time Nzinga was born: the Portuguese intent on colonizing and securing a very profitable slave trade, the Ndongo determined to maintain their independence (and of course, protect

their *own* very profitable slave trade). Portuguese tactics were brutal: burning villages, taking hostages and capturing soldiers and bystanders alike (over fifty thousand, according to some sources) to sell into slavery in their South American colonies.

The kingdom had been holding its own against the Europeans, but things got considerably worse once the Imbangala got involved. These ferocious and highly-skilled mercenaries had arrived in the area a few decades earlier—*from where* remains a highly contentious question ("start a historian bar fight in thirty seconds or less"). But once they got involved, things went downhill fast.

So the Ndongo in which Nzinga grew up was extremely militarized. Her father's favorite, she was trained in formal battle tactics and hand-to-hand fighting—they say she was terrifyingly good with a battle axe—and in diplomacy, assisting the king in negotiations with colonizers and neighboring kings alike.

But when Nzinga's father died in 1617, it was her brother Mbandi who claimed the throne. Nzinga may have been her father's favorite, but she was still a woman and no Ngola in his right mind would name a *daughter* as his successor. Ngola Mbandi lost no time consolidating power within his own bloodline: he immediately slaughtered most of his male family members, including Nzinga's young son. He also had his three sisters forcibly sterilized, ensuring no new claimants to the throne would ever arrive. Whatever else he may have been, Nzinga's brother was certainly thorough.

Very aware that her reprieve might still be temporary, Nzinga fled to the nearby kingdom of Matamba for safety. We can't know her feelings as she watched the ensuing chaos unfold from relative safety 250 miles away, but watching the Portuguese and Imbangalan forces overrun Ndongo with practically zero resistance over the next four years couldn't have been easy. Her brother spent those years absolutely floundering at the whole King gig, making massive strategic errors, blowing any lucky breaks he happened to get and driving the kingdom to the verge of total destruction. Finally forced to admit his own incompetence, Mbandi sent a desperate message to Nzinga: *Hey sis, help a brother out?*

Of course, Nzinga immediately told him to get stuffed.

Just kidding. As unfathomable as it may seem to us now, given what he'd done to her and her family, Nzinga agreed to negotiate with the Portuguese on her brother's behalf—with two conditions: 1) she must have absolute authority to negotiate in the king's name and 2) she must be allowed to get baptized.

Wait, what? Yes, you read that right. Knowing the Portuguese believed it their God-given duty to convert Africans to Christianity, Nzinga anticipated

the possibility that a well-timed baptism might be a powerful tool in her diplomatic arsenal. (She was right.)

Luckily for her brother, Nzinga was an extremely effective ambassador. Incredibly intelligent, forceful yet charming, fluent in multiple languages, strategically astute and willing to play the long game—she also staunchly refused to be *talked down to*. Literally, in one case: arriving for her first meeting with the Portuguese governor, she was ushered into a room with chairs for all the governor's men and a straw mat on the floor for her. *I don't think so.* One of her attendants immediately dropped to his hands and knees and Queen Nzinga sat herself on his back with regal aplomb—silently but firmly establishing her status as the equal (at least) of any man in the room.

Nzinga was also brilliant at playing the hand she'd been given. Rather than try to hide King Mbandi's obvious incompetence, she used her status as long-suffering sister to her advantage, casting herself firmly in the role of "real grown-up finally stepping in to straighten out the embarrassing mistakes of an immature king." *Ugh—brothers, amiright?*

This uniquely disarming approach, plus her unquestionably brilliant diplomatic skills, soon had the Portuguese teetering on the edge of a peace agreement. And that's when Nzinga played the ace up her sleeve: she offered to be baptized into the Catholic church. Thrilled and triumphant—convinced they'd finally "civilized" the Ndongan royals and proved their own cultural superiority—the Portuguese signed the treaty and Nzinga returned victorious to her brother's court at Kabasa in late 1622.

When her brother died just three years later (some think it was a suicide, others claim Nzinga killed him), Nzinga was the obvious candidate to fill his vacant throne. And her first order of business? Revenge, of course! Before his death, Mbandi (doubtless remembering his own nepoticidal tendencies) had placed his only son safely in custody of an Imbangala war chief named Kasa. Naturally, Nzinga immediately asked Kasa to marry her. Charmed and flattered (and presumably *not entirely unaware of* the sizeable Ndongan royal treasury) the Imbangala chief accepted, nuptials commenced—and Nzinga had her nephew assassinated before the honeymoon was over. *Now we're even, brother dear.*

Then for her next trick, she invaded the Kingdom of Matamba. Yes, *that* Matamba—the next-door neighbor who had so generously sheltered her when she'd first fled her brother's deadly wrath. In almost no time, Nzinga had taken control of the kingdom, exiled the Matamban Queen and installed herself on the throne. No good deed goes unpunished, as they say.

The Portuguese were like, whoa. This lady is clearly deranged. And probably also a sexually insatiable man-eater. Or maybe a *literal* man-eater? Yes, very

likely! A sadistic cannibalistic psychopath. Or possibly she's just an empty-headed birdbrain. In any case, *clearly* she must be forced to concede to the superior moral and political authority of Portugal.

Unsurprisingly, Nzinga had other ideas. From her new home base in Matamba, Nzinga continued her successful guerilla war against the Portuguese for decades. Her life was at stake, yes, but, more importantly, so was control over the increasingly profitable transatlantic slave trade.

Then she got a sore throat and died.

But more fierce and formidable queens were waiting in the wings. Women would rule the kingdoms of Ndongo and Matamba for nearly eighty out of the next hundred years and successfully fend off official Portuguese control until well into the nineteenth century.

But by then, any attempt to resist European colonization had come to mean almost certain death. Why? Europeans had mechanized death. They used monstrous weapons, like gatling guns that spat out bullets at an unholy speed. No more one-minute-musket-reloads for European armies: bullets could *pop pop pop*. African resisters, still armed with muskets and swords, didn't stand a chance.

Except. Look again at that map of colonial Africa. See that chunk in the east that remained independent? It's Abyssinia, established by our lady Gudit nine hundred years before. Her legacy was still very much alive among her people. As one Italian colonizer wrote, "All Abyssinian women are brave." He wasn't praising them, though: he was deeply annoyed. Because as Italy tried to get in on the Scramble for Africa, claiming chunks of the north and east, Abyssinia was somewhat exasperating. We'll return to Abyssinia in the nineteenth century for a fabulous, stranger-than-fiction showdown.

You See What You Expect to See

Back in the eighteenth century, could anyone have imagined what the future held? Could they see a horizon where the African continent as a whole would become one of the most extreme examples of frenzied land-grabbing in world history? We know that very few inhabitants of the continent back then even thought of themselves as Africans (much in the way today's inhabitants of, say, South America don't think of themselves as a broad collective). Nor did they even embrace national identities. On the whole, African identity before colonizers was mostly regional, familial, local. (This of course contributed to the slave trade, both in Africa and abroad, because local rivals would

capture and sell each other.) Then colonizers rolled up with their bureaucratic paperwork and said, "Fill out this form. Put down your name and your tribe." As individuals filled out their paperwork, a tribe, only of vague relevance before, was selected and written down. Colonizers expected tribes, so they got tribes. African identity changed.

India was enduring a similar phenomenon, for a culture of British paperwork thrived there, too. The categories listed were different, though. Remembering their World History lectures about the end of (Nur Jahan's) Mughal Empire, the British expected religious polarization: "Fill out this form and check the box Muslim or Hindu. We know that's a really big deal to you guys." Thus, religious hatred was Officially Entrenched.

England and Ireland were still pasting Catholic and Protestant labels on everything and the brutality of life there hadn't waned since Grace O'Malley's day. Spanish America was busy applying their Catholic label to anyone who'd survived colonization. Buddhist and Confucian boxes were being checked in east Asia. What we're saying is, across the eighteenth-century world, colonizers brought their own mental categories to a place and in the process of "making order," embedded their own assumptions into a new social system.

At the same time, the incessant and unending variety of life on Earth kept driving home a different point. Emerging directly from all this exploration and discovery were lots—and we mean *lots*—of different lenses through which to see the world. Before the eighteenth century, you could rise and greet each day knowing that you and your people got everything right and were your gods' chosen. But now that you kept seeing people confidently—successfully—living drastically different truths, the uncomfortable conclusion was *we can't all be right*. Right?

And wait, if we can't know who is really right, what *can* we know? What's going on here?

In tandem with imperialism in the 1700s, an intellectual movement started to emerge to resolve all this uncertainty. Its premise was basically this:

1. If everything going on in the world tells us anything, it's that humans are pretty clever.

2. Our cleverness, especially in the natural sciences, has actually shown us that we've been wrong about most things. Like from the beginning of time until now.

3. The hang-up seems to have been that, for most of history, humans

believed that they weren't as smart as authority figures. They simply obeyed.

4. If we pool the cleverness of all the cleverest people and work really hard at it for many people's lifetimes, we could probably Solve Everything.

No time to waste! The Enlightenment was born. The goal was nothing less than to sort out the answers to everything in the whole entire universe. What a time to be alive!

See, Newton had figured out, using only his own clever clogs, that there are Laws of Gravity out there. Those in turn solved lots of mathematical mysteries. "Imagine!" said nerds in academies across the world. "Imagine if we each did the same, in our respective fields. No, let's not imagine, let's do it: Mark, you sort out the Laws of Philosophy. Matthew, get working on the Laws of Biology. Jacques, you've got Geology. Who's taking Art, History, Physics, Psychology, Music . . . ? Once we've got each field sorted out, we'll come together in one epic Think Tank, compare Laws and find The One Answer™ to rule them all. We'll Solve Everything!"

Pause for resounding cheers.

Then everyone goes home and is about to buckle down, but their cosy couch is calling and yes, a little snack first . . . maybe we can start next week? Because even if you poured your heart and soul and mind into the cause for a lifetime, could you trust that everyone else would be working as hard? The chances that you would live to see The One Answer would be roughly . . . (scribbles algebra on a chalkboard for three days) . . . 1 percent.

How could we possibly launch such a visionary, collaborative intellectual quest? We need inspiration. We need Émilie du Châtelet; we need Bibi Sahiba; we need Wang Cong'er.

Émilie du Châtelet

You'd never have guessed Émilie was going to turn out to be such a big deal. In 1720 she was hiding in a corner at one of the most over-the-top palaces in human history—Versailles. Her father was the Chief of Manners at the court of Louis XIV and young Émilie was a shy and awkward dweeb.

Her father, bless him, must have said to himself, "Well, she's no looker, so it can't hurt to teach her some stuff." Most ladies at Versailles—even the princesses—couldn't read: could not even sign their own name on documents. But Émilie loved to read, she studied mathematics and even learned to fence. Therein lay her deliverance. Because once she turned sixteen, she blossomed into a stunning beauty and suddenly every man at court wanted to put a ring on it. Nothing could be worse, as far as Émilie was concerned: for married women, reading was basically forbidden.

This portrait of Émilie du Châtelet still hangs in her bedroom at Château de Cirey. She loved fashion and science.

So she did what any reasonable person would do. She challenged the chief of the Royal Guard to a duel.

It was a public spectacle—she took off her formal dress, sweatily lunging and parrying his every move. She didn't win, but she didn't lose—they called a draw. But when she surveyed the faces of the shocked audience, she could see it was really a triumphant victory: no one wanted to marry a wild woman like that.

She bought herself a few more precious years and she would not waste them. She'd read this book called *Principia* that the author (some guy named Isaac Newton) had revised and reprinted in 1713. Everyone she spoke to about it was like, *meh*. But she had a rising suspicion that the contents of that book

had the potential to change everything. The problem was that Newton wrote in Latin that was long-winded and stultifying. Further, the more she studied the book, the more it became clear that even his mathematical calculations were unnecessarily complicated and obtuse. *Just phrase it all a different way,* she thought—*just take away all the posturing academic mumbo jumbo and this book will change the world.* So she decided to translate Newton's *Principia* into French. And tighten up the maths while she was at it.

But a lady couldn't undertake such outrageously unladylike activities at Versailles. So she set off to her tumbledown chateau on the edge of nowhere in northeastern France. When she rolled up, she remembered that she'd told a friend from court that he could hide there. He was a sassy playwright, recently released from the Bastille: none other than Voltaire. Turns out, he had spruced the place up and put on his cleanest shirt in the hopes of wooing her. It worked. For fifteen years, they lived together at Chateau Cirey, sending out an endless flurry of letters to intellectuals across Europe, conducting scientific experiments, performing their own plays in the attic and building their best possible life.

They were soulmates. Even their odd study habits were compatible (late breakfast, work in deeply focused solitude until evening, dine, then play music or recite poetry, sleep, repeat). The addressees of their letters are a Who's Who of the Enlightenment. With the greatest minds across Europe, they were dreaming the intellectual dream of a collective quest to find The Answer. People started to catch the spirit. Diderot was so fired up about the idea, he decided to create the world's first collection of all knowledge: an encyclopedia. Crucially, this encyclopedia wouldn't be hidden away in a stuffy university library: it would be mass printed, for the people.

The Enlightenment started to firmly establish itself as a movement for the people. *This knowledge we all work so hard to gain should be shared. Imagine, if everyone and anyone could have access to all knowledge!* But Émilie could see one blaring obstacle: even if everyone had access to books such as Newton's *Principia*, they'd never be able to slog their way through it to understand. Let's take down all the stupid, stuffy barriers that have been put up, said the daughter of Versailles's Chief of Manners.

Then she got pregnant. She was forty-two years old and overwhelmed by a premonition that she would not survive the birth. So, as the sands slipped unceasingly through the hourglass, she worked frantically to finish her translation. Who would ever do it, if not her? The task required someone fluent in the most obscure Latin and equally skilled in mathematics. What's more, it required someone unstuffy enough to be able to filter out the posturing and

jargon and to create something accessible to humanity. Voltaire was there, to cheer her on.

On August 30, 1749, she finished.

Three days later, the baby arrived. She was right about her fate: she died in childbirth and the baby did too. But she died knowing her magnum opus was complete. She had opened the door for the Enlightenment. She had completed her part of the enormous, collective human quest. Her great work was published and humanity started to learn about gravity, energy and more importantly, the enormous potential of the human mind.

Would humanity step up and carry on the collective quest for The One Answer, to the end?

They would; they sure would. In Afghanistan, for example.

Bibi Sahiba

Eighteenth-century Kabul and Peshawar, the double capitals of the rising Afghan Empire, were unbelievably cosmopolitan. Its distinguished colleges, synagogues, madrasas and Sufi centers attracted curious and ambitious minds from Istanbul to Xi'an to Jerusalem. Islam, Judaism, Zoroastrianism and Christianity all cheerfully rubbed shoulders in this new global intellectual hub, joined in the earnest pursuit of truth and knowledge for all.

And smack in the middle of that whirlwind of religions, cultures and ideas stood the madrasa (college) of Bibi Sahiba the Great, one of the most important and most respected Sufi Scholar-Saints in Islamic history. So hold onto your hats, folks—we're about to get *mystical*.

But first, actually, we need to get *educational*. There are well-established steps to becoming a mystic. You begin, as Bibi Sahiba did, with education. You should start school as a very young child and master the basics: reading, writing, learning the Quran. By which we mean *memorizing* the Quran. All of it.

Bibi did that before her eleventh birthday—*what, like it's hard?*—and moved up to the madrasa. At the madrasa she learned, well, everything. Grammar and rhetoric, logic and philosophy, mathematics and medicine—you know, just *all of medicine*—plus politics, scripture, cosmology, ethics and chemistry.

Finally, having fully mastered the exterior world *(phew!)* it was time for Bibi Sahiba to turn her attention to the *interior* world, to the path of oneness with the divine—this is the path of the Sufi mystic. By this point she was already a

very accomplished scholar and teacher, managing two major Sufi colleges while also continuing her own studies. (Exhausted grad students of the world—Bibi sees you!) Over the next few decades Bibi Sahiba would educate thousands of Sufi scholars.

Then, in 1797, Bibi Sahiba's mentor and guide Khwaja Safiullah, premier scholar-saint of the Afghan Empire, led 315 disciples on a pilgrimage to Mecca. As the travelers reached the center of Mecca and completed their pilgrimage rites, Khwaja Safiullah formally turned the leadership of the entire Sufi community over to Bibi Sahiba—acknowledging her as, in the words of historian Waleed Ziad, "the arch-saint of the Afghan Empire." *It's all in your hands now, Bibi.*

She'd certainly got her work cut out for her—and that work was not "only religious" in the way most would think of it now. Bibi Sahiba was a community leader—an educator, an advocate, a counselor. This is what the path to Enlightenment looked like in the Islamic World. She was providing crucial social services, both physical resources and emotional care, for the poor and marginalized of Kabul and Kandahar. She was a model, a light for the pursuit of enlightenment by paths both logical and mystical. Publicly rejecting xenophobia and insularity, she modeled a collaborative inclusivity that still feels revolutionary even today. She was simultaneously practical and mystical, a visionary who has transcended the world—but not *so* transcendent she'd lost track of what it means to be hungry or alone.

And then, on her way home from a visit to the King of Bukhara in 1803, Bibi Sahiba fell ill and died. Given a saint's funeral inside the famed Blue Mosque—the shrine of Imam Ali, son-in-law of the prophet—Bibi Sahiba's remains occupy some of the most rarefied space in the Muslim world. Her people couldn't have given her a more emphatically reverent epitaph if they'd tried—burial here practically shouts "this woman *mattered*."

The Qing Empire

What about China, though? Yes, there lie strong threads of Enlightenment and imperialism both. Starting in 1644, the Ming Dynasty was ousted by a new Manchu emperor from the north who swiftly set about invading his neighbors and his neighbors' neighbors. Imperialist dreams fulfilled. The resulting Qing Empire is usually presented historically as a thriving, peaceful time of diversity and unity. What categories were the Manchu overlords putting on their paperwork?

"Fill out this form. Oh wow, you filled it out! You can write? Check the box marked 'Bureaucrat.'"

Everyone else—the vast majority of the population—would need to check the box marked "Laborer," whose role was to work toward China's dream of an economic boom. Thanks to an influx of New World foods such as potatoes and peanuts (not to mention the growing global tea market), China's population doubled. The population also became increasingly varied as the empire absorbed its neighbors. By the eighteenth century, the Qing Empire encircled Mongolia, Tibet, Hainan and Taiwan.

By 1750, basically everyone in the world was hooked on the stuff China was selling: porcelain, silk, gems, tea, spices and rice . . . what more could a world desire? The Qing Empire's highly efficient economic powerhouse would have left Jeff Bezos breathless. At the same time, China only had to glance at India's dealings with the East India Trading Company, or at the whole of Africa, to conclude that it might be wise to severely limit European access. European ships were allowed into only one port (Canton, now Guangzhou) and were permitted to interact only with a select few bureaucrats. Any violator was swiftly and spectacularly dispatched.

There. Now China can thrive for *China*. And by China, we mean everyone we've absorbed: a diverse and unified population. We'll foster a cultural flowering, we'll introduce some fabulous government-mandated hairstyles. We'll be a light of unity for the world, sending our goods like hopeful messages to a grateful humanity!

Did they, though? Is that what happened? Depends who you zoom in on, of course.

The economy is booming, but are the people thriving? It's one of the eternal questions in human history. In any period you can find examples to suit any preconceived notion of How Things Are. In Qing Empire China, people feasted, innovated, exceeded expectations and built a better world. People also starved, lost everything and gave up. And sometimes, convinced that the status quo was wrong, people dreamed new visions and staged protests. Some things never change.

Let's say you're a woman in the eighteenth-century Qing Empire. You could be Han, Mongol, Tibetan, or hail from any number of smaller ethnic groups. Doesn't matter: in the Qing Empire, as a woman, you have one of two options. Which do you choose?

1. Spend your life shuttered away in the inner sanctum of the inner sanctum of your family home, where you intentionally break your

feet and bind them so they become adorable little nubs. (Sure, you cannot really walk, but that's the point: the need to walk is for the vulgar masses.) Sew, sing, or paint all day and be a sweet obedient presence.

2. Farm the land (not your own) alongside the vulgar masses from dawn to dusk. When the time comes, do it with a child or two strapped to your back. Every night, pat yourself on your (aching) back for fueling the farming boom as you enjoy your daily meal of rice and water.

Most of the historical women we know about from this time period come from Category 1, because those were the ones who could write, or who became a courtesan or a princess. Rarely do we find any biographical details about the 99.5 percent of women who lived Category 2. Except in the rare instances when they draw the attention of authorities, which is where we meet Wang Cong'er.

Wang Cong'er

The Qing Empire lasted for a good long time: 1644 to 1911. For some, that proves it was a well-run operation. But, peeking behind the shiny porcelain facade, we find that revolts and revolutions erupted all the time. The emperor's forces played whack-a-mole so deftly that no single movement gained enough momentum to unify all of China's disgruntled. Sometimes historians lump various revolts together and give them a flashy name, such as the White Lotus Rebellion. Here's what happened.

By the mid-eighteenth century, the grumbling tummies of China's laborers got so loud the emperor could hear it. The peasants were starting to whine a bit, too. "My people would never!" he said. "Something has gone terribly wrong."

"Agreed," said his advisors. "Clearly there is sorcery afoot."

Thus began the Soulstealing Panic of 1768. It was a witch hunt (with a better name), whereby the emperor, his goons and really any bureaucrats anywhere, could remove undesirables by accusing them of sorcery. It started in Zhejiang province but spread like wildfire over just a few months. Individuals who were put on trial were usually found not guilty, but mob violence led to the deaths of hundreds, possibly thousands of people. Beggars, monks and priests were typically listed as the victims. This is interesting, given the historical context.

It tells us not only that there were plenty of beggars in this "thriving, peaceful economy," but also that religious figures were resented. In any case, they're gone now. Problem solved.

But an emperor's work is never done: the laborers' suffering continued despite the elimination of sorcerers. Annoying. Let's try the old ignore-it-and-it-will-go-away and continue to whack-a-mole any uprisings.

"Um, Emperor?" said the financial team, "This is getting really expensive. The army is running out of money." What part of ignore-it-and-it-will-go-away did they not understand?

So, by the time Wang Cong'er got fed up, the empire was in a pretty weak spot. She was an acrobat and martial artist, performing the central China circuit until a local bureaucrat won her heart. Together they became leaders in a local sect of the White Lotus Society, which melded mystical Buddhism with the Enlightenment. White Lotus folks believed in equality between the sexes and between young and old. How do we free more people from the chains of empire? How do we free more women from bound feet or hard labor? Enlightenment would finally come to China, they believed, only when the empire was toppled. Time to get busy.

The plot was uncovered by the government and the leaders executed. They passed right over Wang Cong'er, merely a woman, but they killed her husband. Haven't we seen this plot before? With a sword in each hand, she raised an army of acrobat-martial artists and went on a rampage. Historians now credit her "aggressive" strategy: other White Lotus leaders had taken a defensive approach, holing up behind walls, but that never worked. Wang Cong'er sneak-attacked cities, moving ever closer to the capital and gathering other White Lotus groups along the way. As she went, she trained up women as well as men and in a matter of months her army was forty- or fifty-thousand-strong.

"The deadliest of all the rebels are those led by Madam Wang," said the emperor's advisors. "She personally defeated and killed two of our most brilliant commanders. In a single day."

Boy, was the emperor mad. He sent everything he had.

By now in Sichuan, Wang Cong'er sent messengers sprinting to White Lotus groups across China. *We need you!* The final battle is upon us and if we all join under a single banner, we cannot lose. The empire will fall and China's dawn of Enlightenment will come.

The other White Lotus leaders were like, *nah, we're good.*

You can probably fill in the rest. She fought to the end—all her soldiers did. And when they were reduced by the imperial army to just a dozen or so remaining, they took their banner in hand and jumped off a cliff.

It's weird how, in hindsight, losses become victories and vice versa. The White Lotus Rebellion is now framed as the beginning of the end for the Qing Empire. Its military proved too weak, they say; the emperor showed his hand. "It should have been just another whack-a-mole incident," they say, "it should have been cheap and easy. Instead it drained the government's entire treasury. Probably bureaucrats syphoned away funds—yeah, that's what went wrong. A silly mishandling."

It was an unprecedented disaster for the empire, that's for sure. But to explain away the uprising in terms of bureaucratic idiosyncrasies is to forget that there were tens of thousands of hungry idealists involved. The Qing Empire offered women the choice: bind feet and be sweet, or hard labor all day. The White Lotus Society offered true equality, martial arts training and—if we all work together—Enlightenment. Which side would you join?

The Answer to Life, the Universe and Everything

There were Émilie du Châtelets and Bibi Sahibas and Wang Cong'ers the world over. Collectively, an inspired humanity worked together in pursuit of Truth. Even Russia stopped murdering itself long enough to produce some incredible female scientists and philosophers. But . . . did it work?

One of the best parts about living in the twenty-first century is that we get to skip straight to the end. They did it! Thousands of clever people came together in salons and madrasas and academies and universities, shared new discoveries and compared notes, and found The One Answer. It was so elegant, it could actually be boiled down to a single word:

Liberty.

Liberty is what the universe is striving toward, what every system creates and requires. It's what the mystic discovers at the root of everything, it's how planets form and how nature thrives. It's how enlightenment is born.

Give humans liberty and they will become enlightened. We don't need threats or incentives to grow—we will do it ourselves, if we have the freedom to do it. It's naturally within us, as it is within everything in the universe. We can even become enlightened without shelter, food security, or wifi. Liberty is The One and Only thing we require, to build a better world.

Once word got out that all the world's thinkers had solved Life, there was instant enthusiasm. People were so sold on the idea that historians now call the movement The Cult of Liberty. And it wasn't all one type of person, either: the poorest of the poor and the richest of the rich believed. Professors and

merchants and mystics and farm laborers could all get in on this idea. Sure, some dopes like, oh, the King of France and the Emperor of China chafed under the suggestion that human liberty was the answer. But there were plenty of other leaders around the world who believed it. Britain's King George III, we now know, was Convert Number One. He wrote an essay praising liberty and was prepared to abdicate in its name. (Parliament was like, *please don't sir.* So he didn't). In that same country, Mary Wollstonecraft wrote that it was a fabulous idea and that it applied to women as well as men. (Parliament was like, *don't be silly, Mary.*)

Over in the remote British colonies of the Americas, Virginia bigwigs Peyton and Betty Randolph started inviting people over for dinner so they could all talk about Liberty. Thomas Jefferson and George Washington spent many an hour sitting around their table hashing out what Liberty really meant. All the while, they were attended by Betty Randolph's personal slave, Eve. She kept her ears open, her eyes down and then she made her move.

Eve, Gone to the Enemy

Eve was there on that hot summer day in Williamsburg when Thomas Jefferson's *Summary View of the Rights of North America* was read aloud in the Randolphs' house. In it, Jefferson declared that Americans felt England treated them like slaves. "Hear, hear!" said all the big wigs in Virginia, as they snapped their fingers to order their slaves to fetch a celebratory barrel of madeira.

Amazing conversations were held at the Randolph house and Eve heard it all. She could hear the founding fathers debate the proper application of Liberty. She would have puzzled (silently) with them over the fact that King George III himself claimed to be the most ardent believer in Liberty. How could this be? Isn't a king automatically Liberty's number one enemy? Or could a king protect Liberty, from above the fray of election campaigns and political schemes? Learning by listening, Eve knew more than most Virginians about the political climate of the colonies; she knew more than almost everyone. And she must have spent years wondering and waiting to see if, in the end, Liberty might apply to her, too.

Then the revolution began. We declare our independence, no more will we be slaves to King George!

This means war. Just down the street from the Randolphs' house, staunch British loyalist Governor Lord Dunmore heard the news in his mansion. "Liberty, huh? Is *that* what this is about? Two can play that game." He issued a proclamation:

> I do hereby declare all indentured Servants, Negroes, or others, (appertaining to Rebels) free, that are able and willing to bear Arms, they joining his MAJESTY's Troops as soon as may be, for the more speedily reducing this Colony to a proper Sense of their Duty.

"Slaves: just get to me," he said, "and join the fight against your oppressors. Even if you can't fight, I'll get you to freedom."

What would you do, if you were Eve? Both the British and the Americans were claiming to be the true disciples of Liberty. Who was right? Lord Dunmore's house was mere steps from Peyton Randolph's house, but could you trust Dunmore? He was an eccentric Scottish highlander, after all, who famously festooned the walls of the governor's mansion with weapons. And even if he would, *could* he get you to freedom? There was a revolution going on! The folks you left behind, what about them? Which seemed the best path for safety, freedom, a life worth living?

Eve and everyone else enslaved at the Randolph house did not go. But thousands of others did and Dunmore did, in fact, deliver them safely to Canada. No one knows for sure how many slaves seized their freedom during the revolution, but it's probably between eighty thousand and a hundred thousand.

Back in Virginia, the revolutionary war raged on for years. Eve carried on, day after day, as Betty Randolph's personal slave. Every night, she slept on the floor in the narrow hall outside Betty's room. At all times and in all places, she had to do whatever Betty told her to. All the while, Virginia was in the middle of a catastrophic war and Eve watched and waited.

Then, in 1781, five years after the revolution began, the British army took Williamsburg. Hundreds of British soldiers marched behind General Cornwallis right through the center of town. Some slaves appeared to be following the regiment down the street. Wait. Did Lord Dunmore's Proclamation still apply?

She stared. It was now or never.

And Eve walked right out the gate. She took her son George by the hand and followed the army. Then Johnny the butler walked and Betty the cook. Eight of the Randolph slaves walked away.

In her household inventory that night, Betty Randolph scratched out each of their names in turn and scribbled "Gone to the Enemy."

A happy ending would round out the Enlightenment and Cult of Liberty so nicely. But this is real life. We know *what* happened, but we don't know *how*. Was Cornwallis's army as selective with liberty as American slave owners were? Did Eve and her cohorts stray away from the army, racing to get to British ships? There were roving bands of "slave patrols," capturing runaways to collect rewards.

Eve was identified and captured.

Betty Randolph amended her will:

1782 July 20th

A codicil to the above Will

Whereas Eve's bad behavior laid me under the necessity of selling her I order and direct that the money she sold for may be laid out in purchasing two Negroes Viz; a Boy & Girl, the Girl I give to my niece Ann Coapland in lieu of Eve, in the same manner that I had give Eve. The Boy I give to Peyton Harrison, to him & his heirs forever.

Betty Randolph only mentioned Eve, so did all the others get away? We'll never know.

If ever anyone truly understood liberty, it must have been Eve. Her experience of the American Revolution shines a whole different light on this watershed historical moment.

The scrappy new United States of America, by some miraculous combination of bravado, spycraft and the assistance of French aristocrat-adventurer the Marquis de Lafayette, won the war. The new nation proudly presented itself as a beacon for the world—a nation built entirely on an ideal. To commemorate the hugeness of the event, France would later gift the United States a monumental statue of liberty, embodied. Nowadays, she's widely known as the Statue of Liberty, or Lady Liberty, but did you know she has an actual official name?

Liberty Enlightening the People.

What a poignant reminder of what it was all about. What then does it mean, that now nobody remembers?

Liberty
Enlightening
the People . . .
Or Maybe Not

THE WORLD GRABS LIBERTY AND RUNS
IN EVERY POSSIBLE DIRECTION

It was a crisp October day in 1829 when The Rocket changed the trajectory of the world. The Rainhill Trials in Lancashire, England were staged to test whether steam engines really could operate while moving. The contestants—ten locomotives—had to move *themselves* along a 1-mile stretch of track between Manchester and Liverpool. Turned out, only five were actually fit to compete and four of those never made it across the track. It was a fairly boring day out.

But then it was The Rocket's turn. Had we been there to see her, we would have gasped as she steamed past at the face-melting speed of 12 miles per hour. Once, on the downhill, she reached a positively shocking 30 miles per hour. When she and she alone completed the test mile, the whole world heard about it. What next? Nothing less, they said, than the annihilation of space and time.

They were right. It was the beginning of the Industrial Revolution, one of the biggest shifts in human history. Never before had humans been able to harness power beyond anything in nature, be it wind, water or muscle. Put that supernatural power on wheels, in factories, or on ships and you were about to change the world and everyone in it.

Tomes have been written about why the Industrial Revolution happened when it did and why it started in Britain. It's actually a fascinating and deeply nuanced subject—so, nothing a quick list can't sort out.

YOU PICK! WHAT CAUSED THE INDUSTRIAL REVOLUTION TO START AND IN BRITAIN OF ALL PLACES?

- Strong legacy of the Scientific Revolution and the Enlightenment
- Protestantism promoted individual achievement and competition
- Lots of capitalists ready to invest in crazy schemes
- British culture preferred hands-on experiments over philosophizing
- A large, ready workforce

- Britain had to find *something* to trade China for tea and porcelain!
- Tin, copper and coal in the British landscape

Would you have dared to take a breakneck 12-miles-per-hour ride? What would happen to you if speeds reached 30 miles per hour? *Probably your uterus would fall out,* was the general conclusion. Also, there's the perfectly obvious fact that madness would overtake a person's mind at such speed. Novelist George Eliot dared to ride anyway. With a thrill, she awaited the emergence of "Railroad Madness" in her fellow passengers, but was sorely disappointed. Her uterus also stayed stubbornly in place, as did all the other uteri that traveled by train. *Boring.*

So it didn't take long for the rest of the world to stop just staring at Britain's goings-on and join the fray. *Everything* changed. And the world's people leaned in. *If change is coming, let's push it in the direction of Liberty!* said everyone. But each liberating struggle played out vastly different to the others. In hindsight, the American Revolution that started it all stands out as a fluke. Let's spin the globe and glimpse the world's nations tossing and churning in the sea of change.

Ludlow Tedder

The Old Bailey, London's criminal court, gave an emotionless report of the events of December 17, 1838:

CASE 301. LUDLOW TEDDER born 1791. Place of birth Essex. Gender female. Height 5′ 2″. Hair dark brown. Eyes hazel. Distinguishing marks freckled. Was indicted for stealing, on December 1, 2 spoons, value 1*l.*; and 1 bread-basket, value 10*l.*; the goods of Fitzowen Skinner, her master.

FITZOWEN SKINNER, ESQ. I am a barrister and live at No. 25, Keppel-street, St. George's, Bloomsbury. I rent the house—the prisoner was in my service as cook since March last—I missed fourteen forks and eleven silver spoons, on Saturday night, the 1st of December, after the prisoner and her daughter were gone to bed—her daughter had the charge of the plate, but she had access to it—on the Sunday night her daughter came to me and said her mother would drive her mad—I went down into the kitchen and asked the prisoner what was the matter—she said it was about the plate that was missing—I asked her where it was—she said She had pawned it, but she would get it back on Monday morning— I had said nothing to induce her to confess—I asked her for the duplicates and she gave them up—I sent her and her daughter to bed and locked the house up—next morning I found my wife had missed table-cloths and other things—I asked the prisoner if she knew any thing about them—she denied all knowledge of them— I said, "Justice must take its course"—I went out to the Temple, to get a friend to be in the house and locked the door, as I supposed, but when I returned the prisoner was gone and I did not see her again till Tuesday the 16th, when she was in custody at Bow-street.

JOHN WENTWORTH. I am a pawnbroker. I have a bread-basket, pawned on the 1st of December by the prisoner—this is the duplicate I gave for it—I have also eleven spoons, pawned by her at different times.

MR. SKINNER *re-examined*. I did not miss the bread-basket till she gave me up the duplicates—this is my bread-basket—(*looking at it*)—I had seen it on the Thursday-week previous—I gave the duplicate she gave me to the policeman.

RICHARD LESLEY. I am a policeman. That is the duplicate of the bread-basket Mr. Skinner gave me.

GUILTY. Aged 47.—Transported for Ten Years.

Ludlow Tedder was a widowed mother of four when she stole Mr. Skinner's bread basket. As a domestic servant (to the emerging middle class), she ranked among the lowest in society, working dawn to dusk for pennies, while others made pounds. The Industrial Revolution was changing the world around her, but her life and the lives of all servants, remained stubbornly the same. Never was Ms. Tedder destined for, say, a breathtaking ride on a steam locomotive—though stories about The Rocket could be heard everywhere. Not for a century would the Industrial Revolution create labor-saving devices for lowly domestics. So when she was sentenced to transportation along with one of her daughters, was it a blessing or a curse? What kind of life could the lowliest sorts build on the other side of the world?

Australia

It was kind of America's fault that Australia was finally roped into the global imperialist saga. During the world's obsession with imperialism in the eighteenth century, Oceania was still too far away to bother—you'd have had to be desperate. But, at the end of the 1700s, Britain got desperate. Shipping criminals far away was Britain's signature move and turned out to be great for avoiding looming revolution. But with the recent loss of their ungrateful North American colonies, a new destination for undesirables was needed. Somebody pulled out a dusty old map from Captain Cook's voyages. "James Cook said there's a big old island way over here, with a nice place to land." Everyone shrugged in vague agreement and the Penal Colony of Australia was born.

On the four-month crossing from London to Tasmania, Ludlow became nurse on board the ship—an interesting pivot, given she had been employed as a cook. It probably ensured that she and her nine-year-old Arabella got better treatment, or more regular food. Maybe she was hoping that because of her service they wouldn't take her daughter away at the end of the journey, but they did. Arabella was shipped off to an orphanage and Ludlow Tedder began her sentence at the women's prison. She did everything she could to reduce her sentence and to save money, and after seven years, she was released and able to collect her then sixteen-year-old from the orphanage.

What to do then? Sail back to England? Start a new life in the wilds of Australia? Women were scarce, which had its pros and cons. Then, they say, a Mrs. Kennedy and Mrs. Ferrell sauntered into town bearing gold they'd found on the bed of Bendigo Creek. *Gold.* That you could just scoop up from the ground. The gold rush was on.

Could two women set off on such an adventure alone? They knew women with nursing and cooking skills would be in high demand. Who would dare but an ex-con and her hardened daughter? And if Arabella was looking for a husband who was ambitious, perhaps even rich, she was in the right place. It was a land of possibility.

Apparently, ninety thousand people from all over thought the same thing and moved to Victoria within the year. The Aboriginal people there were in for the surprise of their lives. Rather than become hapless victims, most leaned into the change. Their knowledge of the landscape, of tracking, of finding food and making possum coats was invaluable. They traded, contracted out as guides and built shelters for newcomers. Caribberies (Indigenous ceremonies with singing, dancing and telling Dreamtime stories) were *the* highly-paid blockbuster events of the time. Aboriginal trackers were the first search-and-rescue squads and first law enforcers in the gold fields as well.

All the while, "diggers" kept arriving, pouring off ships from China, Polynesia, Germany, Poland, Italy, North America, New Zealand, Britain and Ireland. Another ninety thousand arrived every year, for twenty years. Most were young men. Many were skilled and educated. So here's an interesting twist: by 1861, Australia had the highest literacy rate in the world.

Through it all, Ludlow Tedder delivered babies (including Arabella's) as the population boomed. She nursed the sick, cooked, traded and speculated as her family continued to grow. And when they did find gold, Ludlow cleverly hid it where no man would ever look: (where else?) the baby's nappy. Ludlow Tedder lived to the age of eighty-eight, presiding as matriarch over four generations and indeed over the whole Golden Square district. Her generation, now known as the Gold Generation, had an immeasurable impact on Australia, taking the reins of the nation and steering it in a drastically new direction.

In short, the history of Australia shows what can happen when Indigenous peoples' intimate knowledge of the landscape meets British criminals' desperation to claw their way out of industrial poverty. Once the starving peasants of Europe and China caught a whiff of the dream, they were in for a pound. And the bigwig leaders of those nations breathed a happy sigh of relief as they waved the ships away.

King Louis of France, on the other hand, was not in the habit of shipping undesirables across the world. Nor did France develop a new industrial factory system to employ the hungry masses. So all the starving malcontents were right there underfoot, seething while French aristocrats were famously eating cake.

Never underestimate the power of *hanger* to change the world.

Louise-Reine Audu

For months, women who sold food at the Paris market literally could not afford to eat any themselves. Their aristocrat customers were persistently blind to their plight. Then on October 5, 1789, another market day dawned with news that the price of bread had increased yet again.

For fruit seller Louise-Reine Audu it was the final straw. She let loose a rant from the heart and the women around her cheered. Someone got her a stump to stand on, so she stepped up and kept going. A crowd gathered. She *went off*—and someone banged a drum to give her words a boost. Now they were a kind of army, seven thousand strong. They dubbed her La Reine des Halles, Queen of the Market Stalls. *What now, La Reine? What should we do?* To the royal palace at Versailles, of course, to fetch the king and queen back to Paris and awaken them to our suffering! Never mind that Versailles is 13 miles away, it's already evening and it's raining.

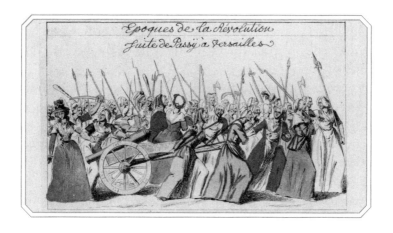

An illustration of the women's march on Versailles from 1789. Just add midnight darkness, biting cold, rain and gnawing hunger.

They reached the gates of Versailles before the break of dawn, where, inside, King Louis XVI and Marie Antoinette were sleeping, full-bellied in their silk beds. The mob let loose on the royal guards. And as it turns out, when you make seven thousand starving peasant women angry enough that they'll march all night just to break down the door of your modest little *most extravagant*

palace in human history—heads roll. The panicked Queen Marie Antoinette ran barefoot through the palace to get to her children, while royal guards were being murdered around her. King Louis decided to face the mob straight on and stepped out onto the balcony. With a panicked smile, he made a short, lovingly paternalist speech to his subjects. He called for bread to be retrieved from the royal stores for the women. The crowd roared their approval. *But where is the Queen? Let her show herself so we can tear out her heart, cut off her head and fricassee her liver!* A ghostly pale Marie Antoinette stepped onto the balcony, her children gathered before her. The crowd didn't like that. *Disgusting coward, using children as a shield! Send the children away!* She led her children back inside and returned to stand there trembling, hands crossed over her chest. The mob glanced sideways at their Queen of the Market Stalls: *tell us, Louise-Reine, should we kill her or cheer for her?*

Louise smiled. "Three cheers for our King and Queen! I knew they would help us!" The crowd roared. "I say we bring them right back to Paris so they can resolve this food crisis personally. No more hiding out at Versailles!"

To Paris, to Paris! Shouted the mob. So the royal family packed up their carriage and headed for Paris. Every mile they were surrounded by the mob, which had now grown to sixty thousand, proudly brandishing pikes topped with loaves of bread and the heads of royal guards. Never before had the monarch bent, so spectacularly, to the will of the people. The French Revolution had begun.

Did you see that? said Danton, Robespierre, Marat, Condorcet, Lafayette and all the other French Revolution dudes you've ever heard of. No money, no education, no status whatsoever and yet that woman convinced thousands to march for miles through a rainy October night! *This Louise-Reine Audu is powerful.*

So you can probably guess what happened.

As the revolution rolled on, different factions pushed France in this and that direction and Louise-Reine spoke her mind just a little too freely. She was imprisoned. Political infighting turned into witch hunts and heroes turned into villains and vice versa. In an unusually daring move, a group of more than three hundred citizens endangered their own lives to sign a petition vouching for her character. So, in an attempt to outsmart Louise and destroy her reputation via public humiliation, long public interrogations were staged. She came out victorious, every time.

Sigh. Messieurs, we simply cannot afford to leave the fate of France in the hands of mouthy peasant females. She seems a bit . . . some would say untamed—I'd say *unhinged*. Yes, by jove, she's clearly lost her mental faculties. To the asylum with her!

They say she died there in 1793, though no one tracked the whereabouts of peasants like Louise, even if they were Queen of the Market Stalls. And anyway, people were dropping like flies in 1793. It was The Terror, when the revolution's factions turned even on their own, chopping off heads in a frenzy unmatched even by the previous four years of head-chopping. Danton and Robespierre lost their heads; Marat was murdered in his tub; Condorcet and Lafayette were imprisoned. It was also the year that Olympe de Gouges, another self-educated Parisian, dared to tweak the *Declaration of the Rights of Man* to include women. She was swiftly guillotined.

So yeah, the French Revolution didn't turn out very well. And now the rest of the world was looking at two very different prototypes: If we embrace revolution to build a nation based on Liberty, will we get a United States-type outcome (stable but hypocritical), or a France-type outcome (unending chaos and bloodshed)? *Asking for a friend.*

Haiti

Despite the rather unsatisfactory outcome for Louise-Reine herself, her eloquent shouts of rage reached all the way to Haiti. It was a French sugar colony and the most lucrative colony in the world. While the French Revolution was devolving into an increasingly circular series of witch hunts, the slaves of Haiti's sugar plantations rose up in the name of Liberty. Armed with farming tools and decades of pent-up rage, the enslaved fought back with a brutality that made even the rebels back in France, standing there waving heads around on pikes, pause and reflect.

It's now considered the most successful slave revolt in history. French plantation owners fled back across the Atlantic (or washed up on the shores of America), quivering with horrific tales of the dangers of Liberty in the wrong hands. *Liberty for us French, yes! But, you see, the trouble is, once the unwashed masses hear about it, the silly little creatures believe it applies to them too! This is why education and ideas should be reserved for a select few.*

For her part, Louise-Reine had cheered on the rebels of Haiti, as did Olympe de Gouge (until she lost her head). Liberty was The One Answer to Rule Them All, they said; it applied to everyone. But to The Man in his many forms across the world, the Haitian Revolution was a prime example of how much could go wrong. How many other colonies were going to take this *Liberty* thing too far? Napoleon Bonaparte took one look at Haiti and decided that France had been terribly mistaken. Yes, he said, we want *Liberty, Equality, Fraternity.*

Of course! he said. But you see: the horrors of The Terror and of Haiti have shown us that *we can't handle Liberty until we have Equality.* So, naturally, he declared himself emperor and began bashing his way around the world, taking down every last monarch in the name of Equality.

So, with threats of Liberty from within and threats of Equality from without, emperors everywhere started biting their nails.

Except the Ottoman Sultans.

Meanwhile in the Ottoman Empire

The Sultans at Topkapi Palace were still so confident in their power and so utterly uninterested in that backwater called Europe, that they feared no revolution. Revolutions were for sad weak empires, for failing states, for pathetic Christians. *Here in the Ottoman Empire, we crush revolutions before they even begin!* Just one glance inside the prisons of Istanbul would show you how many revolutions had been prevented. Behold: a whole host of wannabe revolutionaries, all dying the horrible drawn-out deaths they deserve.

Thus it was that on May 11, 1771, a distraught woman who had traveled hundreds of miles to visit her incarcerated husband, gave birth in an Istanbul prison. The baby was a girl. A common nobody, soon to be fatherless and fortuneless, she would grow up to dedicate her life to liberation.

Bouboulina

Her name was Laskarina Bouboulina and today her surname is synonymous with *strong woman* in Greece.

Let's pick up her story when she's forty. Twice widowed with seven kids, she's sitting on a good fortune because both her husbands had been very rich sea captains. Call it a midlife crisis, call it destiny, but something moves her to use her inheritance to buy her own fleet of ships. She takes to the seas herself.

The more she succeeds as a merchant captain, the more the Ottoman Empire takes notice. Who is this brash woman? Who let her off her leash? Digging into her history, they discover that her second husband had once sided with Russia against the Ottoman government. *Bingo.* They confiscate all her property. *Woman, go home.*

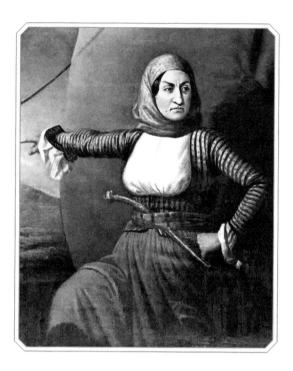

Laskarina Bouboulina at the prow of her warship *Agamemnon*, pointing determinedly at her target: the Ottoman Empire stronghold at Nafplio.

But Bouboulina was untameable. She traveled to Istanbul, the city of her birth, the city of her father's death, to plead her case. She must have known that her own imprisonment was a very real possibility, but she went anyway. She also must have known that bureaucrats and officials were never going to listen to her, so she made an alternate plan. As a woman, she was well aware of Roxelana's lasting legacy in the Sultan's court: the real power was in the harem.

So she knocked on the door of the harem. Her plan worked beautifully. The Sultan's mother reprimanded her son for mistreating this poor, innocent widow and Bouboulina was sent home with all her property intact. Legend says that when Bouboulina asked how she could repay the emperor's mother, the mother replied that in the future she might pay it forward, to other women in need.

But first, start a revolution:

◆ Step one, acquire a massive warship and come up with a badass name that warns the Ottomans, in a high-brow kind of way, that you're coming for them.

◆ Step two, stockpile supplies. We're talking smuggling munitions and stashing them in your house.

◆ Step three, raise and personally finance a private navy, made up entirely of men from her home island of Spetses.

And then she was ready. The first flag of the Greek Revolution was raised by Laskarina Bouboulina on the mast of her eighteen-gun corvette, *Agamemnon*. She saluted it with cannon fire and on April 3, 1821 led her fleet of ships into the first battle of the Greek Revolution.

For a year and a half, she led her men by land and sea. On land, she rode a white stallion (because of course she did) in front of her men. At sea, she stood boldly at the prow of the *Agamemnon* like Washington crossing the Delaware (there's actually a painting of Bouboulina that is the spitting image of that other famous painting). But none of it is pretty, or glorious: she lost two sons during the war and the Greek War of Independence is infamous for the brutality that was enacted on both sides. The vitriol and violence were rooted in the centuries-old Ottoman occupation of Greece. Greeks had long been Christians and the Muslim Ottomans used all the classic colonial tactics to crush the religion out of them. It was a chasm lined with contempt, much like the Hindu–Muslim divide in India, the Catholic–Protestant rift in Ireland, or (as we shall see) the Christian–Confucian conflict in China.

Bouboulina was at the infamous Battle of Tripoli, which is more rightly deemed a massacre. Tripoli was an Ottoman stronghold, inhabited mostly by Muslims and Jews. So when the Greeks finally breached the city, after seething outside the gates through a months-long siege, they unleashed their rage to its fullest. Bouboulina was there among them—it's said she decapitated many men. Twenty-five thousand bodies lay dismembered in the streets before the attackers invaded the palace, ready to unleash hell. But inside, Bouboulina came face to face with the women of the harem, who begged her to spare their lives. She remembered her promise to the emperor's mother years ago and turned around. Wielding her sword against her own Greek troops, she saved every last woman in the palace. This act, much more than all the decapitations or battles won, is the centerpiece of her story in Greece.

The horrors at Tripoli revealed a rift among the Greek rebels. Some thought they had gone too far; others thought they had not gone far enough. Fractures started to appear as the groups envisioned different

futures. So by the time the fighting was over and Greece was free, Nafplio (the new capital) was already endangered. Bouboulina joined the other rebel leaders in the formation of a new nation. The political infighting got so bad that Bouboulina was arrested twice before being forced to flee back to Spetses. She had nothing left and was disillusioned with the politicians, who she deemed to be self-interested schemers destroying the liberty that Greeks had fought and died for. She had given the cause all her money, all her ships, two of her sons and her whole heart and soul. And she had lost everything.

Back on Spetses, human pettiness continued. A neighbor's son had eloped with Bouboulina's daughter, but now that Bouboulina was penniless, the neighbor was upset. As he pounded angrily on her door demanding the marriage be annulled, she leaned out the window and told him what for. Someone shot her in the head.

When he heard the news of the ignoble end of the Greek hero Bouboulina, the Russian Tsar Alexander II was moved to grant her the honor and recognition that she, a woman, had been denied in life. He named her Rear Admiral of the Russian Navy and she was, until recently, the only female admiral in the history of the world.

Bouboulina hadn't just liberated Greece from Ottoman rule: she had shown Greece the power and value of a liberated woman. And by doing that, she helped to liberate every Greek woman who followed in her wake.

Brazil's Twist on Liberty

Meanwhile in South America . . . Liberty arrived in Brazil with a fascinating royal twist. The King of Portugal, after losing battles against Napoleon, opted for the old survivalist strategy of "run really far away." He set up court in his sugar colony in Brazil and when it came time to return to Portugal, Pedro the Prince Royal stayed behind as his father's agent. But Liberty was sweeping the globe, and São Paulo plantation owners, miners and freedmen started to murmur that royalty was *so* last century. With shrewd panache, Prince Pedro wholeheartedly agreed. He started the revolution himself (*take that, Dad*) and quickly became ruler of his very own South American nation.

At the exact moment Prince Pedro was launching his coup (and Bouboulina was besieging her first Ottoman castle back on the Aegean), a remarkable baby girl was being born to a large gaucho family in Laguna.

Anita Garibaldi

Her name was Ana Maria de Jesus Ribeiro (Anita for short), and her destiny (and that of three countries on two continents) was changed forever when a lightning bolt struck in the form of one Giuseppe Garibaldi.

Giuseppe was a dashing young freelance revolutionary-for-hire who'd been kicked out of Sardinia after he and his friends tried to overthrow the king and form a new nation they proposed to call "Italy." South America, Giuseppe's friends had told him, was where the revolutionary action was at. But staring across the water as his ship sailed into Laguna, this mercenary maverick got the shock of his life. *Who is that standing on a balcony looking out to sea?! She's the most beautiful woman I've ever seen! I must have her!* Launching himself straight into the bay and swimming like a madman, Giuseppe soon found himself staring into the dark eyes of Anita—and the world would never be the same.

Anita and Giuseppe embraced a kind of "career revolutionary-ism." *The world is waking*, they believed; *any insurrection will do*. And by 1840, they were firmly in the thick of Brazil's infamous Ragamuffin Revolution. Let's see how things are going, shall we?

Staggering through a relentless fusillade of gunfire we find nineteen-year-old Anita, darting through the cannon smoke, searching frantically among the bodies littering the field for something—or someone. This pathetic figure carefully turns up the face of each dead or dying form she passes—surely this can't help but evoke our pity, our sympathy, our . . . Wait, what's happening? That delicate little waif has . . . just made a flying leap onto the back of an unattended horse? And is now riding hell-for-leather directly *into* the firing line?

What is she doing?! She's going to get herself killed! She doesn't, though. Slipping her way around—or through?—volleys of bullets like some kind of matrix-bending superhero, our heroine makes it through the enemy line before her horse is finally shot down. Unfazed and quickly fighting her way out from under the horse's dead weight, Anita deftly eludes the horde of soldiers now bearing down on her and throws herself into the raging Canoas River.

Well, nobody on Earth could survive those rapids, the soldiers agree and turn back to the battlefield. But Anita *does* survive the river, emerging on the other side to wander the forest for four days before finding anyone who can give her what she desperately needs: food, shelter, sure—but the only thing that really matters to her right now is *news*. She is desperate to hear that her beloved Giuseppe is still alive.

Oh and did we mention she's also *six months pregnant*?

Midway through that infamous battle at Curitibanos, Anita had been captured by opposition forces and informed that her husband had been killed. Refusing to believe it, Anita demanded that her captors produce the body. When they demurred, claiming it lay amid the carnage outside, Anita demanded to be allowed to search the battlefield for herself.

It's easy to imagine the train of thought that led these men to allow it. A heavily pregnant woman, wandering around an active war zone, searching for one body among all those jumbled on the field? She couldn't possibly pose a threat to anyone! And, as for a possibility of escape, where was she going to go? *Right through the front lines and into the river?* Yes, it turns out.

It wasn't the first time a group of men underestimated Anita Garibaldi and it certainly wouldn't be the last.

With Brazil becoming an increasingly dangerous place to be a Garibaldi, and now with a newborn baby to consider, Giuseppe temporarily agreed to give up revolutioning. In 1841, the family moved south to nearby Uruguay, where Giuseppe resolved himself to a new life as a schoolmaster. A resolve which would last for *multiple months*—until Giuseppe *somehow* managed to get himself drawn into yet another revolution: the Uruguayan Civil War.

And when, many years later, the rebels finally emerged victorious, they hailed the Garibaldis as the great heroes of Uruguay's liberation. During Anita's lifetime, governments would rise and fall with the seasons all across the South American stage. Across the continent, revolutionaries envisioned radical changes—championing universal citizenship regardless of race—a truly bold move.

The dream was a brave new world—but the reality was devastatingly disappointing. Textbooks often blame a banal string of bureaucratic failures for undermining the egalitarian movement in South America: the new governments lacked resources and allies; new guns served old grudges; the landscape became more desolate, blah blah blah.

But we find it necessary to point out that, as it turned out, "universal suffrage" actually only referred to about half of the population. Care to guess which half? There had been "Anita Garibaldis" everywhere in South America: Andean women staged dramatic protests; Colombian women trampled royal edicts underfoot; female leaders were publicly executed in Peru. In Bolivia, Juana Azurduy dressed as a soldier, led a cavalry charge and captured the oppressor's flag. She was officially commended for her "heroic actions not common at all in women." *Uh, thanks?*

You get the picture. Women were explicitly uninvited to the revolution. All their stories were shelved by The Man. By 1850, the South American precedent was that governments would not last; new presidents, taxes, or laws would never be sustained. Don't like the current government? Wait a year or two and it will change. What *would* last? What rock could the people build their futures upon? The one thing that seemed tried and true and forever: patriarchy.

So, Anita and Giuseppe gazed longingly across the Atlantic to his former home on the Mediterranean. Remember that whole "united Italy" dream? Should we go chase Liberty there instead?

Arriving in her husband's homeland, Anita had no intention of letting a mere inability to speak or write Italian—or an inability to read or write *at all*, for that matter—slow her roll. Giuseppe and Anita had a few modest, small-scale, entirely reasonable goals for his homeland. Their to-do list included, but was not limited to:

◆ Capture the Pope and kick him out of Rome

◆ Destroy the thousand-year-old Papal State

◆ Dismantle multiple independent kingdoms

◆ Annex large chunks of France and Austria

◆ Launch a new constitutional assembly ensuring freedom of religion, education and the press

◆ Form a brand-new secular nation to usher in the rebirth of the glorious Roman Republic, thereby launching a wondrous new era of unimaginable liberty, reason and peace

And somehow they did it, largely thanks to Anita running the revolution's PR—"campaign stumping" her way across the continent, convincing people a unified Italy was the way to go.

But Anita is not just the "frontman" of the operation. As always, she is also fighting right alongside her husband on the front lines, successfully taking Rome for the revolutionaries, kingdom by kingdom, town by town and, eventually, street by street.

But that victory was startlingly short-lived. Barely five months into the new Roman Republic having been proclaimed A Thing and only nine *weeks* after the Garibaldis' victorious march into Rome, the nation found itself under

attack by a French force, deployed for the explicit purpose of reinstalling the Pope on the Roman throne.

So as the French began pouring into Rome in early July 1849, Giuseppe, Anita and around four thousand of their troops led a strategic retreat northward toward Venice. They were planning to return as soon as a bit of skillful diplomacy—and fingers crossed, another infusion of new recruits— made reoccupation of Rome a viable proposition. But the timing couldn't have been worse for poor Anita. Pregnant with her fifth child, gravely ill with malaria and in far from ideal form for a 250-mile quick-march pursued by the armies of various kingdoms, Anita Garibaldi died in her husband's arms during the early morning hours of August 4, 1849. She was buried in a hasty roadside grave that day before her comrades had to move on.

The Garibaldis' army/legion would never retake Rome—though that was certainly not for lack of trying (and trying and *trying*)—Giuseppe's beloved Roman Republic would never return. But the story of their attempt would prove immortal. Statues honoring Anita Garibaldi's legacy have been erected by everyone from nineteenth-century Brazilian governments, to twenty-first century Uruguayan feminists, to the Italian fascist dictator Mussolini himself— proving that when you're trying to sell the idea of Liberty (regardless of whether any *actual* liberty may or may not be involved), a fabulous story with a dashing hero at its center has always been an extremely popular marketing strategy.

Who Says You Can't Free the World and Make a Buck at the Same Time?

By this stage, Liberty, in the hands of Europeans, had been tidily packaged up with capitalism. Rather than empires exploiting global resources (boo, hiss), why not have venture capitalist companies do it (hearty cheers)?

The good old boys of the British East India Company were the first to try this brand of hustle—er, *business venture*—on a grand scale. And it didn't take them long to figure out that you could make *even more* money by offering the protection of your corporation's massive standing army (because every *totally normal* company has its own army, obviously) in exchange for stuff like: exclusive trading rights or a few thousand acres of tea plantations. And maybe just a tiny bit of political influence over the local government's affairs? In a *purely advisory capacity*, obviously.

Of course, it didn't take long for that "protection agreement" to morph into a full-on protection racket. *Boy, it sure would be a shame if something bad were to*

happen and we weren't around to defend you, amiright? Ancient Persian Empire strategies proved timeless once again.

And that's how—bit by bit, inch by inch—the East India Company took over almost the entire Indian subcontinent, plus most of Burma, Malaya, Singapore and Hong Kong. With a standing army twice the size of Britain's and a net worth higher than several major world powers combined, this private corporation was one of the most influential imperial powers in the world (sound familiar?). By 1853, the East India Company was de facto Emperor of India in everything but name.

Enter Lakshmibai, the Rani of Jhansi.

Lakshmibai

After a decade of peaceful and popular rule (under the benevolent supervision of the East India Company's "advisor," of course) Gangadhar Rao, Maharaja of the Kingdom of Jhansi, is dying. There is no direct heir to the throne—the royal couple's only child had died in infancy years earlier. But the Maharaja has done everything necessary to assure a smooth transition of power.

The day before his death, Gangadhar Rao had officially adopted his cousin's four-year-old son, signing all the necessary forms in front of the kingdom's assigned company agent. He'd even presented the agent with a letter requesting that the boy inherit his throne as his legal son and heir, with his beloved wife Lakshmibai serving as Regent until the boy was old enough to rule on his own. Rani Lakshmibai was well respected for her wisdom, diplomacy and devotion to the care of the kingdom and everyone—the EIC agent included—thought this was a marvelous idea.

Everyone, that is, except the new Governor General of India (aka the East India Company's main man), Lord Dalhousie. A firm believer in the superiority of all things British, Dalhousie wanted the whole subcontinent under *direct* British control—and he was determined to use every tactic legally available to him (and quite a few that weren't) to bring the last few autonomous-ish kingdoms to heel *by any means necessary.* And by dying, the Maharaja had just handed Dalhousie the excuse he'd been waiting for.

An East India Company policy known as the *Doctrine of Lapse* had officially existed for over a decade, but had never really seen much play until Dalhousie arrived on the scene. The doctrine stated that any time a ruler under

a company alliance agreement died "without a male heir," his kingdom could be immediately annexed, to be ruled directly by the East India Company from that moment on. Declaring Jhansi a "lapsed state," Dalhousie immediately took control. He pensioned off Lakshmibai with a very clear message: *Go away quietly and I'll leave you two alone in your fancy palace.*

Dalhousie clearly did not understand who he was dealing with. This was an unusually bold, well-educated, independent-minded Queen, as renowned for her prowess as an equestrian, fencer and acrobat as she was for her intellectual flair—and she was not about to take her son's deposition lying down.

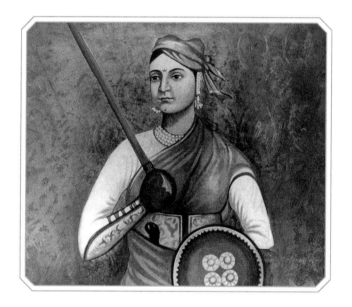

Lakshmibai tried everything before taking up arms.

Neither, it turned out, was anybody else. Everyone who was anyone was firmly on the Rani's side. Queen Victoria's court was positively flooded with letters from basically every prominent British official in India, expressing outrage at Dalhousie's decision and praising Lakshmibai's qualifications for the role. But Victoria was very far away and Dalhousie was unmoved—he'd already deployed the Doctrine with great success to annex the kingdoms of Satara, Jaitpur, Sambalpur and Nagpur, after all. It quickly became clear that nothing was going to change without Lakshmibai taking matters into her own hands. So what did this famously bold and fearless queen do? Raise an army and

launch a violent revolt? Ally herself with a few nearby Rajas and storm the office of the Governor General?

Nope. She took the question to the British legal system. Lakshmibai and her son waited patiently as the case made its leisurely way through the bureaucratic machine of British justice—and they lost. So the Rani appealed again. And lost again. And again, and again, *and again*.

Meanwhile, all across India, discontent was growing, most obviously within the ranks of the East India Company's army itself. A series of spectacularly culturally oblivious moves by the British had caused major, serious grievances among Indians. Most famously, the episode of the Enfield Rifles. The hottest new weapon of 1857, the Enfield was meant to be a huge step forward in terms of the army's effectiveness and efficiency. But loading these new rifles required soldiers to tear the top off each cartridge with their teeth—and rumors quickly began circulating that those cartridges had been greased with a combination of pork and beef fat.

Had the British been *actively trying* to infuriate every Indian soldier under their command, they could hardly have landed on a better strategy. The possibility that they might have been tricked into accidentally ingesting forbidden animal products was horrifying for Hindu and Muslim soldiers alike—and the casual way their British commanding officers dismissed their distress made it worse.

By the time company officers finally caught on to the scale of the problem, it was too late. Soldiers were eventually supplied with ungreased cartridges that they could personally grease with beeswax, but the damage had been done. So when, during a practice exercise in the spring of 1857, eighty-five soldiers refused to use any Enfield cartridges *at all*, their commanding officer understood that rebuilding that trust would require an unusually thoughtful and culturally sensitive act of diplomacy.

Haha, just kidding! He had them all arrested, court-martialed and sentenced to ten years hard labor—then retired to his bed in the certainty that this had been a *totally reasonable and measured response.*

So imagine his surprise the following morning as three full regiments of soldiers stormed the jail, freed their imprisoned comrades and then began a massacre of the oblivious British officers and their families still calmly making their way to Sunday-afternoon church.

A spark had been lit which would swiftly become a roaring fire as the enraged mutineers headed toward Delhi. This wave of mutinies, revolts and small-scale uprisings would eventually spark a continent-wide revolution. But it was not a unified effort and suddenly the East India Company—and the

British government itself—were fighting a war that seemed to come at them from every direction at once.

Many British officers and authorities in Calcutta immediately assumed that Lakshmibai was behind it all. Who else had such an obvious (and, as they knew very well, *fully justified*) grievance? Who else could possibly be efficient enough to organize a revolt on such a staggering scale? It *must* be her. In reality, Lakshmibai was not involved in any way—all she'd ever wanted was to make sure her son was the puppet through whom the British would run Jhansi—but the guys in charge simply would not believe it. Completely ignoring her increasingly frantic assurances that she was ready to turn the city over to the British the moment they arrived, the Company dispatched the infamous Field Marshal Hugh Rose with orders to "retake Jhansi from the [totally nonexistent] rebels by force." Rose was not messing around—as he launched his final siege, he delivered an extraordinary warning: "If the Rani is still in residence when I take possession of the city, she will be executed on sight."

Well, what's a desperately-trying-to-be-loyal queen to do? *Okay Rose, if that's how you're gonna play this, I guess there's only one move left: time for the Rani to finally fight back!*

And by jove did she fight. The bombardment of Jhansi lasted more than a week, with the Rani's forces putting on an impressively ferocious show in defense of their kingdom. But, after seven days, most of her cannon and guns were fatally damaged, the inner fortress's walls had begun to fail and British soldiers were pouring into the city's streets, slaughtering all they encountered—adults and children alike.

The end had come and Lakshmibai knew it—but the word *surrender* was simply not in her vocabulary. (Not to mention Rose's threat, which offered a pretty powerful incentive against turning herself in.) And so—legend has it—as the British breached Jhansi's walls, Lakshmibai strapped her young son on her back, mounted her favorite white horse and leapt from the walls of the fort to the streets several stories below. Miraculously surviving the fall (though the poor horse did not), she and her son fled the city with four loyal companions and disappeared into the night.

Eventually reaching the fortress of Kalpi to join other important rebel leaders, Lakshmibai officially allied herself with the mutineers for the first time. Throwing herself wholeheartedly into the fight, she led revolutionary troops into battle all across northern India.

And then, on June 17, 1858, the Rani led her troops into battle for the last time. According to one eyewitness report, she wore a cavalryman's uniform as she rode into the fray. By all accounts, Lakshmibai fought heroically, but was eventually wounded by a British officer's sword and knocked off her horse.

Bleeding heavily as she lay among the dead and dying, she shot at her assailant with her pistol—and was fatally wounded by his answering musket shot. The British took Gwalior three days later and the Indian Rebellion was over.

The Rani of Jhansi would eventually become a beloved national hero, the most famed symbol of Indian Independence and a unified India—a status which would, presumably, have surprised her, given that she herself had no interest in either independence or unification. Lakshmibai's story has since taken on a life of its own. In statues and paintings, ballads and songs, movies and comic books, the Rani of Jhansi still carries the banners of Liberty, Independence and Unity for India to every new generation.

Isabel, Princess Imperial

Among the nations of Central and South America, Brazil was uniquely stable in the nineteenth century, which made elite Brazilians very proud. By the 1880s, Brazil stood alone as the last American nation retaining both a monarch and legal slavery. *That's* what lent it stability over the years ... so all Brazil's neighbors cast it a disgusted glare whenever they had a second to look up from the ruins of their latest government collapse.

It wasn't that the people of Brazil believed in slavery. Most of the population was opposed, but wealthy planters pulled the strings of government. Pedro II, a thoughtful emperor with a light touch, carefully trod the balance of power, always with an eye to stability. But sometimes ol' Pedro had to travel, leaving his eldest daughter Isabel in charge as Regent. If there was anyone he could trust to do his will, it was Isabel, he thought: he'd personally masterminded literally every minute of her education. He'd even found her a suitable husband—Gaston, a French count—and shipped him to Brazil, wrapped with a bow. (Gaston found Isabel to be ugly, but decided he could make it work.)

So, when he left her as Regent in 1871, she was his Most Reliable Placeholder. But for Isabel, it was her time to shine.

She signed the Free Womb Law, freeing all children who were born to enslaved women and setting up a fund to support them. (*What have you done?* said Pedro II, upon his return. *Know your place!*) Progress was inching forward, but not fast enough for Isabel. What was the point of monarchy, if you couldn't wield power to do the right thing? When her father left again in 1888, Isabel settled it once and for all. She signed Brazil's celebrated Golden Law:

Article 1: From the date of this law, slavery is declared extinct in Brazil.

Article 2: All dispositions to the contrary are revoked.

Seven hundred thousand slaves were instantly freed and slave owners were not compensated. The people celebrated her restoration of the soul of Brazil and named her The Redemptress.

The planters and other patricians, however, did not like it one bit. The words Revolution and Liberty started flying around again. And the following year, the last royal family in the Americas was ousted in a coup, which Pedro II took with quiet grace. The royal family dismissed those calling for a defense of the monarchy and boarded a ship to Europe, never to return.

For her part, Isabel was told by many that it was her brash seizure of power that had pushed the monarchy over the brink. "If abolition is the cause for this," she wrote, "I don't regret it; I consider it worth losing the throne for."

Liberty, independence, unity . . . such fascinating words. They are at once something we can all believe in and pursue—but as soon as we start to compare visions, we realize that liberty doesn't necessarily require independence and that unity might be its foil. What might a life of true liberty look like for you? Because if history has shown us anything these past few centuries, it's that a life of liberty can look like . . . just about anything.

It might, for example, look like a lifetime plundering on the high seas.

Ching Shih

If we were to ask you to name a pirate, odds are one particular name would immediately spring to mind: *Blackbeard*. And this most-famous pirate holds that title for good reason: he of the flaming beard commanded four ships, claimed the loyalty of more than three hundred pirates and terrorized the high seas for over two years.

But then, another, less well-known pirate captain was *also* pretty impressive: she commanded 1,800 ships, 80,000 pirates and led the entire Pirate Confederation of the South China Sea for more than a decade. So it *totally* makes sense that she's not as famous as Blackbeard, yeah?

Ching Shih—also known as Zheng Yi Sao, Shi Yang, Shi Xianggu, Shek Yeung . . . this lady had a *lot* of aliases—was the most powerful pirate in the history of the world. Born in Guangdong in 1775, Ching Shih probably spent her first few decades as a sex worker in a well-known floating brothel (boat of

ill repute?) on the Pearl river. Some claim her family sold her, others say she was kidnapped as a child. Either way, it was there that Ching Shih first met notorious pirate captain Zheng Yi. Legend says he fell hard for this charismatic beauty and immediately begged her to marry him. She accepted, on one condition: on their marriage, he'd turn over half of his pirate fleet to her.

Somewhat astonishingly, Zheng Yi agreed and, the day after their wedding, Ching Shih took control of more than three hundred of his ships. A pretty ambitious career change for a woman who'd never been a pirate—or even a sailor—in all her twenty-six years, but Ching Shih was about to prove just how much she was up for the job.

By the time her pirate era kicked off, the so-called Golden Age of Piracy had been over for nearly a hundred years . . . in the west, that is. But in the east, pirate supremacy would be going strong from the middle of the eighteenth century until well into the twentieth.

The South China Sea was an especially great place to be a pirate. Between a sudden massive increase in ocean traffic and the constant maritime brawling of nearby kingdoms, mounting effective patrols was nearly impossible. Add in complex coastlines riddled with inlets and hidden coves pirates can appear and disappear in the blink of an eye.

Ching Shih had one other advantage over many of her pirate predecessors. In the west, as anyone who's seen *Pirates of the Caribbean* knows, having a woman on board was seriously bad luck. Not here. In China, seafaring women were a complete nonissue and the gendered segregation of ships had never been a thing. (To be clear, sexism was obviously still *very much a thing* in early nineteenth-century Asia—parents selling their daughters into sex work to pay off family debts, for example—we're only saying it was just *regular* misogyny, not special *nautical* misogyny).

And soon Ching Shih was commanding one of the largest pirate fleets in history.

But as great as it was being *The* badass pirate power couple, Ching Shih and Zheng Yi could see rough waters ahead. Serious infighting was breaking out within the ranks, leading many pirate clans to spend more time attacking each other than merchant ships. And as the Portuguese and British Navies begin to show an increasingly annoying tendency to interfere with her pirates' business-as-usual, Ching Shih realized it was either band together or be destroyed. But how do you unionize tens of thousands of pirates from a dozen different cultures, whose only shared characteristic is *being unruly outlaws*?

Luckily for her criminal colleagues, Ching Shih wasn't just a badass pirate captain. She was also an incredible team-building facilitator. When Ching

Shih explains that you and your *sworn arch-nemesis* are actually on the same side—somehow, you believe her. And that's how over eighty thousand pirates merged operations to form the totally unprecedented new Guangdong Pirate Confederation. Ching Shih had somehow persuaded *literal pirates* to give up their autonomy and answer to a higher authority *for the greater good.*

And who exactly was the higher authority in question? Well, for the first two years it was Ching Shih's husband Zheng Yi.

And then he died. How did he die? The stories range from death by natural disaster, to falling overboard, to murder—at the hands of everyone from the Vietnamese royal family to his own son to Ching Shih herself. But however it all went down, by 1807 Ching Shih had seized control of the federation and quickly consolidated that control by banding together with her stepson. By which we mean "marrying."

(Look, they're pirates—they *literally* make their own rules, okay?)

Does it make it better if we tell you he was adopted? Well okay, *first* he was kidnapped, *then* adopted by Ching Shih's husband, back in the day. But Zhang Bao had since become a powerful deputy in his father's Red Flag Fleet. And now he's his adopted-stepmother-wife's right-hand-man.

Ching Shih was running what can only be described as an Empire of the Sea. And certainly she had to be fierce, fearless and good with a sword. But she was about to prove that, when running the world's largest corporate pirate enterprise, what *really* counts is your management skills. And she certainly had them: Ching Shih would rule the Confederation unchallenged for more than a decade.

Really though, this mostly mattered because of a very distinct difference between the way western piracy and eastern piracy functioned. Western pirates were—depending on which decade's pirate movies you grew up on—chaotic, dangerous, but desperately sexy gangs of maniacs (fellow eighties kids, we see you!) or (hi there, millennial youths!) floating utopian bastions of democratic equality and fellowship. I mean, obviously still *murderers,* but murderers with *ideals*!

Asian piracy was emphatically neither of those. This was an extremely authoritarian, extremely hierarchical, extremely stratified power structure. With Ching Shih at the top, everyone below her knows exactly where they stand and you don't *ever* get out of line.

She put her stepson/husband in charge of her old stomping grounds, where he immediately began attacking the Qing Imperial Navy in earnest. Zhang Bao was pretty good at his job, too: in one year, he destroyed nearly half of the Chinese provincial fleet. The Guangdong Pirate Confederation was on a roll and for the first time ever they moved inland to take control of not just the sea, but the Pearl River. This was huge. It meant that the pirates effectively

controlled shipping access to *all* of southern China—and there was nothing anybody could do about it.

Then, in 1809, Ching Shih and her fleet were cornered in Tung Chung Bay by six Portuguese ships—and ninety-three Chinese ones. After a two-week long standoff, the head of the Chinese fleet set forty-three of his own ships on fire and sent them drifting into the bay, hoping to set the pirate fleet alight.

He forgot the number one rule of running the Qing Navy: never, *ever* go up against Ching Shih. She and her fleet quickly diverted all the fire ships, towed them on shore and used them for firewood. Well, they diverted *almost* all the fire ships, except for the two still floating in the bay when the wind changed. Blown straight back into the Chinese fleet, the ships promptly set two of the navy's own ships on fire. Taking advantage of the wind and the distraction, Zhang Bao and Ching Shih slipped through the blockade to freedom. This one encounter cost the Chinese Navy a staggering *forty-six* ships, and Ching Shih zero.

This type of thing rapidly became a pattern. But as the years passed, Ching Shih could feel the tides beginning to turn. European powers were flooding into the region in earnest and they were much harder to combat than the Qing Provincial fleet. Having seen many pirates suffer execution at the hands of the British or the Portuguese, Ching Shih decided . . . to retire. But that wasn't all. Ching Shih decreed that the *entire Red Flag Fleet* would cease pirating immediately.

Leading a delegation straight to the office of Bai Ling, the emperor's official representative in Guangzhou, Ching Shih offered the terms for her retirement: guaranteed freedom for herself and Zheng Bao. A few dozen ships to keep as their own private fleet. And *none* of the pirates surrendering with her could be punished in any way.

These were truly ridiculous demands—and Bai Ling agreed immediately. All in all, over 17,000 Guangdong Confederation pirates were granted a full pardon, as Ching Shih handed over more than 220 ships, 1,300 cannon and 2,700 "assorted weapons" to the Qing authorities. Each pardoned pirate was also given a generous retirement gift of wine, pork and cash, then sent on their merry way. And what of Zheng Bao? He was awarded the rank of Lieutenant and calmly absorbed into the Chinese Navy.

And that was that. The pirate queen said, *That's it, kids—we're packing it in! and they all just . . . did.* And they all lived happily ever after.

Well, okay, we can't speak for all 17,000 of them I guess—but Ching Shih certainly did. This notorious Pirate Empress died in her bed at sixty-nine years old, after thirty years as proprietor of a gambling house somewhere in Guangdong—ending her days reportedly richer and happier than ever.

China's Century of Humiliation

In hindsight, maybe the Qing should have asked Ching Shih to stick around a little longer. She left the South China Sea door wide open.

British Empire: Oh, hello, I just snuck right in here, didn't I? Wasn't there a pirate queen? Never mind. Your silk, porcelain and tea is simply fabulous. Can I interest you in any of our trade goods in return?

China: Just gold, thanks.

British Empire: You sure? Linen? Christianity, maybe? Cabbages?

China: Linen is scratchy and horrible. We're already over Christianity and we have cabbages.

British Empire: Come now, chum, there's got to be *something* you want from here.

China: Just the gold, thanks.

British Empire: Best I can do is supply the people of China with opium. You're gonna need shiploads of this stuff.

China: No, I think we'd rather—

British Empire: Got suppliers at the port already. Thank me later.

China: Hard no. I've banned opium and started an anti-drug campaign.

British Empire: Positively despotic! Time to call up other freedom-loving nations to stand for liberty in China.

China: Sorry, you've got to be joking.

France and USA: We're here to save China for Liberty, huzzah! Don't worry, we brought the opium with us.

And that is a complete and unabridged history of the Opium Wars.

This map of the British Empire from 1886 hung on schoolroom walls, inspiring many young Brits to romanticize empire. Less rosy maps depicted Britannia as a boa constrictor, preying upon the whole world.

The Western world was delighted when Chinese ports were forced open; the Chinese, not so much. Their handicrafts quickly lost value in the flood of European imports and hefty new land taxes laid farmers low. Christian missionaries flocked to test their mettle in China. But hey, at least they had scratchy new linen tunics to wear?

The Qing Empire had absorbed many different peoples and the coming of the West shifted everything again. At the time, the Hakka people were just one of many cultural groups being pushed to the breaking point. In the hills of southeastern China they went into the mines by the thousands, holding up the dream of education as their escape route.

Hong Xuanjiao

It all started with a catastrophic failure. Hong Xiuquan had spent his entire life studying, preparing for the exam that would be his ticket out of the mines. It was the renowned government exam to select the best and brightest bureaucrats. All you had to do was memorize every book ever written and correctly answer questions like, "what is the fifth word on the eightieth page of this book?" Easy.

Because she was a girl, his sister Hong Xuanjiao had grown up bolstering his study and supporting his work. Her family finally sent big brother off to the exam in 1850, pinned with all their hopes. When he returned home a failure, he took to his bed—like, forever.

Hong Xuanjiao rifled through his bag, curiously examining evidence of the wider world that he'd been able to see. Hakka women were not nearly as cloistered as other Chinese women—her feet had never been bound, too much work to do! Still, her world was smaller than her brother's. She found among his things a scroll by Liang Fa, China's first Protestant Christian evangelist. Someone must have handed it to her brother as he passed into the city. It was saying something about a god named Jesus and the last being first and the coming of a Heavenly Kingdom. This was the kind of idea that could turn the whole world upside down.

And in the hands of the Hong Siblings, it did, because when they and their massive army were done fighting, they had created a new kingdom of thirty million people based on Liang Fa's scroll (the New Testament plus bonus content). Their Taiping Heavenly Kingdom promised gender equality, shared prosperity, civility and morality:

Proclamation on the Original Principle for the Enlightenment of the Age

All men in the world are brothers and all women in the world are sisters. Why, then, do we permit self-interest to set up boundaries among us? Why do we tolerate the idea that there must be a division of the people into the rulers and the ruled?

Aha! Thank you, Hong siblings, Liberty is finally going to enlighten the people, isn't it? No wonder folks joined by the hundreds of thousands.

WOULD YOU HAVE JOINED? CHECK THE ELEMENTS OF TAIPING HEAVENLY LIFE YOU'D BE PLEASED TO EMBRACE:

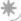 No foot binding of women. If you've joined us bound, unbind yourself and get to work!

Everyone works hard toward the creation of the Heavenly Kingdom of Great Peace.

Men and women are completely equal.

Needlework is nice, but women should be taught useful skills such as fighting, heavy lifting, farming, etc.

Education is extremely important and everyone gets to learn.

All our wealth and possessions are divided equally, without malice.

No more nuclear families. We'll live in gender-segregated units of twenty-five and select our own group leaders.

For previously married couples, a short weekly chat is allowable.

Focus on spiritual things, not your body. Adultery and fornication are punishable by death. Sex between spouses is frowned upon. Maybe once we've set up our dream kingdom, husbands and wives will be allowed to live together again.

Hong Xiuquan is Jesus's younger brother, by the way.

What do you think, are you in?

If you were a fighter, you would have joined hundreds of thousands in the initial military campaign to take Nanjing, throw off the Qing and build the Heavenly Kingdom of Great Peace. You might fall under the command of Hong Xuanjiao herself, who was in charge of the female ranks (the Qing called them "barbarian women with big feet"). Xuanjiao was an uncommonly feisty mastermind, as well as a skilled warrior who fought with a sword in each hand. The campaign worked as well as it did because of her.

But Xuanjiao seems to have chafed under the thumb of her Jesus-brother brother. Some of his prophetic revelations actually just singled her out for reprimand: she was too arrogant and failed to accept that God made her a woman. Hang on, but I thought . . . gender equality and all? And, wait a second, did Jesus-brother just confer the title of "King" onto his five favorite dudes? Sigh. Another enlightenment movement bites the dust.

It didn't really end in dust, though—more like an ocean of human blood. After thirteen years of not-so-Great Peace for the Heavenly Kingdom, things really started to fall apart. Some say it was because they still hadn't allowed anybody to have sex, but there were plenty of other taxing puritanical elements and hypocrisies. In any case, the Qing Emperor, given the failure of his own army, put out a desperate call to regional militias to attack the Heavenly Kingdom of Great Peace. The armies answered.

It was the bloodiest civil war in the history of the world. Brutal massacres on an incredible scale stretched into the 1870s. It's hard to set a final death toll (and it depends if you count deaths by starvation and battlefield disease), but *at the very least twenty million* died. Other estimates are as high as *a hundred million*. Nanjing, the Heavenly Capital City, fell in 1864 and Hong Xuanjiao was never seen or heard from again. Was her body lost among the millions that littered the streets? Or did she escape, change her name and live on, to watch the Qing Emperor frantically cast his eyes around for someone to blame for . . . for everything—for China's whole Century of Humiliation?

Japan Tries a Different Tack

Japan had been watching China with fascination and horror—and, more importantly, taking notes. Anyone who resisted Western imperialism appeared doomed to cataclysmic failure, so Japan took a different tack: if you can't beat 'em, join 'em.

It worked shockingly well. The whole phenomenon launched what's now called "The Japanese Miracle." Japan westernized faster than anyone could have imagined, while retaining a few cultural elements deemed to be Japancore, such as kimonos and Shintoism. It not only prevented invasion, but got Japan a seat at the table of invaders. *What's that you say? An alliance of nations is being summoned to force China to accept opium ships? We're in!*

But to Nakano Takeko, it all came at much too high a cost. Japan, she said, was losing its soul.

Nakano Takeko

It's one of the recurring themes in human history (and probably actually hard-wired into our brains) that Ye Olden Times were the best times. When things get hard, we look to the past, not the future; we talk about getting back to Tradition, we wax nostalgic about the Good Old Days, our lost Eden. But of course the delightfully ironic reality is that Tradition, when you zoom out far enough, turns out to be some past time's rapid change.

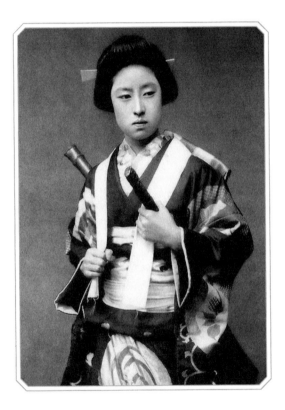

An unnamed actress playing the role of Nakano Takeko in the 1870s.

Nakano Takeko, her sister Yuko and the army of female samurai they trained, were wholeheartedly Team Tradition. They were prepared to fight and die for the soul of Japan—the good old, samurai-dominated soul of Japan. And in the end, they did.

Samurai had controlled Japan since the 1100s, in a feudal-style system that basically gave samurai families unlimited power and legal immunity. You were born samurai—you couldn't attain or choose it—and you lived by the *bushido* warrior code that, by the 1800s, was held up as Tradition with a capital T.

BUSHIDO IDEOLOGY IS MAKING A COMEBACK TODAY. IS IT FOR YOU?

- Master martial arts (daily training from the moment you can hold a sword)
- Master an art form of your choice (to temper the martial-ness)
- Live simply—own only your armor; eat mostly rice
- Train your psyche not to fear death
- Cultivate a peaceful mind through meditation, so you will be wise
- Loyalty above all else

If the samurai really *did* live by that code, we'd put them in charge of everything, too. But by the 1800s Japan was looking down the barrels of cannons strapped to the decks of American steamships belching black smoke on the horizon and demanding change. And samurai families were sitting on a long history of *not* living up to the *bushido* ideal. The Japanese emperor hired consultants from the West, who told him he was going to have to drastically alter the whole Japanese martial system if the nation were to survive imperialist threats. Katanas, they said, were a thing of the past: one gatling gun could do the work of fifty samurai. People were going to have to leave the rice fields and go into factories; railroads and canals needed to be built yesterday. Cities must introduce things like police and courts. The whole medieval social structure had to go. In other words, the samurai were obsolete.

So it surprised no one when a clan of samurai hunkered down at Aizu Castle to plan a rebellion to save the soul of Japan (a soul which, weirdly,

coincided with their own power and status). Loyalty above all, yes—but not when an emperor was changing things. The emperor sent his shiny new westernized army to rout them. What *was* a surprise, though, was that the army of samurai who burst screaming from the castle were all women. Nakano Takeko led the spectacular attack, her warriors armed with their traditional weapon of choice: the naginata.

All the men in the westernized army hesitated. As the terrifying women advanced with the grace and prowess of Michelle Yeoh, the soldiers glanced down at their muskets. The dude with the gatling gun took his hand hesitantly off the crank. They're all women, so killing them would be bad, right?

The patriarchy's moral hesitation bought the women enough time to reach within striking distance. Nakano slashed through six men before the soldiers decided it was actually perfectly acceptable to fight. She was shot directly in the chest. As she fell, her sister ran to her side.

"Don't let them take my head as a prize!" she said with her final breath—which, admittedly, was a quaint thing to fear; westernized armies generally frowned on the whole head-trophy thing. But Yuko was taking no risks. She cut off her sister's head and ran with it, in humiliating retreat to the sanctuary of nearby Hokai-ji Temple. There, Yuko buried Nakano's head under a pine tree, where a plaque still memorializes the last stand of the samurai.

The Taira clan had made an equally heroic stand in the name of Tradition back in the 1100s. They had been fighting *against* the looming new world of samurai control. Nakano Takeko would surely have been raised on their story, in the then-five-hundred-year-old epic *The Tale of the Heike*. Its opening phrase still echoes down through the ages:

The sound of the Gion Shōja bells echoes the impermanence of all things; the color of the sāla flowers reveals the truth that the prosperous must decline. The proud do not endure, they are like a dream on a spring night; the mighty fall at last, they are as dust before the wind.

The only constant is change.

Queen Min

Korea, sandwiched there between Japan, Russia and China, faced the same predicament. Since the rise of the Qing Empire, they'd been a vassal state to China, but what with the state of things during China's Century of Humiliation, a lot of folks were looking elsewhere for inspiration. It was a no-win situation, because with China, Russia and Japan staring you down, you couldn't make friends with one without angering the other. And what do we do when faced with a no-win situation? Allow women to take charge, then blame them when it all falls apart!

It's Tawosret all over again, but this time, it's the most powerful woman in Korean history: Queen Min.

When she was selected to marry the king, it was because she was a nobody from nowhere, with no family ties that would threaten the power of her looming father-in-law. He hand-selected a demure little waif who would do what she was told. Imagine his anger when she turned out to be a brilliant little powerhouse. Let's put it this way: your in-laws got nothin' on hers. Unless, of course, your in-laws also: murdered your infant son, sent a spy/consort to your husband's bed so he wouldn't talk to you anymore and then staged a coup leading to your very grisly demise. It wasn't just a personal feud—it was a political feud that engulfed the whole peninsula. Like Japan and China, Korea was fighting over the future of its own identity.

Here's how it all went down.

YOU'RE KOREA IN THE NINETEENTH CENTURY. WHAT WOULD YOU DO?

- Hold tight to the Qing, the best bodyguard you've got
- Westernize like Japan, quick as you can
- Ask Russia for help, hoping they won't just take over

Queen Min tried to choose all of the above. That's a no-win situation.

Korea had long been a vassal state to the Qing Empire (remember back in the Middle Ages when the Chinese emperor didn't approve of Queen Seondeok?). But watching China implode in almost every possible way over the course of the 1800s, Koreans were wide-eyed with alarm. At the same time, looking east, they had front row seats as America's famous Black Ships rolled up to Japanese ports and demanded entry. It was only a matter of time until the West came for Korea too.

The first surprise was Japan. In 1874, they arrived at Korean ports with their very own Black Ships, demanding the ports open. It was a spectacular turn of events, given that it had only been twenty years since America did the same to Japan. Koreans, including Queen Min, had spent those decades generally mocking the Japanese for donning Western culture. With a wry smile, the Japanese forced a treaty, granting them access to Korean waters, special trading status and legal immunity for all Japanese citizens in Korea.

Empress Myeongseong, known in her lifetime as Queen Min, was wife to Gojong, King of Joseon (Empress was a title given posthumously). As per custom in Joseon society, "Min" was the name of her clan; she never had a personal name.

Queen Min stared wildly at her husband the king: *why on Earth did you sign that?* She could see the writing on the wall. So she sent a dispatch to the Qing, requesting assistance to oust the Japanese. Qing ships rolled up, trumpeting victory and liberty for Korea. Oh and also, claiming the remaining Korean ports for China. Queen Min acted fast, requesting advisors for a rapid Westernizing of the Korean army. Trying to keep everyone happy, she summoned German *and Chinese* advisors. She sent emissaries to the United States on a "fact-finding mission" to scout out possible ways forward for Korea.

But the old guard of the military weren't pleased with the new advisors and the rapid change (hadn't the samurai just taken a heroic stand against change in Japan?). Lo and behold, there was Queen Min's father-in-law, circulating among the ranks and feeding a festering rebellion. When they rose up, they named father-in-law emperor and he promised to return everything to Ye Olden Days. The old guard set about massacring everyone and everything that had even a whiff of the West or Japan about them. Father-in-law was also sure to include Queen Min's relatives, allies, friends and infant son among the casualties.

Then thousands of peasants rose up, crushed by poverty and the destruction around them. As they closed in on Seoul, their rallying cry was "drive out the Japanese dwarfs and the Western barbarians!" Min sent another desperate dispatch to the Qing, who showed up with an army and ousted the old man, shipping him off to Beijing to stand trial. But Japan, too, sent troops, to stand up to China's "aggression." The peasant rebels rallied for liberty from foreigners; Japan rallied for Korea's liberty from China. China rallied for Korea's liberty from Japan. The showdown would happen on Korean soil.

The Sino-Japanese War was a spectacular display of the effectiveness of Japan's transformation. Though China sent 630,000 troops, Japan easily wiped them out with 240,000 Westernized soldiers. The Treaty of Shimonoseki, where China agreed to pay Japan 200 million silver taels (about £6 billion or $8 billion) in reparations, would alter Asia's fate through the twentieth century. China ceded the Liaodong Peninsula, Taiwan and the Penghu Islands to Japan.

But what would happen to Korea? Queen Min was already frantically sending dispatches to Russia, the United States, Britain, *anyone* who could help. Japan looked around. Will no one rid us of this meddlesome Queen? Oh, wait . . . does anyone know where her old father-in-law ended up?

He was all too happy to help. On October 8, 1895, fifty Japanese and Korean assassins breached the palace in Seoul. Leaving her husband untouched, the assassins headed straight for the Queen's chamber, dragging Queen Min and a few of her attendants out. With untethered violence and hatred, they slashed

them with swords before raping them, then displayed their bodies to Russian dignitaries (who had been Queen Min's strongest allies and greatest hope). Finally, their bodies were dragged into the woods and set alight.

As news of the ghastly murder spread across the world, a general outcry forced Japan to stage show trials to bring the murderers to justice. Even though the troop of assassins literally posed for a photograph together, none were convicted but for a few low-ranking fall guys. For his part Min's husband, the hapless king, searched the woods and found a finger bone, which he gave an elaborate funeral, including giant wooden horses to transport Queen Min to the afterlife.

By 1910, Japan had won its showdown with Russia and formally annexed Korea. Twentieth-century Asia had drastically changed trajectory.

Speaking of drastic trajectory changes, we haven't forgotten that we promised to return to Abyssinia. The story makes for a spectacular conclusion to the nineteenth century. Remember how, of all the nations in Africa, Abyssinia emerged uncolonized? Much of the credit goes to Etege Taytu Batul.

Etege Taytu Batul

When it came to marriage, the fifth time was the charm for Taytu Betul. Menelik, ruler of the region of Shewa, was finally Mr. Right and for one simple reason: he listened to her advice. By doing so, he managed to catapult himself to Emperor of Abyssinia. She officially became "Etege Taytu Batul, Light of Abyssinia." He never made a decision without asking her first and she always kept one eye on the wider African continent. Those Europeans were clever. The "White Man's Burden" package was hard to resist: Christianity had long ago come to Abyssinia, so that was nothing special, but *would you look at those engineering marvels*! Bridges could cross long-impassable rivers, roads and canals could make deserts bloom; schools could be built; diseases could be eliminated.

But reviewing the saga of colonization on the African continent, Taytu Batul said to herself, why don't I just do all that myself? No White Man need Burden himself.

First, she said, we've got to build a modern city that everyone will feel proud of and Europeans will see we're not messing around. So she established a new capital and named it Addis Ababa (nailed it). She built a new church to make

clear God was on their side (Etoto Maryam Church still stands). And when she needed more deacons, priests, clerks and bureaucrats, she gathered up all the homeless orphans and set them on an education fast track.

Empress Taytu Batul, on the cover of *Le Petit Journal*, Paris, March 1896.

Europe was impressed and confused. *Wait, these people seem modern already? Also they're Christian, so are we obliged to leave them alone?* Italy kept sending diplomats, merchants and priests to check Abyssinia's pulse. Eventually, the Italians presented a Treaty of Friendship: *simply a token of goodwill and free trade, nothing to see here.* Emperor Menelik was like, cool. Just let me have my wife take a look.

Awkward silence, while she steps away to have a read.

But the wait wasn't long, because soon she exploded out of her room, pointing to Article 17 and shouting. The translated version makes Abyssinia an Italian protectorate! She tore it up.

Italy's chief negotiator Count Antonelli played the only card he had. He famously sneered, "Menelik is playing games on me by giving up his regal authority to a woman."

Taytu Batul replied, "My womanliness and your manliness are going to be tested on the battlefield. Do not absent yourself!"

The Battle of Adwa, 1896, promised to be the final showdown: the last independent nation in Africa would finally fall—it was inevitable, right?

But Taytu Betul had noted the hard-earned lessons from other fallen nations and she knew exactly what they needed: gatling guns. She looked around. Where could they find someone with Western weapons, who could be persuaded to share? Her eyes fell on Russia.

Why Russia? It's an interesting story. *Cue flashback music*

Meanwhile in Russia . . .

A hundred years before, in a fascinating collision of worlds, Peter the Great, Tsar of Russia, had found his passion in science, discovery and imperialism. He actually hired Dorothea, Maria Sibylla Merian's daughter, to come to Russia and set up fabulous new scientific exhibits. He bought Maria Sibylla Merian's notebooks, so they could be displayed in his new museum. Russia was going to win this whole global Risk game!

Russia became an empire, conquering the whole of Siberia with many a brutal showdown. Tartars and Mongols, the Baltic and the Caucasus all fell. By now, Christianity had split and split again, so that Europe was divided between Protestantism, Roman Catholicism, Greek Orthodox and Russian Orthodox variations. The rivalry was fierce and often bloody.

So when Abyssinia's emissaries rolled up at the Kremlin and said, "those awful Italian Catholics want to claim Abyssinia," Russia was having none of it: clearly Abyssinia should remain free and independent. Or at least not Italian, God forbid. Catholics? Unthinkable. But should *Russia* ever absorb Abyssinia and bring the one true Church with it, surely that would be a boon and a blessing, right?

The emissaries were like, "Just give us the guns and we'll talk later." They got the guns.

Back to the Battle of Adwa, 1896

So we return to Adwa, where Taytu Batul's army had gatling guns and Italy had no idea. The Italian army set up in nice tidy lines on the battlefield. They had their gatling guns and their cavalry and barrels of red wine. Back

off: those are for the victory celebration! If you're thirsty, go get a drink of water.

What do you mean there's no water?

That was Taytu Batul's second stroke of genius: she made sure that the entire Italian army had exactly zero sources of potable water. Then she and her well-hydrated army of five thousand, including a hundred women, rolled up on the battlefield, Russian guns in a row. The victory was decisive. And on a Sunday to boot, so she had clearly won over God by building that Etoto Maryam Church.

So colonial Africa's final showdown ended with a perfect twist. Italy retreated in humiliation; Abyssinia celebrated its hard-won independence. The Battle of Adwa would stick in the craw of every Italian military leader for decades—so much so, that when the Fascists took over in the 1930s, their first order of business was to go back to Abyssinia to Set Things Straight. By then, another empress, Menen, was at the helm. *Bring it on*, she smiled calmly: "I shall do it as the august Empress Taytu did in her time."

But let's not get ahead of ourselves.

The twin forces of Liberty and Industry had completely changed the rules of the global game of Risk. Liberty could be championed by everyone, it seemed, with results as varied as humanity itself.

But how did the United States of America fare, given that their revolution was the first domino?

Global American Saga

BY HOOK OR BY CROOK, THE WHOLE WORLD PILES INTO AMERICA

What would it have been like to live in the Sweet Land of Liberty in the 1800s? Well, first and foremost you would have a global experience like no humans ever before. Dreamers and desperados piled in—outcasts and outlaws, snake oil salesmen and slaves. From all over the world, some people moved mountains to get to America—while others got swallowed up by it, despite desperate resistance.

If you could walk the streets of any major hub in nineteenth-century America—from New York to San Francisco, Chicago to New Orleans—you would hear languages from all over the world; you would smell wafting in the air the cuisines of a hundred places; you would see people from every walk of life, from old money millionaires to the most desperate poor. Nineteenth-century America was a spectacle, an unprecedented phenomenon, a spring zephyr where the wildest dreams could take flight and a caustic pit where dreams died. It was a microcosm of the world at large. *Liberty,* yes! But what kind and at what price?

Manifest That Destiny, America!

Thomas Jefferson knew a screaming deal when he saw one: Napoleon wanted to unload France's giant North American colony for a song. And just like that, the Land of Liberty doubled in size. "Congratulations, Indigenous people living in the lands-formerly-known-as-French-territory," said America, "You're all Americans now—*you've been saved!*"

Of course, Indigenous peoples in that area were emphatically not saved. The French approach to colonization had been Native-oriented: for one thing, all Native Americans were automatically given citizen status and the French in America had generally adopted Indigenous ways. The British colonists next door had done the opposite. It's no mystery why Native Americans had sided with the French anytime they went up against the British.

In any case, all that was now the past. Each Indigenous group now had to renegotiate terms with a brand-new nation—one that honestly looked so precarious, no one knew if it was going to last.

"You are lucky to be a part of this!" America said, "This land of Life, Liberty and the Pursuit of Happiness is going to change the world!"

"Cool cool cool," said the Cherokee, Shoshone, Sioux, Apache, Miami and a hundred other tribes. "Right, so we're just going to stay here where we've been for centuries and rock that Liberty beat."

"Yeah, about that," said America. "Could you maybe rock just as hard on this crappy piece of real estate we've set aside for you *over here*? See, we're feeling a new kind of destiny—a Manifest Destiny—where we bring Liberty to everyone from sea to shining sea."

"Oh, we're fully on board with the whole Liberty thing," was the reply. "We've actually been doing that for a while now and we can absolutely do it right here on our ancestral land."

"Don't take this the wrong way," said America, "but we're really only able for you to do Liberty stuff on pieces of land with *absolutely no value whatsoever.* Mmkay?"

Manifest Destiny was a GO! It rested on three core beliefs, which were:

1) The United States of America was a better, more virtuous, more enlightened nation than any that had ever existed and its people* were the best, most virtuous, most enlightened in history.
 *some exclusions apply (e.g., anyone who wasn't male, white, and/or Protestant)

2) The Mission (very much a capital M here) of the US was to "redeem and remake" the western three-quarters of the continent so that it looked and felt as much like the original thirteen colonies as possible.

3) It was the duty and the destiny of Americans to accomplish that Mission—assigned to them by God Himself.

Sometimes America could buy its destiny, like Jefferson did. Sometimes it involved outright war: the Mexican–American war ended in 1848 with the US seizing over half a million square miles of land from its neighbor. But mostly the Manifest Destiny strategy involved just staking out big chunks of land and confidently declaring it *Mine*. All of which is to say that a whole lot of people got swallowed up by America, even though they were very much Not Interested.

Cherokee America Rogers

American cinema has painted many a tale of Manifest Destiny and the myriad responses from Native Americans across the continent. The "Greedy Exploiter goes up against Noble Savage" trope is so well-established these days

it's almost reached mythic status. But zoom in on any Native American life during the nineteenth century and you get stories as varied as the land itself. The gloriously named Cherokee America Rogers, for example, embodies the opposite of almost every stereotype.

Her family history is familiar enough: gold was discovered on Cherokee lands in 1828, so the Indian Removal Act of 1830 quickly forged a path for getting Native Americans out of the US Government's way. Her people were infamously forced to walk the Trail of Tears—when the US Army "relocated" over sixty thousand members of the Cherokee, Muscogee, Seminole, Chickasaw and Choctaw nations from their lands in the southeastern United States.

Thousands died of starvation, exposure, exhaustion and disease on a horrific 5,000-mile forced march to a new Cherokee Territory—a desolate stretch of land in modern-day Oklahoma—which the government was confident nobody would ever miss. *Pfft, what do you mean the Ponca, Otoe and Missouri nations are already living there?*

When the Cherokee finally arrived in their new "home," things must have looked pretty bleak. Dumped unceremoniously into a totally unfamiliar environment requiring entirely different agriculture, with almost no resources and no outside support, Cherokee America and her family got to work: building beautiful and functional communities, establishing schools and learning how to farm this new and unpromising terrain. The Cherokee also launched a newspaper and began reestablishing their own traditionally democratic form of government.

Cherokee America Rogers became an extremely prosperous homesteader. Aunt Check (as she was known, much to her irritation), was a tiny, imperious matriarch who ruled her family—and her massive potato farm—with a firm but generous hand. Employing large numbers of farmhands and members of the wider community, she raised her own eight children as well as taking in orphans of the Civil War.

And though her story might feel like "anachronistic feminist spin," she was not at all unusual in her own community. The Cherokee Nation are a matriarchal and matrilineal society and strong independent women are the norm, not the exception. In fact, nineteenth-century Cherokee women were more educated and more "liberated" than any of the European American women around them—they owned property, participated in government and operated on equal footing with men. In the words of renowned Cherokee author Margaret Verble, "they were smart, they were literate, and they were used to power." But they could not hold back the tide of immigration.

An Across-the-Plains Immigration Tale: Chasing Opportunity

In the established saga of America, there is no more familiar character than the hardy pioneer, crossing the plains in a covered wagon, fording rushing rivers, hunting buffalo and dying of dysentery along the way. An entire generation of Americans (read: us) was raised on the Oregon Trail game back when computer games were a brand-new thing. We all know full well the high-stakes drama and heartbreak inherent in a trek across the plains.

So who was bold enough to try it and why? Desperation was probably the number one driver, but also a fair few were pulled along by their adventure-seeking souls. There was one famous pod of travelers who were actively trying to get as far away from America as possible: Mormons. Though their origins lay in upstate New York, their radical practice of polygamy meant communities hounded them from place to place, until their prophet Brigham Young finally decided to just GTFO.

No matter that most of them had no money: where oxen were absent, handcarts would do! With one epic journey across the plains and into the part of Mexico sometimes called Utah Territory, they could liberate themselves forever to worship however they pleased. Many of the Mormons had already made the arduous journey from Europe, through the ports of New York or New Orleans—a familiar enough American tale. Mormon converts came mostly from Scandinavia and Britain and they joined the Mormons in Ohio or Illinois. Now they were going further still.

Mary Peterson

Mary Peterson was just a kid when she made the crossing to America from Denmark, then crossed the plains to Utah. Once there, her Mormon cohort spread out across the Wasatch Range of the Rocky Mountains, carving out settlements by order of Brigham Young, who turned out to be an HR mastermind (yes, he of the twenty wives). But in 1848, dash it all, America defeated Mexico and the Mormons found themselves in the US again. Still, they were quite remote, almost a religious enclave, and could easily continue their eccentric practices like polygamy and having a Prophet-Governor.

Then came the railroad.

The dream was a railroad that stretched from coast to coast, uniting the continent so that a journey which once took six months could be shortened to six days. The building of the transcontinental railroad gained legendary status even as it was happening. The saga was the stuff of dreams.

Brigham Young saw in it both a threat and an opportunity. It would undoubtedly bring the worldly world to Utah. But also, it was hiring. He sent men by the hundreds to work (they sent their paychecks back to him) and also a couple of ladies, because cooks were in short supply.

That's how twelve-year-old Mary Peterson came to join Jack Casement's notorious crew on the Union Pacific line. She went as cook's assistant to her widowed mother, who was employed as cook. Jack Casement's crew was dubbed "Hell on Wheels" and that was not in any way an exaggeration. If we zoom in on this crew we see blood, sweat and tears, booze and violence, hope and despair, low wages and high stakes. And we see Mary, working dawn to dusk in the kitchen car, cooking hundreds of meals a day for the wildest crew in America.

Mary and her mother cooked everything in one giant pot. The stove was on a separate railroad car at the very end of the line, where they worked, ate and slept. A reporter from the *New York Post* once visited Hell on Wheels and described their whole setup:

> *It is half past five and time for the hands to be waked up. This is done by ringing a bell on the sleeping car until everyone turns out and by giving the fellows under the car a smart kick and by pelting the fellows in the tents on the top with bits of clay. In a very few minutes, they are all out stretching and yawning.*
>
> *Another bell and they crowd in for breakfast. The table is lighted by hanging lamps, for it is yet hardly daylight. At intervals of about a yard are wooden buckets for coffee, great plates of bread and platters of meat. There is no ceremony. Every man dips his cup into the buckets of coffee and sticks his own fork into whatever is nearest him.*
>
> *If a man has got enough and is through, he quietly puts one foot on the middle of the table and steps across.*

The craziest part? Mary and her mother were only allowed to eat the leftovers.

The inhabitants of Hell on Wheels were mainly Irish immigrants and African Americans, many of whom were former slaves. They all worked twelve-hour days, six days a week. But by the time Mary joined the team, they were working around the clock. The Union Pacific was locked in a spectacular

competition with the Central Pacific: they were racing to Ogden, Utah—where, by order of President Ulysses S. Grant himself, the two lines would finally meet.

The Central Pacific had its own immigrant saga. Those workers, 90 percent Chinese, had come to America for the gold rush, but quickly discovered that white miners were not going to allow them on site. So they took the only job that they could get, at the railroad. In the race to Ogden, it was the Central Pacific that would break the record for most track laid in a single day (10 miles), putting the Union Pacific to shame.

When the much-anticipated moment came for the lines to join together at Promontory Summit, they actually wired a telegraph line to the tracks, so the world could hear the driving on the final spike. Mary and her mother were there, but not as part of the festivities. They were cooking full-out, to provide a vast amount of food for the feast.

With the driving of the final golden spike, the impossible had been achieved. Newspapers hailed the completion of "one of the greatest engineering works that has ever been accomplished." And then it was over—quite literally, the end of the line. Thousands of railroad workers were sent on their way.

Mary Peterson poses for the newspapers at the Fiftieth
Anniversary Celebration of the Golden Spike, 1919.

For Mary and her mother, who returned to their little settlement, the arduous handcart journey they had taken west was now a thing of the past. But the world had also come to their theocratic enclave and nothing would be the same again. In the coming decades, women came to work for the railroad in increasing capacities. Eventually, they called them Women of Iron. Also, Mormons gave up polygamy and got a governor who wasn't the prophet.

The Transcontinental Railroad is a saga of America's disenfranchised. On the sweeping stage of an entire continent, individuals seized their moment. It seems like everyone involved were the underdogs: Native Americans being pushed off of their land by the unstoppable engine of progress; Irish immigrants driven reluctantly to America by famine at home; former slaves leaving behind the brutality of the postwar South; Chinese immigrants who left a war-torn country in search of gold; and Mormons, whose religious extremism was so unpopular that they had to move to the middle of nowhere.

These were the misfits who metaphorically and literally brought America together. The ceremony at Promontory signified unity in 1869—unity that came at a steep cost. And that story is as relevant as ever.

A Gulf of Mexico Immigration Tale: Captive

African immigrants rarely sailed willingly to the New World, but sail they did, by the millions. Ending up in North America would have been an unusual twist of fate for any captive African. Around 5 million Africans were taken to Brazil, for example, and another 4.5 million were taken to the Caribbean, while maybe 500,000 went to the United States. To study the transatlantic slave trade is to dig around in the depths of what it means to be human. You can see economic forces at play, and powerful cultural beliefs about race, gender and religion; you can see hatred and heroism; you can see Dahomey warriors and individual ship captains and bewigged politicians passing grand sweeping laws. But what would it have actually been like to *live* it? Redoshi's story is an almost universal tale of slavery and yet (as with every person's story, when you zoom in close enough) very unusual indeed.

Redoshi

Redoshi was just coming of age among the Yoruba in West Africa when Dahomey warriors raided her village. The famously ferocious female warriors often called "Dahomey Amazons" raided almost every year during the dry season, capturing people to sell to slave traders on the west coast. It was 1859 or so and the Atlantic slave trade was dying, since transporting slaves had long been outlawed in Europe and the Americas. Now only Cuba continued to purchase slaves on the African coast. But if the odd schooner from the United States or Brazil rolled up, the cash-strapped Dahomey would be pleased to fill their ships with human cargo and send them on their way.

That's how twelve-year-old Redoshi found herself packed onto the *Clotilda* with over a hundred others, bound for Mobile, Alabama. The first thing the slavers did was shave the heads of every captive. To prevent lice, they said—but hair was the key cultural identifier among west Africans. It signified status, gender, cultural identity, everything—so off it went. The captives were also stripped of their clothing then laid flat onto large wooden slats in the ship's hold. As the ship left the African coast, booming sounds and terrifying waves rocked the boat (perhaps a British patrol ship attempted to stop the *Clotilda* as it made its getaway?).

Redoshi and everyone else on board had never heard or felt the ocean before. The endless rocking, the chafing of wooden slats on naked skin and the eternal darkness of the hold was so terrifying they could only conclude that the ruler of the sea was angry. Day and night were the same, time stopped and the *thirst* was worst of all.

Then, an eternity later, the ship's crew came into the hold and led the captives up on deck. Redoshi's legs had atrophied; like everyone else, at first she couldn't walk. The light of the sun was almost blinding, the fresh sea air was incredible and most sublime of all was the endless sea. They were sailing beyond any imagined horizon.

On one hand, the crew of the *Clotilda* were less monstrous than the slave traders of the eighteenth century. For the remainder of the voyage (once safely at sea where no patrols would spot them), Redoshi and her fellows were allowed to walk on the deck. They were fed well and there was no rape, abuse, nor rampant disease on board. On the other hand, the crew was a deviant band of Alabama businessmen whose main goal was to give the finger to a fifty-year-old American law banning the transportation of slaves.

After weeks of sailing, one of the crew members showed them all a green branch: they were nearing land. Redoshi and her fellows were crammed back into the hold as the *Clotilda*, disguised as a common coaster, passed two more slave patrols without suspicion. They swung wide into Mobile Bay, where a tugboat met the schooner and towed it up the Mobile River. Down in the hold, the captives heard a terrifying low rumble and panic spread—what could it be but a massive swarm of bees?

Then the rumbling stopped and under cover of darkness, Redoshi took her first steps on American soil. No swarm of bees, but maddening swarms of mosquitoes, and the captives were forced to set up tents in grassy thickets on the bayou, moving camp every night. Was this what they had been captured for? Weren't they meant to be sold? And why did the crew of the *Clotilda* set the ship alight and then sink her?

Redoshi, the only female survivor of slavery to appear on film and interviews, in a US government film highlighting rural life in the 1930s.

Then one day a man ferried into their isolated bayou. Redoshi and the captives were forced to stand in two lines to be inspected. The man stared at them like cattle, peering at their teeth and pinching their skin. He pointed to Redoshi and to an older captive man, Yawith—not Yoruba, he had never been able to communicate with the rest—and, just like that, they were purchased as a "married" couple and taken to a plantation in Dallas County, Alabama. The separation from the others was wrenching.

But five years later, in what must have felt like an incredible twist, the end of the American Civil War meant every slave was free. Redoshi was just seventeen. She and Yawith stayed together, had a daughter and settled in as sharecroppers. Other *Clotilda* survivors gathered into a Yoruba community dubbed Africatown, but Redoshi and Yawith never joined. Among the *Clotilda* survivors there was, at least at first, chatter about returning to Africa, but none could ever amass the funds for the journey.

By the 1930s, when Redoshi was an old woman, Ellis Island was being hailed as an important symbolic gateway for immigrant America. But for African Americans, there was no such space to memorialize their ancestors' devastating immigration journeys. People started to remember old rumors about a ship—it had been a clandestine journey, the last slave ship to arrive in the United States, and it had been sunk somewhere in Mobile Bay. The search for the *Clotilda* began.

The more people searched for the ship and its story, the more mysterious the story became. *Did* a band of Alabama rednecks really sail all the way to Africa in a schooner? Why would they take the treacherous trip across the Atlantic when the slave markets of Cuba were so much closer? Are we too quick to believe that those men were even capable of such a feat? Is it really credible that they sold their cargo from makeshift tents in a secret, mosquito-ridden swamp? And why would they have burned the valuable ship, when they could have just repainted it and carried on?

In the late 1920s, a young Zora Neale Hurston had spent months interviewing survivors, including Redoshi, intending to publish the story—but she suddenly pivoted and hid away her manuscript. The *Montgomery Advertiser* interviewed Redoshi, too, and printed a fantastical account of "a dark supple princess of the African Congo [who had] lived peacefully with her husband in the heart of the dark continent." The US Government even filmed her for a promotional video that aimed to convince African Americans to stay in rural areas. On the one hand, her stories were heart-wrenchingly authentic. On the other hand, the stories of all the survivors contradicted each other. Everyone from the *Clotilda* told strikingly different tales in almost every detail. How do you know who to believe when no single narrative matches any other? Everything about the story was up for debate.

Then, in 2019, the Alabama Historical Commission announced that the wreck of the *Clotilda,* burned and scuttled, had been found and identified without a doubt, in the muddy banks of the Mobile River.

What will we do with it now? Make it a National Monument, or bury it forever?

A West Coast Immigration Tale: Sold

Immigrants from all over the world steamed into California ports. When immigration officials met the ships, they were required to place everyone, from all over the world, into three official categories, as determined by Congress: European, Asian, or Chinese.

Hang on, you've come from South Africa, Brazil, or Mongolia? Madagascar, Haiti, New Zealand? You are now European or Asian, take your pick—but trust us, in America in the late 1800s, you don't want to be Chinese.

Chinese people were very explicitly not welcome in America. After labor unions felt threatened by the Chinese railroad laborers (yes, those workers who laid a miraculous 10 miles of track in a single day), they lobbied Congress to restrict Chinese immigration. In 1882, the American Dream officially excluded the Chinese, by the Chinese Exclusion Act. Immigration was halted, citizenship and property ownership were off the table. Chinese men already in America were banned from testifying in courts against white people and from marrying white women. And so, in hindsight, you might see all the elements in place for the emergence of a powerful human trafficking ring that smuggled Chinese women to America.

So, just as human trafficking was declining on the Atlantic, it was beginning to boom on the Pacific. Untold numbers of girls sailed from China to California because they had been sold by their own families. It was a common enough story: parents enduring the political chaos of the Century of Humiliation decided to send their daughters to America. Of course, the trafficked girls were not, as some parents chose to believe, destined for dreamy wealthy husbands in the New World. They were, almost inevitably, destined for San Francisco brothels.

Liang May Seen

Liang May Seen was fourteen when her parents in Guangdong, China sold her to an agent, who took her to a ship. She sailed for weeks across the world's largest and deepest ocean until the sound of a fog bell heralded her arrival in America. As the San Francisco immigration official met her ship, she would have been forced to pose as a wealthy man's niece or daughter, a "paper daughter," to exploit an immigration loophole. Then,

straight to a brothel in the San Francisco underworld for a life of sexual slavery.

But Liang was a resilient soul and she plotted her escape. She would never be able to save enough money to buy herself a ticket out of town, but where could a Chinese girl possibly go anyway, to start a new life alone? And she couldn't just quit the brothel: the trafficking ring was a powerful mafia. She needed a safe harbor, she needed food, she needed an impossible way forward. Then, when she was eighteen, she discovered the Presbyterian Mission Home, operated by Christian women to help enslaved Chinese women escape. The Mission offered safety and security with a side helping of Jesus the Saviour. Women who escaped to the Mission were expected to convert and to spend their days learning wholesome middle-class-lady skills. Liang dove in head first. She converted wholeheartedly and spent three years learning English, maths, Cantonese and all the requisite lady skills.

But what did the future look like for a Presbyterian Chinese woman in the Victorian Era? The Cult of Domesticity was at its peak and all things domestic equated to all things woman. It was marriage (to a man who wouldn't mind her past) or working at the Mission forever—those were the only two respectable ways forward.

The Mission informed Liang that a Chinese man from Minnesota was looking for a wife. He was Presbyterian, he'd come for the gold rush but traveled east once he witnessed the prejudice and racial violence in California. He'd become a central figure among Chinese immigrants in Minnesota and had opened the state's first Chinese restaurant. When she agreed, he came to San Francisco and the Mission hosted their wedding in 1892. Off to Minnesota!

Liang and her husband Woo Yee Sing opened business after business adjacent to the Presbyterian Church in Minneapolis. Liang opened her own emporium, *Yuen Faung Low*, "Exotic Fragrance from Afar." Did she ever ponder her fascinating twist of destiny? Once sold as chattel herself, she spent the rest of her years bringing beautiful things from China to add to the global tapestry of American life.

She never had any children. But while returning to San Francisco for a visit in 1906 (the year of the infamous earthquake), she adopted a little boy, Howard, whose own twist of fate meant he came of age in 1920s Minneapolis. Over the decades, as more Chinese migrated to Minnesota, Liang founded a Presbyterian women's organization to help the new members find their feet.

Liang May Seen poses joyfully with her adopted son, Howard Woo, 1910.

So often it is through food and through beautiful objects that people come to accept and even love foreign cultures. In Minnesota, Liang and her husband Woo's heritage became an asset and an opportunity. They stood as representatives of what it means to be Chinese. They chose what to cook, what to import, what to promote and what to leave out. In a way, they were curating their own heritage, while at the same time forging a new path that had never been dreamed before.

A Canadian Immigration Tale: The Spirit Moves

In the 1800s, what was the difference between Canada and the United States? There was that whole War of 1812 which was about . . . what was it about, again? Anyway, it's what inspired Francis Scott Key's poem that would become the national anthem of the United States and that's what matters. Canada and America had, up to that point, identified as relatively friendly neighbors and many immigrants from Britain and Ireland started out in Canada and eventually migrated south. Why? Did America have better food, lower taxes,

no pesky king? It seems like what it offered was more opportunity—if for no other reason than it had more real estate that wasn't literally frozen in ice.

But when John and Margaret Fox migrated their family to upstate New York, they could never *ever* have predicted the outcome: that their daughters would launch a uniquely American religion that would take the world by storm.

The Fox Sisters

The family had scarcely moved into their new home when the noises started. Loud cracking, persistent knocking that seemed to have no source, uncanny sounds seemed to follow fourteen-year-old Maggie and eleven-year-old Kate everywhere. It was enough to fray a parent's nerves to the bone. So Margaret was already near breaking point when, in March 1848, the girls called from their bedroom, "Uh, Mom? There's a ghost up here!" Charging upstairs with a visiting neighbor in tow, Margaret was treated to a remarkable demonstration of a ghost answering questions by rapping on the bedroom floorboards.

Who was he? The ghost of a murdered peddler. Why was he here? His murderer had buried his life savings somewhere under the house.

From that point, as they say, things escalated quickly. The next thing the girls knew, the farm had been sold and they were shipped off to their older sister's house in Rochester for safety. Unfortunately (and perhaps, given the circumstances, unsurprisingly), the supernatural phenomena followed them and soon the spectre was giving nightly performances for increasingly large, and increasingly enthralled, audiences.

Oldest daughter Leah Fox Fish, by all accounts rather more sophisticated than the rest of the family, was the first to rumble her sisters' secret. Under direct interrogation, and in the privacy of their own bedroom, the girls soon came clean about the tricks of their eerie new trade. Maggie revealed that she had a knack for cracking her toes inside her shoes, creating a noise so loud it could be heard several rooms away. Kate's part of the scam was rather more prosaic—an apple on a string under her long skirts made those ominous thumping floorboards (literally) child's play. Mature, respectable Leah immediately put an end to her baby sisters' games, revealing the truth to their parents and the world.

Just kidding! Leah wanted in on the act too, and quickly established herself as a talented medium who could "channel" the dead. Interested visitors could

now experience all these uncanny attractions at nightly Fox Sisters séances—admission one dollar—but it wasn't until influential Quaker abolitionists Isaac and Amy Post got involved that things really took off.

Lithograph from a daguerreotype of the Fox Sisters at the start of their long career, 1852. Left to right: Maggie, Kate and Leah.

After a particularly spectacular séance in which Leah convincingly channeled the Posts' recently deceased daughter, alongside the usual toe-cracking, apple-thumping fireworks, the Posts were convinced the sisters had a true "gift." Booking the largest hall in Rochester, the Posts formally launched the Fox Sisters into the public eye. And the world would never be the same.

In another time and place, the Fox sisters' performance may have created only a momentary sensation. But in the hotbed of religious and scientific innovation that was mid-nineteenth-century America, their claims sparked a

movement that spread like wildfire . . . and Spiritualism was born. Victorian sensibility teetered on a brink between two worlds—old and new, superstition and science, religion and "rationalism"—and Spiritualism offered believers a perfect blend of both. *Death is not the end,* it promised, *and your loved ones live on. Heck, you can even ring them up (through your nearest Spiritualist Medium) for the low, low price of a dollar a chat!*

Once the world got a taste of what Spiritualism had to offer, there was no looking back. By the 1880s it was the fastest growing religion in the world. By 1897, one out of ten Americans claimed Spiritualism as their primary religion. And the appeal was hardly limited to the United States—believers around the globe were "turning tables" at séances, flocking to the faith's tantalizing promises of a loving, benevolent God, a peaceful, sociable afterlife and a "thinning of the veil." Millions dove wholeheartedly into the promise of a future where death might lose its sting.

Spiritualism offered another revolutionary blessing to women in particular: a brand-new career path. Possibly because of the Fox sisters' pioneering examples, the vast majority of professional mediums were women. This granted the enterprising woman a level of independence, social power and financial autonomy almost unheard-of in the nineteenth-century Western world.

As for the girls who'd launched it all, they seemed to be getting tired of the circus they'd accidentally started. Kate and Maggie began backpedaling almost immediately—but Leah was unwilling to return to her humdrum life and made sure her younger sisters understood that *the show must go on.*

The show must also *get bigger.* Spiritualist believers demanded physical evidence of the spirit world and the Fox sisters gave it to them. Kate became especially adept at producing visible ghosts which wafted their way through her séances, swathed in what was described as "psychic light." She also became proficient at channeling two spirits at once—with one dead person speaking through her voice while another used her hand to write out their message.

Perhaps unexpectedly (perhaps not), the Spiritualist movement was particularly popular among the scientifically minded; an unusual percentage of followers sported a "Doctor" in front of their name. And the patronage of celebrity believers like wildly popular author (and Doctor) Arthur Conan Doyle, abolitionist William Lloyd Garrison and even First Lady Mary Todd Lincoln certainly helped raise the movement's prestige.

On the other side of the scale were the most famed critics of Spiritualism— the magicians. Celebrated illusionists such as Harry Houdini and the "Queen of Magic" herself, Adelaide Herrmann, were adamant that Spiritualist mediums were preying on the vulnerable. *These kinds of tricks make wonderful*

entertainment, Adelaide argued—*but tricking grieving people into believing they're talking to their departed loved ones is the most despicable kind of fraud.* So Adelaide set out to debunk the worst of the Spiritualist offenders. Sneaking into séances incognito, she would discover and then reveal the secrets of famous mediums' most impressive illusions.

Some séance tricks were quite straightforward—ploys of the most basic, *apple on a string* variety—but others were much more elaborate. That "ectoplasm" emanating from a celebrated medium's mouth during her "spirit communications"? Plain old cheesecloth, swallowed preshow, then vomited back up again *right on cue.* Those eerie blue flames that encircled—but never consumed—a medium's hands each time she spoke to the dead? Just good old freshman-level chemistry at work.

But despite critics' attempts to derail Spiritualism's popularity, public demand continued to grow. And with six hundred and twenty thousand souls fallen in the American Civil War, compounded by the *normal, everyday death toll* of life in nineteenth-century America, the zeal of those looking for communion with the dead was reaching a fever pitch.

Maggie Fox, meanwhile, was becoming increasingly unhappy with life under her sister's thumb—especially after her engagement to the renowned Arctic explorer Elisha Kane was thwarted by his horrified family. And when public opinion turned against her little sister Kate, who was being trashed in the press as a drunk who was unfit to care for her own daughters, Maggie finally cracked. In 1888, she gave a blockbuster speech in New York revealing all the tricks of her trade and publicly outing herself, her sisters and Spiritualism itself as nothing more than a fraud.

But the movement had long since outgrown its makers and nothing could stop it now. Devoted believers merely shrugged their shoulders, insisting that evil spirits had forced Maggie to say those terrible things—and the Spiritualist tide rolled on.

And so did American Imperialism.

A Polynesian Annex Tale

Say you lived on the most remote archipelago in the world, smack in the middle of the Pacific Ocean. Probably the unfolding Manifest Destiny of the United States of America was not something you'd be pondering during your morning swim, right? But the annexation of Hawaii is one of the more surprising twists of modern history and it was basically a miniature version of

Britain's takeover of India, where businessmen roped their government into seizing land.

American businessmen, bogusly claiming support from the US military, overthrew the Queen Lili'uokalani of Hawaii and held her supporters hostage. In exchange for the lives of her supporters, Queen Lili'uokalani agreed to abdicate and the Americans swiftly set up the provisional government of the Republic of Hawaii. Almost immediately, they launched programs to eliminate Native culture and control. The future of Hawaii looked bleak and unknowable.

But that April 1895, a baby girl was born. She was delivered by her grandmother, the wise matriarch of her tribe. And when her grandmother saw her, she knew. "This one is special," she said, "she will be our *Puna Hele*, our *Source Moving Forward*. Those men might try to erase us, but we will save it all, inside her."

Mary Kawena Pukui

It's a rare person who is handed their destiny at the moment of their birth—a life's work so momentous it's hard to imagine where you could even begin. And it's a rarer person still who sees it all through. Mary Kawena Pukui, more than any other individual, saved Hawaiian language and culture from annihilation.

Her childhood was basically the perfect movie montage: raised by her grandmother, intentionally in isolation from the rest of the children, she spent her days absorbing all the old ways, from foraging to fishing, hula dances to medicines. Hawaiian culture had for millennia been an oral culture—nothing was written down, but instead told and retold, danced and sung. Kawena learned too from her grandmother that she was descended from Pele, the goddess of the volcano.

When she was nine, Kawena's grandmother died, leaving her to fulfill her destiny alone. She returned to live with her parents and to further come to terms with her biracial identity. Her mother was Native; her father was Scottish American. A proud descendent of Anne Bradstreet (famed poet of seventeenth-century colonial America), her father gifted her a book of Bradstreet's poetry, telling her that this powerful female voice was also a part of her heritage. Because Kawena was immersed in both worlds English and Hawaiian, she was especially able to translate them.

And so, for the rest of her life, Kawena traveled across the Hawaiian Islands, gathering all the cultural traditions, proverbs, dances, even words—and wrote

it all down. Her magnum opus was a Hawaiian–English dictionary, recording the nuances of the oral language with painstaking accuracy and scholarship. Imagine, being one of the pioneering scribes who decide *how to write down a language* for the first time—the ones who decide what gets recorded and how words are defined!

Mary Kawena Pukui. In addition to writing seminal texts in Hawaiian language and culture, Pukui was a hula expert and composed more than 150 songs.

As she grew older, it became clear that Hawaiian was a dying language, spoken only by the elders who remembered it from The Before Times. Many bureaucrats and potential financiers questioned the value of spending so much time and energy recording a "dead language." But Kawena faced a lot of pushback from Hawaiians, too, who resented her for opening up the Hawaiian language to any who wanted to learn. She shared too much, they said, printing it for the masses.

But that's how the Hawaiian language and so much Hawaiian culture survived. Mary Kawena Pukui, the Puna Hele, Hawaii's source moving forward, answered a call that required her whole life and her whole heart. Carrying an ancient language and culture on her shoulders, she kept traveling, listening and recording. The best part is, she lived to see the Hawaiian cultural renaissance begin in the 1970s, when the islands bloomed anew with a deep interest in the past. It could not have happened without her. Few of us could hope to achieve as much.

A Tale of the American Dream Gone Wild West

At the same time Mary Kawena Pukui was born to her Hawaiian destiny, another was becoming manifest in the mountain wilds of Colorado. The gold rush of 1849 had altered the American West in many ways, but produced remarkably little gold. Fifty years later, the Cripple Creek Gold Rush of 1891 prompted a revival of all the Wild West tropes, but with one important difference: it *actually produced gold*. Lots and lots of gold. Three hundred thousand pounds of gold in the first twenty years alone. Twenty-three millionaires would be made in Cripple Creek, not to mention all the folks making a fortune off the miners rather than the mines—the blacksmiths, the grocers, the madams. And, in Cripple Creek, one madam stands head and shoulders above the rest—in fame, in ingenuity and in marketing savvy (not literally, though—she was reportedly pretty short).

Pearl DeVere

Exactly how Eliza Martin, respectable middle-class daughter of Evansville, Indiana, became Pearl DeVere, the most renowned madam in Colorado history, remains a mystery. But the red-headed stunner who stepped off the train in 1892 was unmistakably *a woman with a plan*. Within months, Pearl's new parlor house was up and running, but this was not just *any* parlor house. A handful of these "upscale" brothels—the type where customers could enjoy a game of cards and a hot meal alongside the house's other attractions—were already doing brisk business in the city's bustling red-light district. But, standing there on the train platform, surveying this rough-and-tumble boomtown full of new-money mining millionaires, Pearl announced, *I know what this place needs: French wine and Russian caviar!*

And she was right.

In a town brimming with brothels—from the seedy one-room "cribs" of the aptly named Poverty Gulch to the glittering, high-end houses at the posh end of Myers Avenue—Pearl was determined to create the grandest parlor house of them all. She furnished her new business venture with crystal chandeliers, the finest linens, a famous cook, and of course the most exquisite women wearing the latest Parisian gowns. Her "Old Homestead" aspired to rival any high-end "gentlemen's establishment" on either coast and it succeeded spectacularly.

Pearl's parlor house soon became such a hot commodity, she was literally turning men away at the door.

Actually, she was turning them away *before* they got to the door, because one did not simply *arrive* at the Old Homestead. There was a rigorous application process.

Hoping to visit Pearl's famed parlor house? First, you'll need to supply:

1. A formal letter of application

2. Bank statements verifying that you are *at least* a millionaire

3. Letters of introduction from several highly reputable references, declaring knowledge of you as a man of integrity who will comport himself accordingly

After submitting your completed application, you will be notified by mail whether your petition has been successful.

But be warned: this wasn't some sham formality. Getting into Pearl's was tougher than getting into Yale: *just* being a millionaire wasn't enough. Only *true gentlemen* were allowed, thankyouverymuch—the scruffy success stories of the gold fields were *persona non grata* at Pearl's.

Pearl DeVere (or possibly one her "girls") from the Old Homestead House Museum, Cripple Creek, Colorado.

This wildly audacious strategy would cement Pearl's status as an entrepreneurial prodigy, because she'd quietly turned her brothel into the best business networking venue in the nation. Hammering out your next corporate coup over Pearl's card tables meant knowing your potential new business partner had already been thoroughly vetted. In fact, Pearl's stamp of approval became such a badge of honor that men who would never venture within a thousand miles of Colorado were filling out applications *just to see if they could get in.*

Pearl believed in spreading the wealth—each of her "girls" made $250 a night. For comparison, a Cripple Creek miner making $3 a day would have considered himself very well-rewarded. And, by the way, that $250 did not include the food, drink or musical entertainment available in Pearl's downstairs parlor, or any of the other extras on offer, such as Pearl's titillating and unique innovation, the Viewing Room, where patrons could watch through a window while the girls undressed. (For a much larger fee, a customer could even watch one of the girls bathing, in a mirrored bath.)

Who knows what might have been if Pearl's domination of the world's oldest industry had been allowed to continue. But her reign came to an abrupt end in the summer of 1897, when she suddenly and mysteriously died of an apparent morphine overdose. Whether it was an accident or (the more credible explanation among Pearl's girls at the time) a deliberate murder by person or persons unknown, Pearl was gone and the whole community was heartbroken. In the most extravagant funeral ever seen in Cripple Creek, four mounted police led hundreds of mourners and a forty-piece brass band up the hill to the cemetery to lay her to rest.

Pearl had been the real-life embodiment of the classic Madam with a Heart of Gold: the one who personally funded everything from soup kitchens for the down-and-out, to train fares for young widows desperate to get back to their family homes, to buying nifty new uniforms for local Little League baseball teams. But perhaps there was a reason such a character became a recurring motif? The truth is, so many wild west madams *really did* run their towns' ad-hoc "social services" in exactly this way. What does it all mean? Maybe beloved and notorious Madams like Pearl DeVere exposed the rotten underbelly of the American Dream—"soiled doves" who everybody knew could expose the darkest truths about the Big Men who Ran the World. Or it could have been the opposite—the Pearl DeVeres of the world were proof that even women at the bottom of the pile could build an empire, using the only building blocks allowed them by their sexist, patriarchal world.

A Tale of the American Dream Gone So Fantastically Right

In the Land of Liberty, destinies manifested with such spectacular variety that we can find real-life examples of every Hero's Journey and every descent into the nine circles of Hell. Mark Twain called the late 1800s the Gilded Age, meaning that all was golden gleam on the outside, but rotten underneath. It was the era of electricity and psychology, record players, expeditions, photographs, automobiles, steel, refrigeration, flushing toilets And it was the buzzing hub of America that kept cranking out innovation after stunning innovation. What a time to be alive! But nothing in the Gilded Age is what it seems, they said: the Land of Liberty might actually be the Land of Crushing Captivity; the Land of Dreams might be the Land of Despair. How far *could* you go, with a dream and some willpower and that American flair for the dramatic? One woman's most unusual American Dream encapsulates the Gilded Age like no other.

Her dream was made possible by one of those Gilded Age inventions: the bicycle. People went mad for it all over the world. Susan B. Anthony famously quipped, "the bicycle has done more to emancipate women than anything else in the world." For Annie Cohen, it was certainly true.

In 1895, she circumnavigated the globe with a bicycle.

With a bicycle.

Annie Londonderry

Nothing is quite as it seems with Annie (Cohen) Londonderry. This lady could spin an utterly fabulous yarn and in the wild Land of Opportunity, she used it to her spectacular advantage.

An Orthodox Jewish immigrant from Latvia, Annie Cohen settled in Boston with her (arranged marriage) husband and had three children before the age of twenty-three. It was then that she admitted to herself that, despite living during peak Victorian Cult of Domesticity when all things woman and all things home were melded together, she was not domestic. She did not enjoy homemaking; she yearned for a life of adventure. She found a job selling advertising for a local newspaper and honed her ability to sell a good story, while at the same time discovering all the wild human schemes going on across America. She dove in head first.

There'd been a gentlemen's wager, she said: a debate about women's equality and whether women were capable of heroic feats. They'd challenge a woman to ride around the world on a bicycle and bet on the outcome. Annie was, she said, selected as the contestant. By the terms of the mystery wager, she had to cycle around the world in fifteen months or fewer, had to earn five thousand dollars en route and could accept no charity. In a grand send-off by the press, she became Annie Londonderry, naming herself after the bicycle company who gifted the bike for the journey. It was catchy, it was artful and it obscured the fact that she was Jewish. She had never ridden a bicycle before hopping on the shiny new bike at the send-off, but she went "flying like a kite down Beacon Street," and the adventure was on.

The probable *actual* route of Annie Londonderry as she circumnavigated the globe with a bike, June 27, 1894–September 12, 1895.

The fantastical episodes of her journey were covered by newspapers all over the world. She herself telegraphed the press ahead of arriving at each destination, posing as her own publicist. Giving exuberant public speeches at every opportunity (in France, her strategy was to just keep shouting, "Vive la France!"), she was discovering that a woman could create her own destiny and she was limited only by her own imagination.

Annie Londonderry became so larger than life that newspapers couldn't resist. "I found out what they liked," she said, "and I gave them plenty of it." Annie was reported at various times to be a wealthy heiress, a Harvard medical student, a lawyer, a tragic orphan, an accountant, a newspaper tycoon and a prisoner of war. She claimed to be fluent in many global languages, but that the terms of the wager forced her to speak only English. She boldly agreed to stage races against prominent men's cycle clubs—and somehow, they always got canceled at the last minute. She sold advertising space on her own body— ten cents to pin an ad on her arm, twenty cents for a leg—and became a human billboard on wheels.

In India, Annie described hunting Bengal tigers from the back of an elephant, with a Raja as her tutor. She fended off "gentle Asiatic natives" who wanted to stick knives into her tires. "She wore her bicycle around her neck like an opera scarf when not riding it," the papers said, "and kept her hand close to her gun."

When she reached east Asia, Annie was caught up in the Sino-Japanese war: at the same time that she was circumnavigating the globe, Queen Min was facing her bloody downfall in Korea. Annie Londonderry cycled to the war front, she said, where she was captured and thrown into a Japanese prison. Without food for three days in the bitter cold, a fellow prisoner in her cell died. A Japanese soldier dragged a Chinese prisoner up to her cell and killed him before her very eyes, drinking his blood while the muscles were still quivering. Miraculously escaping the jail, she then, for unknown reasons, cycled up to Siberia and saw chain-gang prisoners working in the mines.

None of it was true. She traveled around the world, yes—but the reality was, she'd gotten on a steamship in Marseilles and didn't get off again for any significant period of time until she steamed into the port of San Francisco. She did cycle for long stretches eastward from California and even had a brush with the mob in Texas. When she rolled into Chicago, the finish line of the journey, she had a broken arm and seemed to be "far from well as she claimed to be." There was no press event, no crowd in celebration—probably because Chicago newspapers became wise to the reality of her story.

But the *New York World* saw that beneath Annie Londonderry's facade lay her actual genius. She was a performer, a storyteller, a spectacular one-woman circus. They offered her a job. She returned to her husband and family, working as one of many "girl stunt reporters" of the Gilded Age.

So, no, Annie Londonderry was not, in fact the first woman to cycle round the world. But that, as Annie would be the first to point out, is an almost irrelevant detail. Annie Londonderry proved a much deeper truth: clever

thinking, courage and a wild imagination was all this poor immigrant woman needed to undertake a fantastical round-the-world quest. In a matter of months, Annie Londonderry went from misery and total anonymity to global sensation with a thrilling new career. And she did it without money, education, example, or guide.

With Liberty, anything is possible—not even reality can hold us back.

How will the American experiment in Liberty turn out? It's an open question of course, and it's happening now—live—as we look back on our past and try to figure out how we got here. It could be that America survived its revolution by kicking its civil war down the road, rather than having it out right away. Or perhaps America's enemies were far enough away that burning hatred had time to simmer down. Maybe America already had the infrastructure in place that other revolutionaries were forced to build from scratch. It could be none of those things—or all of them.

Maybe the global migration to America is what in the end saved it—that everyone piling in, by hook or crook, from every corner of the world and seeking every kind of dream, created a historical phenomenon humanity never saw before or since. New American citizens who had come from all over the world pledged allegiance to "one nation indivisible, with liberty and justice for all." (God hadn't been inserted into the pledge yet.) It was a dream we could all agree on, aim for, and hope one day to achieve.

Sticking It to The Man

DOWN WITH THE MAN! . . . IF YOU COULD
JUST POINT HIM OUT FOR ME?

The first decade of the twentieth century would have been an amazing time to be alive. Newspapers were overflowing with great feats of exploration, miracles of engineering, and life-changing new technologies. Prodigious musical performances could be recorded, and famous stage actresses could make a hundred appearances at once at the cinema. Humans were more connected than ever, and more aware of our glorious global diversity. Before a generation had concluded its hour upon the stage, The Man would be toppled from all kinds of surprising places.

Who is The Man, exactly? The Man wields the power and keeps the rest of us down. The Man is the establishment—He controls governments and enforces gender roles, and in the sage words of Jack Black, "The Man ruined the ozone, he's burning down the Amazon, and he kidnapped Shamu and put her in a chlorine tank!" The Man revels in economic exploitation. The Man is heartless and entrenched, The Man is the worst of human nature! *We must dismantle The Man if we are to have any hope for the future!* shouted changemakers across the early-twentieth-century world.

The world's people cheered *huzzah!* and shot their best death glare at The Man. And in hindsight, we can see that they were all staring down a different Man. The Man has many forms and wears many hats ("Ms. Mullins? She's The Man.") As soon as you tear down one, another one appears—or do you become The Man yourself? If you tear down enough The Mans, will the world finally be free?

The Great War That Really Was Not Great, Not Even a Little Bit

The people's awakening might have started with a war. Not a war like the British or Japanese empires—or any form of The Man—liked to present it: of Good vs. Evil, brimming with spotless uniforms and white horses and barbaric enemies and badges of heroism. Rather, a war that mechanized death, that pulled most of the world into its black hole of devastation. It was a war so heartbreakingly pointless that The Man's constructed reality crumbled under the scrutiny of the people.

When war was first declared in 1914, Europeans collectively cheered. They sent their brave young soldiers off with patriotic parades and clapped their hands with glee that the world would finally discover, once and for all, that We Are The Best. "We," of course, varied per the countries that initially declared war: Austria–Hungary, Serbia, Germany, Russia, France, Britain. Before long, Belgium, Japan and the Ottoman Empire were drawn in, and

the dominoes were off: Italy, Bulgaria, Portugal, Romania—then Greece, the United States, even China joined the fray. These nations had long histories of being imperial or imperial-adjacent. They'd fought over bits of Eastern Europe and Africa, they'd had standoffs in east Asia; now they would face each other directly. Because their empires stretched across the globe, the European spat quickly became a global war as their colonies (including India, Vietnam, Laos, Cambodia, Australia, New Zealand, Canada and almost all of Africa) were pulled into the black hole. The Boer Wars in South Africa had foreshadowed what happened when industrialized nations turned on each other, but The Man doesn't seem to have noticed or cared. *It will be over by Christmas,* everyone was saying in September 1914, *better get in and grab those badges of heroism before it's too late!*

Unless you're a woman, of course. Stand aside and let the boys through.

Maud Fitch

In the remote desert mining town of Eureka, Utah, Maud Fitch heard that the United States had finally joined The Great War and the government was calling for volunteers. Women were invited to serve as nurses, but that was not Maud's jam. She could, however, drive a truck, as well as repair it, thanks to a local chauffeur who took her under his wing. Surely this skill would be useful, since cars had only recently been invented? She proposed to join up as an ambulance driver on the western front.

A lady ambulance driver? Hardly! said the government. *Can you imagine the drain on our war budget, having ladies flitting about on the front?*

Maud Fitch and many others like her stared down The Man. Eventually, it was conceded that if women could:

A) purchase their own ambulance
B) ship said ambulance to France at their own expense
C) provide their own long-term supply of gas and oil, shipping it to France as well
D) pay the government a monthly fee for their room and board
E) work for free

—then they would be permitted to help.

Even after doing all that, more obstacles of paperwork and bureaucracy hampered Maud's progress, until she was finally able to sign on with a

French ambulance unit. Her letters home from her fourteen months of service comprise some of our best records of women's experiences in the Great War.

June 1918

Dearests,

We've moved about so that I had none of your dear longed-for letters for a week. Perhaps it's not a week, as I've less idea of time now than ever. I'll go back to June 9th now, as since then it's been fairly hectic, from a matter principally of lack of sleep and food. On that day at noon, I went on my 24 hour duty evacuating a hospital in front of the advancing Huns.

Got back the next day at two, having lunched and dined and breakfasted on bread and jam. Worked on my car until dinner, rushed in to wash at the first gong and at the second, just as I was about to sit at the table, three of us got rushed off again in our cars on an emergency call. I took the worst Blesses [wounded] I ever have had and ever hope to have again . . .

The Blesses got delirious and screamed and groaned and moaned until I thought I should lose my little remaining brain power. I had to go the whole distance in bottom gear [because of the bombed-out roads] and it took me five hours. And what was the worst of all, I found myself going to sleep at the wheel. Absolutely losing consciousness for whole seconds at a time, so that three times I had to get out and wash my face in the wet grass.

Then I had the most extraordinary hallucinations. Such as an immense hand that reached out from a passing car and I found myself lurching sideways so as not to hit its finger. Then another one, a man floated ahead of me, in a horizontal position, face down, so that this made me laugh and I got out again and washed my face.

Psychologically, I should like to know what was wrong with me that night. Could I really have been dreaming with my eyes open? As a climax, while I waited for about 50 camions

[military trucks] to pass me, one lurched out and caught my front wheel, and if the traffic man hadn't shouted at the top of his lungs, he would have dragged me over and goodbye Blesses.

A man with a pipe thing helped me straighten it enough to get on and I couldn't even thank him. I was so afraid my voice would tremble. And imagine, a driver in the war zone, near to tears. After getting on, I realized the accident was really heaven sent as it woke me up completely. Or I think something worse, and of my own doing, would have happened. I got in at 5.30, dumped the Blesses, and went to the hotel, where after pulling off my belt and tunic and shoes, I crawled into bed.

This was almost par for the course for Maud, who had previously persisted through incredible obstacles to get her "Blesses" to the hospital (things like: push her own ambulance out of a giant blood-filled pothole in complete darkness). But, for her daring rescue of the wounded under heavy fire that night, the French government awarded Maud the Croix de Guerre. Lady driver wins national medal for bravery—score one for progress.

The Great War didn't just prove that ladies were capable of daring physical feats. It proved, agonizingly slowly over the course of four years, that The Man didn't know more than the rest of us; that The Man, in fact, had led us all into an unending hellscape of his own creation: slippery trenches and barbed wire and mustard gas and flame-throwers. The Man had settled into a futile, brutal war where a few miles of French farmland were lost or gained at a cost of two men per centimeter. How many millions would be sacrificed at the feet of power? How many times would heroic ambulance drivers, doctors and nurses slide organs back in place and stitch skin grafts over melted faces—only for The Man to ship the soldier right back to the front?

Death and despair brought profound disillusionment in their wake and it could no longer be contained. Peace movements gained rapid momentum. The crew of a German U-boat refused to follow orders; the British and French feared large-scale mutiny. By 1918, people's revolutions had toppled four of the warring nations. The Man could finally see the writing on the wall and a ceasefire was arranged. *But let us retain decorum*, said The Man—*the war will end elegantly on 11/11 at 11:00, as if a curtain were merely closing on the play.*

No one won; Germany definitely lost. But at least, people said, we could distill from the horrors a deep and eternal truth: nothing like that should ever happen again. They dubbed it The War to End All Wars. And in hindsight, a fair few historians mark The Great War as the death knell of The Man. It's an interesting idea . . . let's explore.

Post-War Disillusionment

War + pandemic = disillusionment, it's one of the persistent patterns in history. (And if a pandemic is big enough, you don't even need a war.) So, thanks to a boost from a global flu pandemic, a radical new global youth culture began tearing down All Established Truths in 1919. It was called Dada and Avant Garde and Jazz and The Roaring Twenties and Prohibition and the Mad Decade and the Lost Generation and the Progressive Era and so much more. Collectively, the world's next generation essentially all agreed that *the only thing we can know for sure is: our parents were wrong.*

Amrita Sher-Gil

And when those young people become parents, then what?

Hungarian-Jewish opera singer Marie Antoinette Gottesmann and Sikh aristocrat and scholar Umrao Singh Sher-Gil Majithia were deep in Budapest's bohemian scene. When they had children, they were determined to give their daughters a life of wild freedom like they never had.

So little Amrita Sher-Gil was much less regulated, policed and controlled than most children of any sex, in either India or in Hungary. She wasn't just free to follow her artistic whims, she was actively encouraged to do so. By the time she was five, she was constantly scribbling on anything she could get her hands on—paper, furniture, the walls of the house—and by seven she was painting startlingly good portraits of friends and family members. In 1921, when Amrita was eight years old, her father's de facto political exile from his homeland was finally lifted and Umrao moved his young family back to his old stomping grounds at Summer Hill, a fancy British-colonial resort town in northern India. They brought their bohemian vibes with them.

Amrita continued to be Amrita in all her plucky, untameable glory. At nine years old she publicly declared that she was an atheist and got herself kicked out of her convent school. Unchastened and un-stifled, Amrita filled the extra time by continuing to paint everything in sight, often cajoling the household's servants into posing for her. But she wouldn't let anyone boss her art around— even art itself: "I detested the process of 'coloring in.' I always drew and painted everything myself, and resented correction or interference with my work."

Could there be a more apt symbol for the life of Amrita Sher-Gil, the little girl who quite literally *refuses to color inside the lines*? Ever supportive, her parents decided to find her an art teacher—a proper, serious one. Hey, wasn't there some famous British painter hanging around these parts? Maybe we should try and get him in?

And that's how renowned military portraitist (and one-time illustrator of wildly popular and only moderately scandalous tabloid pinup girls) Hal Bevan-Petman became Amrita Sher-Gil's painting instructor. He quickly recognized that he had an actual prodigy on his hands and within months he'd informed her parents that Amrita was too good for him. *She should really be studying at one of the top art schools in Europe*, he advised. Amrita was eleven years old.

So, in true Sher-Gil family style, Amrita's mother Marie promptly whisked her young daughter off to Florence and enrolled her in the acclaimed Santa Annunziata art school. (Marie's relationship with a handsome Italian sculptor who *just happened* to be returning home that year may have also contributed to that decision . . . who's to say?)

Amrita dove in, confident that this experience would be better than convent school. *This time will be different*, she told herself—after all, this was *art school*—and in sophisticated, cosmopolitan Florence no less! And it *was* quite different this time, because Amrita didn't even make it one term before being once again expelled. Her infraction this time (brace yourself, gentle reader), was *drawing nudes* during art class.

So back to India they go, where Amrita will carry on refining her skills, blissfully unconstrained by the *ridiculous prudery* of any teacher.

By age sixteen, Amrita's back in school again, this time at the illustrious École des Beaux-Arts—the most famous art school in Europe. And she is absolutely smashing it. Her work is making major waves and winning major prizes. She is soaking up Paris, possibly the world's hub for Post-Impressionism, Dada, Cubism and Avant-Garde movements that break all the rules. But Amrita's true arrival as a Really Officially Real Artist came in 1933, when her painting *Young Girls* won a gold medal at the Paris Grand Salon—the

most important art competition in the western world. The win was especially astonishing because nineteen-year-old Amrita was the youngest person—and only Asian—*ever* to be given that honor. She still is, actually.

She was a star of modern art. After five years in Paris (and a multitude of romantic relationships with both women and men, plus a couple of near-miss engagements), Amrita felt an "intense longing" for her home in India. She missed the landscape, the people and the art—but she also felt that she had learned all she could from European teachers. As she wrote to a friend, tongue only slightly in-cheek, "Europe belongs to Picasso, Matisse, Braque—India belongs only to me."

Amrita Sher-Gil in 1930 with three of her paintings.
Boris Taslitzky (left), and two self-portraits.

Traveling all over the subcontinent, Amrita launched herself into a comprehensive national tour of the country's art—and changed almost everything about her work. Though western critics were baffled, the Indian art world immediately understood they were witnessing something unprecedented—a bona fide Master sending all her favorite bits from centuries of classical Indian art hurtling directly into the twentieth century. As India's national identity was being roused to resist British control, Amrita's

self-appointed mission became to paint the soul of India. Like everything else in her life—her sexuality, her religion, her politics, her race—Amrita's art rejected all boundaries. Like so many others who joined the rule-shattering movements of the 1920s, that little girl who refused to color inside the lines grew up to fundamentally redraw them.

Russia Goes for the Jugular

The people of Russia toppled The Man in 1917. It was a revolution that, in hindsight, the Tsar might have seen coming a million miles away, but such is power. The whole nest of the powerful in Petrograd had already seen a revolution in 1905, which was dispersed after promises were made to improve the lives of the poorest. They were (surprise!) empty promises and, as years went by, it was clear that the Industrial Revolution was not coming to Russia in any way that would benefit starving serfs. Peasants ranked so low in the social system that they were only barely human. Over a decade, the message and the organizational power of a new party calling themselves Bolsheviks was impossible to ignore.

YOU'RE A RUSSIAN PEASANT c.1915. PICK YOUR POLITICS!

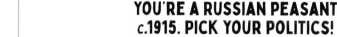 IMPERIAL RUSSIA

* Hey, at least you're not a serf anymore (abolished in 1861)

* You have your own plot of land (that the landlord chose, from his worst parts)

* Your parents bought that land with a mortgage from the landlord and payments keep rising

* To facilitate liberation of all serfs, the government provides reimbursement . . . to landlords

* Keep building that empire. *China, Korea, here we come!*

```
  ■ BOLSHEVIK VISION
  * Exit the Great War
  * Land for all peasants sans predatory loans
  * Employee-controlled factories
  * No more empire-building
  * Gender equality (class matters, not gender!)
  * Racial equality (class matters, not race!)
  * Launch the world into a fair and equal future
```

Maybe it was the conditions of early twentieth-century Russia that led revolutionaries to swing the pendulum in such a drastic new direction. The whole complex, swirling world of Russian empire, equality and social change comes alive in a young Tartar woman, who one day defied her parents and went to see the traveling theater.

Sahibjamal Gizzatullina

The largest Indigenous group conquered by Russia were the Kazan Tartars (Volga Tartars), whose thriving capital city was on the banks of the Volga river. With historical ties to both the Mongols and the Vikings, Kazan was a Sunni Muslim city replete with colorful onion-dome architecture. Sharia law had long steered the city and so its ladies were firmly enthroned/restricted in the domestic sphere. And also, its people had not seen (or even conceived of) the theater for centuries. Public spectacles of storytelling smacked of idolatry and were not approved.

But one fateful day in 1907, word spread through Kazan that the city's first theater troop (made up of a band of daring young men) was staging a performance. Twenty-two-year-old Sahibjamal Gizzatullina pulled a *Girls Just Want to Have Fun*, bravely defying her parents to go and see the production. In an instant, her future was laid out before her. After the

production, she marched straight up to the director and their conversation went like this:

Sahibjamal: "That was amazing, I loved every single second of it. But, you guys are really *so* bad at playing female characters. It shatters the illusion."

Director: "What can I do? Women aren't allowed to perform in public. I have what I have."

Sahibjamal: "I'm in! Problem solved."

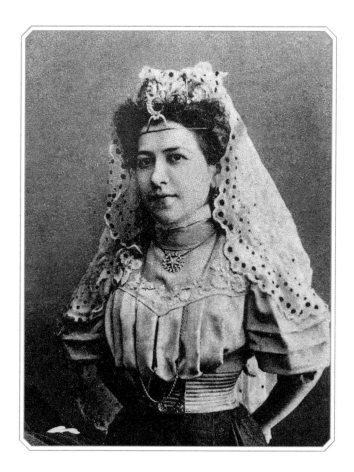

Sahibjamal Gizzatullina c.1910 at the start of her long career.

Sahibjamal Gizzatullina had just become a pioneering Tartar stage actress. It was not a successful, well-established organization she had joined. They had no budget, no home base, no stability whatsoever. And their challenge wasn't just to try to make money, but, in Islamic culture, to defend the existence of theater

itself. They were constantly harassed, booed off the stage, morally condemned. But as any theater geek knows, if the stage calls you, you just can't let it go.

After years of itinerant theater life that was as dramatic as anything on stage, Gizzatullina set out on her own. She started her own troop and called it *Nur*—light. Believing she could use the stage to shine a light on the future, she actively recruited young people, spotlighting their voices and their issues. That's when her theater troop finally found success.

And then it was 1917. Word arrived in Kazan that a revolution had toppled the Tsar and pulled Russia out of the Great War. The government was gone.

Having spent years dreaming up stories of possibility for the future, Gizzatullina seized the historical moment. What if we start a revolution, too, to free ourselves from Russia? What if we stage a play about an independent Tartarstan: the biggest play we've ever done, that shows not just an independent nation, but equal rights regardless of religion—or even gender? We could pour our heart and soul into it, invest every last penny we've got. We can join up with other theater troops. Heck, let's add a symphony. It will be the most powerful thing the people have ever seen!

The day arrived. Everything hung in the balance—it was the performance of their lives.

Their audience was like, *m'kay*, and went home.

The people of Tartarstan were not quite ready to fight for equal rights regardless of religion or gender. But over in Moscow, the revolutionary Bolsheviks, who were busy defending their control of Russia from . . . everyone, had been promoting very similar ideas. "We heard about your theater spectacular," they said to Gizzatullina, "and we are all about that message. Come work for us!"

So Sahibjamal Gizzatullina joined the Bolshevik movement and set up the party's Theatrical Brigade, whose job was messaging along the fronts where Bolsheviks were fighting. The Bolsheviks moved in with guns; Gizzatullina moved in with stories of class solidarity, racial and gender equality, and sticking it to The Man. Essentially, their message was that The Man has, for too long, kept us divided against each other by race, gender and religion. We got so distracted by those irrelevant dividers that we failed to notice that it was actually us, the people, vs. The Man. At the time, their practices regarding racial and gender equality were truly remarkable: Black Americans emigrated to Russia by the thousands and any feminist would have found it obvious to join the cause. By 1922 the Union of Soviet Socialist Republics was established.

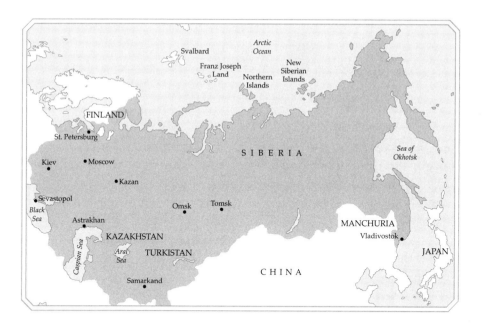

Russia had been enthusiastically conquering its
neighbors throughout the nineteenth century.

No one could see what they would become. With hindsight, *we* know what happened with Stalin. We know that the great experiment in equality turned into a tyranny, whereby thousands and then millions were murdered either in camps or by famine. We know that they decided that Jews did not figure into the equality and that intellectuals were the enemy. We know that Russia's long and rich cultural traditions were intentionally destroyed in the pursuit of a dream that could not be achieved without crucial industrial infrastructure which the Bolsheviks did not build. Sahib Gizzatullina, when she joined, could have anticipated exactly none of those things. But through all of it, she remained in charge of the Theatrical Brigade—sharing the party's message far and wide, until she died in the 1970s.

What a time to live through, to be a storyteller of the stage! Russia's revolution was one of the most dramatic in history in terms of political reimaginings. In the end, did the Bolsheviks just become The Man 2.0? Russia spent a century testing hard questions. What must The Man and the people do to finally be free?

Meanwhile, to the southeast, the Qing Empire and all its varied people were asking themselves the very same questions. Over there, at the time, The Man was, in fact, a woman.

Cixi

Few historical characters have been as vilified as Dowager Empress Cixi. The favorite bogeywoman of Chinese History, the infamous Dragon Lady of the Qing Dynasty is cast as the tyrannical, power-hungry conservative who brought the entire Qing Empire crashing down—when the opposite was (mostly) true. But let's start at the beginning, shall we?

In 1851, a sixteen-year-old girl joined the harem of the Qing Dynasty's eighth emperor, Xianfeng. Her name was not recorded. (Why would anyone care about the name of a sixth-ranked concubine?) She, like the young Wu Zhao a thousand years before her, entered the Imperial Court as not much more than a glorified maid.

But Emperor Xianfeng quickly became a fan of this clever, clear-thinking young woman and soon she was pretty much always at his side. Court officials were incredibly uncomfortable with this unseemly behavior: talking poetry and philosophy with her husband was one thing, advising him on crucial matters of state and openly participating in executive decision-making was quite another. But the emperor really liked her, so *shrug*, *what're you gonna do?*

But as the Second Opium War reached its bloody and probably inevitable final chapters, the emperor was spiraling into deepening depression and dementia. Wallowing in drugs and alcohol even more than usual (he was not known for his dedication to sobriety at the best of times), Xianfeng was falling apart and he knew it. In the summer of 1861, he summoned his most trusted officials and appointed eight "Regent Ministers" to run the country until his five-year-old son—Cixi's son—was old enough to assume power on his own.

Then he died. And then the two young Dowager Empresses, Cixi and Ci'an, pulled off a flawless (and nearly bloodless) coup d'état—the first in 500 years. In under a week and without a single shot fired, two twenty-five-year-old widows seized control of one of the most male-dominated regimes in human history.

And nobody really seemed to mind. So Ci'an and Cixi took over the day-to-day running of the kingdom together—while still banned from entering, or even looking at, the Hall of Supreme Harmony where Cixi's son sat enthroned. Outside of the harem quarters, the Forbidden City was still very much *no girls allowed*.

So how on Earth were the empresses meant to run things? Why, from the harem, of course! Seated side by side behind a yellow silk screen, with poor

bored little Prince Tongzhi on his tiny throne in front, the pair conducted all imperial business from the carefully guarded seclusion of the "woman's sphere." But Cixi definitely knew how to make her presence *felt* even when she couldn't be seen. Rumors quickly spread that she could "hear thoughts," and anyone attending an audience with the Dowagers knew he'd better arrive with a pure heart and an honest agenda.

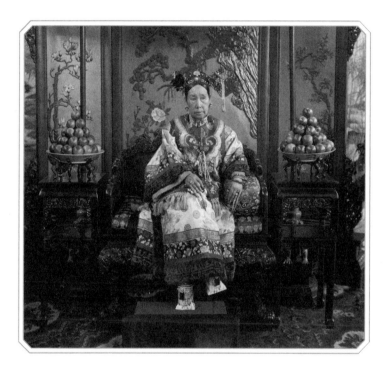

Cixi resplendent on her throne, wearing, among other glories, her famed gilded fingernail guards.

The Dowagers launched an ambitious program of reforms, successfully modernizing and streamlining the breathtakingly complex red-tape wringer that was the Qing bureaucracy. And in their free time, they also: created the first Foreign Ministry to deal with international relations, modernized industrial factories and armories, and reversed a century of tradition by installing Han Chinese officials in major roles which had always been reserved for Manchu elites.

But while Cixi was doing all that, her son was growing up. In the blink of an eye, Prince Tongzhi was teenaged, about to be married and itching to throw

off the yoke of his mother's domination. So in 1873, Tongzhi was *in* and the Dowagers were *out*. The Regency was dissolved, imperial power was once again in male hands and the women were back in the harem where they belonged.

But not for long.

Tongzhi was prone to sneaking out of the Palace to, er, "revel with eunuchs" at some of Beijing's more disreputable establishments. But his nighttime festivities were cut short when he consulted his doctors about a minor skin rash and . . . was diagnosed with smallpox. (Or was it syphilis? Who's to say.) Despite benefitting from every treatment available—poultices of healing herbs, earthworm tea, an altar to the Goddess of Blisters just outside his chambers—the eighteen-year-old emperor died a month later.

Aside from being an obvious personal tragedy for Cixi, this was also a political catastrophe. The emperor left no heir and his death set off a succession crisis that put the Dynasty in danger. It also left the Empresses Dowager at serious risk of being shooed off to some remote mountaintop convent to eliminate them from the political equation.

Not to worry—Cixi had a conveniently-too-young-to-rule nephew to adopt! And in very short order, four-year-old Guangxu was installed and Regency 2.0 commenced. *All of this is very normal and proper and fine,* cheered Cixi's supporters, *nothing to see here, folks!* And China heartily agreed.

But Guangxu, like his cousin before him, stubbornly insisted on growing up, and when he finally married in 1889, Cixi re-retired as Regent. (Spoiler alert: she'll be back, baby!) It was a hectic time to be in charge of China and by his twenty-fifth birthday the new emperor had already lost a war with Japan, been forced to concede large chunks of territory to Russia, Germany, France and Great Britain, and was now facing another looming catastrophe in the form of a powerful secret society known (we are absolutely thrilled to report) as the *Society of Righteous and Harmonious Fists.* English reporters, clearly lacking in both taste and creativity, promptly renamed them the Boxers.

The Boxers' agenda was nothing if not direct: *Foreigners get out!* Foreign influence was the cause of all China's problems, the Society proclaimed, so all foreign influence (and probably the foreigners themselves) must be eliminated *tout suite!*

The crisis peaked in June 1900, when Boxer forces swarmed into Beijing, determined to "exterminate the foreigners" once and for all. With around nine hundred foreigners and three thousand Chinese Christians crammed into the tiny Foreign Legation Quarter, the Boxers laid siege to the city. Recognizing this as the golden opportunity they'd been waiting for, a loose

alliance of foreign governments immediately sent a small international squadron into Beijing to liberate the prisoners.

Sorry, did we say "a small squadron"? We meant "a colossal army of fifty-two thousand soldiers." And by "liberate the hostages," we meant "establish a permanent international military presence in China after looting and pillaging for six to eleven months."

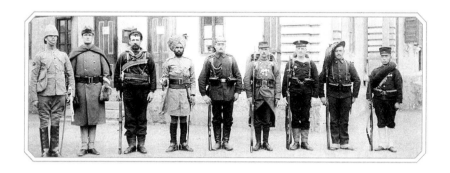

Soldiers representing the Eight-Nation Army, which invaded China to end the Boxer Rebellion. Left to right: Britain, United States, Australia, British Raj, Germany, France, Austria-Hungary, Italy, and Japan. Britain, Australia and the British Raj were all technically one nation (the British Empire). Russia, not pictured, was the eighth nation.

Until the invasion, Cixi had been unsure which side to back, but her kingdom being suddenly overrun by the Eight-Nation Army made up her mind rather decisively. Issuing a proclamation, she effectively declared war on every major western power at once. Determined to make a brave show of it, she refused to evacuate the palace until the international army was battering down the doors of the Forbidden City itself.

But wait, you say, *why is Cixi making these decisions when Guangxu is supposed to be in charge?* Excellent question. Until very recently, the accepted explanation was simply that Cixi was pretty much the "evil stepmother routine" on steroids. *This devious, power-hungry Dragon Lady had such an insatiable greed for power, she brazenly usurped her adopted son's throne, drowned his favorite concubine and then held him prisoner in his own palace for nearly ten years.*

It's a marvelous story. A few parts of it are even true! Cixi *absolutely did* seize imperial authority for herself. She *absolutely did* keep her son incarcerated under house arrest for the better part of a decade. And she *absolutely did* have his favorite concubine thrown down a well!

But the thing is, they totally deserved it.

Cixi had been hearing rumors of a plot between Guangxu and the Japanese for a while. But in 1898 she finally received undeniable evidence that her son was embroiled in a plot to essentially hand China over to the Japanese . . . and to assassinate his own mother. We know how that worked out in Korea.

What was a royal mum to do? If word got out that Guangxu had nearly sold out the kingdom, the Dynasty might never recover. And if the people ever learned that their emperor had conspired to kill his own mother?! The rupture would be cataclysmic. The principle of filial piety—respect for one's parents *no matter what*—was the very heart of Chinese society. So if Cixi wanted to save the country from her son, she could never let them know what she was saving them *from*.

Even if that meant taking the blame herself.

So here we are once more, back at that crucial moment in August, 1900. With foreign troops literally on the Palace doorstep, the royal family will have to skip town, leaving most of the members of their entourage behind.

But what is she to do with her son and his traitorous posse? Cixi knows it's going to be hard enough to keep Guangxu under control while they're on the run—she certainly won't be able to keep eyes on both him and his favorite lady. And she obviously can't leave this turncoat concubine behind to spill her insider-knowledge guts to the Europeans the moment they arrive. So what real options does she have?

With time running out and the invaders mere minutes away, Cixi has the concubine tossed down a well in the corner of her courtyard—then clambers into a mule cart to take the last remaining vestiges of the mighty Qing Dynasty on the road.

And while this particular crisis would eventually resolve, the threat of her son's treasonous and murderous intentions would not. For the rest of her life, Cixi would have to keep her son under house arrest, maintain an empire under constant threat of attack (from within and without), and maintain a public show of perfect normalcy and familial harmony. Meanwhile, her son's coconspirators are doing everything they can to convince the world Cixi is a tyrant and usurper . And, oh yeah, her son is still openly trying to kill her.

When Cixi died in 1908, the Qing Dynasty was all but over. Her traitorous son Guangxu had died under mysterious circumstances the previous day (recent forensic testing shows he'd almost certainly been poisoned with a massive dose of arsenic), and power passed into the hands of Cixi's chosen successor, Guangxu's two-year-old nephew Puyi. His reign would last until

the age of six, when he would be forced to abdicate, as the 1911 Revolution proclaimed China officially a Republic.

Like its neighbor Russia, the centuries-old Qing Empire was toppled. The Man was torn down and imperial palaces breached by the unwashed masses. Historians attribute all kinds of causes for the upheaval: physical, religious, psychological, economic. Especially when you zoom out on a global scale in the early twentieth century, it gets really interesting. Why did some empires fall while others didn't? Korea, China and Russia had all fallen . . . what about Japan?

Kanno Sugako

In the beginning, Kanno Sugako was a pacifist who wanted Japan to stop attacking other countries (as it had Korea, China and Russia in her childhood). She joined a Christian Temperance Union and campaigned to shut down Osaka's red-light district. She just wanted Japan to be Good Again.

When Kanno was fifteen, she had been sexually assaulted by a man working in her father's mining camp (according to one of her later lovers, the event was orchestrated by a quintessentially evil stepmother). Shamed by society and desperate to find a way forward, she'd happened upon an essay written by Sakai Toshihiko, a socialist, who argued that it wasn't women who should bear the burden of shame in such situations, but predatory men and the system that supports them. She sought out the author in Tokyo and joined his socialist cause.

Come 1908, her band of Socialists came together with various other groups in a Tokyo rally to celebrate the release of a political prisoner. The crowd sang songs of revolution and some waved red flags. The police ferociously attacked.

Kanno Sugako spent the next two months in prison and the brutality she endured changed her perspective on everything. The Man responds only to violence, she said: pacifism will never achieve social change. *Burn it all down,* she said, *all the way to the very top.*

Once released, she started publishing her ideas. It was time for the women of Japan to awaken themselves. No more focus on superficial fashion and appearance, she said; no more idolizing geisha as the highest potential for women. No more women carrying around the guilt of rape; no more blaming the women in the red-light district for moral decay. No more waiting for men to enact the change. No more allowing tenant farmers to starve while elites grow rich on their rents. No more believing the emperor is divine.

Then she masterminded a plot to blow the Meiji Emperor to smithereens, as you do.

> *Emperor Meiji, compared with other emperors in history, seems to be popular with the people and is a good individual. Although I feel sorry for him personally, he is, as emperor, the chief person responsible for the exploitation of the people economically. Politically he is at the root of all the crimes being committed and intellectually he is the fundamental cause of superstitious beliefs. A person in such a position, I concluded, must be killed.*
>
> Kanno Sugako, translated by Mikiso Hane

The plot, however, was uncovered and Kanno Sugako was sentenced to death for treason. When the judge asked if she wished to make a final statement, she declared that her only regret was that she had failed the people.

The newspaper *Miyako Shimbun* reported Kanno's execution on January 25, 1911:

> *She mounted the scaffold escorted by guards on both sides. Her face was covered quickly by a white cloth . . . She was then ordered to sit upright on the floor. Two thin cords were placed around her neck. The floor-board was removed. In twelve minutes she was dead.*

Like the Samurai Takeko sisters forty years before her, Kanno Sugako and her movement could not prevail against the power of the Meiji Emperor, nor could any of the other rebel movements in Japan at the time. Why? Why was The Man so powerful in Japan? Were the rebels too divided among themselves? Or maybe the question is, why was The Man so weak in China and Russia? Your answer can change dramatically, depending on which lenses you're wearing as you peer into the past.

Meanwhile, in the Ottoman Empire

How had the Ottoman Empire fared through the Industrial Revolution and Gilded Age? Not so well. Its long heritage of masterful artisan skill—crafting things such as porcelain, woven rugs, hand-painted tiles and blown glass—had earned it dominance over the global Silk Road trading

network centuries ago. So when the British had started experimenting with steam power, the Ottomans sniffed with bemusement. When factories started mass-manufacturing, the Ottomans waved away the news with calm smugness. *Whatever the Christian barbarians are doing over there is of no concern to us.*

Of course, by the end of the nineteenth century, the whole global economy had shifted so much that the Ottomans were forced to sit up and pay reluctant attention. Why has the bottom fallen out of the glass market? Why have our porcelain exports practically halted? I mean, we all know that no one in their right mind would buy British-factory-made teapots, right? And we all know the oafish United States of America cannot possibly compete with the mighty, righteous Ottoman Empire. So what gives?

In an isolated Egyptian harem within the Ottoman Empire, a young girl named Huda was also asking herself what gives, but on a smaller scale. Why wasn't she allowed to learn from the tutors who came to teach her brother? Since she was born into a high-class family, she understood that it was her privilege to be removed from society—*above it*—in a harem. But what harm was there in learning science and history and maths, when the tutor came to their home? So, she snuck into her older brother's lessons and stole his textbooks to read by night. She had a gift for languages, a hunger for knowledge and a passion for music. Whenever she had to go out in public, she wore a veil across her face as a sign of social status. Working women didn't live in harems and they didn't wear veils: they worked sunburned in the fields and streets, like the other riff-raff.

From the very beginning, Huda was intelligent, curious, strong-willed, wealthy and free of spirit. A woman like that had the potential to shake the Ottoman Empire to its core.

If we asked Huda "who is The Man?" we would probably have received different answers over time. First, The Man was her parents, who wouldn't let her learn the stuff her brother learned. Then it was the Ottoman Empire, who had, she thought, held back Egypt for centuries. Then it was the British, who barged into Egypt to build a canal and divide Egyptians from each other. Then it was men, who welcomed women as rebels in the fight for independence but refused to formally acknowledge them as equals. And finally, The Man was the veil women willingly put on themselves.

Huda Sha'arawi

After The Great War, the Ottoman Empire crumbled. The moment was right (at least the League of Nations said so) for self-determination: the people should choose their own national boundaries. Egypt understood the assignment. However, the time was also right for Britain to, ahem, *oversee* the completion of the Suez Canal, in which the British government had a 44 percent share.

Britain therefore high-fived itself for nipping Egypt's nationalist movement in the bud, in 1919. They locked up all the men who were stirring the pot and called it done and dusted. Any similarly nationalist women were shut away in the harems, they grinned—what could they do? Nothing! Brilliant.

Three unnamed women participating in the Women's
March led by Huda Sha'arawi, 1924.

Huda Sha'arawi saw it, too: *touché*, Britain, *touché*. By then she had become a powerhouse of a woman who had personally funded the creation of schools

for girls and support programs for widows across Egypt. Her husband was also one of the nationalist leaders who'd been locked up. She sent word to the women in harems across Egypt: *it's time, ladies.*

When they turned out by the hundreds to stage a march in Cairo in 1919, students from the university flanked both sides of the women, in a show of solidarity and support. There was a standoff with British troops when they blocked the path of the march. Huda moved to push past the soldiers, having been warned by the British that such a move would lead to violence. "Let me die, so Egypt shall have its Edith Cavell!" she said. But behind her, one of her friends asked her to pause and think. *If this turns violent, you'll have your revolution, but many more women here will lose their lives.* Huda chose non-violence and instead the women stood still in protest, baking in the blazing sun all day long.

It could have been a bloody revolution. But Huda Sha'arawi had connected with a global network of feminists working for women's liberation from across the globe and together they had envisioned a different kind of revolution. In 1911, Fatima Nisibe had written: "Pay attention to every corner of the world. We are on the eve of a revolution. Be assured, this revolution is not going to be bloody and savage like men's revolutions. On the contrary, it will be pleasant and relatively quiet, but definitely productive. You must believe this, ladies."

It was a (relatively) quiet road to independence. First the British agreed to a sort of semi-independence, where elected officials could draft a new national constitution. The Egyptian nationalist party (the Waft) gathered to draft it. You probably already know what happened; it's a tale as old as time. *Hold on now ladies, we'll get to equal suffrage and citizenship eventually . . . there are just so many other important things to do that are super-duper urgent. Probably best to go back to your harems to wait, we'll call you when we need you.*

Huda Sha'arawi was so done (according to her memoirs written in 1924):

Exceptional women appear at certain moments in history and are moved by special forces. Men view these women as supernatural beings and their deeds as miracles. Indeed, women are bright stars whose light penetrates dark clouds. They rise in times of trouble, when the wills of men are tired. In moments of danger when women emerge by their side, men utter no protest.

Yet women's great acts and endless sacrifices do not change men's views of women. Through their arrogance, men refuse to see the capabilities of women. Faced with contradiction, they prefer to raise

women above the ordinary human plane instead of making them on a level equal to their own. Men have singled out women of outstanding merit and put them on a pedestal to avoid recognizing the capabilities of all women.

Women have felt this in their souls.

Their dignity and self esteem have been deeply touched. Women reflected on how they might elevate their status and worth in the eyes of men. Women rose up to demand their liberation, claiming their social, economic and political rights. Their leap forward was greeted with ridicule and blame, but that did not weaken their will.

Still shocked by the actions of the Waft men she had fought alongside for so long, Huda left Egypt for Rome. She went to meet other feminist leaders from across the globe, at the International Conference of Women. Perhaps it was conversations during that conference that allowed Huda to consider her veil anew. Before, it had been a privilege and a sign of status. Now, it had become a symbol of The Man. The veil was patriarchy that women were willingly imposing on themselves. Upon her return, at the train station in Cairo in front of a welcoming crowd, she removed it. Her act caused a media frenzy of celebration, condemnation and everything in between. She never put her veil on again.

Blocked from political equality, Huda spent the rest of her life doing all she could to move women forward in other ways, both in Egypt and internationally. There are, after all, as many ways to impact the world as there are women doing it.

There were Huda Sha'arawis in nearly every country around the world. They even came together in large international conferences. But as real life took its toll on ideology, women's movements flowed differently across the globe. It became clear soon enough that, though everyone was working toward women's rights, the devil was in the details. Which rights, exactly? Precisely how are we defining equality? Do we care about voting rights alone? Are we talking about employment, or reproduction? What is our stance on veils? Should we focus purely on educated elites, or are we advocating for the poorest? Come wartime, are we a voice for peace, or are our national loyalties more important?

In other words, who, exactly, is The Man from whom we are seeking liberation? Egypt's Man is a very different Man from the one in Australia, for example.

McDonagh Sisters

In the early 1900s, a newfangled fad called "moving pictures" took the world by storm. People across the world were picking up movie cameras and creating powerful visuals nobody had ever dreamed were possible. And by "people" we mean mostly men. Though plenty of alluring female faces were to be found on those flickering screens, there were almost no women behind the scenes—whether writing, directing, managing or producing these early movie masterpieces.

But in 1926, three Australian sisters set out to change that.

Isabel, Phyllis and Paulette McDonagh had been left $1,000 in their father's will "to make a film." With it, the sisters would launch themselves into global fame, founding the first female-owned production company in Australia, producing some of its most popular and critically acclaimed films and quickly distinguishing themselves as the most successful all-female filmmaking team in the world.

The McDonaghs found success almost overnight, combining their considerable talents to become a silent film dream team. Twenty-five-year-old Paulette wrote and directed each film, taking stylistic and narrative risks that made a McDonagh movie instantly recognizable. Instead of mimicking the "outback adventure" movies being churned out by other Australian filmmakers, Paulette wrote heartfelt, dramatic storylines that gave twenty-seven-year-old Isabel plenty of room to show off her over-the-top acting chops and then filmed them in a glossy, hyper-expressive style that obviously owed more to German influences than Australian ones.

Making the most of her glamorous looks and melodramatic style, Isabel played fashionable young flappers navigating parental disapproval and/or romantic peril, honorable young ladies driven to a life of cat-burglary for the sake of true love, and even (in the sisters' controversial final film) a grieving rape victim rejected by her husband, who has returned from WWI only to accuse her of "having born a child to the enemy." (That one famously made the Prime Minister cry in the front row of a Sydney theater!) Middle sister Phyllis was the team's producer and art director, promoting their films to local and national movie houses, and recasting the McDonagh family home in each production to create elegant, expensive-looking settings while minimizing expense.

The McDonaghs's high-flying trajectory seemed unassailable—until the talkies arrived to ruin everything. As a glut of not-so-silent movies from America

flooded Australian theaters, the sisters scrambled to add a partial soundtrack to their completed film, desperate to compete with this brave new world of talking pictures. The results were . . . not great. The hastily added audio was jerky and poor-quality, and theaters often failed to sync the sound correctly. This led to some excruciatingly awkward moments when inappropriately timed sound effects ended up playing over the most dramatic scenes of the film.

The film was a flop. And as their collective career started to flounder, the sisters began drifting in separate directions. Isabel married a Scottish rubber-broker, moved to London and launched a moderately successful theater career, before retiring to raise her three children. Phyllis left filmmaking to become a freelance journalist and newspaper editor in New Zealand and Australia. But Paulette was less ready to move on from their glory days as the queens of Australian cinema. Working on several documentary film projects and attempting to raise funds for a new romantic epic film, she was unable to drum up the necessary budget and her project was eventually scrapped. As the movie industry spun speedily on, the McDonaghs's films were all but forgotten, until two of them were screened at a film festival in the 1970s—and the sisters were a sensation again. In 1978, the McDonaghs were finally awarded the Australian Academy of Cinema's Lifetime Achievement Award for their contribution to "Australia's greatest achievements in film."

The power of visual media was elevated to a new plane during the Roaring Twenties, and in many ways, the world we live in now feels eerily familiar to the one the McDonaghs inhabited. Technological revolutions in energy, engineering and communication are connecting the world in ways we never could have dreamed. Innovative new media formats are making it faster and easier for regular human beings to amplify their voices—*no approval from The Man required.* Collectively, we came to realize that we could share our stories and our ideas with people living in places we'll never visit—or never knew existed at all! And if we can share our stories with each other, maybe The Man will have a harder time keeping us in line.

Like many people today, some folks living through the early twentieth century felt overwhelmed by the bewildering pace of changes that seemed to be transforming everything about the world they'd known—the sheer, staggering *Extra-ness* of it all. Others found it an exhilarating adventure they couldn't believe they were lucky enough to experience.

One of those who felt right at home in the "world of the future" was Ruth Nichols. But was the future ready for her?

Ruth Rowland Nichols

Eighteen-year-old Ruth Rowland Nichols, class of 1919, has just been given a rather unusual graduation gift: a short jaunt on an aeroplane. The ride was meant as an extravagant reward from a doting (and fabulously wealthy) father—but Ruth herself was terrified. She didn't even like riding in elevators and now she was supposed to go up in a plane? But she was even more afraid to hurt her father's feelings, so up she went—10,000 feet in the air in a ramshackle contraption of linen and wood, with a brash young pilot determined to impress his pretty passenger by demonstrating his very best aerial acrobatics. A few minutes—and a few rolls, inversions and loop-de-loops—later, the flight was over and Ruth had discovered her destiny. She was *born to fly*.

The tricky part was going to be convincing her parents. It had been hard enough to persuade Daddykins (as she called him) to allow Ruth to indulge in a few semesters of college before settling into the life *he* believed she was born to live: a "good" marriage to a prominent man, the prompt production of an appropriate number of well-behaved children and a lifetime of genteel social hostessing, with *perhaps* the occasional Good Works thrown in to pass the time.

Young Miss Nichols knew which way the land lay, so when her parents insisted she leave Wellesley for a semester to "winter in Miami" (aka: catch a husband), she cheerfully agreed. Quietly, she added one extra item to her packed social calendar: flying lessons. *What Daddy didn't know couldn't hurt him, right?* Right.

Fast-forward a few years. Ruth Nichols has now earned: from Wellesley, a premed degree; from the Federation Aeronautique Internationale, a pilot's license; and from the newspapers, a nickname she utterly despises—"The Flying Debutante." By 1929, she and her friend Amelia Earhart founded a new organization for women pilots—the Ninety-Nines. And by the end of 1930, Ruth clinched the world record for fastest cross-country flight, hurtling from Los Angeles to New York in 13 hours and 21 minutes—smashing Charles Lindbergh's record by well over an hour.

Ruth had found her wings and nothing was going to hold her back. In quick succession in the Spring of 1931, she claimed the women's world altitude record soaring to 28,743 feet, and the women's world speed record at an astonishing 210.7 miles per hour—beating her friend-slash-rival Amelia Earhart's months-old record by almost 30 miles per hour.

Ruth was officially America's favorite Fly Girl and she had one more big trick up her sleeve: she was going to be the first woman to fly solo across the Atlantic.

But the first and biggest hurdle was funds: her family's fortunes had changed since Ruth's debutante days. Daddykins was a member of the New York Stock Exchange and . . . well, we all know how that turned out in 1929. Money was a major issue, one made more complicated by the fact that Ruth was adamant that no one could know of her plans. Not her family, not the papers and especially not her fellow pilots.

"I want to keep the matter entirely confidential," Ruth wrote in 1931, knowing that if word got out before she was ready, other pilots would try to beat her to it. And so, assembling a fundraising team of prominent male pilots (including her very first flight instructor from back in Miami, Harry Rogers) and well-connected friends, Ruth sent out careful feelers to anyone she thought might be interested. Broadcasters, movie studios, private investors and well-heeled friends all received a letter from the passionate yet practical pilot. *If my bold venture succeeds,* Ruth reminded these profit-minded men, *returns on investment are likely to be in the neighborhood of ten-to-one.*

"Besides," Ruth declared with her trademark blend of audacity and practicality, "there is no possibility of failure . . . except the usual law of Fate, which we meet every day of our lives." And astonishingly, in the middle of the biggest depression in US history, it worked. People couldn't help believing in Ruth and they showed that belief in the form of cold hard cash.

With funding in place, all Ruth needed now was somebody with the experience to stage-manage the whole affair. So she turned to New York businessman Hilton Railey—the man who had launched Amelia Earhart from obscurity to stardom three years earlier by arranging her debut as the first woman to be flown (not *fly,* merely *be flown*) over the Atlantic Ocean. But this time, Railey was having none of it. *The trip was too dangerous,* he claimed. *Ruth would never make it alive* and he *refused to be responsible for her flying headlong into death.*

Infuriated, disgusted and fully conscious of the *real* reason for Railey's reluctance—"just because I'm a girl"—Ruth spat out the most scathing appraisal she could summon: "You're, you're . . . *mid-Victorian!*"

The shot hit home. And, after a few more reminders that Ruth *would* attempt the Atlantic crossing with or without his help, Hilton Rainey agreed to take the job—for $13,000. But Rainey was good at his job and within weeks offers were flooding in. Book deals, endorsements, magazines—everyone wanted a piece of Ruth Nichols's limelight.

Ruth Nichols in front of *Akita*, the plane she would
use to attempt to fly across the Atlantic.

Ruth kicked off her transatlantic flight on June 22, leaving New York in a
flurry of flashbulbs, but she would only make it as far as New Brunswick before
disaster struck. The airfield where she'd planned a stopover was not the broad
open field she expected, but a tight, deep bowl surrounded by dense forest. This
runway was "a veritable trap"—but there was no going back now. Bringing
the plane in fast and blind, she realized too late that she was going to run out
of room. Trying to take off again, she couldn't rise fast enough and the plane
slammed into a wall of rock at full speed. The fragile wooden frame shattered,
splintering into bits—and Ruth's body did, too.

Clambering out of the cockpit to a chaos of flashbulbs, she made a brave
show for the cameras, shouting to shocked onlookers to "Wire for another
plane!" But of course there *was* no other plane. Ruth's adventure was over,
the endorsements and movie deals evaporating into thin air—and her body
was in about the same shape as her plane. Ruth had broken her back and
would spend the next two months flat on her bed in a body cast. She was

What's Her Name

fortunate, her doctors reminded her, not to be paralyzed—lucky to be alive at all!

And though she would be back in the air with astonishing speed—setting a new women's distance record just four months later—Ruth had missed her window for a transatlantic attempt. Amelia Earhart would claim the record instead, flying from North America to Ireland in May 1932, but with one small difference: Earhart would *take off* from that perilous New Brunswick airstrip, but she wouldn't *land* there. A pilot friend had delivered the plane there for her a few days earlier.

Now, we are absolutely not dissing Amelia Earhart here, but it's hard not to feel a bit frustrated by the unfairness of it all. If her luck had gone differently—if Ruth Nichols had never tried to fly into New Brunswick—who knows what could have happened? Would awed schoolchildren write reports about Ruth's courage and derring-do instead of Amelia Earhart? (Or would Ruth have died a gruesome and tragic death halfway across the Atlantic Ocean?)

Whatever might have happened, what *actually* happened was pretty incredible on its own. Ruth would become the first woman to pilot a commercial aeroplane, fly for several human rights organizations and in 1939 found Relief Wings, a women-run auxiliary to the US Air Force that provided crucial humanitarian aid, medical care and civilian relief throughout World War II. Through her work with Relief Wings, Nichols would eventually earn the rank of Lieutenant Colonel in the Civil Air Patrol. She also led missions for UNICEF, helped aid organizations rescue refugees, was part of the first cohort of women to be tested by NASA's astronaut training program and set new women's speed and altitude records at fifty-seven years old. Not too shabby for a "darling debutante."

Who Is The Man in Africa?

After centuries of colonial, post-colonial, then colonial-again hijinks across the whole continent of Africa, The Man took some interesting forms. Let's say you lived in Africa in the 1920s and you gave everybody a survey:

WHO IS THE MAN THAT'S KEEPING US ALL DOWN?

- Britain
- France
- Belgium
- Spain
- Slave traders
- Boers
- Capitalist tycoons
- Missionaries
- Schools and other bureaucratic systems
- Lack of schools and other bureaucratic systems
- Christians
- Muslims

You'd have a whole lotta checks on every single option.

And there was, of course, the interesting case of Abyssinia, still independent thanks to Taytu Batul and her epic Battle of Adwa. Her (loosely defined) heir, Ras Tafari and his wife Menen Asfaw were crowned Emperor and Empress in 1930. There was as much pomp and circumstance, glitz and gold as Africa had seen since Meroë.

Across the ocean in the British colony of Jamaica, downtrodden souls marveled at news of the coronation: A Black African King and Queen. It must have been ordained by God, right? Come to think of it, wasn't there some prophecy about this in the Bible? Wait, could it be—is Ras Tafari the literal second coming of Christ the Messiah? Yes! Hail, King Alpha and his bride Menen, Queen Omega. And, now we're seeing things clearly, Abyssinia must actually represent the True Africa. And Africa is the Biblical Zion.

To commemorate the hugeness of the moment, Ras Tafari changed his name to Haile Selassie, but in Jamaica, the people celebrated his *true* nature as the Messiah: Rastafarianism was born.

Empress Menen Asfaw

Imagine you are Menen Asfaw, Empress of Abyssinia, standing in the figuratively big shoes of Taytu Batul, and then you find out that thousands of people across an ocean believe that your husband is the second coming of Christ. It's one thing to revere someone from afar, but when you wake up next to them and smell their morning breath, it's harder to believe in their divinity. Seems like whatever response you choose would be a misstep. The story is giving so many people hope! Hundreds, even thousands of Black people across North and South America are finding beauty in the idea that the Messiah is back. Thousands more don't buy into the Messiah-Selassie idea, but they are rallying behind the idea that Africa is the new Zion. Descendents of slaves across the Americas are starting Back-to-Africa movements, dreaming of returning "home" to a new free nation, a kind of Pan-African Zion.

"Wait, *new* nation?" you say (because you are Empress of Abyssinia), "Nothing *new* is necessary. Abyssinia has been here all along and is doing just fine, thank you."

"But, truly free nations don't have Emperors and Empresses," they say. "And also? Probably shoulda freed those hundreds of thousands of slaves a long time ago, right? It's the 1930s for heaven's sake."

Well, now you don't know what to think. How could these people believe that Abyssinia is the heart and soul of the True Africa, while at the same time believing that the royals—and the slaves—*who have saved Abyssinia from colonizers all this time*, need to go?

And then there are the Rastafarians who literally worship you as Alpha and Omega. Seems like an awfully tight rope to have to walk, as Empress of Abyssinia.

Menen decided that a life of piety was the path with fewest pitfalls. Sporting a truly spectacular crown (rivaled in splendor only by her husband's), Menen dedicated her entire life to charity. She built cathedrals, started girls' schools, was patron of the Red Cross. She spent her life building up Abyssinia and its colonies to rival the greatest empires on Earth. (And if those colonies were to rebel? Well, we'd need to set them straight.)

Let's return to that moment in Chapter 7, when in 1936, Italy returned to Abyssinia to settle an old score. Empress Menen was like *bring it on*, "I shall do it as the august Empress Taytu did in her time," and dropped the mic.

But also, she dropped the ball—there was no epic stand; instead, the royals hustled off into exile. From their mansion in Bath, England, the royal pair spent the next few years recruiting allies to help them retake Abyssinia. They watched from afar as Italy, the colonizer, abolished slavery and instantly freed four hundred and twenty thousand Abyssinian slaves. Empress Menen took the opportunity to go on pilgrimage to Jerusalem. At the Church of the Nativity, she made a promise to the Virgin Mary: "Get me my empire back, and I'll give you my crown."

Mary must have liked the look of the crown, because Menen got her empire back in 1941. (The British army helped the Virgin Mary a bit.) Reclaiming the throne, King Alpha and Queen Omega agreed to retain the abolition of slavery, although in practice, slavery made a comeback. Alpha and Omega also declared that Abyssinia had always been the *colonizers'* name for their nation; Ethiopia would be its name going forward. It was emblematic of a wider movement of self-determination that was taking the whole of Africa by storm: *we're choosing our own names, our own nations now!*

When groups within Ethiopia's own empire declared themselves independent, King Alpha and Queen Omega were having none of it. Ethnic and religious minorities were crushed, new political ideologies were, sometimes brutally, suppressed. After all, *someone* had to make a stand for the soul of Africa. Who else but Ethiopia could claim to be the True, Authentic, Never Fully Colonized Africa?

Empress Menen did send her crown to the Virgin Mary—it rests in the treasury of the Church of the Nativity to this day. She sent it almost immediately after regaining her throne, pausing only as long as it took for the royal jewellers to make an exact replica, for Ethiopia to keep.

So, what does it mean to be liberated? It seems to depend entirely on how you define The Man.

The
Atomic Age

IS THIS THE END? THE WHOLE
WORLD TAKES STOCK

Empire-building was back in style in the mid-twentieth century and no one was more excited about it than Germany, USSR, Japan and Italy. In each country, age-old disputes about borderlands ballooned into full-scale invasions of their neighbors. Once they'd absorbed their neighbors, there were new neighbors to invade, so the global game of Risk was back on. This time, with a genocide expansion pack!

But does the game of Risk play out differently if the world has just spent a couple decades toppling The Man? All of humanity had been presented with the interesting opportunity to look around and ask, what unhinged force is running this show? The people? Technology? A handful of narcissists? The new global media? Love—or maybe Hate? As the Atomic Age and all its ramifications played out across the globe, we paused to take stock. Are we about to bring about The End? Or do we have the power to launch ourselves into a brighter, better world?

"There Are Starving Children in China"

Many a Western child was guilted into finishing their meal by parents who aggressively observed that the whole of China was starving in the 1950s. Of course, sending excess food to China was Not An Option—*support the communists? Not a chance!* Best thing you can do for humanity is finish your meatloaf.

But how did the Communist Party come to rule China and why was everybody starving? It's a Shakespearean saga that jams the whole human story into one incredible plot.

After Cixi's nephew Puyi was ousted and the Qing Empire fell, China imploded into civil war. The old Qing Empire had brought together such distinct regions and vastly different ethnic groups, that the question was both obvious and immediate: what does it mean to be Chinese, anyway? The Kuomintang (Nationalists) thought that the elite classes could carry on running China just fine. The Communists believed the moment was right for the dawn of true equality in China: *the Russian peasants had achieved it, why not us?* The Manchu held onto the storied tradition of emperors and placed Puyi on a throne up north. Japan watched and smiled. *He will make a perfect puppet*, they said—and invaded Manchuria.

Xia De-hong

Red boys and green girls walk on the streets,
They all say what a happy place Manchukuo is.
You are happy and I am happy,
Everyone lives peacefully and works joyfully free of any worries.

Manchukuo children's song, 1930s

At school, Xia De-hong learned that Manchuria was paradise and in her city Jinzhou, 100 miles north of the Great Wall, everything was perfect. The Japanese occupation was so complete that a whole new social system had been created—the Japanese held all positions of power and the Chinese labored for them. All the schoolteachers were Japanese and for girls, "the way of the woman" made up the whole curriculum: cooking, sewing, tea ceremony, flower arranging, obedience to one's husband, how to dress and style one's hair—you know, the important things. De-hong's mother fretted about her daughter's "rebellious bones," for De-hong learned none of those things.

At school, the children were also compelled to watch newsreel footage of the Japanese *invasion of everywhere*. It was psychological conquest. Children who closed their eyes or screamed were punished, as they watched footage of soldiers cutting people in half, or resisters tied to stakes to be torn apart by dogs. The censorship and propaganda in Manchuria were so effective, locals had no idea that World War II was raging out in the wider world.

Come 1945, the Japanese overlords appeared to be more agitated and aggressive. Every now and then, American B-29s passed in the sky. One of De-hong's school friends somehow got hold of a banned book and went looking for a hidden place to read. A forgotten countryside cavern would do—except, when she approached, a piercing siren went off. It was an arms depot and she was seized by Japanese soldiers.

Two days later, the whole school was assembled in the snow, to witness "the punishment of an evil person who disobeys Great Japan." De-hong barely recognized her friend—she had been tortured, her face was swollen and she could barely walk. Riflemen lined up, the suffering girl attempted to say something and shots rang out. She crumpled into the snow. The school headmaster scanned the crowd: any show of distress or emotion would be punished, so De-hong forced herself to stare at the body of her friend with

a blank face. In the silence, the suppressed sobs of Miss Tanaka, one of the Japanese teachers, was audible. So the children watched as their headmaster beat Miss Tanaka to the ground until she stopped moving.

Come August, when word spread that the United States had dropped two atomic bombs on Japan and the empire had surrendered, you can imagine how the tables turned. Lynchings and suicide were rife. Jinzhou was a place of violence and chaos, then wave after wave of new overlords. First it was the Soviet Red Army—the first white people any of the locals had ever seen, who seemed mostly interested in trading long-rationed cloth for clocks. The Red Army dismantled entire factories to ship to the Soviet Union. Then, with American support, the Kuomintang (Chinese Nationalists) took the city, to great celebration. But soon the locals were disillusioned—the Kuomintang soldiers only seemed interested in stealing concubines and bribes. There was widespread looting, corruption, scarcity and inflation. What the locals didn't know was that a brutal civil war was raging elsewhere, as the Kuomintang and Communists fought for the future of China. In Jinzhou, Kuomintang soldiers and bureaucrats kept seizing contraband for themselves, staging elaborate feasts while others went hungry and—most annoyingly—requesting to take De-hong as a concubine or wife. She refused until her parents told her it was too dangerous to refuse anymore. *It could be worse*, they said.

De-hong raged at the "traditional" role for women in China—they couldn't work or have their own money, they were entirely dependent on the man they were associated with and could be treated worse than one might treat a dog. The subtle brutality of it all—presented as "morality"!—on top of all the physical brutality around them was enough to make her despair. Then, a cousin filled her in on the Communists' revolutionary views on women: they believed that gender was irrelevant among comrades and that all the injustice toward women needed to end *yesterday*. She joined the movement, aged fifteen.

Jinzhou soon became the key battleground in the Chinese civil war. De-hong was part of the underground, first distributing informational pamphlets and intelligence. The stakes were high: one of her school friends absent-mindedly placed one of the pamphlets in her bag and when it fell out at the market, was immediately hauled off for interrogation and died under torture. Inflation, corruption and scarcity continued under Kuomintang control, so while officers feasted, everyone else starved. One of the teachers at De-hong's school ate a piece of meat he'd found in the street. He knew it was rotten, but was so desperate he thought it worth the risk and died of food poisoning the next day. The Communist-controlled north was faring far better and its army was closing in everyday.

Finally, De-hong was given a mission to sneak detonators into an arms depot, which she achieved by posing as a silly girl on a date with a boy. She left a bag behind in the depot and that night, when the explosion rocked the entire city, the Communist army made its final assault. De-hong and her family shut themselves up in their house and days passed in a shadow of dark smoke, flying bullets, raining shrapnel and nightmarish screams. Then the noise faded and a voice called from the gate: "We are the People's Army. We have come to liberate you." De-hong went outside and found streets littered with body parts and sewers overflowing with blood.

China's Cultural Revolution called on the young Red Guards to "Destroy The Four Olds": Old Ideas, Old Culture, Old Habits and Old Customs.

These new overlords, the Communists, were different. They were shockingly disciplined and polite. They treated captured Kuomintang soldiers (all eighty thousand of them) with respect. In a pirate-like move that would make Ching Shih proud, captured soldiers were given the option to join the

Communist army, or to return back home to the countryside. Either way, said the Communists, it was a win, because word of their discipline and good treatment of the people would help spread the gospel that this was a revolution For The People.

In Jinzhou, inflation dropped drastically. Food was restored, as well as security—unlike all the past overlords, the Communists were so disciplined that corruption ended. Even more incredible to De-hong, there were no rapes or forced marriages for women. She watched with great hope: they had talked the talk, now they were actually walking the walk. The banks reopened, electricity was restored, running water returned and the railroads were rebuilt. De-hong was assigned to the Women's Federation, a Communist unit whose aim was to liberate women from concubinage and brothels and provide them with an education. The future was Now.

In hindsight, *we* know what happened to Mao Zedong's Communist movement. We know about their astonishing feats of the human spirit—like the Long March, which De-hong marched, while pregnant and starving. We know how Mao's vision for the future turned into fantasy, forcing thousands to fake "miracle harvests" to live up to impossible quotas. We know that, by the 1950s, millions starved and Mao couldn't understand why. He blamed internal saboteurs who had been infected with capitalist greed and he rallied young people across China to join his new Red Guards who would complete the final phase of China's transformation: the Cultural Revolution.

By then, De-hong had married a high-ranking Communist officer and become one herself. But doubts and disillusionment were seeping in. Her young daughter, though, was all-in for the Red Guards. The army of passionate young people swore to Chairman Mao that they would "smash the four olds": old ideas, old culture, old customs and old habits. It was a generational war and teachers, intellectuals, traditions and culture were the targets. De-hong and her husband knew it had all gone sideways and dared to write to Chairman Mao about it. They were arrested, tortured, then sent to the Himalayas for "thought reform," a favorite method of Chairman Mao. *Hard peasant labor and starvation in a camp would do the trick.*

What he didn't anticipate was that their daughter, Jung Chang, would win a scholarship to England, awake from the Red Guard dream and write the whole story of her family in a global best seller, *Wild Swans.*

Camps were all the rage in that era. It was, they must have thought, a clever way to force your enemies to work themselves to death for your cause. In the USSR, as in China, intellectuals and other "bourgeois" enemies were worked to the bone; in the US, Japanese Americans from the entire West Coast

were shipped inland to remote, barbed-wire-laced camps for "security." Most notorious of course were the Nazi concentration camps in Europe, built to exterminate Jewish and Roma people, homosexuals, the disabled and other Nazi undesirables. A lot of people refused to believe something so villainous was happening on such a scale. But among those who did believe, some felt themselves called to action. Like the teenage sisters who became the most feared and effective assassins of the Dutch Resistance. Wait . . . *assassins*?! For real? Yes.

Truus and Freddie Oversteegen

Truus and Freddie Oversteegen were little girls when the first Jewish refugees started flooding into the Netherlands. It was illegal to house them, but the Oversteegen family did it anyway. Truus and Freddie often even gave up their own beds to Jewish people in need. With a dedicated anti-war activist mother, it's no wonder the girls quickly got involved. When the Nazis took control of the Netherlands and Haarlem became occupied territory, they started handing out literature for an anti-Nazi group called the Council of Resistance. But, seeing Jewish people being imprisoned and openly murdered, the girls demanded they be allowed to take "direct action." The Council finally agreed to introduce sixteen-year-old Truus and fourteen-year-old Freddie to twenty-one-year-old Hannie Schaft. An idealistic young law student who'd been kicked out of law school after refusing to declare allegiance to the Nazis, Hannie had "gone underground" to work for the resistance and was already training for the kind of work the Council thought these young women might be perfectly suited for.

At first, it was "standard espionage" work—things like bombing railway stations (to prevent the Nazis from getting supplies), burning down government buildings (and the records that allowed the Nazis to identify Jewish families), and smuggling Jewish children to safehouses, since they could easily pass for young mothers traveling with their own children.

But that work was beginning to feel increasingly pointless—like swimming upstream against an endless flood of death. The trio were tired of watching innocent people die. They wanted to stop the deaths at the source.

So Truus, Freddie and Hannie soon started pushing for a new assignment—removing the Nazi officers responsible for those murders. In short, they wanted to become assassins.

Because nobody—especially not officers steeped in the ultra-misogynist machismo of Nazi ideology—would ever suspect teenage girls of being killers, the Oversteegens knew they'd have a unique advantage. They could approach their targets openly without setting off mental alarm bells, and the shock factor of their attacks would give them a few vital extra moments to escape.

Over the next few years, the girls perfected two different methods of assassination—the spicier "seduce and kill" model, or a good old plain-vanilla "street liquidation."

When the target was a Nazi officer known to be susceptible to a pretty face, one of the girls would doll themselves up in their best fluffy finery, then hang out in his favorite bar doing her very best cosplay of a "moffen girl." Moffen girls, Dutch women who cozied up to Nazi officers trying to get special privileges or black-market goodies, were broadly despised by everyone else, but German officers tended to loosen up in their company. Once she'd gotten the target officer's attention, Truus, Freddie or Hannie would invite him out for a pleasant little stroll in the woods (nudge nudge, wink wink)—a romantic assignation from which he would never return.

Usually, one of the other girls would be waiting in the woods, to "liquidate" the target at a strategic rendezvous point. But sometimes—especially if the officer was getting a little too handsy before the rendezvous was reached—the "Moffen girl" would have to do it herself. Then the girls would strip the body of its uniform (for the resistance to use later), and bury the body in the woods as quickly and quietly as possible.

Street liquidations, on the other hand, were much more public and perilous: "bike-by shootings" in the middle of the road. Always working in pairs, two of the girls would head out on a bicycle—one girl pedalling, one sitting on the back. Approaching the target in the street, usually in broad daylight, they would verify the target's identity . . . and then shoot them. The bikes were invaluable for getting away swiftly, but an even more useful tool was the shock and disbelief of any witnesses. *Of course I couldn't have just seen two lovely young nurses shoot a German officer in the middle of the street—I must have made a mistake.*

The demoralizing effect this campaign had on the Nazi army was powerful—this was psychological warfare of the most delicious kind. After being absolutely convinced they were the strongest, most-genetically-superior men on the planet, the level of mortification these officers felt as their colleagues were routinely and publicly assassinated by little girls was unbearable.

The girls were being actively hunted now and had to relocate often—frequently taking refuge in the same safehouses as the refugees they were smuggling. Hannie Schaft, now infamous among the Nazis as "the red-haired girl," was named the SS's Most Wanted and had to dye her hair black. The sisters started wearing fake eyeglasses and Truus began disguising herself as a boy.

Then, on March 21, 1945, Freddie Oversteegen and Hannie Schaft were both stopped at separate Nazi checkpoints. Freddie was cycling through the city when she heard people screaming "Raid! Raid!" so she quickly detoured into the forest and hid her gun among the trees. When the officers at the checkpoint demanded her papers, she replied that she "didn't have any, because she wasn't old enough yet." The ruse worked (Freddie had always looked much younger than her age) and she made it home safely. But when Hannie was stopped and forced to open her bags, the Nazis found communist newspapers. They did not find the secret Resistance intelligence documents she'd been trying to deliver to a nearby city (using the newspapers as a "double-bluff" cover), but she was arrested anyway. The Germans still had no idea who they'd got and if they hadn't found her hidden gun once they got her to prison, she probably would have been okay. But once they found the gun—and then noticed the red roots of her black hair—the Nazis realized with glee that *this* was the girl who'd been humiliating them for years.

Meanwhile, Truus and Freddie were beside themselves trying to find out what had happened to Hannie. When they heard that a girl matching her description had been taken into custody, they immediately began to form rescue plans. They alerted all the resistance workers who were undercover in various prisons and Truus visited the prison dressed as a German nurse to try and get access to Hannie. But she had gone to the wrong prison and the Resistance wasn't able to even locate Hannie, let alone get her out, for the next three weeks.

On May 5, 1945, the country was finally liberated. Prisoners were being released all across the city and Truus stood outside the prison clutching a bouquet of flowers, waiting to welcome back their beloved friend. She waited all day, but Hannie never came out. Because two weeks earlier—well *after* the Nazis had accepted that they were going to lose and agreed not to execute any more prisoners—Hannie Schaft had been taken out to the sand dunes and shot.

Their comrade-in-arms was dead, and the Oversteegen sisters would never really get over it. The war was over and it was time to move on. But how can you possibly move on when you have done the things that these women have done and seen the things they've seen?

The sisters coped in two very different ways. Truus became an artist. She would become a well-known public figure, speaking out about their

experience during the war, and insisting on honoring Hannie Schaft's legacy. But as anti-communist agitation ramped up across Europe, the Resistance groups who were lauded as heroes during the war itself were increasingly seen as suspect. Still, whenever Truus spoke about her experiences, especially to young people, she was adamant that when the world is "failing at being human," people have a responsibility to join the fight against the forces of evil in whatever ways they can.

Freddie, on the other hand, went the "escape" route—focusing on her children and domestic life, and almost never speaking of the war. She would even leave the country altogether for months every year, to avoid the annual commemorations of Liberation Day. Although Freddie was clearly deeply traumatized by her experiences, and never again engaged in active resistance work, she also continued to be active in antiwar efforts for the rest of her life. Unlike her older sister, who used her voice and her art to force their community to confront and remember the *past*, Freddie channeled her energy into relief efforts and humanitarian aid for those *currently* being harmed by wars all over the world.

World War II in the Pacific

As war spread like a virus across Europe, the same thing was happening in the Pacific, where Japan was busy building an empire as aggressively as the Nazis. By 1942 Japan had invaded the Philippines, a strategic base in the vast Pacific Ocean. Immediately, a resistance movement formed among Filipinos and one of their most effective spies was someone the Japanese soldiers would least suspect: a social outcast with leprosy.

Josefina Guerrero

It's probably no coincidence that Josefina Guerrero's childhood hero was Joan of Arc. Joey (as they called her) believed she too had a heroic destiny. But the things life kept throwing at her didn't feel heroic at all. Her parents died and she was sent to an orphanage. Then, when she contracted tuberculosis, she was sent to a convent. Still, she kept the faith—Joan of Arc didn't step into her destiny until age sixteen, after all.

Sure enough, when Joey turned sixteen, things started happening. She married into a prestigious family and bore a daughter the following year. But she had a rash that wouldn't go away. Weird—could it be some kind of divine calling? She was diagnosed with Hansen's Disease (leprosy) and her husband left immediately, taking with him their two-year-old daughter. Not the heroic fate she had in mind.

The following year, Japan invaded the Philippines and occupied Manila. Japan's colonizing tactics were, like its Nazi allies, calculating and efficient and local populations were frequently brutalized. Women were forced into particularly horrific roles as "comfort women" for the Japanese army, which means exactly what you think it means. A thousand Filipinas were captured and forced into such a role. But not Joey. She was, after all, a leper, required to wear a bell anywhere she walked so people could hear her coming and retreat. The stigma was real and the fear of exposure was powerful. Even soldiers conducting body searches waved her away with panic in their eyes . . . and that's how she found her destiny.

Josefina Guerrero eventually emigrated to the United States for medical treatment. Moving and changing her names multiple times, it wasn't until after her death that her story was pieced back together.

Joey joined the resistance and almost immediately proved to be an incredible asset. She reported on troop movements, transported messages and even weapons, smuggling items on her body and in her hair. As years passed, intelligence gathered by the resistance gave the people hope: rumor had it that the United States was coming to liberate the Philippines. To succeed, they

needed to know the locations of all the Japanese guns and mines on the Manila waterfront. So Joey got to work.

And on September 21, 1944, American bombers used Joey's map to take out all the Japanese defenses on the coast. The liberation had begun. By January, American troops were inland, closing in on Manila. But they could not make the final push until they had a map of all the Japanese land mines that flanked the city inland. The resistance needed to deliver the map in person: someone had to walk across 35 miles of active war zone.

Symptoms of leprosy include extreme fatigue, debilitating headaches and muscle weakness, but everyone knew Joey was the best hope for the cause. The Japanese were stopping everyone; no one else would ever be able to get through. She taped the map to her back and started walking.

Joey walked 25 miles through devastated landscape, fighting her own internal battle against her weak body and pounding head. She had to slip into a little fishing boat to get around an active battle, only to be chased by river pirates. Again, the leper bell helped hold the enemy at bay. Once she finally arrived at the American headquarters at Calumpit, she was told that the troops had left three hours earlier. They were already moving toward Manila and anxiously awaiting her map. So she walked miles more, backtracking through the battle site she had previously taken the boat to avoid. Finally, she caught up with the captain of the 37th Infantry Division and handed him the map.

Joey had definitely earned a rest, but as the Battle of Manila commenced, she moved with the infantry, running past flying bullets to tend the wounded and carry children to safety. It was a brutal battle that leveled the city and left a hundred thousand Filipino civilians dead. Japan left in defeat, but vowed never to surrender, never to quit, until victory in the Pacific was restored.

They didn't know two atomic bombs were coming, to bring the war to a sudden and horrific close. The whole world looked on, stunned. *Did we just witness human destruction on a whole new plane?*

Japan surrendered aboard the USS Missouri on September 2, 1945 (Germany had already surrendered on May 8). And collectively, the world's people were like, "this time it really *does* need to be the war to end all wars." The United Nations was more than just a dream—it was now a human necessity. It would be the first truly global political organization, where each nation had a voice and where conflicts could be resolved with diplomacy rather than bombs. Luckily, as the war had raged on, delegates from all over the world had been gathering in San Francisco, in pursuit of the end of all wars. Item number one on the agenda? Draft a constitution for the whole world.

Thank goodness the Latin American delegation was there.

Latin America Leads the Way

Remember how, in the 1800s, most Central and South American nations saw governments rise and fall, while Patriarchy persisted as the supreme stabilizer? Brazil, by contrast, had remained stable via monarchy and slavery—until both systems were finally retired at the end of the nineteenth century. At the dawn of the twentieth century, no one had more experience of the persistence of patriarchy than the women of Latin America. Over two hundred years, they had learned the same hard lesson Huda Sha'arawi had: governments will not spontaneously enshrine women's rights at some magic, future date. No, women's rights had to be explicitly stated and protected, right out of the gate. This was the one thing they knew for sure.

So by the 1920s, when international women's movements had started booming, feminist leaders from across Latin America stepped into the lead. *Trust us*, they said, *we've learned from two centuries of missteps. We know how to move global women forward.* The Pan-American Conference of Women in 1922 introduced onto the global stage a Brazilian biologist who would spend her lifetime in a resilient battle against stultifying bureaucracy. That she emerged victorious from such a long, boring battle makes our hearts leap. That she managed to enshrine women's rights in the first Constitution of the World? It's the stuff of dreams.

Bertha Lutz

What do poison dart frogs and global politics have in common?

Together, they made up the life's work of Bertha Lutz. Born in Brazil just after the monarchy was deposed, she broke the mould by traveling to Paris to study biology at the Sorbonne (where Marie Curie was professor of physics). Her years of study were also the horrific years of the Great War, and Paris was not far from the front. She graduated in 1918, the same year Maud Fitch had watched the war sputter to its conclusion. Returning to Brazil, she declared loudly that women shouldn't have to sail to Paris to learn. From there it was an easy step to advocate for women's suffrage and equal pay. And the people of Brazil were with her: in 1932, Brazil was the third nation anywhere to grant women the right to vote.

Bertha could have claimed her badge of achievement and retired to ivory-tower glory for the rest of her days. She had by then achieved renown as a specialist in poison dart frogs, native to Brazil and fascinating to everybody. But Bertha was all too aware that there were still millions of women around the world fighting for liberation. Why not aim for nothing less than equality for women everywhere? Sure, the road would be long and riddled with international political pitfalls and bureaucracy. But Bertha knew about poison dart frogs and that was her power.

Poison dart frogs are nature's finest example of *aposematism*. They use their loud, bright coloring to advertise to predators that they are not worth eating. One exploratory munch on a poison dart frog will teach any lizard, bird, or bird-eating spider (hey there, Maria Sibylla Merian!) that *Whoa! those bright red ones are gnarly.* Aposematic creatures have no need for speed or agility—they only have to be tough enough to withstand a few bites. They don't need to sit still and they don't need camouflage. They are playing a long game: basically, they allow their predators to Learn Lessons and then they carry on their merry way, in broad daylight, without a worry in the world.

Now apply that strategy to global politics and you have a pretty good idea of how Betha Lutz pulled off one of the greatest feats in modern political history.

Bertha Lutz was there, at that fateful United Nations conference in 1945, where they drafted the first ever Constitution of Planet Earth. And she was there for *three months*—playing the long game for us all, everyday. "The men like to hear themselves very much," she famously quipped. Have you ever sat in a meeting for some committee or board, where you had to hash out verbiage for a mission statement, press release, or even social media post? Imagine that meeting—then make it last not hours, not weeks, but *months*. Also, raise the stakes so that you're arguing over the wording of the instruction manual for the whole world.

In the end, her persistence resulted in the inclusion of three gigantic little words. First, in the preamble—"the equal rights of men" became, thanks to Bertha, "the equal rights of men **and women**." At the time, notable British and American feminists scolded her: it's *understood* that women are included, they said—to spell it out is "vulgar." But Bertha understood how all the women of Latin America would have responded to that with a resounding *No, trust us, you have to spell it out. You have to make sure it is indisputable.*

The Preamble to the UN Charter—a downright inspiring document—with Bertha Lutz's contribution bolded:

WE THE PEOPLES OF THE UNITED NATIONS DETERMINED

to save succeeding generations from the scourge of war, which twice in our lifetime has brought untold sorrow to mankind, and to reaffirm faith in fundamental human rights, in the dignity and worth of the human person, in the equal rights of men **and women** and of nations large and small, and to establish conditions under which justice and respect for the obligations arising from treaties and other sources of international law can be maintained, and to promote social progress and better standards of life in larger freedom,

AND FOR THESE ENDS

to practice tolerance and live together in peace with one another as good neighbors, and to unite our strength to maintain international peace and security, and to ensure, by the acceptance of principles and the institution of methods, that armed force shall not be used, save in the common interest, and to employ international machinery for the promotion of the economic and social advancement of all peoples,

HAVE RESOLVED TO COMBINE OUR EFFORTS TO ACCOMPLISH THESE AIMS.

Accordingly, our respective Governments, through representatives assembled in the city of San Francisco, who have exhibited their full powers found to be in good and due form, have agreed to the present Charter of the United Nations and do hereby establish an international organization to be known as the United Nations.

Then, as the delegates began drafting a Universal Declaration of Human Rights, Bertha Lutz was at it again. For months, she fought for the inclusion of the word "sex" to be included in the list of things that have no bearing on a person's rights:

> Human rights are rights inherent to all human beings, regardless of race, **sex**, nationality, ethnicity, language, religion, or any other status. Human rights include the right to life and liberty, freedom from slavery and torture, freedom of opinion and expression, the right to work and education, and many more.

With three little words—"and women" and "sex"—Bertha Lutz had placed the United Nations on an intentional path toward gender equality. Her final heroic move in 1945 was to recommend the creation of a UN branch entirely dedicated to women's rights. Today, it is the United Nations Commission on the Status of Women, still working to bolster women's rights around the world.

In May 2023, the papers of Bertha Lutz were added to the UNESCO Memory of the World register, cementing her legacy as a global leader for women's rights, whose impact is still being felt the world over.

Empires Fall

One of the more amazing results of World War II was the global shift of borders after it all ended. Empires were so out of style that, even though the great immortal *Britannia* had rebranded its colonies as "dominions" or "protectorates," rebel movements snowballed. Self-determination was a *whole mood* and long-held colonies such as Sierra Leone, South Africa and Australia, plus countless islands across the world, found firmer footing.

India's independence movement has generally taken center stage in text books. It's presented as a heroically nonviolent Gandhi-led movement for the whole of India, but of course the reality was much more . . . human. After all, what does it mean to be Indian? There were as many different answers as there were in China, Russia, Abyssinia, Germany, Brazil and everywhere else. So the independence movement that emerged turned out to be non-violent (but violent), united (but crippled by division) and righteous (but riddled with irony).

The identity struggle in India asked in a nutshell: what defines us? The caste system—social hierarchy on steroids—had for centuries determined who did

what jobs, who had access to education, health care and other little things like, oh, food. So was the caste system at the core of what it means to be Indian, or was it a scourge to be finally cleared away? In an era of self-determination, which "selves" were legitimate enough to be allowed to "determine"? Could the Brahmins, India's supreme elite, "determine" for everyone else how the nation will be structured?

Or is religion more important than caste? Some of the world's oldest religions, Hinduism and Buddhism, are Indian, and the Mughal Empire had long ago brought Islam to northern India. Sikhism had deep roots that grew alongside the British Empire—and there was Charvaka and Christianity, too. So if the British were to relinquish control of the Indian subcontinent, would we draw new boundaries based on religion?

There are racial identities, too, which overlap sometimes with ethnic or linguistic identities. Do we want a hundred little nations, or one giant united one? If we're aiming for one nation, what can unite us? Could it be good ol' Patriarchy, that transcends religion and class and ethnicity? Could Patriarchy be the uniting force for us all?

You see why India's independence movement (and every independence movement, everywhere?) was unsettled. But through all that uncertainty, the clear and hopeful voice of Sarojini Naidu calibrated Indians' collective identity.

LIFE

CHILDREN, ye have not lived, to you it seems
Life is a lovely stalactite of dreams,
Or carnival of careless joys that leap
About your hearts like billows on the deep
In flames of amber and of amethyst.
Children, ye have not lived, ye but exist
Till some resistless hour shall rise and move
Your hearts to wake and hunger after love,
And thirst with passionate longing for the things
That burn your brows with blood-red sufferings.
Till ye have battled with great grief and fears,
And borne the conflict of dream-shattering years,
Wounded with fierce desire and worn with strife,
Children, ye have not lived: for this is life.

Sarojini Naidu

Sarojini Naidu

They called her the Nightingale of India. And nightingales sing their most beautiful songs when everything is darkest, right before dawn.

Sarojini Naidu had already published three celebrated books of poetry and was a leading suffragist before joining Gandhi's nationalist cause. She was a Brahmin who'd married of her own choice, beneath her caste and studied at university, despite her society telling her that all those things were unacceptable. "You know what would really catapult this movement to success?" she told Gandhi, "inviting women to join!"

Gandhi was like, *nah.*

Sarojini Naidu convinced Gandhi that women might be a useful addition to his political movement.

She defied him and showed up anyway—at marches where only men were invited and in the patriarchal halls where decisions were being made. Yes, we will defy the British, she said: yes, we will refuse to carry the ID cards and we will take their blows and we will make them see their own inhumanity. But also, we will paint a vision of India that reaches deep into the past. We will celebrate the heritage of our folktales and our landscapes. We'll praise our

bazaars, our rich foods, our weddings and our handicrafts. We'll tell love stories that transcend race and share tales from every religious tradition. Most of all, we'll awaken the women in India. Looking to Gargi Vachaknavi, Nur Jahan and Bibi Sahiba, we'll build a united and free India that sets aside patriarchy.

With charisma and humor and a poet's way with words, Sarojini's speeches drew massive audiences. (That's about when Gandhi decided she was handy to have around.) She was witty and self-deprecating, she smiled and laughed. She was a Brahmin who referred to her lowly audience as "friends," and she drew from stories of Buddha, Allah, Hindu goddesses, and the Christian God, to elegantly unite the crowd. As the independence movement gained traction—and more importantly, international attention—Westerners started to say that India was too sexist and too religiously divided, to be capable of self-rule. So, Sarojini became an international ambassador, modeling an alternate India to the world.

Decades passed and their political progress was miniscule. Some rebels decried the nonviolent approach, saying only an armed revolution would work. Hindu and Muslim organizations fought for control rather than cooperation. Men resented women in the public sphere. Brahmins resented the empowerment of peasants. All the while Britain held tight to the reins, for fear of unleashing a monster of their own creation. World War II broke out and India was pulled right in by Britain. Japanese troops were wreaking havoc just over the border.

In the face of such a world, can we believe in the path of nonviolence? Yes, was Saronjini's answer, but only if we stick together, despite all attempts to divide us against each other.

In 1942, the Quit India Movement launched their boldest campaign yet. It called for a boycott of all things British, including government systems, movies and other foreign products whose profit "goes to the tyrant government." Thousands joined, but thousands of others did not. One Hindu nationalist party openly condemned the movement, because it did not envision India with Hindus ascendent. Likewise, a Muslim nationalist party openly opposed Quit India, to make clear that what India really needed was Islam ascendent. Meanwhile, the Indian Communist party condemned it because it did not do enough to dismantle the Brahmin caste's power.

Sarojini was among the first arrested. The crackdown was swift and thorough, though every attempt was made to *not* martyr the movement's leaders. Hundreds were thrown in prison, where they would languish for nearly two years. Gandhi famously went on hunger strikes, knowing that the British were actively avoiding the death of any leaders, lest they be turned into icons. The plan was, essentially, *ignore it and it will go away*. But, even without its leaders, the Quit India movement kept going as the next generation stepped up.

Then it was 1945, the UN was forming and self-determination was the global mood. The Labor Party swept British politics on a platform of change and Britain's whole posture toward empire shifted.

Britain: "Okay fine, we're ready to hand over the reins. You really seem so terribly divided *notthatwehadanythingtodowiththat*. Can we really trust you not to kill each other once we're gone?"

Indian National Congress (led by Gandhi, repped by Naidu): "Yes, these are differences we can transcend."

Khudai Khidmatgar (Muslim resistance movement led by Abdul Ghaffar Khan): "Yes, these are differences we can transcend. Under no circumstances should you partition land based on religion, it would be disastrous."

Communists: "Yes ... except for the Brahmins, no offense, they'll need to go."

All-India Muslim League: "Yes ... as long as Muslims have a land of their own. Otherwise we can't be held responsible for what might happen."

Hindu Mahasabha: "Yes ... as long as Hindus are in charge. Otherwise we can't be held responsible for what might happen."

Britain: "Ugh, what a mess. We simply cannot allow political chaos to unfold and make us look bad for leaving. Here's what we'll do: in the northwest there are a lot of Muslims, so there we'll create a new Islamic nation called Pakistan. Oh wait, there are also lots of Muslims on the opposite side of the subcontinent too, aren't there? Well ... that chunk can be Pakistan too, I guess. The rest can be a nice unified India. Perfect compromise!"

Thus, in the moment India gained independence, religious mob violence swept the land, resulting in mass migrations—and the deaths of 1 to 3 million people. Between fifty thousand and a hundred thousand women were abducted on all sides of the conflict. Gandhi was assassinated by a Hindu, for being too tolerant of Muslims. (His Muslim counterpart, Abdul Ghaffar Khan was beaten in the streets of Pakistan and imprisoned, for advocating for religious unity.) In short, the horrors the British had hoped to avoid played out ten-fold. Amid the shocking hatred, migration and violence, Sarojini Naidu was appointed Governor of Uttar Pradesh. It was the historical seat of India's past

empires—the home of Nur Jahan's palace and of the Taj Mahal—and one of its most densely populated regions. Its 300 million people were diverse, urban and poor. They were Hindu, Muslim and Buddhist.

Sarojini's work was cut out for her, but she was the Nightingale of India, readying to sing in the dawn. She "played a noble part as the ambassador of amity, goodwill and friendship" said Leader of the House, Gopala Reddi, "especially between Hindus and Muslims." She was seventy years old, much beloved as the voice of the people and with a mammoth task before her, when she had a heart attack and died on March 2, 1949. All of India reeled at the shock—then turned out by the tens of thousands for the last darshan of a woman now holy. Abdul Ghaffar Khan made a public speech to the nation in mourning: Sarojini Naidu "was so great," he said, "Muslims might say she was a Muslim in reality, Hindus that she was a Hindu, Christians that she was a Christian, and so on. She belonged to all religions . . . and her service was great, irrespective of caste or creed."

Her birthday, February 13, is now celebrated as Women's Day in India.

Across the world in the 1940s, Civil Rights movements emerged as all kinds of downtrodden groups agitated for freedom and equality. Nonviolent protest was championed as a powerful tool for social change from South Africa to Ireland, Indonesia to the United States. Inspired by both the UN Charter and by each other, they collectively pushed the limits imposed upon them by The Way Things Are. And though they shared a belief in the power of civil disobedience, as groups they had surprisingly little in common but the experience of oppression. Some groups were defined by (and oppressed because of) their religion, others by race, others by nationality or language. Again, if nations are self-determining, which "selves" make for a legitimate unifier? *Should* we build nations based on religion? Or race? Or linguistic heritage? Or current beliefs? What actually has the power to bring people together and forge bonds where there were none?

Could it be music?

Mary Lou Williams

From the moment of her birth in 1910, Mary Lou Williams was marked out as special. In Atlanta, Georgia, being born "with the veil" (a piece of the amniotic sac over her face) meant this baby girl could be expected to navigate "between the worlds"—to see spirits and receive visions from the dead and be especially gifted in the arts.

Say what you will about superstitions, it'd be hard to think of a more perfect test case for that one than Mary Lou's life. When she was three years old she sat down at a piano and started picking out melodies so astonishing, her mother hightailed it out the door to the neighbors. Not so much out of parental pride—*Come see what my daughter is doing y'all!*—as panic. How *is my daughter doing this? Does this gift come from God, or from . . . somewhere else?*

Wherever it came from, she was eerily gifted. By ten years old, she was headlining packed jazz clubs across her new home of Pittsburgh, up until the wee hours, then playing for several different churches on Sunday mornings. It was her gift that financially supported her mother and ten siblings.

Maybe that's too heavy a burden for a child, because when she was twelve, a traveling vaudeville show passed through town and she went with it. She was an instant hit on "trick piano," playing difficult pieces using just her elbows, playing multiple pianos at once, or spinning around on the piano stool fast enough to make her skirt balloon up—giving the audience a glimpse of her bloomers.

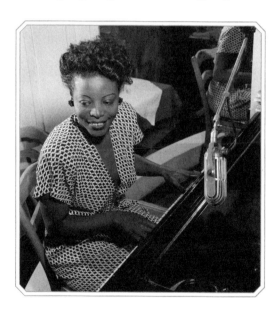

Mary Lou Williams at the piano in 1946.

Having reached the grand old age of seventeen, she married John Williams, who had just been offered a spot with the up-and-coming big band Andy Kirk and His Twelve Clouds of Joy. So off the couple went to the famed jazz capital of . . . Tulsa, Oklahoma. Andy had been very clear that there will be no females

in his band—he already had a piano player, thankyouverymuch. The thing was, he said, even though Mary Lou was clearly very talented, she couldn't read music. No one had ever taught her and she had always gotten by, she said, by "sensing what the musicians around her were going to play before they played it." But *to be in a band, you gotta be able to read the charts!*

So Mary Lou took a gig transporting bodies for the local undertaker. As you do. Until the day a famous music producer came to town and invited the Clouds of Joy to try a recording test. When the band's pianist failed to show, Andy grudgingly pulled in Mary Lou to sub. Delighted by what he heard, the producer offered the band a contract and the Twelve Clouds of Joy were off to New York City. Everyone, that is, but Mary Lou. As Andy had made clear, she was *extremely not invited.*

Strolling into the recording studio where the band was setting up, the producer looked around the room and raised an eyebrow. "Where's Mary Lou?" Scowling, Andy waved a dismissive hand, "We're fine, we don't need her."

"Oh, you *absolutely do* need her," the producer replied. "She's the whole reason you're here. No Mary Lou—no contract." A few frantic (and, we hope, abjectly apologetic) telegrams and one cross-country train ride later, Mary Lou arrived to save the day—and join the band.

But Mary Lou was no longer content to just play music. She was itching to start writing it. She knew she could hear better music in her head than the band was playing, but she didn't know how to get it out. It was obvious to Mary Lou that if she was going to write her own music, she needed to be able to, well, *write* it! So Andy grudgingly agreed to teach her music notation and soon she was off and running . . . or, should we say, *swinging.*

Within a few years, from the mind and pen of Mary Lou emerged some of Big Band's all-time classics. Finally given the tools and the freedom she needed, Mary Lou didn't just break the music theory rules, she rewrote them. She pushed at the boundaries of jazz—and the boundaries moved. It was a new sound that reverberated around the world, emerging like an anthem from the liberating strife of Black America. Jazz had rules while also breaking them. Jazz combined instruments, words and emotions to express the human spirit in an arresting new way. Jazz could reach into the souls of men and women, Hindu and Muslim, rich and poor. It was a sound so powerful, it transcended skin color. Big Bands and their players defied America's racial barriers. Jazz helped to desegregate nightclubs, streets, neighborhoods and then entire cities.

And Mary Lou kept pushing the boundaries. When bebop came bopping onto the scene another few years later, it was an earthshaking shift that left most jazz composers in the dust, unable to adapt to this radically new sound.

Bebop was worlds away from the world she came up in. It's aggressively young, male and above all, *cool*—all about throwing out the past and starting something new. So obviously, Mary Lou Williams, the certified *Queen of Swing* now fast approaching middle age, was the absolute antithesis of everything these cool cats stood for—and they absolutely adored her. Charlie Parker, Dizzy Gillespie, Thelonius Monk, practically the whole jazz pantheon sat at her feet on any given night, learning from a woman they recognized as a crucial musical mentor and kindred spirit—a fellow genius determined to rewrite the rules of what music could be.

But, despite her growing fan club of jazz superstars and her pioneering new work in avant-garde and orchestral jazz, public recognition never materialized for Mary Lou. As her students' names started going up in lights, Mary Lou was still just "the lady on the piano." While they were headlining sold-out venues, she couldn't even get a recording contract. The world didn't know what to do with her—and it was starting to feel like she didn't know what to do with herself, either. This music wasn't something she loved, it was something she *had to do to stay alive*. She always spoke of composing more in terms of an exorcism than a birth—she "had to get the music out of her" or it would eat her alive. And as the depression that had always dogged her finally became too much, Mary Lou suffered a total breakdown. She described "feeling that I would never play jazz again."

And then she heard the voice of God. It told her (rather unexpectedly for a Georgia-born Southern Baptist) to buy a rosary. For the next several years, Mary Lou would spend every morning in her local Catholic church attending mass—then go back home to bed. Finally, a Jesuit priest who had become a trusted friend implored her, "This *is* your gift, Mary Lou! Jazz is how you serve God, it's what God has always been calling you to do!" And slowly, Mary Lou realized that Father Crowley was right. For her, music had always been worship.

Once Mary Lou got the music back, it came faster and more extraordinary than ever. Jazz masses, hymns, mind-blowingly unexpected religious music unlike anything else before, or since. She would eventually become an Artist in Residence at Duke University, mentoring the next generation of jazz musicians, just as she had the icons of bebop thirty years earlier in her living room.

Still composing quite literally on her deathbed, Mary Lou Williams was adding to her musical legacy until the end. And though the fame she deserved still mostly eluded her, in the end, her life was beautiful, complicated, tragic, inspiring, heartrending, heartwarming, always unexpected and endlessly compelling. In other words . . . jazz.

The Cold War

As soon as America dropped atomic bombs on Japan, the USSR got to work making some of their own. Then everyone who was anyone had to have an A-bomb of their own. It was a bizarre arms race, because even Stalin (who we can all agree was a mad man) acknowledged that "atomic weapons can hardly be used without spelling the end of the world." We all knew that if we pushed even one LAUNCH button, the bad guys would push theirs and we'd blow the world to smithereens. Still, if they've got fifty, we'd better be sure we've got fifty-one!

And you know what might be nice? If we could have our own nuclear missile launchpads *all over the world!* No matter where the enemies lurk, we want to be able to nab 'em, right? Not that we *would* launch the missiles, but just to be safe. America and the USSR gazed out across the global landscape for the loveliest spots to stash a nuclear bomb or two. The most strategic places became crisis points: Egypt, Afghanistan, Congo, Korea, Vietnam, Angola and Berlin. Then America thought, why limit ourselves to land? What if we continuously fly at least a dozen B-54 bombers over the border of the USSR, each armed with multiple bombs packing seven times the destructive power as Hiroshima? *Good plan.* We'll be guaranteed first strike. *Nothing could go wrong.* (One such plane crashed while refueling over Spain and they are still cleaning up the fallout in Andalusia.)

But it was in Cuba, so achingly close to the United States, that the Cold War served up a *this is how I die* moment to the entire world.

The World Almost Ends in Cuba

What does it mean to be Cuban? By now you know the variety of possible answers. In the 1950s, after a series of militant dictators, the Communist Party in Cuba was rallying behind a charismatic twenty-seven-year-old Fidel Castro. They were looking for a safe place to build up their forces, a stronghold where they could regroup after each attack. The Sierra Maestra mountains seemed ideal for their purpose, but how would they run a revolution from such a remote and rugged place?

Castro needed a logistical mastermind—a Savant of the Supply Chain, so to speak. Someone capable of keeping all the food and medicine flowing, overseeing construction of camps and schools and hospitals, and making sure all the guns and books and *enormous herds of cattle, apparently?* got where they were needed, when they were needed.

Scouts started asking around for likely contenders and one name kept popping up. Over and over they heard, "If you want to get anything done around here, you're gonna need Celia Sanchez on your side."

Celia Sanchez

Celia Sanchez was a gifted organizer, compassionate humanitarian and brilliant strategist. The "woman behind the curtain" for every major social campaign in the whole area, she had been involved in everything from trying to improve local labor conditions to trying to overthrow the dictator Batista's regime. And *keeping a complicated revolutionary operation running from a top-secret HQ hidden in a remote mountaintop village* sounded exactly like Celia's jam.

Diving right in, Celia swiftly became indispensable, finding herself in Castro's most trusted circle of advisors in a matter of months. In fact, she was crucial to keeping the revolution alive even before it really got off the ground— it was Celia who planned the secret mission to successfully smuggle Fidel Castro and dozens of other revolutionary fighters back into Cuba in 1956.

With Celia keeping all the pieces of the revolutionary machine moving, victory seemed all but inevitable. But she was also single-handedly conducting an extremely unusual and under-appreciated wartime project: documenting the revolution as it happened.

The daughter of a passionate amateur historian, Celia knew the power that would come from being able to tell the story of a movement. She also knew she was the only one in the room with the slightest interest in doing anything about it. Fidel Castro, Frank País, Che Guevara—none of these men were going to keep track of this stuff. So Celia would have to do it herself.

Throughout the revolution, in any situation, she could be found with a leather book bag slung across her shoulder—a mobile archive containing detailed copies of every decision, every meeting, every memo that passed between the Movement's top leaders throughout the war. With this meticulous treasure trove, she would eventually establish Cuba's first official archive of the revolution. In fact, Celia Sanchez's determination to preserve this history is pretty much the only reason we know *anything we do know* about the inner workings of the Cuban Revolution.

But that was nothing compared to what she would do after the war finally ended. Channeling her indomitable energy into massive public works projects

of every kind, Celia seems to have transformed Cuba almost overnight. Any casual stroll around Havana today quickly turns into an Accomplishments of Celia Sanchez Tour. Hospitals and libraries, apartment buildings and parks, clinics and schools—anything that could improve the lives of the average José and Juana, Celia was going to make it happen.

But *why* did she do all of this? Though arguments may rage regarding her political affiliations, tactics, methods, etc., thanks to her letters to her family, friends and fellow revolutionaries, Celia's core agenda is startlingly clear. This was a woman who evaluated every decision in her life via one simple question: *Will it make life better for people?* If the answer was yes, then Celia was *all in*. And as the nation had learned throughout the long revolution, when Celia was *all in*, nothing on this Earth was capable of stopping her.

Not even American secret agents.

Annoyingly for this woman whose mission was to keep everything running smoothly, American CIA agents kept popping in to attempt to assassinate Castro. (America denied this for decades, but newly declassified documents prove it was true.) Castro turned to the USSR for support. *Let's line up some nuclear missiles on Cuban soil*, said the USSR, *that'll teach 'em*. When American spy planes spotted the missiles, the crisis kicked off. And when American newspapers got hold of the information and vividly illustrated the potential Armageddon, global panic set in.

On October 22, 1962, American President John F. Kennedy appeared on televisions in shop fronts across the world, warning that if the USSR didn't back down, the consequences would be dire. Soviet Premier Khruschev sent warships steaming toward Cuba. JFK drew a line on a map: *any Soviet ships crossing this line will "require a full retaliatory response."* Khruschev ordered his ships to proceed. The ships charged toward the line and the whole world watched, helplessly holding its breath.

This is how we die—this is how it all ends.

The Soviet ships blinked. And we all thank them for it: at JFK's imaginary line, they turned. The world collectively took a deep breath and hugged everyone around them.

And Celia was deeply invested in the lives of everyone around her. Unlike many radical idealists, she didn't see the world in the abstract. Even in the midst of managing massive infrastructure projects that would transform the lives of thousands, Celia Sanchez never forgot that *individual people* make up The People and she never stopped working to make their lives better. Will this make *this* person's life better? Will it help *that* person succeed? She is her peoples'

beloved national heroine—the woman who fought for them on the front lines, then spent the rest of her life working tirelessly for their welfare.

After the Cuban Missile Crisis, there was a new global mood: *stop this nonsense*. So a whole host of global leaders came together to find a diplomatic solution. In the end, said diplomats *helpfully decided against* calls to end nuclear weapons, reduce the number of nuclear weapons, or even reduce the size of individual nuclear weapons. Instead, they agreed to stop testing newer, stronger nuclear weapons, and patted themselves on the back for establishing the nuclear test ban treaty.

But how could we, as nations, prove our superiority to everyone else if we were no longer playing Keep Up With the Joneses' Potential Atomic Holocaust?

By launching people into space.

Valentina Tereshkova

The USSR had launched the first dog in space and the first man in space. Then, rumor had it, America was plotting to put the first woman in space.

"We cannot allow this to happen," said Khruschev. "Time to call up some of our female cosmonauts and send them to space!"

Sorry, great Premier, no can do. We have no female cosmonauts—girls are not allowed in the program. (Wait, but . . . gender equality was foundational to the communist movement and . . . and fierce female soldiers, and a comrade is a comrade . . . yeah, we know.)

"Start a female cosmonaut program yesterday," said Khruschev. "Find a woman and fast-track her into space."

How do you find the ideal female cosmonaut with a moment's notice? Parachuting skills are the place to start, apparently. They put out the call: attention ladies with a parachuting hobby! If you are under thirty, shorter than 5 feet 7 inches and less than 154 pounds, come and try your hand at being the first woman in space!

In a textile factory in the smoky industrial city of Yaroslavl, 160 miles northeast of Moscow, Valentina Tereshkova heard the call. Her father had been a tractor driver on a collective farm before he died commanding a tank during the Soviet invasion of Finland. Her mother worked in a textile factory, so when Valentina quit school she worked there too. But she had bigger dreams: she'd taken up parachuting in her free time and kept it secret

from her family. But when she was selected for cosmonaut training from among four hundred candidates, her secret was out. Under the call sign Seagull, she began eighteen months of rigorous training.

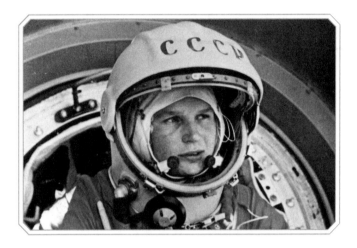

The first woman in space, Valentina Tereshkova, broadcast live from orbit to Soviet television in 1963.

On June 16, 1963, Valentina climbed into a claustrophobic Vostok pod and was hurled into space. The launch was seamless and once in orbit, she famously radioed:

> It is I, Seagull! Everything is fine. I see the horizon—it's sky blue with a dark strip. How beautiful the Earth is . . . everything is going well.

She circled the Earth forty-eight times. Soviet television broadcast live footage of her inside the pod and she spoke directly to Khruschev via radio– this was publicity *gold*. Over the course of three days, Valentina conducted experiments on her own body (forty-eight orbits = major nausea, apparently), as well as taking photos of Earth from space. She had food and water, but they'd forgotten to give her a toothbrush. But, said Valentina years later, "my toothbrush was nothing compared to the fact that the spacecraft was programmed to ascend, but not to descend. Now that was a mistake." The pod, it turned out, was unable to return itself to Earth and would instead spin on and on, forever into outer space. It had been an inherent risk, she knew, but wasn't the point of the whole project to show the world the great success of communism?

In a marvelous rally, the Soviet ground crew was able to send and equip a new computer program that guided her pod back. She parachuted from the pod nearly 4 miles above Earth, only to find that strong winds whipped her chute almost out of control. With immense skill (and a bash to the face), she landed in Kazakhstan, where local villagers helped her out of her space suit and fed her dinner while she awaited pick up. Hailed as a hero back in Moscow, she was given a hug and kiss by Khruschev before delivering a speech from Lenin's tomb. She chose an interesting message: "We know the bitterness of war. We don't need war." She'd seen the beauty and unity of Earth from above, after all.

You're right, we don't need war, the USSR agreed—we need good publicity! The following week, Moscow hosted the International Women's Congress (yes, that same convention that inspired Huda Sha'arawi decades earlier) and Valentina was the star. Women from a hundred and nineteen countries scrambled to invite her for a visit. She couldn't just jet off anywhere, though: her travel required approval by the Ministry of Foreign Affairs, Ministry of Defense and of course the KGB. They sent her to Cuba, where she met Fidel Castro and Celia Sanchez, as the one-year anniversary of the Cuban Missile Crisis approached. She visited New Delhi and was hailed as a "feminist standard bearer bringing a message of hope for 'enslaved' Indian womanhood." She married another cosmonaut in a Soviet-engineered fairy-tale wedding, and went on to meet Queen Elizabeth II while both were pregnant. She represented the Soviet Union at the World Peace Conference in 1966 and at many successive global women's conferences, including the UN.

She did her duty, but all the while she wanted to get back to the cosmonaut dream. She studied hard to make up for past losses and graduated from Zhukovsky Air Force Academy in October 1969.

"That's lovely my dear," said the Soviet command, "but you are far too valuable to us down here. If something were to happen to you in space . . . we really can't allow it."

"Excuse me?" said Valentina.

"In fact," said the USSR, "I think we've made our point about gender equality with the women's cosmonaut program. We're disbanding it now. Please, carry on representing women's equality to the world." They appointed her leader of the Committee for Soviet Women.

Go! Do great things for women! Just not . . . space things.

Continuing to hope, Valentina earned a doctorate in aeronautical engineering. She kept up her training and even underwent medical tests to qualify for space flight, but she would never go to space again. It was her

colleague, Sergei Krikalev, who returned again and again, breaking all kinds of records and chasing endless opportunities.

As if in tandem with her fading dreams, the USSR decayed. By the late 1980s, media censorship loosened, the grip of the Community Party eased and the Baltic states led the way in 1989 with an awe-inspiring demonstration. The whole world watched as an estimated 2 million people joined hands in a "Chain of Freedom" that stretched 370 miles across Estonia, Latvia and Lithuania. Two months later the Berlin Wall came down. Voters ousted Communist Parties all over the Soviet Union and voted for independence next. Valentina Tereshkova had a front row seat, down here on the ground; cosmonaut Sergei Krikalev witnessed the official collapse of the Soviet Union from the Mir Space Station.

It was the end of an era.

Decades later, Valentina Tereshkova attended the opening of a London Science Museum exhibit which displayed her pod (and other Soviet artefacts) outside of Russia for the first time. She stroked the scorched Vostok pod, calling it "My best and most beautiful friend—my best and most beautiful man." She spoke of her regret that so few Russian women had followed her into space. Her dream was to be a cosmonaut, but she was thrust instead into a lifetime advocating for women's equality. The irony is too beautiful for words.

"I think the attitude to women will change," she said at the exhibit opening. "The attitude to women will change, do you hear me?"

Back to Africa

The very same year Valentina Tereshkova was flying in space, Frances Baard was being detained without trial, for twelve months in solitary confinement in a South African prison.

Why? Because, after World War II, Afrikaaners asked themselves, "what does it mean to be South African?" and decided that the important thing was race. Afrikaans (descendants of long-ago Dutch colonists) made up less than 30 percent of the population, but had most of the money and power. And in 1948 when their National Party gained control, racial segregation expanded and was given a snappy name: apartheid (apart-ness). *What we need is to separate all races into distinct districts*, they said. How many races are there? Exactly four: white (all white or white-passing people regardless of origin), Bantu (all Black Africans regardless of origin), Colored (mixed-race) and Asian (mainly from India who'd been brought in for labor). *Of course, if we're putting all people*

in separate race pods, it's the mixed-race people that are most problematic. So, a law was passed banning all interracial relationships. Weirdly, 80 percent of the land in South Africa was set aside for the minority white population (what a surprise!). Black Africans were then further separated once the government decided to reinforce old tribal identities—each individual tribe could live in their own district. *Tribes?* said many Black South Africans, *those were forgotten generations ago. In bringing them back, are we celebrating a cultural renaissance, or are we being divided?*

On the wider stage, African nations were gaining independence almost like dominoes. Even the Rastafarian second coming of Christ, Haile Selassie (King Alpha to Menen's Omega), faced a rebellion from within Ethiopia. Self-determined nations emerged by inspirational nonviolent diplomacy and by terrible bloodshed. Over the decades, it became clear that South Africa was that one weird uncle at the party. Independent, yes—among the first to become so—but its long colonial history was turning into a creepy collection of prejudices.

Frances Baard

Through all of that, Frances Baard, a widowed mother of two, was quietly working in a Port Elizabeth factory. But as apartheid progressed and law after law continued to restrict the movements, lives and rights of Black people in South Africa, she got involved. She joined the African National Congress (ANC; of which Nelson Mandela was a rising star). Now, naturally, women were not allowed in positions of leadership no matter how egalitarian the cause, so Frances Baard became an organizer of the ANC Women's League, where ladies could pursue racial justice in their own dainty ways. Mostly, she poured years into unionizing workers and rallying women to the cause. In 1955, the ANC joined an alliance of organizations to draft and present a, now celebrated, Freedom Charter to the South African government. Frances Baard's Women's Congress had to add an appendix, "What Women Demand," since none of those demands had made it into the official charter (silly little things like equal pay, financial and legal autonomy and child care).

The apartheid government didn't like the Freedom Charter, not one bit.

Things escalated madly. When Black Africans adopted nonviolent protest tactics, the government banned Black people from congregating in large groups.

Frances Baard got creative: she organized a Women's March where twenty thousand women of all races marched on the capital, in small groups of two or three. But no manner of protests would deter the Afrikaaner hold on government (not even when protests turned to massacres that horrified the world). Every form of resistance was, in turn, legislatively outlawed. Eventually, the government's coup de grace was to ban the African National Congress—*easy! Now simply belonging to the organization is grounds for arrest.* The roundup began.

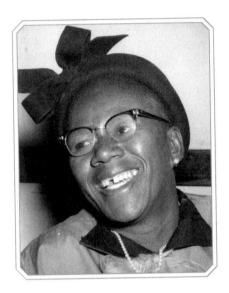

Frances Baard led the African National Congress
Women's League from the 1940s to the 1980s.

Which is where we meet Frances Baard, detained without trial in solitary confinement for an entire year. Finally, she was released, only to be arrested again (this time for, er, uh . . . being a Communist, yeah that's it) and sentenced to five years in prison. How do you keep your sanity in such a situation, never knowing when or how it might end? "My spirit is not banned," she said, "I still say I want freedom in my lifetime."

We know how it ended, though, and it's downright beautiful. In the 1970s, the world finally awoke to reality in South Africa. The UN led the way, denouncing apartheid and imposing a global arms embargo. The UK and US imposed economic sanctions; the South African government started to feel the squeeze.

Okay, okay, said the apartheid government, *Black people won't be required to carry passes (that any white person can demand to check) anymore. You happy?*

"Not good enough!" said the whole world. Rock stars, sports heroes and global celebrities refused to visit South Africa. U2 sang protest songs; Muhammad Ali refused to fight South Africans. Scientists and academics refused to engage with the nation. South Africa was banned from participating in the Olympics. Collectively the whole world joined together to say *no more*. And in a world that was more connected than ever, that was a powerful force.

A newly elected political party started repealing Apartheid laws in 1991 and didn't stop until they were all undone. The dream that Frances Baard had worked and suffered for her entire life became a reality. She was old and frail, still living where she had been banished after release from prison. But when a reporter asked her if she had any regrets, she answered simply, "No, not at all." Her only remaining dream was to vote before she died. And fulfillment was on the horizon: South Africa's first free election was slated for 1994. The African National Congress, no longer banned, had placed Nelson Mandela on the ballot.

When she was eighty-four years old, Frances Baard and millions of Black South Africans voted in a general election for the first time in their lives. Aerial footage showed the world a beautiful, hopeful sight: patient, eager people waited in lines stretching miles along dirt roads to cast their vote. "The images of South Africans going to polls are burned into my memory," said Mandela, "old women who had waited half a century to cast their first vote, saying they felt like human beings for the first time in their lives. It was as if we were a nation reborn."

Frances lived to witness not only the triumph of her life's work but the election of Nelson Mandela as President. The world awaited his inaugural speech with baited breath. What could he possibly say, now endowed with such power but representing as he did a lifetime of injustice? Would he rage against the past? Would he call the people to "hold accountable" those who had oppressed them? Would he tell the ladies to bide their time—that equality would come when the men got around to it?

Mandela spoke of "a united, democratic, nonracial and nonsexist South Africa":

> We shall build a society in which all South Africans, both black and white, will be able to walk tall, without any fear in their hearts, assured of their inalienable right to human dignity—a rainbow nation at peace with itself and the world.

Peace, hope and gender equality were recurring themes . . . *we see you, Frances Baard.*

The game of Risk *did* play out differently, as the world globalized in the twentieth century. In what other century could an Irish rock star and an American heavyweight boxer help swing an entire foreign nation in the direction of equality? It was one of the most explosive centuries in history—and what force *was* running the show, after all? The plotline was absolutely unhinged, from inconceivable devastation to the most soaring triumphs of the human spirit. We witnessed the worst of ourselves, and the best of ourselves. And as the century closed, we collectively took a good, hard look in the mirror: Are we about to bring about The End? Or do we have the power to launch ourselves into a brighter, better world?

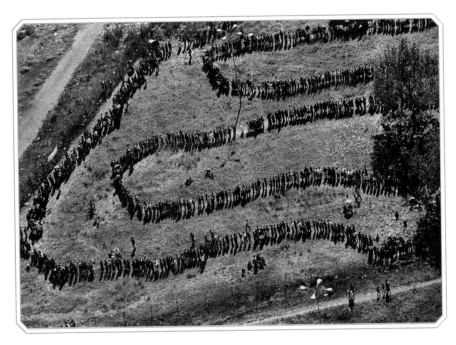

The world watched in awe as South Africans turned out for a historic free election in 1997.

It's a better brighter world already. By every statistical measure, across the entire globe, things are better than they *ever were*. When things feel bleak, it's helpful to remember that the past sheds so much light on the present.

Just now, Millennials across the world are in the wings, about to step into their hour upon the stage. Sociologists tell us that, for the first time ever in the history of the world, this generation has more in common with *each other*,

globally, than they do with the elderly in their own countries. For the first time, a whole generation has shared values. What are they? Authenticity, equality, tolerance. Millennials want meaningful work, to help build something they can believe in. They want people to be able to be themselves, without harassment, restriction, or prejudice. They want to celebrate differences, explore the world and collect experience.

Now that's new. How did a whole global generation come to be that way? Well—in their youth, they witnessed humanity's attempts to atone for World War II, and watched the Berlin Wall torn down by young people. They lived through the cultivated fear of the Cold War, then smiled with surprise when the Internet connected them directly to those "enemies" on the other side of the world. Eventually, inevitably, Millennials will be sitting in all the seats of power and the next chapter in the human saga will be like nothing we've ever seen.

Afterword

The Future Is Now

What can the lives of these eighty women teach us? That the human saga is almost unfathomably long and achingly beautiful. That none of us are alone in our searing pain and our soaring joy. That there is a reason there's such a fine line between crying and laughing. One hundred billion people have played their hour upon the stage, setting up the plot for us. We are this hour of humanity's most incredible creation: our story.

If we had chosen a different set of eighty women, the story would be entirely different, with radically new plot points, enlightening in a new way. That's the whole point: there is no one, correct history of the world. There is no fixed cast of main characters. Human history is a mine of truths we can return to again and again. When we tell the real stories of real people, not the idealized heroes and villains of dusty old textbooks, we see that our human story is made up entirely of people who were ragged but hopeful, broken and beautiful, charging the horizon and yearning for home. In other words, they were all exactly like us.

There are 8 billion stories going on *right now*—each a journey from cradle to grave full of heartbreak and triumph and beauty and destruction, where profound truths are uncovered and the soul grows. Some of the stories are delightful and hilarious, and some are pretty gnarly. All of them are enlightening, especially when you connect them in a chain that stretches down the millennia. You see the whole arc of human history and how you are connected to it all.

When you pause to think about all the lives that have come before—all the souls who have lived and died and passed the baton—your life becomes a little less heavy, a little more beautiful. The stakes aren't as high as you think. But also, the impact of your minor character on the grand play turns out to be profound. As each of us lives our own unique story—a story no one has ever lived before or will again—humanity as a whole is learning, growing. The saga would not be interesting if it were a story of contentment and ease. The saga would teach us nothing if souls were perfect from first to final breath. The saga wouldn't be worth singing, without the struggles that test the limits of the human spirit.

What or where is that limit, to the human spirit? We've been searching. One hundred billion characters over hundreds of thousands of years haven't found it yet.

Selected Bibliography

Books and Articles

Andronicos, Manolis. *Delphi*. Athens: Ekdotike Athenon, 1997.

Bodanis, David. *Passionate Minds: Émilie du Châtelet, Voltaire, and the Great Love Affair of the Enlightenment*. New York: Crown, 2007.

Chambers, Anne. *Granuaile: Ireland's Pirate Queen Grace O'Malley c. 1530–1603*. Dublin: Wolfhound Press, 2003.

Chang, Jung. *Empress Dowager Cixi: The Concubine Who Launched Modern China*. New York: Knopf, 2013.

Chang, Jung. *Wild Swans: Three Daughters of China*. New York: Simon & Schuster, 1991.

Chasteen, John. *Born in Blood and Fire: A Concise History of Latin America*. New York: W. W. Norton, 2001.

Cooney, Kara. *When Women Ruled the World: Six Queens of Egypt*. New York: National Geographic, 2018.

Dai, Yingcong. *The White Lotus War: Rebellion and Suppression in Late Imperial China*. Seattle: University of Washington Press, 2019.

Dalmia, Yashodhara. *Amrita Sher-Gil: A Life*. New York: Penguin Viking, 2006.

De la Cruz, Sor Juana Inés. *Poems, Protest, and a Dream*. Translated by Margaret Sayers Peden. New York: Penguin Books, 1997.

Demertzis-Bouboulis, Philip. *Laskarina Bouboulina*. Spetses, Greece: Bouboulina's Museum, 2001.

Giovinazzo, Diana. *The Woman in Red*. New York: Grand Central Publishing, 2020.

Guenter, Stanley. "The Queen of Coba: A Reanalysis of the Macanxoc Stelae." In *The Archaeology of Yucatán*, edited by Travis W. Stanton. Oxford: Archaeopress, 2014.

Heathcote, Angela. "The Little-Known Story of Australia's Convict Women." *Australian Geographic* (June 4, 2018).

Heywood, Linda M. *Njinga of Angola: Africa's Warrior Queen.* Cambridge: Harvard University Press, 2019.

Hodges, Glenn. "Most Complete Ice Age Skeleton Helps Solve Mystery of First Americans." *National Geographic* (May 15, 2014).

Kennedy, Maev. "First Woman in Space Recalls Teething Troubles." *The Guardian* (September 17, 2015).

Kenward, H. K. *Archaeology of York.* Vol. 14. York: Council for British Archaeology, 1995.

Korshak, Yvonne. *Pericles and Aspasia.* Caryatid Imprint, 2022.

Lal, Ruby. *Empress: The Astonishing Reign of Nur Jahan.* New York: W. W. Norton, 2018.

MacKell, Jan. *Cripple Creek District: Last of Colorado's Gold Booms.* Charleston, SC: Arcadia Publishing, 2003.

Marino, Katherine M. *Feminism for the Americas: The Making of an International Human Rights Movement.* Chapel Hill: University of North Carolina Press, 2019.

Marshall, Peter. *Heretics and Believers: A History of the English Reformation.* New Haven: Yale University Press, 2018.

Messer, A'ndrea Elyse. "Women Leave Their Handprints on Cave Wall." *Research/Penn State* (October 15, 2013).

"Mrs. Sarojini Naidu Passes Away." *The Indian Express* (March 3, 1949).

O'Brien, Keith. *Fly Girls: How Five Daring Women Defied All Odds and Made Aviation History.* New York: Houghton Mifflin Harcourt, 2018.

Olivelle, Patrick. *Upanishads.* Translated by the author. Oxford: Oxford University Press, 2008.

Pan, Emery. "The Murder of Empress Myeongseong of Korea." *China and the Modern World*, Digital Archive of the Gale Review (August 2022).

Pierce, Leslie. *Empress of the East: How a Slave Girl Became the Queen of the Ottoman Empire.* London: Icon Books Ltd., 2018.

Poldermans, Sophie. *Seducing and Killing Nazis: Hannie, Truus and Freddie, Dutch Resistance Heroines of WWII.* Netherlands: SWW Press, 2019.

Rea, Jennifer A., and Liz Clarke. *Perpetua's Journey: Faith, Gender, and Power in the Roman Empire.* Oxford: Oxford University Press, 2018.

Rosling, Hans. *Factfulness: Ten Reasons We're Wrong About the World and Why Things Are Better Than You Think*. New York: Flatiron Books, 2018.

Rothschild, N. Harry. *Wu Zhao: China's Only Woman Emperor*. New York: Pearson Longman, 2007.

Rutter, Michael. *Upstairs Girls: Prostitution in the American West*. Helena, MT: Farcountry Press, 2005.

Selassie, Sergew Hable. "The Problem of Gudit." *Journal of Ethiopian Studies*, Vol. 10, No. 1, Institute of Ethiopian Studies (January 1972).

Shaarawi, Huda. *Harem Years: The Memoirs of an Egyptian Feminist (1879–1924)*. Translated by Margot Badran. New York: The Feminist Press, 1986.

Sippial, Tiffany A. *Celia Sánchez Manduley: The Life and Legacy of a Cuban Revolutionary*. Chapel Hill: University of North Carolina Press, 2020.

Spyrou, Maria, et al. "The Source of the Black Death in Fourteenth-Century Central Eurasia." *Nature* 606 (June 2022).

Tabor, Nick. *Africatown: America's Last Slave Ship and the Community It Created* (New York: St. Martin's Press, 2023).

Talhami, Ghada. *Historical Dictionary of Women in the Middle East and North Africa*. Lanham, MD: Scarecrow Press, 2012

Tiruneh, Fentahun. "Taytu Betul: The Cunning Empress of Ethiopia." *4 Corners of the World*, International Collections at the Library of Congress (March 9, 2022).

Todd, Kim. *Chrysalis: Maria Sibylla Merian and the Secrets of Metamorphosis*. New York: Harcourt, 2007.

Toler, Pamela D. *Women Warriors: An Unexpected History*. Boston: Beacon Press, 2019.

Weatherford, Jack. *The Secret History of the Mongol Queens: How the Daughters of Genghis Khan Rescued His Empire*. New York: Crown, 2010.

Williamson, Edwin. *The Penguin History of Latin America*. New York: Penguin, 2009.

Zheutlin, Peter. *Around the World on Two Wheels: Annie Londonderry's Extraordinary Ride*. New York: Citadel Press, 2007.

Ziad, Waleed. *Hidden Caliphate: Sufi Saints beyond the Oxus and Indus*. Cambridge: Harvard University Press, 2021.

Websites and Film

Meikle, Olivia, and Nelson, Katie. *What'sHerName*. Podcast. https://whatshernamepodcast.com

Abbott, K. "The Fox Sisters and the Rap on Spiritualism" (SmithsonianMag.com, 2012). https://www.smithsonianmag.com/history/the-fox-sisters-and-the-rap-on-spiritualism/

Caldwell, Ellen C. "Cheng I Sao, Female Pirate Extraordinaire." (*JSTOR Daily*, 2017). https://daily.jstor.org/cheng-i-sao-female-pirate

De la Cruz, Sor Juana Inés. "You Foolish Men." Translated by Michael Smith. Poets.org

"Our Lives, Our Stories." Virtual Tour of the Randolph House and other properties at Colonial Williamsburg, including historical interpreters. https://virtualtours.colonialwilliamsburg.org/randolph/

"Sarojini Naidu Poems." MyPoeticSide.com. https://mypoeticside.com/poets/sarojini-naidu-poems

Picture Credits

The publisher would like to thank the following sources for their kind permission to reproduce the pictures in this book:

Page 13: Venus figurines. Photo (left) PhotoStudio/Alamy Stock Photo

Page 13: Venus of Willendorf. Photo (right) Album/Alamy Stock Photo

Page 15: World's oldest known handprint, Sulawesi, Indonesia. Photo (left) Kinez Riza

Page 15: Red handprints in La Cueva de las Manos, Argentina. Photo (right) Mariano via Wikimedia Commons

Page 16: Painting from Caves of Lascaux. Photo Hemis/Alamy Stock Photo

Page 17: Susan Bird recovers the skull of Naia. Photo Hoyo Negro/Paul Nicklen

Page 21: Three thousand stones at Carnac, Brittany, France. Photo Bidouze Stephane/Dreamstime.com

Page 23: Remains of Cranborne Woman. Photo Martin Green

Page 27: Izanami and Izanagi giving birth to Japan. Photo Chronicle/Alamy Stock Photo

Page 31: Polynesian twin goddesses of tattoo and war Taema and Tilafaiga. Photo Roland Pacheco

Page 32: Early World Civilizations. Map by David Woodroffe

Page 33: Script of Minoan Civilization. Photo Olaf Tausch/Zakros Archaeological Museum

Page 34: Blue Ladies fresco from Crete. Photo Carole Raddato

Page 37: Prehistoric dancing girl statue. Photo Angelo Hornak/Alamy Stock Photo

Page 38: Cuneiform tablet inscribed with Enheduanna's poem *Innana* and *Ebhi*. Photo Daderot via Wikimedia Commons

Page 44: Pythia depicted on a Greek cup, fifth century BCE. Photo Adam Eastland/Alamy Stock Photo

Page 55: Steps of the Pnyx, Athens. Photo Public Domain

Page 59: The spread of Christianity. Map by David Woodroffe

Page 61: Modern icon of Perpetua and Felicitas. Photo © Elisabeth Lamour/www.icones-lamour.com

Page 72: Seondeok of Silla, Korea's first reigning Queen. Photo Universal History Archive/ Universal Images Group/Getty Images

Page 77: The spread of Islam in the Middle Ages. Map by David Woodroffe

Page 82: Gold coin struck around 790. Irene depicted alongside Constantine. Photo CNG via Wikimedia Commons

Page 84: Skeleton of Coppergate Woman displayed at Jorvik Viking Center, York. Photo York Archaeology

Page 95: Ruscelli's 1561 map of New Spain. Photo UTA Libraries Cartographic Connections

Page 97: Depiction of Malintzin interpreting on behalf of Cortés. Photo Chronicle/Alamy Stock Photo

Page 98: Zazil-Ha wearing a Mayan royal headdress. Illustration by Mera MacKendrick/ meramackendrick.com

Page 105: Granuaile being introduced to Queen Elizabeth I. Photo Public Domain

Page 111: Petrifying well in Knaresborough. Photo Chris via Wikimedia Commons

Page 112: Poster showing Mother Shipton and many of her prophecies. Photo Public Domain

Page 119: Nur Jahan holding a gun. Photo Courtesy of Rampur Raza Library

Page 129: Merian's illustration depicting a spider eating a bird. Photo Courtesy of Rampur Raza Library

Page 134: Africa under European Colonial Powers, 1913. Map by David Woodroffe

Page 140: Portrait of Émilie du Châtelet. Photo Pictorial Press Ltd/Alamy Stock Photo

Page 157: Illustration of women's march on Versailles. Photo Wikimedia Commons

Page 161: Laskarina Bouboulina at the prow of her warship *Agamemnon*. Photo The Picture Art Collection/Alamy Stock Photo

Page 169: Lakshmibai. Photo Dinodia Photos/Alamy Stock Photo

Page 178: Map of the British Empire from 1886. Photo World History Archive/Alamy Stock Photo

Page 182: Unnamed actress playing role of Nakano Takeko in 1870s. Photo Public Domain

Page 186: Empress Myeongseong. Photo World History Archive/Alamy Stock Photo

Page 189: Empress Tatyu Batul on cover of *Le Petit Journal*, March 1896. Photo Hi-Story/Alamy Stock Photo

Page 198: Mary Peterson at the Fiftieth Anniversary Celebration of the Golden Spike, 1919. Photo Utah Department of Cultural & Community Engagement

Page 201: Redoshi. Photo U.S. National Archives/U.S. Agriculture Department

Page 205: Liang May Seen poses with her adopted son. Photo Minnesota Historical Society

Page 207: Lithograph of the Fox Sisters. Photo The Library of Congress

Page 211: Mary Kawena Pukui. Photo Hawaii State Archives

Page 213: Pearl DeVere. Photo Sonja Oliver/Pikes Peak Courier

Page 216: The route of Annie Londonderry. Map by Mera MacKendrick/meramackendrick.com

Page 226: Amrita Sher-Gil. Photo History and Art Collection/Alamy Stock Photo

Page 229: Sahibjamal Gizzatullina. Photo Public Domain

Page 231: Russia in the nineteenth century. Map by David Woodroffe

Page 233: Cixi on her throne. Photo Pictorial Press Ltd/Alamy Stock Photo

Page 235: Soldiers representing the Eight-Nation Army. Photo Public Domain

Page 240: Unnamed women participating in Women's March, 1924. Photo Bettmann/Getty Images

Page 247: Ruth Nichols in front of *Akita*. Photo PhotoQuest/Getty Images

Page 256: China's Cultural Revolution poster. Photo Venimages/Alamy Stock Photo

Page 262: Josefina Guerrero. Photo The National WWII Museum

Page 269: Sarojini Naidu and Gandhi. Photo Yogi Black/Alamy Stock Photo

Page 273: Mary Lou Williams. Photo Granger/Shutterstock

Page 280: Valentina Tereshkova. Photo Sovfoto/Universal Images Group/Shutterstock

Page 284: Frances Baard. Photo Eli Weinberg, UWC-Robben Island Museum Mayibuye Archives

Page 286: South Africans voting in 1997 election. Photo Associated Press/Alamy Stock Photo

Every effort has been made to acknowledge correctly and contact the source and/or copyright holder of each picture and the publisher apologizes for any unintentional errors or omissions, which will be corrected in future editions of this book.

Index